THE FUTURE IS IN YOUR HANDS

MATERIAL VERNACULARS

Jason Baird Jackson, editor

The *Future* is in Your Hands

PORTRAIT PHOTOGRAPHY FROM SENEGAL

BETH BUGGENHAGEN

INDIANA UNIVERSITY PRESS

This book is a publication of

Indiana University Press
Office of Scholarly Publishing
Herman B Wells Library 350
1320 East 10th Street
Bloomington, Indiana 47405 USA

iupress.org

© 2023 by Beth Buggenhagen

All rights reserved
No part of this book may be reproduced or utilized in any form or by any means, electronic or mechanical, including photocopying and recording, or by any information storage and retrieval system, without permission in writing from the publisher. The paper used in this publication meets the minimum requirements of the American National Standard for Information Sciences—Permanence of Paper for Printed Library Materials, ANSI Z39.48–1992.

Manufactured in the United States of America

First printing 2023

Library of Congress Cataloging-in-Publication Data

Names: Buggenhagen, Beth A. (Beth Anne), author.
Title: The future is in your hands : portrait photography from Senegal / Beth Buggenhagen.
Other titles: Material vernaculars (Series)
Description: Bloomington, Indiana : Indiana University Press, 2023. | Series: Material vernaculars | Includes bibliographical references and index.
Identifiers: LCCN 2023016998 (print) | LCCN 2023016999 (ebook) | ISBN 9780253067685 (hardback) | ISBN 9780253067692 (paperback) | ISBN 9780253067784 (ebook)
Subjects: LCSH: Portrait photography—Senegal—History. | Portrait photography—Social aspects—Senegal. | BISAC: SOCIAL SCIENCE / Folklore & Mythology | PHOTOGRAPHY / Subjects & Themes / Portraits & Selfies
Classification: LCC TR575 .B844 2023 (print) | LCC TR575 (ebook) | DDC 778.9209663—dc23/eng/20230414
LC record available at https://lccn.loc.gov/2023016998
LC ebook record available at https://lccn.loc.gov/2023016999

A free digital edition of this book is available: https://doi.org/10.2979/TheFutureIsinYourHan

For Evelyn and Ada

CONTENTS

Acknowledgments ix

Introduction: Portraits and the Weight of the Future 1

1. "Uncontrollable Circulation": Portraiture in and out of Senegal 36

2. "Send Us Your Photos": Portraiture in *Bingo* Magazine 85

3. Family Portraits 134

4. Ibrahima Thiam's Vintage Portraits 167

5. Cut from the Same Cloth: Omar Victor Diop's *The Studio of Vanities* 202

Epilogue: New Thresholds for "Reigniting Collections" 237

Bibliography 245

Index 261

ACKNOWLEDGMENTS

I THANK MANY PEOPLE for their generosity, thoughtfulness, and contributions to this scholarly work. No one ever writes the book that they set out to write, in part because writing a book is not actually a solo project; it involves exchange and collaboration over a long period of time through which one's thinking is shaped. I thank many friends and colleagues across the US and in Senegal.

The seeds of the book were planted more than a decade ago when Katherine Wiley, who at the time was a PhD candidate in anthropology at Indiana University (IU) and a scholar of Mauritania, described the photo archive at the National Archives of Senegal and suggested that I might be interested in the materials there. This led to many research trips to Senegal but also to other collections worldwide where portraits from Senegal are held. Although I did not make it to many of the institutions that hold collections from Senegal due to the pandemic and the resulting prolonged closure of many museums, their digitization of early photographic materials enabled me to get sense of the breadth of the worldwide dispersion of these materials.

Early on in this project, I received support from the Institute for Advanced Study at IU that enabled me to travel to the Smithsonian National Museum of African Art and the University of California, Berkeley to research photographic materials and Bingo magazine. I thank the Director, Eileen Julien and the Associate Director, Suzanne Godby Ingalsbe. I visited the Smithsonian collection twice and I thank the curator of the Eliot Elisofon Photographic Archive, Amy Staples, Senior Archivist, for her assistance.

Many of the ideas developed here were first explored during my time at the Mathers Museum of World Cultures at IU. It was an immense privilege to have support from Jason Jackson and the Mathers Museum of World Cultures at IU where I held a Faculty Curatorship from 2012 to 2015. During this time, I invited the photographer George Osodi to IU. It was an honor to be able to host him. I am indebted to my colleagues at the former Mathers Museum and the many students who led me to a deeper understanding of collections, including Ellen Sieber, Matt Sieber, and Sarah Hatcher.

During my time at the Mathers, PhD student Kristin Otto, who was working on the global circulation of Mende Sowei Masks, suggested that I think about attending the Smithsonian Summer Institute in Museum Anthropology at the Smithsonian National Museum of Natural History. This led me to think more deeply not only about issues confronting museums and collections but also about close looking at objects. While put on hold for two years during the pandemic, I was ultimately able to attend in 2022 and I thank Joshua Bell, Curator of Globalization, and Candace Greene, Research Associate, for an exceptional research opportunity.

I learned a lot from my colleagues at IU and beyond. Eileen Julien generously convened a seminar through the Institute for Advanced Study on the first chapter I drafted, and many of my colleagues in African Studies at IU contributed to the early formation of my thoughts on this project. I also benefited from conversations with Santu Mofokeng, whom Alex Lichtenstein had invited to the IU Campus. Betsy Stirratt, Director of the Grunwald Gallery of Art, helped me invite Omar Victor Diop to the IU campus as part of the "Framing Beauty" exhibition and I am grateful for the opportunity to host him.

I also received funding from IU New Frontiers in the Arts and Humanities as well as a travel grant from the College Arts and Humanities Institute for this book project to travel to Senegal multiple times.

I would like to thank the assistance of several additional graduate students, Cheikh Tidjane Lo, Gaya Morris, and Dick Powis, who have since earned or are well on their way to earning PhDs.

My work intersected with many scholars and curators at various points, and I thank Patricia Hickling and Joseph Underwood for reading parts of the manuscript in their very earliest stages. I also thank Joseph Underwood for introducing me to Ibrahima Thiam and ultimately driving him to IU for a visit during his exhibition "The View from Here." Certain readers come along at just the right time, and they enthusiastically and generously took me up on my request to read portions of the manuscript and offered much-appreciated

encouragement for the project. I am also grateful for the conversations with Joanna Grabski and Amanda Maples.

At IU I have the privilege of bringing my research into the classroom. I taught a seminar in Photography and Ethnography through which my thinking about collections, methods, and ethics was enriched through interactions with students as well as collections staff at IU. I appreciate how much I learned from my class visits to the Lilly Library, the Eskenazi Museum of Art, IU Archives, and the Archives of Traditional Music. Over the years I benefited from participation in the Scholarly Writing Program at IU directed by Laura Plummer and Genevieve Creedon.

In Senegal, I am grateful to the many families that allowed me into their homes and neighborhoods, shared photos with me, and fed my curiosity. I thank the archivists and curators at the National Archives of Senegal, the IFAN photo archive, and the Raw Material Company.

During the pandemic I was lucky to work with a developmental editor Megan Pugh at the early stages of the manuscript, and my former student and now academic colleague Katherine Wiley who not only had the initial idea but also did the final read, for which I thank her for making this work stronger with her careful editorial eye. I would also like to acknowledge the two external reviewers for their careful and thoughtful read. Their labor has made the work stronger.

I undertook the collections, fieldwork, and writing of this book while I raised two daughters, and this book is dedicated to them. The final stages of the book were written when we were all at home during the first year of the pandemic. Our frequent hikes and our forays into bread baking, solar ovens, and cheese making gave me the space to think deeply about motherhood and my academic work. I thank them for their patience with the process of completing this book; it is stronger because of them. At certain points over the past ten years, I would not have been able to do any of this with young children and in the end, in a pandemic, without the support of my sister Katherine Buggenhagen.

THE FUTURE IS IN YOUR HANDS

INTRODUCTION
Portraits and the Weight of the Future

"When you see my mother, tell her to come home," said Ami, the youngest of three sisters.

"Tell her it doesn't matter if she doesn't have money," added the middle sister.

The oldest picked up the refrain: "Just tell her to come home, just come home."

As they spoke, I began to feel the weight of the digital camera with its neck strap wrapped around my wrist. Standing in the living room in their grandmother's home, with the wind blowing the heavy damask curtains inward, I had been ready to take pictures of these young women for their mother. Each gust of wind brought with it the muggy, gritty air and snatches of the neighbors' conversation. As I listened, I wondered why I was taking their pictures, whether and how it mattered since the three girls had not seen their mother for over six years. Throughout this time, I had also worried about how the separation wore on their mother. I would think of this as I navigated the three flights of stairs up to her studio in Bedford-Stuyvesant in Brooklyn, New York. We would sit on her bed after she turned on the fan or the space heater and look at pictures of her daughters, and when our conversation steered toward the topic of returning to Dakar, her face would tighten up and she would throw her shawl over her left shoulder. She would say that she could not return until she had earned enough money, but each year raised the ante. The longer she was away the more she felt she had to show for her absence.

Ami's mother and I met in the early 1990s when I first lived in Dakar as an exchange student. We were neighbors, occupying adjacent rented rooms in a boarding house next to her family home in the urban outskirts of Dakar. She

often sent her daughters to my room asking to borrow this or that and they would linger as I asked them what the Wolof names for things were. Ami's grandmother, whom I had met during an internship on women and finance at ENDA Chodak (en chômage Dakar, or "out of work Dakar"), had helped me rent the room next to her daughter and invited me to family meals. Soon after graduating from college, I started a graduate program and, with each subsequent research trip, I continued to stay with various members of this family or rented a room in the same neighborhood. Over time, as family members moved overseas, I visited them and our sharing of this and that transformed into my bringing things back and forth between the US and Senegal. Once I brought a facsimile machine on the plane from Chicago to Dakar. Most often I brought bolts of cloth, jewelry, and religious paraphernalia. Carrying these gifts across the Atlantic made me realize their importance to families. These valued objects, especially family portraits, stood in for fractured social relationships that the givers and recipients sought to make whole.

By the time Ami's mother left Senegal for the US in the early 2000s, she said that she felt more impoverished than enriched by marriage. She had been married twice. Her first husband, a Senegalese trader in Italy, never returned, which is how she landed in the rented room next to mine. After constant friction with her second husband's co-wives, she explained, she returned to her natal home again, hoping he would intervene on her behalf. He didn't. Ami's mother explained that once she returned to her parents' home, her adult siblings expected her to contribute to household expenses just as they did with their earnings abroad. Over the years, I watched as she sold a variety of goods, including wax-print cloth from the Gambia, skin-lightening cream from China, and gold-plated bracelets from India, attempting to make ends meet.

Eventually she set her hopes on leaving for the US as so many women in similar situations do (Reynolds 2006). She was able to leave Senegal in the early 2000s. Her migration was part of larger migration flows in Senegal that stretch back to independence in the 1960s. While some migrants such as Ami's mother moved abroad, rural-to-urban migration has also become common over the last fifty years with the expansion of the Sahara reducing farm yields and pushing herders farther south. Those families who remained in the rural towns rooted in agriculture aimed to send their children to the city to relatives who were better off. Ami's family hosted both cousins from smaller towns who hoped for a better life and aunts, uncles, and grandparents seeking extended medical care. Although the risks associated with migration had steadily risen since independence, such movement was not new.

In New York, not yet able to speak English, Ami's mother settled in with one of her younger brothers near Fulton Street and sought out relatives of her estranged second husband as she tried to find her way. Unable to help her find a job or give her money, they instead weighed her down with plastic bags of food that came from the restaurants that lined Fulton Street, giving it the nickname of "little Africa." Each time she would return to her brother's laden with containers of fatty lamb doused in mustard and showered with diced vinegary onions, and fried, stuffed dorade fish on a bed of seasoned rice.

Her separation from her daughters weighed heavily on her. She expressed concern about their marriageability and respectability and at the same time wanted to make sure that they were focused on their education and not getting distracted by romantic relationships. However, she explained how, due to her unregulated status, she considered returning to Senegal carefully; any trip back would likely be permanent since, if her immigration status was discovered, she could be barred from returning to the US for ten years.

Back in the living room in Dakar, with its multiple couches pushed up against the exterior of the room and soft rugs overlapping each other, where Ami and her sisters sat, I was still clutching my camera. I raised it to take a few portraits. The three daughters had tied up a few gifts for their mother in a bright blue plastic bag that they set on the coffee table next to the empty containers of juice and a platter of fish-filled pastries known as *fatayer*. I picked up the bag before I left, promising that I would let their mother know their pleas for her return when I delivered the gifts.

Once I was back in the states, I came across a portrait that Ami posted on social media of her and her mother. The foreground showed Ami from the shoulders up, with her mother in the background, looking forward. Both of their bodies were hidden by the way the portrait faded into black. It was a remarkable double exposure that could be read as both wish fulfillment and heartache. The picture signaled Ami's wish to be reunited with her mother and her sadness that their separation continued. Through this evanescent image, Ami sought to connect to memories of her mother, suture the rupture in her present, and author her own future. When Ami uploaded the portrait to social media, she shared those sentiments with her community of friends and family, indexing her attachment to her mother as well as her desire to be close to her again.[1]

Double exposures, whether filmic or produced by digital editing, extend across West Africa, where they are often used to eulogize a lost twin or other loved one (Sprague 1978). A double exposure image combines two exposures—in this case that of Ami and her mother—into one photograph, sometimes

resulting in a spectral image. Double exposures allow persons separated by death or distance to appear in the same place at the same time. But where these memorial portraits often hang on the walls above dressers or are placed in albums, the photograph of Ami and her mother, as far as I could tell, disappeared into the ether, like many digital portraits. On social media people commented that it was *diis naa* in Wolof, or "heavy," people refer to important conversations, attractive portraits, and successful family albums as heavy. It was a striking portrait; years later, I remember seeing the portrait just as well as I remember hearing Ami's pleas for her mother to come home. When I visited Ami many years later in Brooklyn, where she had reunited with her mother to attend nursing school, I never saw the portrait. Recently, I revisited her social media profile to get a closer look, convinced that the picture told a story I now wished to convey. It was gone. Once in Brooklyn, Ami had become a more devout Muslim and when she embarked on her new spiritual path, which included veiling, she told me she had deactivated her account and with it, her portraits showing her uncovered hair.

When Ami edited the photo to place herself and her mother in the same frame, she was participating in a set of practices around West African photographic portraiture that, while they have changed considerably over time, have been as central to Senegalese life for nearly a century as outward migration. Women and men have long enjoyed having their portraits taken, working with their photographers to produce images of themselves. Women have also exchanged these portraits with friends and family members, in part to cement these relationships. Although Ami could only share this digital image on social media with her distant mother, her public display of it also echoed the role that portraiture has long played in migration. In the early twentieth century, Senegalese who had migrated to France for education were conscripted by the French to fight in World War I, World War II, and the French Indochina War. They had also migrated to North Africa and the Middle East for trade, education, and to make religious pilgrimages. Migrants often sent portraits home and mothers often sent portraits back of prospective brides to soldiers and students overseas as they arranged their marriages in their absence. For these migrants, personal portraiture endured as a means of displaying success and affection, and people often returned home to rural areas with these keepsakes. As personal and cell phone cameras became more available to migrants abroad from the late 1990s on, migrants often sent snapshots of themselves at important markers such as the Eiffel Tower or the Statue of Liberty. As overseas migration to Europe and the US increased in numbers and in danger throughout the 2000s, young people snapped selfies of themselves with smartphones on urban

streets in fashionable clothes to demonstrate their safe arrival and, eventually, their marriageability.

Critical work analyzes the period of studio-based portraiture produced in West Africa from about the 1930s until the 1970s by renowned photographers and details concerns related to art markets, preservation, and heritage (Keller 2021; Bigham 1999; Bajorek 2020; Rabine 2010; Evans 2015; Paoletti and Biro 2016). Among these concerns are the appropriation of vintage studio portraits by the art market and worries that preservation efforts can at times echo the colonial impulse to collect and salvage bygone worlds by locking them away in museums and archives. This paternal impulse to remove portraits of a vibrant life from their social contexts for display to a museum-going audience plays into the ongoing exoticization of African sitters from this period (Gruber 2021, 215). In this book, I look at the efforts of lens-based artists in Senegal to regain control over the circulation of portraits from this era.

The art system's fascination with midcentury studio portraiture overshadows the varied and expansive image worlds across West Africa today as well as many of the prolific photographers of the past. Although many photo studios have closed their doors, unable to compete with automated color-processing labs, portraiture continues to flourish across Senegal through digital cameras, smartphones, and social media. Portraiture endures as a mode of personal presentation. Moreover, in the space between the demise of studio photography, the unviability of black-and-white photography, and the digital revolution, photography as an artistic medium and the market for contemporary African photography have flourished (Moore 2020, 2). This movement was aided in part by the establishment of the French-funded Rencontres Africaines de la Photographie in Bamako in 1994 as well as the gradual opening of Dak'Art, the Biennial of Contemporary African Art in Dakar, to photography.

What this history makes clear is that portraiture—from Ami's photo to the fine art photographs displayed at Dak'Art—has played and continues to play a major role in Senegalese life. While this book in part traces the history of portraiture in Senegal from the colonial period to the present, it also focuses on photography in use, exploring portraits' visual properties as well as their role in the family and social life as objects that are displayed, exchanged, and circulated. My research was inspired by the following questions: What meaning has portraiture had for Senegalese people over the past century and how has it changed over time? What makes a portrait diis naa, or heavy, and how do its properties operate beyond the level of the visual? What role has photography played in people's attempts to build meaningful lives and assert themselves as valued persons? How do contemporary lens-based artists who

draw on portraiture in their work build upon, extend, and challenge these historical practices?

Portraiture plays into an encompassing image world in Senegal of "visual overload" (Roberts et al. 2003, 28) that includes a range of popular expressions in the past and present. The popular culture of portraiture includes commemorative cloth, T-shirts, pendants, and pins depicting portraits of religious and political figures to celebrate official visits or holidays and to demonstrate membership in religious associations or political organizations. In the early part of the twentieth century, portraits also appeared affixed to reverse-glass paintings that embellished them. Illustrated magazines such as *Bingo*, printed portraits of readers, artists, and literary figures and religious and political leaders. In more recent decades, graffiti artists often reproduced portraits of political and religious figures on city walls, extending the museum into the community.[2] This vast visual culture "is the manifestation of visuality in daily life, as well as in its epiphanal moments" (Roberts et al. 2003, 21). It embodies the visual hagiography of the central figures of the Sufi congregations, politicians, and musicians as well as ordinary persons.

For many men and women in Senegal, portraiture has continued to serve as a vital index and creator of social connection (Buggenhagen 2014; M. Konaté 2012; Mustafa 2002; Paoletti 2018; Bajorek 2020; Rabine 2010). This is no less true of portraiture created by a digital camera or smartphone, manipulated by photo-editing software or filters, and uploaded and shared on social media. Such digital photography and the assemblages the medium affords are as much a form of what Jennifer Deger calls "thick photography" as its analog predecessor, mobilizing and layering "affect, image, and meaning" into something more, something thicker (2016, 112). The digital space enabled Ami's remediation of her mother's matrimonial portrait and her own. She combined two images and two moments into a single frame; a feat unobtainable in real life, but which provided meaning for her. When such creative work is effective, on the screen or in albums, women in Senegal often comment on the portraits in the way they responded to this one, as diis naa, or heavy. A "heavy" portrait is one that is not just aesthetically pleasing, but that also might stir emotion in the viewer or convey important messages about the sitter's persona and social position. Thus, portraiture in Senegal is as "heavy" as it is "thick" in the way that Deger discusses. Its heaviness provides a counterweight to the structural pressures on families such as environmental and economic devastation that compel migration, and it solidifies relations fractured by these pressures. Portraits and their digital remediation anchor families thus caught in dangerous seas. As forms of value, as images, and as material objects, framed photographs and digital

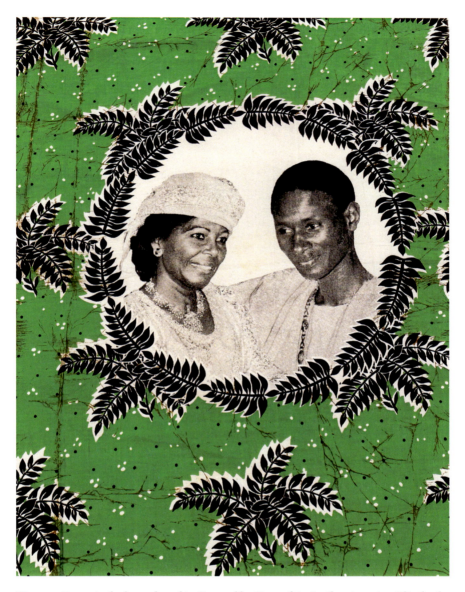

Fig. 0.1 Portrait cloth produced in Senegal by Simpafric-Sotiba picturing Elizabeth and Abdou Diouf (president of Senegal from 1980 to 2000). *Smithsonian National Museum of Natural History, Department of Anthropology, E432591.*

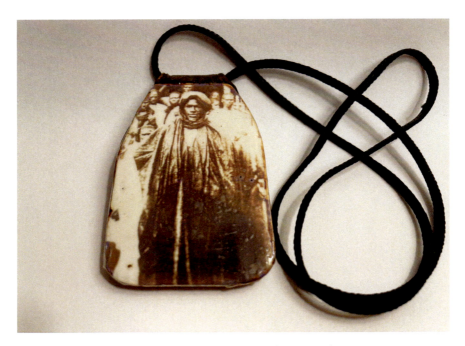

Fig. 0.2 Pendant featuring Cheikh Ibrahima Fall (1855–1930), the first disciple of Amadou Bamba, founder of the Murdiyyah tariqa. Leather, paper, cordage. *Courtesy of the author.*

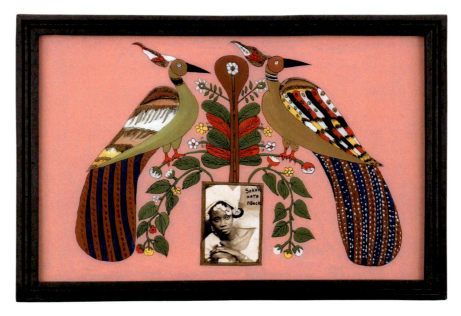

Fig. 0.3 N'Diaye Lo, painting with photograph of Sokhna Nata Mbacke, 2001. Reverse glass painting with applied photograph, 48.7 × 70.8 cm. FMCH TR2002.1.10. © *Photo courtesy of the Fowler Museum at UCLA.*

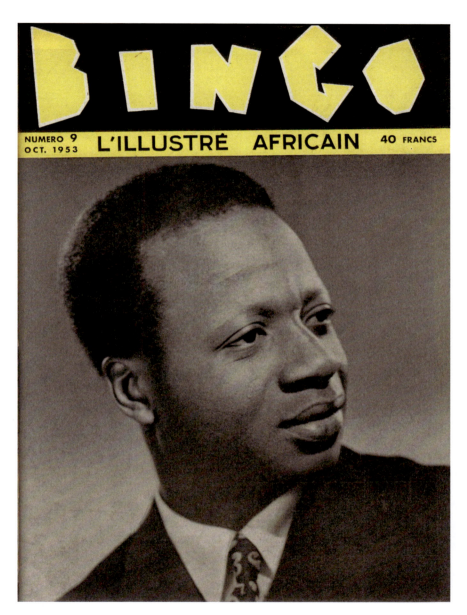

Fig. 0.4 Cover of *Bingo* magazine, October 1953. *Emile-Derlin Zinsou, Conseiller du Dahomey, Photo NATKIN, Paris.*

portraits, and the screens that display them, continue to carry weight in social life alongside other valued objects of material culture, including textiles and religious texts and images. Valued objects such as these materialize social relations across and against distance and time.

From my first visit to Senegal, I noticed how much photography and sharing photographs serves as a major pastime for young people; examining photo albums and swapping portraits was an activity I often enjoyed participating in before I conceived of it as a research project. Women would often linger over photos from a recent dance, religious conference, or family celebration, which they might spread out across a bed as they gathered around picking them up and passing them around. Such photos provided ample fodder for gossip. They also were models for the latest fashions and styles. At the tailor shop, where many people obtained their clothing and socialized, shoppers would pore over albums of the tailors' recent designs and thumb through fashion magazines published locally, such as *Amina*, or brought from overseas. Women took out photographs for visits from friends that they would peruse as they enjoyed the elaborate and elongated sweetened mint tea rituals that would fill an entire afternoon. Not only did many young people possess packets of portraits from dances, religious gatherings, and family celebrations, but they also commissioned photographers to create albums to mark occasions such as their own weddings, their children's births, and milestones of their friends, siblings, and cousins, even as they also spent a lot of time posing for selfies and posting images to social media for family members who had long been abroad.

In homes across Senegal, women still pull photo albums out for visitors as habitually as they pour glasses of cool water and turn on fans. In the 1950s, women would often go to the studio with friends and have multiple prints made so they could each have one, the exchange of portraits cementing the friendship. Today, they might slide portraits out from plastic sleeves of their photo albums and offer them as souvenirs of a visit, just as they might repost a friend's photo on their social media account partly to reinforce their relationship. At the homes of wealthier families, these albums might be heavy and cloth-covered or leather-bound with embossed pages. More often, in the more modest self-built dwellings on the peripheries of Dakar, family albums feature vinyl covers that become sticky with age, making smacking sounds as they are opened and as their pages are unstuck. These cheap plastic albums reflect the ephemeral nature of remittances from migrant husbands, brothers, or sons to their families as well as the precarious nature of migrant life more generally, especially after the global recession of 2012, the imposition of increasingly strict immigration policies across Europe and the US, and the global COVID-19

pandemic. Rather than a static archive of a family's past, these store-bought albums serve as temporary vessels, like the pirogues that carry new passengers with each risky crossing. Women swapped portraits in and out among friends as quickly as their fortunes changed, buttressing social bonds, and hoping for better futures in the process.

During my various visits when I was working on this project beginning in 2011, I searched in vain for storefront studios that I had once known in migrant neighborhoods in the outskirts of Dakar. If the heyday of the studios was from the 1930s to 1970s, when they were fixtures in every neighborhood across Dakar, Saint-Louis, and a few rural areas, they have largely been replaced today by young, itinerant photographers. In part this shift in Senegal, and elsewhere on the continent, came after the introduction of 35 mm color film and less expensive, automated color-processing labs in the 1980s, but it was also due to the inability of studio photographers to replace outdated equipment and chemicals, which were both costly and increasingly unavailable, and in some cases related to declining health, which some people attributed to toxic darkroom chemicals (Buckley 2000; Gruber 2021; Zeitlyn 2019; McKeown 2010; Werner 1996; Tatsitsa 2015; Bajorek 2020). Moreover, color film's quality was inferior to that of black-and-white film, a fact that also contributed to the demise of skilled photographers (Moore 2020, 56). Further shifts away from studio-based photography followed the introduction of digital cameras around the 2000s. By 2014 and later, smartphones and social media had shifted the terrain of photography further away from the studio and toward the photographer for hire (Gilbert 2019).

In Senegal, these new, itinerant photographers snapped portraits at parties and family and religious celebrations rather than in the studio. They deftly moved from 35 mm to digital cameras taking portraits with their rented equipment from the Korean-owned photo labs that quickly processed and printed out their photos that they could sell to sitters at an affordable price. However, these new photographers lacked their predecessors' skill of composition, lighting, and arranging poses as well as their ability to conduct the darkroom printing where much of the magic happened (Moore 2020, 56). Despite the photos' lower quality, women continued to buy portraits for themselves and their friends as souvenirs just as women in the past had gone to the studio together to have their portraits taken to cement their friendships. When their friends remarked on how well the photographer captured their charm, women would burst into praise for the photographer. When the sitter did not come out well, they would throw the photographs back at the photographer and hurl insults at him for his lack of skill. As often as not, women lacked consensus on what

exactly makes a good portrait and gatherings often became an occasion to talk about sitting for photographs, finding striking poses, and hiring a good photographer. During these gatherings, women often commented on the collaborative nature of photography in that sitters and photographers worked together to produce ideal images as well as photographs' role in furthering their reputations in their communities.

Flipping through Senegalese photo albums reveals the contours of these vibrant and dynamic social networks, but one must read between the lines to appreciate the absences and silences. Portraits reflect deeper concerns with the vital labor of social regeneration. Leading up to independence in 1960, portraiture reflected the social and political aspirations of many Senegalese men and women and their increasingly international outlook as sitters copied poses and photographers borrowed lighting techniques from portraits of foreign celebrities. In the postindependence era, as social, economic, and political ambitions went unfulfilled, those aspirations were tempered. Portraiture reflected the changing fortunes of many young men who had migrated to larger cities and eventually overseas in an era of economic boom only to be met with the worldwide recession of the 1970s.

Over the past century, through the medium of portraiture, Senegalese have made a meaningful and connected life amid enduring stress and the foreclosure of fiscal futures over the decades of strife from structural adjustment, economic liberalization, the global recession, and the COVID-19 pandemic. The visual and the material continue to be the primary media through which these transformations are realized. Against isolation, rupture, social stress, and loss, these printed and digital portraits reflect efforts to renew and reimagine a vital social world. This book explores these changing portraiture practices over the last hundred years, arguing that to understand the weight of contemporary practices we need to examine the roots of Senegalese portraiture. Exploring colonial-era portraiture, the display of portraits in the midcentury illustrated publication *Bingo*, and the circulation and curation of images through family albums helps us better grasp portraits' shifting meaning through the decades. Furthermore, the book demonstrates how exploration of these past practices provides insights into contemporary Senegalese portraiture, particularly the ways in which lens-based artists such as Ibrahima Thiam and Omar Victor Diop have adapted and reworked portraiture practices to speak to issues of heritage and preservation as well as the ways in which portraiture can suggest future worlds. The book illustrates the essential role portraiture has played in Senegalese life and thus also provides insight into the medium itself as a powerful art form that works not just on a visual level, but also on a visceral and

affective one. It is this complexity and richness that makes photography such a central feature of Senegalese social life.

In sitting for a portrait, Senegalese not only imagine a better life, but they also create a vision of themselves in an object form that circulates in social life. Through the exchange of personal portraiture, they create the dense social networks that sustain their worlds. A baby "sweetens the marriage," and the mother's portrait taken during the *ngente*—the baby-naming ceremony held seven days after the birth of a child according to Islam—indexes her new status as a mother who has standing in her family and community. It is these images that, in part, help the mother become part of a community of mothers swapping and saving each other's portraits in their personal albums. By helping people create and circulate desirable personas, portraits act as shields against miscarriages, divorces, and the stresses of financial strife, disease, or the search for work that drives a wedge between spouses caught up in lives on different continents. Photographs buffer sitters from the fragility of life. For this and other reasons, Ami's mother often studied the portraits that I brought back in those initial years before social media and the proliferation of smartphones and asked me questions about my perception of her daughters' appearances, seeking to discover their social potential.

FROM THE VISUAL TO THE VISCERAL

As Ami's mother and her daughters well knew, portraiture, whether on the screen or in an album, has the potential to work as a "force that produces certain kinds of selves and social formations as well as whole constellations of imaginaries and networks of many kinds" (Wright 2013, 12). These personal portraits express larger "strategies communities use to materialize their social relations, desires and values" (J. Bell and Geismar 2009, 3). As material objects that condense these social relations, photographs work in tandem with verbal exchanges "recursively and creatively" (Jackson 2016, 4). For example, I understood and felt Ami's digitally manipulated photo more deeply when I viewed it on social media because of the conversations we had had about her separation and longing for her mother. As I examined this image, I thought about how both online and in person many people often commented on the capacity for young women to *munn*, a Wolof word meaning to endure or be patient with the separation that is so common in this community, historically rooted in dry-season migration, overseas work, and religious travel (Buggenhagen 2012). The picture of her mother on which Ami based her assemblage conveyed patience: it depicted a newly married woman whose husband had

embarked on overseas commerce in Italy. During my research, I observed how the circulation of portraits like these bound families strained by distance, difference, and dissonance, like Ami and her mother, and like Ami's mother and her first husband. The circulation of personal portraits in and beyond print media form and materialize individual and collective identities such as family, community, and nation (Foster 2002; Strassler 2010, 4). At the same time portraits are formed through these very relations. They are, like other media including radio, "doubly articulated" (Spitulnik 1998 quoted in Gershon and J. Bell 2013, 261). Photographs as objects are forged through social practices that also facilitate social interactions. Senegalese women thus take portraits together with family and other community members, and the exchange of such images further articulates and cements their communities.

Through ethnographic research during which I formed relationships through screens, in homes, and in and out of the archives and collections with photographers, I was moved beyond seeing images as screen-based or paper-based objects or as merely visual or digital objects. I came to appreciate photographs as visceral objects as we held photos and laughed at them, shook our fists at them, passed them back and forth, or discussed various aspects of them. They would become what Elizabeth Edwards describes as "objects in the telling of history" (2006, 27). As she elaborates, viewers grasp these histories through touch, so holding photos becomes central to seeing photos. Photographs may also contribute to how histories are retold. Beyond their material qualities and their abilities to represent and tell history, photographs "socially enfold historical experience" (Morton 2015, 253). Photographs, as sensory objects that are held and viewed, convey historical understandings, feelings, and memories that exist below the level of discourse.

Understanding the social potential of photography entails a turn from the visual to the visceral, not only to capture the sentiments underpinning the making and circulation of portraits but also to explore the way in which their material qualities work to elicit the senses and thus affect. Edwards has shown the myriad ways in which photographs are more than surface images and material objects; they are "object[s] of affect" (2012). As moving entities, photographs not only hold the capacity to record but also to materialize relations; this capacity is true of both the analog and digital formats since photographs are more than the sum of their materials and more than mere objects (Deger 2016, 129). Indeed, the portraits that Senegalese women circulate and exchange among friends make and strengthen their bonds with others. Similarly, Ami's digital portrait of herself and her mother was not just a reflection of her inner

feeling. It was a powerful affective device that worked to constitute her migratory path toward the US and her eventual reunion with her mother.

As artifacts of visual culture as well as pieces of material culture, photographs convey the touching and visceral experiences of those who produce and possess them. The multisensorial and multimodal approach to photographic objects that I employ throughout the book yields insights into how these forms of value constitute social relations through their evocation of affect. Recent interventions in the field of visual anthropology have considered peoples' affective, oral, and haptic relation to photographs past and present (Buckley 2014; Geismar and Herle 2011; Pinney 2004; Roberts and Roberts 1998; Strassler 2010). This multisensorial approach to social life—understanding the interconnection of aural, oral, and somatosensory perception and the ways in which they overlap (Pink 2009, xiii)—complements visual appreciation and apprehension. Bringing into focus these social and affective processes in Senegal not only shows how photographs circulate in social life, it also portends what happens when they are collected and stored in archives and museums.

Portraits and the relations that they weave can only begin to be understood by anthropologists when we are part of the social life in which they circulate. With the advent of COVID-19, my relationships abroad were suspended since travel was foreclosed; however, social media posts announcing the passing of someone I had known, most of which featured portraits, sent an emotional wave through me that shocked me out of my isolation while at the same time bringing it to the fore of my consciousness. These posts mourning the loss of a family member were often met with the reposting of portraits of the person over time, a sort of collective community sourcing of images via social media. Through ethnographic research, especially that which is long-term, reciprocal, and rooted in local languages, we can also make more of the sensorial aspects of image-making and circulation in relation to the making of publics and counterpublics. Whether on social media or in real life, ethnographic research makes it possible to be attuned to the uptake of images circulated in social life and thus to gauge their affective weight (Larkin 2013a).

The social process through which material objects circulate and gather meanings in new contexts has also been described as "bundling" (J. Bell 2017; Keane 2005, 188). Bundling might be described as the process whereby the weight of any one element shifts as objects move from one social context to another or from one medium to another. Consider the example of Ami's assemblage featuring her mother's matrimonial portrait, which hung on the wall of her grandmother's living room. The large-format print showed a young mother

dressed in brilliant green silk formal wear, hung low enough to reveal the tops of her shoulders, her eyes lined with kohl looking upward, and filigreed gold jewelry encircling her neck. As the years passed, Ami's mother's ensemble began to look dated and faded, as did the portrait. It hung slightly askew, the paper warped by the humidity, and it was dwarfed in size by several larger and more colorful factory-printed images of Mecca. Once a reflection of the marriage payments that helped fund the bride's finery, the portrait now reflected a past aspiration unfulfilled since Ami's mother returned to her natal home with her first two daughters in tow after her husband migrated to Italy, unable to shoulder the responsibilities of the marriage.

When Ami took her own portrait and combined it with her mother's, she combined two moments in time, the past and the present; two places, Dakar and Brooklyn; and two different media, analog and digital, which she then uploaded to a new context for a new audience. The weight of her mother's first marriage no longer determined the meaning of her matrimonial portrait when Ami combined it with her own in the context of her mother's absence. Such is the power of valued objects such as portraits to both reflect and repair social engagement and estrangement (J. Bell 2021, 169). Ami's interactions and those of her audience with the photographic object produced new meanings. When recombined with Ami's portrait and placed on social media, the meaning and value of her mother's portrait shifted to her role in fostering Ami's ambitions. As "likes" accumulated, friends commented on the shared beauty of the mother-and-daughter pair and offered blessings for their future potential. Loss shifted to nostalgia, hope, and potential yet to be fulfilled. The migrant mother behind her, looking down on her, now empowered her own journey abroad. It is "bundling" like this, and the way that photographs gain new meanings as they move throughout shifting contexts and times, that I focus on in this book.

PORTRAITS IN HAND OR IN THE ARCHIVES: ADDRESSING HERITAGE AND VISIBILITY

The curator and art critic Okwui Enwezor lamented that archives across the African continent remained "in a state of historical incarceration, played out in media experiences, museums of art, natural history, and ethnography, in old libraries, in memorabilia concessions, as popular entertainment, in historical reenactments, as monuments and memorials, in private albums, on computer hard drives" (2008, 40).[3] In a related vein, the historian James Searing (2002) observed that the National Archives in Senegal in particular amounted to a set

of documents for the prosecution as a collection of French-authored materials in support of colonial efforts. As fraught and at times painful as archives may be, contemporary lens-based artists have been unlocking them and rethinking how these materials might be addressed and made relevant to contemporary audiences in Senegal and beyond.

Artists have increasingly turned to archives as a basis for creative exploration, to engage with the past and to understand the present (De Jong and Harney 2015, 4). For Ibrahima Thiam and other lens-based artists, archives serve as a "conceptual platform ... the political screen" for this work (Firstenberg 2001, 179). As Enwezor argues, "yet, against the tendency of contemporary forms of amnesia whereby the archive becomes a site of lost origins and memory is dispossessed, it is also within the archive that acts of remembering and regeneration occur, where a suture between the past and present is performed, in the indeterminate zone between event and image, document and monument" (2008, 47). As Ibrahima Thiam has remarked, "Even for archives and memory, I think it's necessary to visualize them as being part of the present. And projecting them into the future" (Underwood 2018, 34).

If resting in an archive or museum collection might be understood as just one moment of a photograph's circulation, then possibilities open up for it to be understood in other registers (Edwards 2003, 92). Visual materials such as photographs contain an excess of meaning that furthers possibilities for their reinterpretation (Poole 2005). It is this surfeit of meaning that provides space for Thiam to explore the indeterminacy and ambiguity of colonial-era photography. His work is similar to that of Tsinhnahjinnie's (2003) engagement with family photographs and their redemptive possibilities amid the context of settler colonialism in North America. For Thiam, photographs in the archive present the opportunity to disrupt the periodization of the archive as they hold past, present, and future time in them at once and thus hold the capacity, when reignited, to address a fractured history told from the colonial documents. They also provide the important possibility of reengaging young people in their history.

Many other lens-based artists have taken similar approaches to colonial and apartheid-era archives and family collections. Samuel Fosso's *African Spirits, 2008* (Njami 2010), Nomusa Makhumu's re-enactment in *Self-Portraits*, and Santu Mofokeng's counter archive, *Black Photo Album/Look at Me, 1850–1950* are just a few examples of ways of politically engaging with this fraught visual past by revising and restaging that past, often using satire and wit. Thiam's work stands out in its focus on the regenerative possibilities of archives (De

Jong and Harney 2015, 1) to create a counter archive (Buckley 2005). Through his art, Thiam seeks to restore social and aesthetic value to unidentified family photographs that he has found as well as to his own family's photographs.

Yet, Thiam and and other photographers including Omar Victor Diop discussed how young people in Senegal were indifferent to these historical photographs, which struck this new generation as simply part of the past, closed and locked in tin trunks or stashed at the back of old albums held in armoires. Since I had first gone to Senegal in 1992, I too had noticed how in recent years young people expressed less and less curiosity about old photos or in the context of what Barthes (1981, 76) describes as "that-has-been" in reference to the indexical traces of the past that photos provide. Indeed, Liam Buckley observed that when he shared colonial-era photographs with viewers in the Gambia, they found them old and aesthetically unappealing (2014, 720). These old photographs were not, according to Buckley, viewed as other contemporary photographs, which were *jamano*, a Wolof word used to refer to something hip or stylish, such as fashion and hairstyles. Because photographs are seen as part of the present they were also not viewed as *coosan*, or a part of tradition or local history. Therefore, they could only be seen as out of date. If the heyday of studio portraiture had waned throughout the postcolonial period and into the present, and young people were no more interested in its aesthetics, which they saw in their parents' photos, than they were in historical photographs belonging to their grandparents' generation, how would Thiam foster the acts of remembering and renewal of which Enwezor spoke? How would Thiam unlock the archives for this generation, which to the artist seemed so vital to their understanding of their own subjectivity amid a history of global volatility?

To address this question, Thiam pushes the contradictory forces of conservation and change, what the anthropologist Annette Weiner (1992) described as "keeping-while-giving." He collects and conserves fragile portraiture from family archives to preserve Senegalese photographic heritage. He also seeks to prevent collectors looking for the next Seydou Keïta or Malik Sidibé, Malian photographers who were discovered by the art world in the late 1980s and whose work is sought by Western collectors. Already aware of how much of Senegal's photographic patrimony rests in Europe and the US he seeks to prevent international collectors and gallerists from buying up family collections, figures Érika Nimis refers to as "vintage portrait hunters" (2014b, 397). In chapter 4, I discuss how Ibrahima Thiam engages in collection and preservation to keep photos in Senegal and out of the hands of fortune seekers. Studio archives and family albums have been appearing on the international art market sought by

Euro-American collectors and institutions alike for their aesthetic qualities and monetary potential (Micheli 2012; Haney and Schneider 2014, 308). Consequently, photographic heritage from the continent, whether family albums or studio portraiture, often resides in private hands, from collectors to gallerists and museums (Bajorek and Haney 2010). Thiam thus preserves Senegalese photographic patrimony while at the same time controlling its circulation through his digital portraiture and installation work, thus guarding against loss.

Many of the early photographic materials from Senegal now belong to major institutions and circulate in economies and property regimes outside of Senegal. Although I have been arguing that a focus on the circulation of objects with attention to different moments in their lives opens a space to consider their rearticulation in new contexts, in fact, scholars have also been arguing for an inversion of the object biography (Appadurai 1986) and relational entanglements (Thomas 2009). Dan Hicks (2020, 153), for example, suggests that rather than biographies, "necrographies"—the writing of loss—might better respond to calls for addressing colonial violence and the return of valued objects to their communities of origin. More specifically, colonial-era images of Senegal landed in Euro-American museums largely because they were alienated from their sitters through commodity trade such as postcard production and circulation, in addition to serving as colonial documentation for a variety of projects from surveilling religious leaders and movements to service in colonial exhibitions and displays. Ownership rested with the photographer, who was often French, the photo editor, and the colonial state, not with the sitter or the photographer's apprentice, both of whom may have been African.

When lens-based artists such as Thiam and Diop discuss their heritage, they include not only early photographic materials and their myriad reproductions in postcards and other forms but also the practices, discourses, knowledges, and understandings associated with photography that underpin Senegalese image worlds. They do so because they see photographs, like archaeological artifacts and other precious objects, not as of the past but as "ongoing durations" (Hicks 2020, 13) and thus as inalienable possessions (Weiner 1992) inextricably linked to practices in the present. They seek to give life to photographs that are stopped in time because they are locked away in archives and museum collections. They also recognize that museums and archives are not spaces of heritage; they are spaces of loss, both of objects and of their dynamism. Heritage thus not only inheres in the material culture and cultural knowledge, but it is also wrapped in global power dynamics. As part of a larger process of value formation, the circulation of heritage and heritage regimes involves

objectification, exploitation, commoditization, and profit (Geismar 2015, 72–73). In the epilogue, I take up evolving debates over conservation, preservation, and the return of African artifacts and focus on heritage as a discourse of value.

Returning these objects to circulation might provide the opportunity to connect them to other visualities and other narratives in their community of origin (Araujo et al. 2019, 1652). For now, against the worldwide dispersion of photographs from Senegal, lens-based artists have turned to local collections and to their own family archives as ways of recovering memories and family histories. In so doing they work with these valued objects, these inalienable possessions, as a means of reconstituting community relationships. This process contrasts with that of a museum that serves as a locus of display of objects such as photographs thought to represent a culture for a wide audience. Artists like Thiam and Diop seek to inspire young people to value their historical patrimony and reconsider how the visual contributes to the development of their own subjectivity and action in the world. To do so, they bring life to objects such as early photographic materials and vintage portraits. Portrait photography can help people author their own futures, suture ruptures in the present, and connect familial and regional pasts as Ami had done by placing portraits of herself and her mother in the same frame, as Thiam does by placing vintage and contemporary sitters in the same images, and as Diop does by juxtaposing reinterpretations of colonial-era postcards with the present. It is to those pasts that I turn in chapter 1 to discuss how photographs from Senegal ended up in museums worldwide.

In chapter 4, I discuss how Thiam takes up the ambulant practices of photographers at the turn of the twentieth century, reconstructs midcentury photo studios, and reconnects young people to their family portraits and national patrimony by getting them to pose with historic portraits from his collection. For his series *Portraits "Vintage,"* he canvasses the island of Saint-Louis with his "mobile studio" like the mobile portrait photographers who traveled the coast of Atlantic Africa beginning in the late 1800s. He invites young people to sift through his collection of vintage prints taken in Senegal from the 1930s on and to sit for a portrait. They hold the print to obscure their faces, collapsing the past and the present as well as paper and electronic images. The resulting images have a slowed-down, contemplative, quiet presence. Other works by Thiam feature portraits from his collection in a digital medium, allowing them to circulate along new paths and platforms, even as his collection remains safe at home in Senegal.

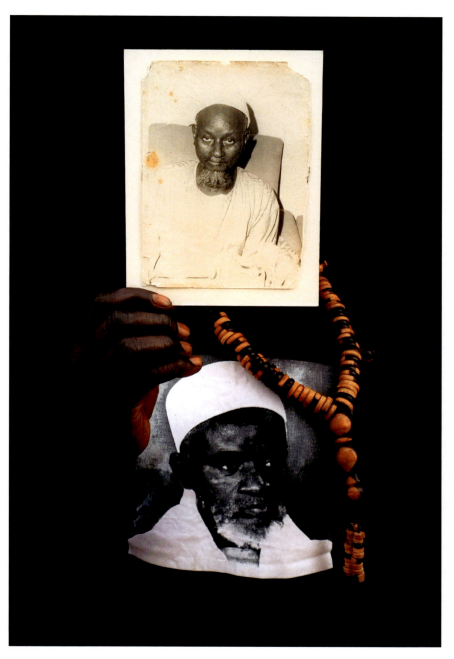

Fig. 0.5 From Ibrahima Thiam, Vintage Portraits series, 2018. Portrait of Serigne Abdou Khadre Mbacke. *Photo T-shirt Serigne Saliou Mbacké, Muridiyya tariqa.*

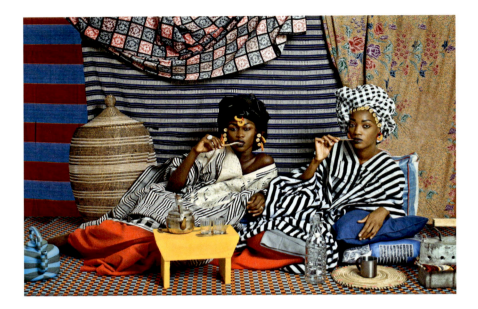

Ibrahima Thiam juxtaposes early and contemporary photography as well as digital and analog, calling attention to what is known and unknowable. He thus undermines the art historical claim to the original and the copy by combining both in his work. Allison Moore describes similar ideas among Mandé speakers about original and copy as form and embellishment (2020, 42). For Thiam, portraiture has both a visible and a hidden side, a thought prevalent in Sufi eschatology and its notions of hidden knowledge that play a large role in his work. For example, as we worked in the archives together, I noticed how Thiam, as a devotee of the Murid Sufi congregation, would also lightly press certain photographs of shaykhs to his forehead transferring *baraka*, or blessings (Arabic), from the image to his body. His ability to "see" these images, both their seen and unseen or otherworldly qualities, their *zahir* and *batin*, also involved touch. Attention to photographic practices in the religious lives of Muslim families shows how practices ideologically separated as "Islamic" or "secular" converge in compelling ways.

Thiam's movements echo the way in which Christopher Pinney (2004) has remarked on the "sensory embrace" of photographs in India as "corpothetics," a term usually reserved for the bodily ways in which people engage with fine art. They also resonate with David MacDougall's observation that "meaning is produced by our whole bodies, not just by conscious thought" (2006, 3).

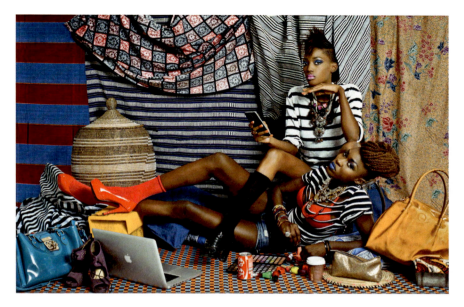

Facing and above, **Fig. 0.6** Omar Victor Diop, *Alt-shift-ego*, 2016. *Photo courtesy of Galerie MAGNIN-A, Paris.*

Meaningful, embodied experiences and ways of knowing are not just individual. Affect is intersubjective, reflexive, and relational (Richard and Rudnyckyj 2009). And it is through recourse to affect and the senses that Thiam seeks to reawaken his generation to portraiture's possibilities. In so doing, he says that he wants young people to understand that by controlling their past, they control their future, and that the visual is a medium for this project. His vision resonates with the story of Ami. Unable to convince her mother to return to Senegal, Ami eventually joined her in the US. While the portrait illustrated her longing to be reunited with her mother, it also signaled her hope to seek a better life abroad. The remediated portrait that she produced and circulated online helped her bridge her mother's past shame and her own future ambition.

Omar Victor Diop's work also addresses the divide between Senegal's rich photographic past and the interest with which young people flock to the digital. Consider a portrait from Diop's *Alt+Shift+Ego* series, staged as an environmental portrait and comprising two different views of two women. The two sides, or two moments, which seem to represent past and present, are almost like the pairs of images on stereo cards. Stereoscopic images are a pair of separate images depicting left-eye and right-eye views of the same scene, which

become a single three-dimensional image when viewed through a device called a stereoscope. Such viewing provides complexity and life to an otherwise flat paper-based medium. One can imagine parlors of Victorian audiences viewing stereoscopic images used to spread colonialist fantasies. Responding to the ghost of the stereoscopic image and reinscribing it in Diop's work asks us to look at his image with the multidimensionality of history itself.

The portrait also suggests a panorama, as the camera sweeps across fashion models SashaKara Dieng and Yayou Sarr who pose on each side of the image, wearing clothing by the Dakar-based designer Selly Raby Kane. Diop's use of panorama echoes colonial photographers' attempts to capture a sweeping view of a place. Such early panoramas were made by putting two daguerreotypes together, much like Diop's placement of two portraits side by side. A panorama also suggests the sweep of time. In Diop's image, against a backdrop of locally woven and dyed strip cloth, machine-printed fabric, and woven baskets, each pair represents a moment of photography. On the viewer's left is a portrait of two reclining women sitting side by side with henna-stained lips and *soccu*, or small acacia twigs used to clean teeth, such as one might find reprinted from a local studio on a colonial postcard during the golden age of postcards in the early 1900s. The portrait on the right, of two women with makeup and nail polish laid out in front of them, looks more like it belongs to the genre of fashion photography, such that the whole composition could represent a full spread in a magazine with the binding down the middle. The women are painting their nails, and one model holds a cell phone, as if perusing social media. If the aspect ratio and angle were different, the whole scene could suggest an Instagram selfie. On the left, the women are at leisure, with tea served, but on the right, that elaborate social ritual has been reduced to the trappings of casual consumption: a teacup has been replaced by a disposable coffee cup; the offering of water to visitors to the home has been replaced by a Coke can; the plastic kettle on the left for performing ablutions to enter a state of ritual purity for prayer has been replaced by a laptop—a new container for other forms of connection, community, and sociality, and even sometimes disconnection. Here the two women do not sit in parallel fashion, and their sitting one over the other suggests a growing inequality and incommensurability. In this book, I explore how Diop's photographic practices both reference the past and push viewers to consider how the past and future intertwine.

Omar Victor Diop has remarked that in his lens-based work he is challenged by stereotypes of the continent: "We have competition, our competition is the stereotypes, the zebras, and the giraffes . . . Wakanda . . . this is not our

reality—it is an interpretation of the African experience or the African future. Every pair of eyes that we catch at any time of the day has seen hundreds of other images and many of which are images of Africa that are not the reality that we want to share."[4] High-profile figures—footballers, politicians, religious figures—and their mendacity dominate stories about Senegal. Also prevalent are images of poverty demanding a humanitarian intervention: the shape of a single White female figure surrounded by young children, for example. Such humanitarianism "in its current form relies, whether consciously or not, on a white-savior ideal, which positions the global North as donors (whether institutional or individual) and the Global South as recipients of political aid" (Moyd 2016, 95). The visual here serves as the impetus for the intervention.

When not deployed as the object of intervention, the visual in Senegal serves other purposes. Travel stories frame Senegal as an outpost for surfers, a tropical country with exotic birds and groves of palm trees flanking tourist sites, and a culinary destination, where—given its role in the transatlantic trade in slaves—people go to understand the roots of Southern cuisine in the US. From the photographs of pristine mosques to huts dotting beaches, to brilliantly colored pirogues, travel-related photographs reflect the picturesque, not unlike those discussed by Krista Thompson (2006) in Jamaica and the Bahamas from the early colonial period on. The picturesque was both a call to tourists and adventurers and a testament to colonial science, rationality, and order (Landau and Kaspin 2002).

As Diop is quick to point out, the clever, creative, and sometimes hilarious moves underpinning Senegal's rich visual culture do not merely arise in response to, or in opposition to, touristic and dehumanizing images of the continent.[5] He contends that these creative workings were always there, buried under the detritus of the larger world in which they take part. The two women on the viewer's left, in other words, were always part of the two women on the viewer's right, and the two images are not in opposition at all, they are hinged together like a diptych that suggests connections. Imaginative enterprises such as this operate along the sensorial and affective spectrum of the visual. They provide ballast in a world of contingency and deferred futures.

Omar Victor Diop recreates portraiture for a new generation that breaks the nationalist frame by presenting his sitters as global subjects. Borrowing codes from his family albums, Omar Victor Diop revives studio-based portraiture from its golden age, the 1930s to the 1970s, while illustrating his generations' particular aesthetics. He offers space for his sitters to be seen on their own terms. He engages in critical self-imaging, reflexively considering how

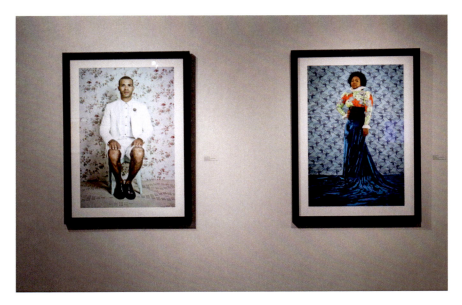

Fig. 0.7 Omar Victor Diop, works from *The Studio of Vanities*, since 2012. Gallery photographs by Kevin O. Mooney, courtesy of Grunwald Gallery, Indiana University.

individuals and communities wish to see themselves and be seen by others. Omar Victor Diop's portraiture thus transcends documentary photography to engage questions of self, history, and visibility. Visibility highlights how inclusion changes how people see, think, and transform the world. Diop's portraiture work aligns with Deborah Willis's (2009) canonical work to recenter beauty in African American and diasporic photography as reparative justice, Ariella Azoulay's (2008) nuanced work on the politics of visibility, and Tina Campt's (2019) recent work on the practice of refusal, where visibility remains central.

While portraiture has become synonymous with the domestic sphere, and with popular and vernacular practice in Senegal and elsewhere, Diop—much as the illustrated magazine *Bingo* published in Dakar and Paris did in the 1950s—pushes it into a broader and more public sphere. Like Thiam, he frames his work behind glass to circulate in the context of museum and exhibition spaces worldwide, claiming a visibility that, in Europe and America, has often been denied to Black and Black diasporic artists.

Although portraiture in Senegal and across West Africa tends to be participatory and collaborative, when Thiam and Diop show their work in fine

art settings, the framing foregrounds qualities of originality, singularity, and authorship of the photographer. These museum images are, as one critic puts it, "available for effortless reinscription by curators and audiences" (Willumson 2004, 73). Thus, personal portraiture, when recast in the context of fine art, takes on new meanings as it is viewed and valued by new audiences with different stakes.

In contrast to the museum as a space devoted to exhibition, the archive stands as a space devoted to documentation. While both spaces are dedicated to collecting and preservation, only the latter is linked with historical analysis (Willumson 2004, 68). The capacity to move in between archives and spaces of exhibition remains central to Thiam and Diop's practices. So is the artists' engagement with other photographies, from family albums to party pics through which young Senegalese people live their lives and have their experiences reflected to them. It is these contradictions between conservation and change through which both lens-based artists seek to assert control over the circulation of portrait photography from Senegal that I explore in this book.

Both Ibrahima Thiam and Omar Victor Diop are based in the art world city of Dakar and to a lesser extent Saint-Louis, an emergent locus of possibility for artists seeking a global platform and to transcend the national frame (Grabski 2017). These cities operate in a strikingly different political moment than that of the previous era of state-supported arts and the context of modernism (Harney 2004). No longer supported by the state, artists create and transact art within the confines of their studio or the virtual spaces where photographers circulate their images. Unhinged from the national frame, from representing that which is authentically African or Senegalese to advance a postindependence vision for the nation, lens-based artists are diving into archival and family collections to recognize and reconsider their contribution to a global history of visuality. Of Dakar, Diop says, "I can only create here, I used to fight that, but now I own it and I think that is a privilege ... for me this can only happen here in Dakar, it is 90 percent of the creative process and the shooting and retouching is just 10 percent. For me, it can only happen in Dakar, it feeds me—gosh, I love this place, I do."[6] In this book, I explore how these artists stay grounded in Senegal and its history of portraiture, while also employing new practices and techniques that reanimate the archives and extend them into the future.

FIELDWORK AND ETHNOGRAPHY IN AND OF COLLECTIONS

Both Ibrahima Thiam and Omar Victor Diop collaborate with their sitters as they reengage with historical archives and collections in contemporary

contexts. They are not unlike anthropologists, who also engage in collaborative work by getting close to their interlocutors. Much of my fieldwork for this project unfolded in homes, at family ceremonies, in the studios and streets with photographers, at exhibitions, and in collections. One such methodology, referred to as photo-elicitation, is an older anthropological approach taken by John Collier that involves asking with pictures (1986). In this method, the anthropologist shows images to interlocutors, asking them to describe what they see as well as posing specific questions about the images. Yet, rather than treating the research process as one in which the anthropologist elicits information from the key informant, a process that Elizabeth Edwards has called "forensic," ethnography can also explore how photographs, new and old, "assume their own dynamics of sociability within communities" (2011, 181). In the book, chapters on the magazine *Bingo* and on family albums explore the meaning that portraits take on through viewing and circulation as well as their role in creating and sustaining communities. Further continuing to move ethnography away from the "forensic" approach, a rich body of recent literature has arisen in this spirit as scholars and museums have engaged collaboratively with communities around photographic collections either through repatriation or digitization projects (Binney and Chaplin 2005; J. Bell 2005; Edwards 2006; Geismar 2006; Morton 2015; Buckley 2014). In chapters 1, 4, and 5, I consider how contemporary lens-based artists such as Omar Victor Diop and Ibrahima Thiam approach Senegal's photographic past and create its future for and in collaboration with young people who participate in their craft.

As I sought to engage with lens-based artists from 2013 on regarding collections, their efforts to revitalize them, and their attempts to animate their communities, I encountered foreclosures, interruptions, and happy diversions. I first became interested in the topic when I visited the *Short Century* exhibition at the Museum of Contemporary Art in Chicago in the early 2000s after having returned from dissertation fieldwork in Senegal. The large-format prints of Seydou Keïta crystallized for me that the photographic practices that I had participated in since the early 1990s had a longer history in the region and, as an anthropologist, I reacted to the framing of that history without context. Although research rarely unfolds as planned, whether field, archive, or collections-based, being flexible can often yield unexpected surprises and take you in new unanticipated, directions. These changes open us up to seeing what our interlocutors want from us as scholars. They remind us of the iterative nature of fieldwork, that as we learn more, we recalibrate our questions to understand and get closer to the questions that people are asking themselves. If my first book on the global circuits of Senegalese Muslims and the valued objects that

they exchanged was interrupted by the foreclosure of those networks after 9/11, this book was interrupted by the attacks at the 2015 Bamako Biennial of Photography in Mali, where 20 people were killed and 170 people were taken hostage in the biennial hotel the week the event opened, as well as by the subsequent attacks across West Africa.[7]

Although I missed meeting Ibrahima Thiam at this important venue, I met him the following year at Dak'Art in Dakar. However, the attacks and the general feeling of insecurity across the region led to me to a diversion when I invited photographers to Indiana University for funded residencies. In hosting these lens-based artists, I was able to reciprocate their openness and generosity toward me regarding my research and to collaborate with colleagues at Indiana University who also invited various photographers to campus. These photographers largely, though not exclusively, worked in the portraiture genre and included George Osodi, Santu Mofokeng, Omar Victor Diop, Ibrahima Thiam, and Emeka Okereke. Through these sustained engagements, I had the opportunity to further engage in discussions about photographic collections and to think more deeply about the worldwide circulation of photography from the continent as museum artifacts and contemporary art, in addition to my ethnographic research in Senegal on the practice of photography. Although I had not originally intended to organize these residencies, my research benefited from these sustained, collaborative, and reciprocal connections that forge social relationships over time. This relational approach to generating knowledge contrasts with the history of anthropology as extractive whereby anthropologists have mined knowledge, recordings, artifacts, and texts among other materials for their research (Beliso-de Jesus and Pierre 2020, 7).

My interactions with these artists helped crystallize archival and museum collections as field sites in which to collaborate. If photographs, like other objects, contain a "bundle of relations," then collaborative fieldwork sheds light on these relations (J. Bell 2017, 243–45). Chapter 1 focuses on my collaboration with the lens-based photographer Ibrahima Thiam in the National Archives of Senegal. There we viewed and discussed a collection of historic postcards together to generate knowledge on the history and circulation of the photographs before they became part of the collection, their status as part of the archival collection, and how their prominence in collections and auction sites around the world affected their value.

During a sabbatical in 2020, I planned to return to Senegal to further my research in collections there with Ibrahima Thiam and others. The foreclosure of my research occurred when Senegal closed its borders in early spring to prevent the spread of COVID-19. A series of cancellations began to unfold for

artists, scholars, and curators worldwide. In these emergent conditions, the ever-evolving now of fieldwork began to look strange and unknowable. These new constraints, which no one knew would carry on for more than two years and come to define an era, would alter the nature of my research.

Unable to engage in field-based research with artists, curators, and archivists, and unable to enter archives and work with museum and family collections, I reconsidered my research methods and materials. My time was also fraught with added family responsibilities in the context of so much sickness and disruption in my community. I found myself turning this question over in my mind: Could I imagine engaging in the intellectual and personal questions that led to the writing of the book in the first place absent my ability to have these conversations with the scholars and artists who shared these concerns? Would it be possible to find a way to supplement the hundreds of hours of fieldwork, interviews, and collaborative experiences that I'd already conducted as part of my research with something that did not require travel?

In museum anthropology scholars look closely at objects in collections to generate field data often accompanied by interviewing the broader community about these objects. This participatory and collaborative method situates objects in space and time and creates meaningful connections between collections and communities. If I was unable to continue my collaborative work with Ibrahima Thiam in collections in Senegal, then how could I continue to engage in museum anthropology? If I had to do museum anthropology outside of collections and communities of origin, could I still look closely at objects, and would doing so open a door to another way of approaching the same project?

Museum anthropology involves research in collections as well as research about collections and research that contextualizes museums as social institutions. If the mantra of ethnographic fieldwork is long-term intensive research that centers around participant observation, then the mantra of museum anthropology is looking closely at objects in collaboration with communities from which they originate. Before the pandemic, Dak'Art had served as a platform for these convergences and conversations. When Dak'Art was canceled in 2020 and museums closed worldwide, I turned to digitized collections. My discovery of early photographic materials as well as postcard reproductions in European and American museums led me to consider both how these materials had traveled out of Senegal over time and other questions related to their provenance. How has ownership and custody been conceptualized over time, how has it been documented, and what does it tell us about the worldwide circulation of these materials? The danger of the digital is that visual ethnography

is not of communities, but rather that it is undertaken *with* communities. Ethnography emerges from spending time with scholars, artists, and community members, building rapport. It relies on the social and the material, relationships that the digital interrupts. Moreover, when conducting ethnography in collections, museum professionals hold a wealth of knowledge and insight into their collections that one cannot access through viewing digital images in isolation. There are accession records to be hunted down as well as personal stories and experiences often connected to the acquisition of collections.

Given my background in ethnographic fieldwork, I had initially approached the digital as an impoverished form of sociality. Yet since my only option was to look through digitized collections of portraiture from Senegal in museums worldwide, I soon realized my growing curiosity about how the digital arose from the material and how it might be yet one more stage of the material form to consider (Geismar 2018). In this context, it was only through museum digitization projects that these images' very existence outside of Senegal became known to me and likely to others. Their digitization enabled me to see their embeddedness in and connections to circuits through time, connections that began when cameras first arrived on the coast of Senegal in the late 1800s and spawned a vast industry of portraiture. How I assessed these connections is the subject of chapter 1 where I focus on articulations between the digital and analog in photography. The shifts in my research illustrate the importance of anthropologists being flexible and shifting their fieldwork in response to ever-changing circumstances. They also illustrate how, while the insights of participant observation cannot be replicated by other methods, digital study can help us better understand the origins, histories, and circulation of objects.

As much as the process of fieldwork is often prone to interruptions and cancellations, so too is the collection of materials, which are often generated in the context of relationships formed through fieldwork over time. Most of the photographs within this book are not my own. When writing the book, I found at key moments that I lacked the photographs that would illustrate my arguments, such as the digital portrait that Ami had created of herself and her mother. Such absences point to the contradictory nature of photographs; they are meant to extend the present moment in time, yet the digital is ephemeral and print photographs have the potential to deteriorate and become lost. Such absences also reveal that sometimes we forget to document key moments in our research because we do not realize how central they are at the time. Only later, upon sustained reflection, do we realize how important they have become to our experience. Such was the case with the iterative nature of my fieldwork

over the past decade, which was not characterized by long immersion, but more often by short trips dependent on release time from the university, childcare coverage, and elementary school schedules.

Furthermore, sometimes we are so wrapped up in social interaction that we do not think to document it because we are experiencing it. I also sometimes did not take photographs at key moments because at the time it felt extractive, or at the very least, would have interrupted the flow of conversation or social action. Sometimes I avoided taking photographs because they would have gotten in the way of my listening to what I was being told and would have led to me directing the nature of the interaction, which can undermine the iterative process of fieldwork. Moreover, I was trying to learn how to look from my peers and taking pictures would have been imposing an anthropological way of looking as a means of documenting the moment or creating a visual record to support an argument. For example, I did not take pictures of photo albums, which I discuss in chapter 3, because it was not the way that people looked at photographs. Instead of visually documenting the albums, I was focusing on what was being pointed out to me and listening to others discuss the albums with each other. Instead of trying to capture the ideal photograph, I opened myself to being pulled into people's lives and allowed these relationships to be the priority, a practice that I found ultimately strengthened the research. When, where, and how I took photographs is also a reflection of my desire not to take business away from commercial photographers, who often chided me for competing with them during family celebrations and larger events. However, when I did take photos, I learned so much. People always pointed out what I got wrong, or why my pictures were inferior, which helped me to understand local ways of seeing and valuing portraiture.

OUTLINE OF THE CHAPTERS

Photographic practices have particular social and historical contexts with distinct visualities (Roberts et al. 2003), ways of seeing (Berger 2014), and genres (Strassler 2010). In what follows, I understand these photographies with a humanistic, sensory-based exploration of photographic technologies, practices, aesthetics, and semiotic ideologies from the early twentieth century in Senegal to the present. This includes displaying framed portraits, viewing magazines, keeping albums, posting photos on social media, and staking new positions in and developing new vernacular languages for photographic portraiture. Through explorations in colonial-era photography in which Senegalese were

both participants and photographers (chapter 1), studio portraiture at midcentury (chapter 2), family albums (chapter 3), and the interventions of contemporary lens-based artists to transform ways of seeing self and other (chapters 4 and 5), these photographies emerge as both technologically and socially constructed. These images are both the sum of and more than either of these perspectives.

In the chapters that follow, I show how Dakar, Saint-Louis, and Senegal more generally have been central to the global unfolding of photography. Photography in Senegal, as elsewhere (Poole 1997; Sealy 2019; Thompson 2006; Edwards 2021), has been entwined in circuits of global capital from the moment of its invention in 1839 to the present. In the late colonial period photographers—most of them European—created portraits of exotic tropical landscapes in Senegal's coastal cities as they did elsewhere across the colonized world. In rural areas their landscape photography focused on unique vegetation such as baobab trees that lose their leaves in summer to emphasize the unfamiliar for European viewers. European landscape and portrait photography not only played into the postcard craze in the early part of the twentieth century but also supported the colonization of French West Africa through visual strategies that affirmed European ideas of racial difference and inequality. In chapter 1, I consider how a nostalgic view of colonial-era photography set on capturing a disappearing world contrasts with photographic activities in the coastal cities that were also nodes in the Atlantic networks of itinerant photographers of varying nationalities and backgrounds who took commissions for personal and family portraits. Studio portraiture established connections to urban and urbane ways of knowing and being, and to a diaspora of African students, workers, soldiers, and veterans, as well as politicians throughout the century. These formal portraits of well-dressed individuals and families in the early part of the twentieth century preceded the better-known aspirational character of midcentury studio photography where technological changes such as shorter exposure times and lighting allowed for greater creativity on the part of sitter and photographer.

In chapter 2, I turn to the flourishing studio culture in West Africa when the illustrated magazine *Bingo: L'illustre africain* captured this creativity. The magazine first appeared on newsstands around Dakar in 1953, just seven years prior to independence in 1960. Studio photographers created and portrayed their sitters' aspirations during a booming economy and intense migration to the city. Viewing studio portraiture on the eve of independence in the new international register of the Black-illustrated magazine published in Dakar and

Paris, by and for Black audiences, reveals how sitters may have seen themselves and wished to be seen by others (see, e.g., Campt 2012; Thompson 2015). As the social contexts of the circulation of photography shifted to include illustrated Black magazines, sitters began to think about themselves differently and their aspirations began to shape portrait photography in Senegal. Reader-submitted photographs in *Bingo* offered a new register in which readers could "be seen being seen," to borrow a phrase from Krista Thompson (2015).

Where chapter 2 considers photography in the realm of publishing, in chapter 3 I analyze portrait photography in a less optimistic era, marked by structural adjustment in 1985 and the intensification of migration abroad and financial pressures at home. I show how as the burgeoning unregulated economy expanded so too did the numbers of peripatetic photographers untethered to studios. Though ethnographic encounters and relationships, I reflect on how sitters turned to portraiture to uphold reputations and cement social relations as they attempted to stay afloat in tough financial circumstances. If chapters 2 and 3 bring into focus how sitters think about changing photographic practices over time and across space, then together chapters 1, 4, and 5 show how photographers understand the import of photography in Senegal in relation to what is happening to photographic practices, their photographic heritage, and visibility.

The lens-based artists I discuss in chapters 4 and 5 tune in to such social capacities of photography on a level that is simultaneously artistically, politically, and historically minded. The photographers Ibrahima Thiam and Omar Victor Diop address Senegal's photographic past, the worldwide dispersion of its photographic patrimony, and ultimately, how to get young people to engage with a local portraiture tradition beyond the social media selfie. These contemporary artists working in the medium of photography are like family archivists, choreographing and preserving their family's and communities' lives. They interweave family stories with the pairings and sequences of albums, fictions, and omissions to reimagine, reawaken, and reclaim their visual past. By mining multiple, fragmented, and heterogeneous archives of visual images by and of Africans, Thiam and Diop both work to create a new vernacular language of portraiture. Whether in the early colonial period or the postindependence period, through the circulation of personal portraits Senegalese created and sustained their social personas and their social networks. In the chapters that follow, I show how photographs from Senegal have become entangled in different circuits over time—familial, colonial, social media, museums and galleries, and art markets—and how new meanings are created through new contexts of circulation.

NOTES

1. I have not included those portraits of Ami and her sisters here because they were under eighteen at the time.

2. For a striking example of the elaborate image world in Senegal focused on the Murid Sufi congregation, see Roberts et al. 2003.

3. Elizabeth Edwards calls the archive "a stereotype of its own, a dead controlling space in which photographs gather dust in the sense of being removed from active social contexts" (Edwards 2003, 92).

4. Omar Victor Diop, Virtual Afripedia Discussion, curated by Amanda M. Maples, North Carolina Museum of Art, May 21, 2020, YouTube video, https://www.youtube.com/watch?v=I-A0F4pPcPs.

5. For further discussion of the limitations of crisis as a defining concept in African Studies see Makhulu, Buggenhagen, and Jackson 2010.

6. Diop, Virtual Afripedia Discussion.

7. For further discussion see Akanji 2019.

ONE

"UNCONTROLLABLE CIRCULATION"
Portraiture in and out of Senegal

THE INTERNATIONAL ART WORLD'S appetite for vintage studio portraiture from West Africa has become so insatiable that the curator and art critic Simon Njami has described it as a "photographic gold rush" (Njami 2017). Regarding the traffic in photographs from the continent, lens-based artist Ibrahima Thiam has observed, "I see that there are lots of tensions in the art market, problems of negatives, and other family issues. . . . Millions are gained in the sale of Seydou Keïta's or Malick Sidibé's photos, but their families don't benefit from it. There is a problem."[1] Thiam continued, "People in Ndar and Dakar are not interested in photography."[2]

Thiam spoke of his concerns about Senegal's photographic heritage as we sat in the shady courtyard of the West African Research Center in Dakar in May, the week before the start of Ramadan. His exhibition *"Portraits 'Vintage,'"* curated by Joseph Underwood, had just opened during Dak'Art 2016, a biennial monthlong exhibition of contemporary African art. As we spoke, Thiam gestured to the wind that was blowing our materials off the table to explain why he was taking down his outdoor exhibition. During the first week of the festival, Dakar is a rush of gallerists and art enthusiasts looking to buy works from up-and-coming contemporary artists from the continent, but the week before Ramadan, the energy was winding down. We were meeting partly to discuss the possibility of my visiting the National Archives. Although the archives had been closed for several years as a new temperature-controlled building was being completed, Thiam had used the temporary location for his own research and thought he could help me access the collection. Once we entered the unmarked building, Thiam and I ascended the staircase and headed toward

Fig. 1.1 Ibrahima Thiam pictured with the author at the National Archives of Senegal, May 2016. *Photographer unknown.*

a small room with large, shuttered windows. There we found a few large metal cabinets along with boxes stacked on tables.

We sat at the only empty table, opening brown paper envelopes of film-based photographic materials that the archivist offered us. The collections of the Archives nationales du Sénégal dates to 1913. It serves as the repository for the archives of French West Africa (Afrique Occidentale Française, AOF)[3] and its materials, including the iconography collection, were relocated from Saint-Louis to Dakar after 1958. As we looked through the photographs, Thiam and I discussed these materials in relation to Senegal's global history as a crossroads of Islamic and European trade, a nexus in the transatlantic trade in slaves, and now, a global art center. Tables lined the perimeter of the room and each held stacks of archival documents organized by pastel colored folders stuffed into brown accordion files held together with an elastic band. One side there was a large metal two-door cabinet that held the photographic collection.

I had anticipated that Thiam would leave once I had been introduced to the archivist and received permission to view the collection. Instead, he sat down, bowed his head with his *Laafa* or Cabral cap (Siga 1990, 22)—a black-and-white

knit wool cap as worn by nationalist leader Amílcar Cabral, the hero of Guinea-Bissau War of Independence—and started picking up photographs. As Thiam studied the photos with his head down, the top of his cap revealed black-and-white stripes radiating from the center. As we sorted through the postcards that primarily comprised the collection, we talked about how the postcard-collecting craze of the early twentieth century in Europe and America had spurred the sale of photographs of the African continent. These images depicted lush, tropical landscapes, feats of colonial engineering such as bridges, military photographs, and group and individual portraits. Photographers in Senegal, who were both European and African, not only worked in the colonial service but were also entrepreneurs who ran stationery shops selling their postcards and took commissions from wealthy African families for portraits.[4] Not all portraits printed on postcard stock or in cabinet-card form were intended for public sale. In Senegal, families printed portraits on postcard stock because it was less expensive than photography paper and widely available (Bajorek 2010b, 162). These private commissions became part of the photographer's stock and thus could be diverted from their intended contexts of circulation among families to commercial sale, use in scholarly works, and use in government documents (Hickling 2014).

A century after this early circulation of West African photography, enthusiastic buyers for early print and vintage portraiture, family albums, and contemporary digital photography continue to drive the traffic of photography from the African continent. Senegal has a rich photographic history, yet as Thiam and I observed during our visit, the photographic collection at its National Archives fits into just three steel storage cabinets. Like Thiam, historians and museum scholars frequently lament the state of collections in places like Senegal, where insufficient state support for preservation efforts poses just one more disappointment of the economic strife of the postcolonial period (see also Buckley 2005 for a discussion of the Gambia).[5]

As we continued our conversation, Thiam and I found several portraits that were not printed on postcard stock, but that appeared to be vintage prints. A vintage print is a photograph that is produced within ten years of the exposure of the negative (Willumson 2004, 76). Although multiple reprints can be derived from a negative, the vintage print shows the artistry of the photographer in the darkroom and is often signed by them. The negative and the print together are widely regarded as a singular and unique object whose value lies in their authenticity. Collectors seek out both negatives and vintage prints. Questions of authorship are tricky to resolve for many of the photographs that circulate in and out of Senegal, as a simple relationship is often lacking between

Fig. 1.2 Front and back with label identifying the photograph as a reprint. *Photographer unknown. National Archives of Senegal.*

the negative, the print, and features identifying an author such as an embossed stamp of the studio or signature of the photographer.

As we flipped the prints in the collection over, we discovered an inked stamp affixed to the reverse side with the imprimatur of the French Overseas Colonial Archives (Archives nationales d'outre-mer) in Aix-en-Provence, France; indicating that the prints were reproductions. Senegal's photographic patrimony rests almost entirely outside of Senegal, much of it in the French archives in Aix-en-Provence,[6] whose collection consists of negatives and prints.

Beyond the collection in Aix, numerous museums worldwide and private collectors hold additional photographic collections from Senegal. Early photographic materials in and from Senegal have been thought to be safely tucked into boxes and placed on shelves for preservation in the collections of major museums and archives in Europe and America. My catalog searches of these collections revealed materials such as daguerreotypes, glass-plate negatives, carte-de-visite portraits and cabinet cards, albums, postcards, and vintage prints in the collections of the Musée du quai Branly in Paris, Bibliothèque nationale de France, Tropenmuseum in Amsterdam, the British Museum, the

Smithsonian Institution, the Metropolitan Museum of Art, and the Museum of Fine Art, Boston,[7] among others. Did these museums acquire these photographic materials by purchase or donation from private collectors? Were they part of France's colonial patrimony?

According to the 2018 Sarr-Savoy report on the restitution of African art, 90 to 95 percent of African heritage remains outside the continent.[8] While the photographic collection at the National Archives of Senegal exemplifies this problem, Thiam pointed out that efforts have been afoot in Senegal for some time to address the removal of photographic materials from Senegal for safekeeping in museums in Europe and the United States during the colonial period and after. For example, the collector Adama Sylla, the notable retired director of the Center for Research and Documentation in Senegal (Centre de recherches et documentation du Sénégal, CRDS), which houses the collection from the Library of Colonial Senegal,[9] has contended with the flight of photographic patrimony from the continent, as has the current director, Fatima Fall.

Exploring these primary materials poses challenges in terms of both the deterioration of the matter itself and of evolving views of museums as suitable locations for these collections. Original negatives have often been lost, and many collections consist of reproductions such as postcards. In many cases, it can be difficult to locate negatives or vintage prints and reprints may be the only remaining artifacts.[10] The reproducibility of photographs, I argue, complicates the relationship between a negative and its copy so critical to concerns of authenticity and value. Moreover, as a tactile object of glass, paper, and solvent-based and extruded materials, a portrait deteriorates and as such is further subject to loss.

The instability of the medium itself mirrors the instability of the context in which it has the potential to be understood, since "any object is at least as unstable as its context" (Hicks 2021). As the current debate over restitution of objects from Euro-American museums demonstrates, many question the museum as a meaningful context for objects such as early photographic materials from Senegal. Rather than depicting an ongoing life, or life as it was, these photographs signify the moment of dispossession; resting in storage in a museum or archive, or being placed on an auction site, does not suggest the photographs' aliveness or immortality but rather their mortality (Hicks 2021). Fine art museums, natural history museums, and world cultures and ethnographic museums that hold postcards and other artifacts thought to stand in for the cultural processes and persons they represent have the potential to objectify the persons and cultural contexts depicted as timeless and ahistorical, and to create difference. For this reason, many scholars and artists call for

returning the artifacts to their source communities where they might become "objects in the telling of history" (Edwards 2006, 27). It is that history, as told by Thiam, to which I now turn.

THE ARCHIVE OF AFFECT

As Thiam and I sat next to each other, I noticed how he studied the writing on the front and back of postcards. When he came across a postcard portrait, he would feel for the embossed studio seal in the corner. If he could not find it, he would pass his hand over the surface of a photograph, turning it over, feeling the paper between his index finger and thumb. The physical properties of the paper would lead him to deduce the location of the photo's printing and possibly its age. Again and again the way in which Thiam engaged with the materiality of the photographs brought me back to Christopher Pinney's notion of corpothetics as engaging with art through the body and the senses such as touch to produce knowledge (Pinney 1997). We would discuss the possible identity of the photographer or photo editor, who would reproduce photographs for other purposes such as postcards or inclusion in scholarly works, by scrutinizing the name, if it was printed on the front in the lower right-hand corner, embossed, or stamped in ink on the reverse. Thiam would point emphatically at the image with his index finger to draw our attention somewhere, sometimes bringing the photograph closer to his face to focus on a detail, then pushing it away to call my attention to it. When twists and turns of our conversation sparked the archivist's interest, he would look up from his newspaper and hurry around his desk to our table. He would then pick up the photo, raise his glasses above his eyes so that he could see the photo better without them, and then set it down head over to the steel storage cabinet to find another image with a similar detail to show us. Our spirited and collaborative exchanges, our huddling around photographic prints and postcards, and our passing them back and forth highlighted for me that these were not just images. They were tactile objects of value that circulated in social life. As I explore below, while these images resided in the archives, similar images had circulated widely in Europe during the colonial period as well as in Senegal, accruing different meaning and value along the way.

During our visit to the National Archives, Thiam would, at times, place his hand on his chest as he explained how he knew where a certain photograph was taken based on his recognition of the buildings, the courtyards, or the street corners. He would describe running through the open courtyards of two-story homes, washed-out vestiges of French colonial architecture, on the island of Saint-Louis as a child, which he called by its Wolof name, Ndar. He

would explain that a particular enclosure in a photograph appeared familiar and knowable since he had often traversed it as a child. In Thiam's hands, the photograph was not a static object; it conjured up his own movements across space and time (see for comparison J. Bell 2005, 116). His bodily response to these photographs told me more than his words alone could convey. His reaction showed how affect is often experienced bodily and ties one's experiences with deeper histories "while gesturing toward what these descriptions cannot grasp" (Rutherford 2016, 289). Thiam returns time and again to these buildings and intersections, and to the families who once inhabited and crossed through them, in his lens-based work.

Other times, Thiam would say such things as "this is not a portrait," as he shook his head and wagged his index finger at me, explaining that researchers often did not understand portraiture from the colonial era because they did not look closely enough. For example, Thiam picked up a 1909 postcard captioned "Une demi-mondaine" by the French photographer Pierre Tacher (1875–1938) to demonstrate his point.[11] I asked about the translation, since in the early 1900s "demi-mondaine" could have referred to prostitution. Thiam laughed and said that this was not a portrait of a prostitute. In fact, this was not really a portrait at all, but a test shot to determine lighting levels, depth of field, and correct exposure. He said that the sitter was merely a stand-in, so that the photographer could set the lighting for another sitter who would come later. He pointed out the signs that supported his assessment: the photographer had neglected to properly prepare the sitter by arranging her clothing or lighting her face; her left arm was not visible; and the shadow of her dress eclipsed her feet. Her wrinkled, informal clothing, he said, indicated it was likely that she worked as a maid in the compound where Tacher's studio was located. Tacher often used a backdrop to hide the courtyard and recreate a domestic interior, but there was no backdrop here. Thiam said that since researchers do not look closely enough at such details, colonial-era portraiture is often misunderstood. Then he reminded me that labels were often added to postcards later by the editors who reissued them—in this case, an editor aiming for something salacious. Researchers, he emphasized, did not understand that, while photographic postcards contained histories, they were not realist documents of the past.

Captions and the paper on which postcards were printed lend few clues about the identities of the photographer, photo editor, or sitter. Oftentimes, different iterations of the same image carry different attributions. Photo editors also often reprinted the same scene or portrait and added a different caption with little regard for accuracy. For example, one of the postcards in the Eliot Elisofon Photographic Collection of the Smithsonian National

Fig. 1.3 Pierre Tacher, *Saint-Louis. Une demi-mondaine*. Postcard. National Archives of Senegal 4FI-0122.

Museum of African Art carries the caption "Dakar—Une Famille," yet the family portrait shows wide-brimmed hats that are characteristic of parts of East Africa. A handwritten note attached to the sleeve indicates that "it's probably a mistake."[12] Postcards and portraits printed on the less costly postcard stock also reveal little regarding the relationship between photographer and sitter,

including whether the sitters commissioned the portrait, whether the sitters consented to how they were depicted, and how the images would circulate and for what purposes. While some portraits may have been commissioned by the sitters themselves, others belonged to the photographer's collection, not to the sitter; this understanding of ownership explains why many of these materials are in the collections of museums in Europe. Furthermore, colonial postcards often depicted White European stereotypes about Africa, thus reinforcing notions of hierarchy (Landau and Kaspin 2002). Other postcards glorify technological feats and military campaigns (Killingray and Roberts 1989).

One might conclude that materials with such fundamental flaws have little to contribute to contemporary explorations of African subjectivity. Yet when Thiam saw Tacher's postcard "Une demi-mondaine," he saw multiple histories: that of a colonial photographer, that of a domestic laborer, and that of a building whose courtyard was a visceral reminder of his own childhood. In fact, the postcard prompted him to reminisce about a particular sachet that held herbs and was placed above the doorframe as a protective talismans or objects imbued with spiritual power. He explained to me that he often took the sachet down to try to unravel the mysteries of its contents knew that if the adults caught him, they would disavow what they deemed to be pagan and un-Islamic practices such as placing supernatural protection over the entrances to homes. To call the island of Saint-Louis "Ndar" from the Wolof (meaning island) and to touch sacred objects meant to be hidden was to speak of the water spirits that were thought to inhabit the island. Early inhabitants had avoided this area prone to flooding and it was not until the French fortified the island that homes could be built by the colonial powers. Yet even today, many continue to pacify the water spirits. For Thiam, the colonial postcard was more than its materiality; it had "layers and depth" like the ocean, or like what Jennifer Deger has called "thick photography" (2016, 116). Indeed, Joshua Bell has commented on how photo-repatriation, photo-elicitation projects, and interviewing with photographs in and from colonial archives and museum collections create a counternarrative that might crack open colonial histories and provide new understandings of the past (2003, 111). For Thiam, the postcard depicting the young woman in the courtyard captured multiple histories, including conjuring up a personal memory, which was sparked by the architectural heritage of Saint-Louis whose homes and courtyards that appeared in colonial postcards endure into the present.

Tacher's postcard and Thiam's discussion of it illustrate how openness, indeterminacy, and ambiguity characterize the photographic medium. As multivalent objects of value, photographs convey multiple meanings as they circulate

in new contexts (Keane 2005, 188). Some examples of these new contexts might be the difference in meaning created when a portrait is removed from a family album and placed in a museum collection or framed on an art gallery wall. These qualities of the openness, indeterminacy, and ambiguity of the photographic medium lead to appropriation and exploitation by new audiences in new contexts of circulation. It is these shifting meanings and multiple audiences that I explore, including audiences in the metropole as well as Senegalese themselves. When postcards were a new media form, their meaning was largely interpreted by the intended audience, people abroad for whom West Africa was exotic. When this new media form became old, it presented an opportunity to challenge representations (Gershon and J. Bell 2013, 262). Thiam analyzed the old postcard to correct researchers' misinterpretations and, in the process, expressed nostalgia for the place that was depicted. Postcards suggest complex networks of circulation of the media itself, and of photographers and equipment, as well as of the single moments and places depicted within them. Early photographic materials such as glass-plate negatives allowed the transfer and reproduction of prints to new producers, audiences, and contexts, first by photographers and then by photo editors who reissued portraits in postcard form. Later, roll film and digital sharing facilitated the reproduction of photography in new contexts such as print media and social media.

That the photographic collection in Senegal's National Archives consists mainly of postcards is not surprising. Many photographic collections from Senegal are composed of postcards because they were an artifact of popular culture of the early 1900s. As I mentioned, photo editors reissued and circulated postcards to worldwide audiences, leading to large numbers of these materials being in circulation. The widespread duplication of postcards from Senegal and elsewhere means that they are of little value. Their ubiquity challenges the art historical categories of originality, authorship, and style through which value is attributed to an object and raises the question of why they have been collected by museums as all. Even today, many auction sites offer the same postcards held in prestigious museum collections at inexpensive prices because these images were reissued multiple times.

Yet the contemporary worldwide circulation of portraiture invites a viewer to imagine the story of the complex movement of photographers, their equipment, and their photographs over the late nineteenth and early twentieth century, raising questions about our understanding of images as African or European, whether privately commissioned personal portraiture or commercial postcards imagery. Whatever the context, early photographs of and in West Africa both suggested and created particular social and political relations, as

do their scattered locations today. The circulation of portraits through family networks and postcard producers, their changing contexts and associated meanings, and the mobility of photographers across the African continent created a "diaspora of images" (Peffer 2013, 8). These images meet a changing "global image ecology" today in which African artists and photographers seek to rewrite the past and chart the future (Enwezor 2006, 19).

PORTRAITS AS NETWORKS OF PHOTOGRAPHERS, EQUIPMENT, AND PHOTO EDITORS

The island city of Saint-Louis in northern Senegal provided a hub for a bustling network of photographers who traversed the Atlantic coast almost as soon as camera technology was developed in 1839. European and African photographers took pictures in cooperation and competition along the West African coast beginning in the 1840s (Bajorek and Haney 2010), creating a "polyvalent . . . culture of photography" (Bajorek 2010b, 158). European, Black American, and African photographers built clientele and endeavored to earn a living by traveling along the Atlantic coast from Saint-Louis in the north to Ghana in the south, carrying cameras, tripods, movable backdrops, and glass-plate negatives (Haney 2010; Hickling 2014). Photographers from French Sudan, North Africa, Lebanon, France, the Gambia, and Liberia also circulated through the urban capital and commercial center of Saint-Louis and later traveled down the railway to the port town of Dakar to practice their trade (Hickling 2014). Some stayed longer than others, with some establishing thriving studios.

As the former colonial capital of the French Sudan from 1673 to 1902, Saint-Louis now bears the designation of a UNESCO World Heritage Site for its unique colonial architecture and quays.[13] In the late 1700s, the entrepôt city served as a base for the trade in gum arabic and the trade of enslaved Africans, the latter of which the French abolished in 1794. From this trade economy grew a wealthy class of women, known as *signare*. Signare, from the Portuguese *senhora*, entered temporary marriages with European traders, officials, and soldiers. When these men died, the signare inherited the assets that these men garnered through their engagement in businesses prohibited by the French and whose profits could thus not be sent back to their wives in France. These African and Afro-European women owned property and brokered mercantile relations between the French on the coast and Wolof speakers further inland. By the end of the eighteenth century, the Métis families of the signare became significant economic agents on the island (Jones 2011; Klein 1998; Searing 1988). Saint-Louis society consisted of these Catholic Métis families, Muslim clerics,

"UNCONTROLLABLE CIRCULATION" 47

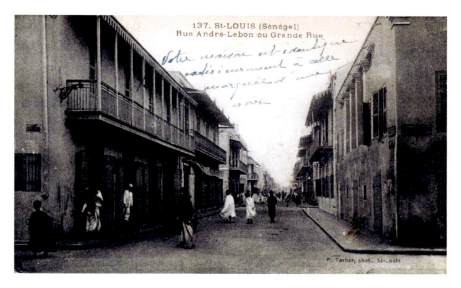

Fig. 1.4 Photographer's studio captured in Pierre Tacher, *Saint-Louis, Rue André-Lebon ou Grande Rue*. Postcard. *National Archives of Senegal 4FI-0075*.

the descendants of former slaves, and craftspersons, who were members of endogamous hereditary occupational groups, or *nyenyo*, such as blacksmiths and jewelers, leatherworkers, and oral historians or griots. The city they inhabited was a commercial and strategic center for the French, whose Ministry of the Navy and Colonies sent the first camera to Saint-Louis in 1862 (Chapuis 1999, 51).

Back in the archives, Ibrahima Thiam pointed out a landscape postcard by Pierre Tacher showing the balconied homes of Saint-Louis, with the photographer's sign visible on the corner building on the viewer's right. The sender had marked an *X* on the upper-left building, scrawling across the front of the postcard, "your house is identical on the outside to the one I marked." The reverse side is blank, aside from the address. Thiam explained that Tacher's residence and studio would have been similar to the one depicted in the postcard, with Tacher living upstairs and using the courtyard below as his studio. Its façade faced the street, and the courtyard would have been located in the middle of the building. It was open and thus had good light; he would hang a backdrop to hide the interior of the building.[14]

In spaces like Saint-Louis, photography soon became a globally disseminated technology, rather than a Western invention, since it was appropriated by

local photographers and their clients (Pinney and Peterson 2003). Throughout the late nineteenth and early twentieth century, wealthy upper-class signare sat in high-backed Victorian chairs for portraits in their homes in Saint-Louis (Jones 2013, 93). These portraits were also central to the creation of the so-called *évolué* or civilized classes of Senegalese in the four French administrative districts or communes of Dakar, Gorée, Rufisque, and Saint-Louis (Mustafa 2002, 177). Residents of the four communes held French citizenship with elected representation in the French Assembly until the interwar period.

Some of the earliest photographic materials from Senegal originate from Saint-Louis. From 1842 to 1843 a French employee of the Customs Service, Alphonse-Eugène-Jules Itier, traveled to Senegal as well as Guyana and Guadeloupe in the West Indies carrying daguerreotype equipment (Massot 2015, 345).[15] Itier is thought to have produced one view of Saint-Louis during his travels, the earliest extant photograph from Senegal. It is likely that this daguerreotype represents the earliest example of photography from the continent along with photographs taken in North Africa and Egypt (Gimon 1981, 322). Daguerreotypes, introduced in 1839, were made by depositing tiny particles on the polished silver surface of a copper plate. The process produced a singular image and could not be reproduced (Killingray and Roberts 1989, 197). Daguerreotypes were like jewels. Delicate and unstable, they required a glass sheet and a silk- or velvet-lined leather case to protect them (Batchen 2002, 60). The cases for daguerreotypes and the leather-bound cases that held Korans resembled one another: both sized to be held in the hand, both expressing an otherworldly connection. Both were also objects of value used for contemplation. Daguerreotypes were visual and haptic and were both the positive and the negative of the photograph. Where Islam is often thought to deride the human image, here photography, especially of Muslim figures, facilitated Sufi practices of contemplation.

After Itier, the American-born daguerreotypist Augustus Washington (1820/1821–1875) set up shop in Saint-Louis in 1860. Washington had begun his career as a scholar, teacher, and daguerreotypist in the United States. He had an African American father and a South Asian mother, and after a difficult time immigrated to Monrovia, Liberia (Shumard 1999; Viditz-Ward 1999; Chapuis 1999). He had done so under the auspices of the American Colonization Society, though Washington, like many others, disparaged it: "I abhor with intense hatred the motives, the scheme, and the spirit of colonization" (Shumard 1999, 6). In the dry season, he tended to his sugar farm in Liberia, which he supported through his work making daguerreotypes during the wet season. He traveled the Atlantic coast with his photographic equipment to Sierra Leone,

the Gambia, and Senegal (Shumard 1999, 14).[16] Another daguerreotypist by the name of Decampe followed Washington, setting up his trade in Saint-Louis in 1861 (Chapuis 1999, 51).

By this time, the daguerreotype had been succeeded by a new photographic medium that originated around 1850: the wet-collodion negative, a master image from which other images could be reproduced. These flat sheets of glass were less expensive, required less exposure time, and produced richer, sharper images than daguerreotypes. Although this kind of photography reduced exposure time and the glass plates could produce large numbers of prints, this process remained labor intensive and still required exposure times of up to fifteen minutes, which did not make it suitable for portraiture. The prints were made on paper coated with albumen, or egg white, which made it glossy and smooth. The paper would then be coated in a solution of silver nitrate and together the albumen and silver nitrate would form light-sensitive silver salts on the paper, creating the image. Other practitioners of this medium included the Gambian photographer John Parkes Decker, who began taking portraits in Saint-Louis and Gorée, an island off the coast of Dakar, in 1867, and a French photographer, J. Lascoumettes, who set up shop in Saint-Louis in 1871. These early photographers were risk-taking entrepreneurs who secured the capital and connections needed to obtain large-format cameras and equipment as well as chemicals for the wet-plate process.

It was not until 1871, when a new dry-plate method using a gelatin emulsion was introduced, that photographers could reduce exposure time to a second or two, which was more suitable for portraiture (Killingray and Roberts 1989, 198). This method also allowed them to prepare plates in advance and easily store them. Once these dry-glass plates were introduced, new photographers entered the trade. Figure 1.5 shows a silver gelatin bromide negative on a glass plate, which can be identified as such because of the black, gray, and clear tones. This glass plate depicts two separate portraits. Taking two portraits on one photographic plate reduced the cost for the photographer and increased the portability of their supplies since they had fewer plates to carry. The larger portrait is of a formally dressed man who is seated. Superimposed upon it is a smaller portrait of a woman in the right-hand corner. She wears the *Kostine*, or symmetrical gold necklace with three medallions of a married Wolof woman, along with bracelets on both hands. The display of wealth suggests that the smaller portrait may have been a wedding portrait.[17]

By 1908, French photographer Etienne Lagrange had opened a studio and was engaged in training several African photographers (Chapuis 1999, 51). He may also have been a photo editor. Like other photographers of that era, he

Fig. 1.5 Anonymous (1904–1938). Untitled silver bromide gelatin negative on the glass plate, 13 × 18 cm. *Fonds Senegal, PV0034490. Musée du quai Branly.*

traveled from town to town with his heavy box camera, tripod, glass plates, and rolled-up mass-produced backdrops, seeking to build clientele. In Saint-Louis, European and African photographers collaborated with, borrowed from, copied, and competed with one another for clients. Many of these French photographers had African apprentices who became photographers as well. Photographers worked in various ways from capturing official dispatches in service to the colonial regime, to producing photojournalism, to running commercial studios offering personal portraiture and identity cards, to working as shopkeepers selling postcard souvenirs and other items.

Photographers also reproduced the card-mounted images known as *cartes-de-visite* or calling cards, that led to cartomania between 1860 and 1900. These 3½" × 2" paper prints (usually albumen) were mounted on 2½" × 4" cardstock to keep them from rolling up, especially in Senegal's dry climate, and were often exchanged among friends. People collected images of famous figures to place alongside family portraits and those of friends, arranging them in albums created for this purpose, suggesting an aspirational intimacy with fame. At the same time, photographers produced the larger cabinet cards that were 4" × 5 ½" photoprints mounted on cardstock measuring 4 ¼" × 6 ½", often with an embossed studio name in the corner and/or the studio signature and location imprinted on the back. These were calling cards for sitters as well as photographers, whose reputations were mutually imbricated in the photographic medium.

An 1884 or 1885 *carte-de-visite* portrait created by Felix or Blaise Bonnevide (1824–1902/6), a French photographer who had established a permanent photo studio in Saint-Louis by the 1870s (Hickling 2014), illustrates how these cards were meant to depict a particular image of the sitter. This photographic print is attached to a cardboard backing, the reverse of which is embossed with the studio name. In this portrait, a man sits on a chair in front of a solid backdrop, allowing the copious layers of his garments to be seen by the viewer (fig. 1.6). He wears leather amulets around his neck that might have contained Koranic passages and a locally dyed and embroidered three-piece ensemble of shirt, pants, and *mbubu* topped with an appliquéd and lined cape. The photograph is taken from an angle rather than with the typical full-frontal shot used by colonial officers when photographing for documentary purposes, suggesting more of a collaborative portrait.[18] If this is the case, the sitter and photographer likely staged the portrait to emphasize the sitters' sartorial mastery and high status.

Tracing authorship, and thus photographers, of early photographs in Saint-Louis is made difficult by the large number of photographers and photo editors whose names appear on postcards of the island from the late nineteenth

Fig. 1.6 Blaise Bonnevide, *Portrait d'une Sénégalaise*, 1884–1885. *Portraits carte-de-visite à Saint-Louis du Sénégal*. Bibliothèque nationale de France.

Fig. 1.7 Louis Hostalier, 1900. Albumen print, 13 × 18 cm. *Archives nationales d'outre-me (ANOM), France 8Fi92/19.*

century on. Not only did most photographers travel rather than being tethered to a single location, but those like Bonnevide who owned studios transferred them along with their photographic equipment and glass-plate negatives to their successors, who might reproduce these images and credit themselves on later cards. They also employed African assistants who became photographers themselves (Hickling 2007, 50).[19]

Bonnevide was followed by his assistant and business partner Louis Hostalier (active between 1890 and 1912) (Geary 2018, 18). This albumen portrait by Hostalier from 1900 would have been reproduced from a glass-plate negative (fig. 1.7). It shows a frontal portrait of a formally dressed woman, seated on a chair placed on top of a rug in front of an imported backdrop. She displays affluence in the expensive cloth that comprises her ensemble, suggesting that she wanted to impress viewers with her social standing. Knowing who can claim authorship of such photos is complicated by the fact that in 1885, Bonnevide moved from Saint-Louis to Dakar where he associated with Émile Noal (and likely his brother; together they were known as Noal Frères) who also claims successorship to Bonnevide. Both Hostalier and Noal could have possessed Bonnevide's glass-plate negatives. Similar images were published under both photographers' names.

From 1890 to 1900 Émile Noal created an album of photographs of the Muslim reformer and military leader Samory Touré (1830–1900) and his family. He embossed the front of the leather album with "Collection Émile Noal," indicating that rather than a possession of the Touré family, this album comprised a collection of stock photographs Noal would have profited from (figs. 1.8–1.9).

This album contains portraits of Samory Touré with his family, a portrait of a woman who may have been one of his wives or daughters, and various other portraits that are less formal and look more like snapshots, along with various landscapes. At the end of the album is a self-portrait of Noal (fig. 1.8). Noal partnered for a brief time with François-Edmond Fortier (1862–1928), who succeeded him. Fortier possessed Noal's glass-plate negatives and later reissued Noal's images as postcards under his own name, again illustrating how the authorship of images is difficult to discern. Fortier arrived in Saint-Louis around 1898 or 1899 and moved to Dakar in 1901, just before Dakar became the capital of French West Africa in 1902. He opened a shop where he sold his postcards and other items (Geary 2018, 18; Hickling 2007; David 1980). Other photographers of French and Lebanese origins soon followed, including Jean Benyoumoff, Etienne Lagrange, Émile Sursock, and Pierre Tacher, among many others.

Although during this period photography was a widely disseminated technology used for personal portraiture, this medium was also used in the consolidation of colonial empires. From the late nineteenth century until the World War I, European powers systematically used photography to expand their empires (Landau and Kaspin 2002, 142). As the colonial capital of the French Soudan, Saint-Louis became a center of trade and technological development, including roads, railways, canals, bridges, and buildings. In the context of these commercial and technological influences, photography flourished. Photographers in the colonial service photographed technological feats, including roads, bridges, and military campaigns. Their images also captured the colonized people, their occupations, and their forms of material culture, including architecture and tools. The images of these colonial triumphs circulated in Europe and served to make visible the success of the empire.

Colonial photographers also took portraits that would represent what they viewed as essential cultural features of a group. These practices furthered evolutionary assumptions dominant in the scholarship and politics of the day, a dynamic that some scholars describe as the "anesthetization of images that objectify or instrumentalize human beings" (Amkpa, Garb, and Walther Collection 2013, 14). The French commissioned photographs from missionaries, explorers, and others who had visited the African continent to support "visual codes and stereotypes through which the West interpreted Africa and its peoples" (Lamunière 2001, 13). As Krista Thompson argues, "people with different agendas have employed the medium to define blackness and to deny the rights of blacks as subjects and citizens capable of self-possession or governance" (2015, 17). These photographs were circulated for military, commercial,

Fig. 1.8 Émile Noal, Cover and last page with a portrait of Emile Noal, from the album featuring Samory Touré (1830–1900), *Collection Emile Noal, 1890–1900*. PA000076. Musée du quai Branly.

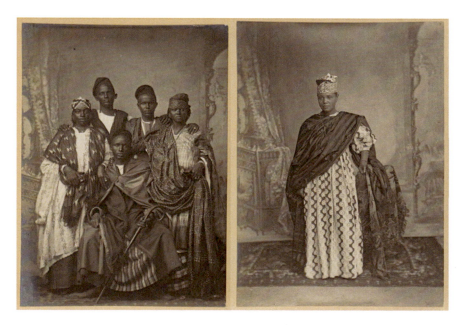

Fig. 1.9 *Left* and *right*, Album pages, Samory Touré (1830–1900). *Collection Emile Noal, 1890–1900*. Musée du quai Branly.

and educational purposes through newspapers, educational slides, postcards, ethnographic monographs, and other means (Killingray and Roberts 1989).

Many of these portraits were reproduced as postcards. Photographers made real photo postcards one at a time from the glass plates using special postcard-sized paper. These silver gelatin photographs were more expensive than mass-produced lithographs and collotypes printed by photo editors.[20] This medium provided a lucrative and early outlet for photographers to publish their work before publishing in newspapers and magazines was common (MacDougall 2006, 195). As the anthropologist Patricia Spyer (2001, 181) has argued, postcards had a ubiquitous, global reach and mass circulation. Postcards preceded illustrated magazines and thus gave people early access to the lives of others.

As Krista Thompson writes, postcards were popular because they played into European and American fantasies about and romanticism of the tropical world. These fantasies supported tourism, but, more dangerously, they also supported the idea that wild nature lay waiting to be ordered by colonial knowledge and power. Seemingly premodern landscapes, and the people photographed within them, were "imagined as aspiring to, yet lagging behind, the time and history of the 'civilized world'" (2006, 257). Thompson shows how postcard editors embellished these views by eliminating modern details like electrical wires, employing hand painting to play up tropical vegetation, including captions that reflected European views, and reissuing iconic images multiple times.

The documentary and realist power of postcards thus derives from the infinite reproduction of scenes and portraits that confirmed White European ideas of Africa as well as of themselves (Landau and Kaspin 2002, 2). Inattention to the correctness of titles might have reflected how consumers located the veracity of a postcard in how well it reflected their ideas of a given place. Consequently, photographic postcards reflect histories of whiteness as well as colonial ideas that reinforced racist typologies (Sealy 2019, 25). Christraud Geary and Virginia Webb (1998) have written about how the camera conquered and divided colonial subjects, setting up clear distinctions between African subjects and the European photographers and audiences who exploited them. Postcards thus reinforced colonial epistemologies relating to hierarchy and difference. As Thiam observed, French photographers like Tacher rarely got close to their Senegalese subjects, preferring to photograph them from a distance. Colonial-era photography played into the expansion of the European empire by dehumanizing its subjects, and a significant number of early postcards depict nude women and scenes of corporal punishments.

For Europeans, circulating images of others was thus a way for them to make statements about themselves (Geary and Webb 1998, 2). That included

assertions of their power to gaze upon the image of others (Prochaska 1991, 46). This dynamic was reinforced not just by the early 1900s mania for sending and collecting postcards, but also by using photographic plates in scholarly works concerning the continent, in anthropological and natural history photography, and in colonial exhibitions that established clear distinctions between Europeans as photographers, African women and men as subjects, and Europeans as the audience.

Thompson's research on these dynamics in the Bahamas holds for the colonial project writ large. An undated postcard by Fortier, for example, positions two university students against a lush backdrop in Dakar that features a colonial building (fig. 1.10). The French planted palm trees, hibiscus, and bougainvillea in largely European enclaves like this, thus creating rather than capturing the tropics. After all, Dakar sits in the dry savanna of the Sahel belt. Such images serve to reinforce an idea of the steamy tropics and to tether Senegalese women and men as natural objects to a landscape imagined as tropical.

Across French West Africa, photographers and photo editors produced 7,210 different postcards between 1901 and 1918 (Prochaska 1991, 40), 6,000 of which depicted Senegal (David 1978, 5). Little is known about most of the names appearing on the postcards, whether the person was a photographer, a photo editor, or a producer of photo paper (Prochaska 1991, 43). Photographers shipped their photographs to France where photo editors reissued multiple quantities of each image as postcards for eager French audiences. Photo editors also shipped postcards back to the colonies where they became part of the photographers' stock used to attract new clientele (Geary 2003). Local European residents of the colonies also bought postcards from shops selling a variety of goods including stationery, sending them back to the metropole.

Elsewhere, postcard views of landscapes and their Black inhabitants were heavily critiqued. Consider Jamaica, where the Universal Negro Improvement Association, founded by Marcus Garvey, condemned these portrayals at their 1915 meeting. H. A. L. Simpson, a mayor and Garveyite, criticized photographers for paying sitters "to pose in almost any manner they [the photographers] wanted" (Thompson 2006, 73). Further concern was expressed by E. Ethelred Brown of the Jamaica League about the reception of these images in the metropole and the misconceptions such images would produce, given that most postcard images featured workers and hawkers (Thompson 2006, 260). Residents of West Africa had good reason to make the same objections.

Some of the critiques of these images likely reflect the fact that, although European audiences may have viewed photographs as unmediated depictions of reality, photographs—including those on postcards[21]—were often staged

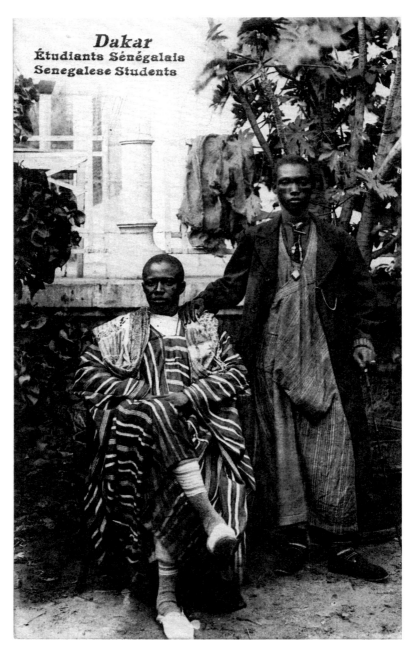

Fig. 1.10 Anonymous. *Dakar, Senegalese Students*. Postcard. *Collection of the author.*

performances in which narratives of both science and fiction were at play. For example, David MacDougall reveals how staged collaborations between sitters and the French colonial photographer Jean Audema in the French Congo disclosed the fraught nature of colonial power as well as the potential for sitters to satirize the form from the inside (MacDougall 2006, 204). These photographs, the lens-based artist Nomusa Makhumu argues, were "marvelous fictions that legitimated colonialism, racism and sexism."[22] Even so, they occasionally splintered the colonial frame, because images lend themselves to myriad and competing interpretations. Images contain an excess of meaning and this is in part what enables their reinterpretation (Pinney and Peterson 2003; Poole 2005). For example, colonial mug shots of Muslim shaykhs suspected of agitating against the French became devotional objects for their adepts (Roberts et al. 2003). In Senegal and other West African settings, photographs taken in service of the colonialist project became symbols of local resistance, a reminder that, as images circulate, their meanings do not remain fixed.

Consider an 1885 photograph on albumen paper from collodion glass negatives, attributed to Bonnevide, belonging to an album titled *Paysages et types de mœurs du Sénégal* (Landscapes and customs of Senegal) (fig. 1.11). The title of Bonnevide's album suggests the way portraits were used to document and create ethnic classifications of people to facilitate the political administration of the colonies. In this portrait, the sitter squarely faces the camera in a pose common to this kind of classificatory project. Yet, in contrast, the caption for the portrait suggests that this is not an ethnographic portrait created to document an ethnic type. The caption reads "clothes for a party," suggesting the possibility of a more complex persona for the sitter, in that she has clothes for various occasions rather than one standard ethnic costume. Although the sitter wears a hairstyle and head covering typical among Peul women, her jewelry is a mix of Wolof elements, such as filigree, and Peul styles, which featured more granulation and hammering (Johnson 1994). Were these pieces from her personal collection or did they belong to the studio? Again, the fact that the portrait is shot curiously close for an ethnographic image casts doubt on its authorship since European portraits of this nature were largely taken from a distance. This portrait illustrates how difficult it is to ascertain authorship and the degree to which sitters participated in their portrayal. It also demonstrates how photographic objects and practices during the colonial period led to a "blurring and instability of categories" such as distinctions between photographers, sitters, and audiences, thus raising questions about the degree of participation and collaboration that took place (Edwards 2013, 49).

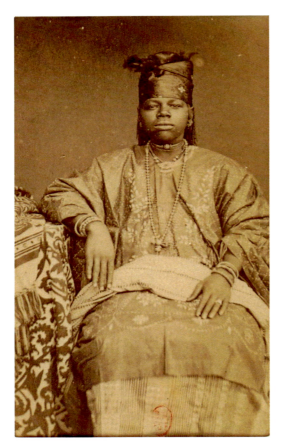

Fig. 1.11 Blaise Bonnevide, *Paysages et types de mœurs du Sénégal*, 1885. Albumen paper from collodion glass negatives. Bibliothèque nationale de France (BnF), Dept. Estampes et Photographie, Société de Géographie.

PORTRAITS AS FAMILY NETWORKS

During our time at the archives, Ibrahima Thiam described discovering a photograph of his great-grandfather Mame Samba Lawbé Thiam in the archives in Senegal. His great-grandfather, he explained, "was a *tëgg* (a blacksmith and a jeweler) working on iron" who would "take iron objects to France." The photograph was taken at the l'Exposition Universelle de Paris in 1889, where, as another photo in Thiam's home illustrated, he won honors. "On his photo, I could read his résumé and a certificate of his participation. He was given medals." Thiam told me that he learned that his great-grandfather initially opposed having this photograph taken. He protested the low pay that the Senegalese blacksmiths received in France for their participation in the exposition. In the

end, despite his opposition to the French labor practices, he allowed himself to be photographed for the occasion.

Here Mame Samba Lawbé Thiam's portrait tells two histories: that of the Senegalese experience of exploitation and that which commemorates French dominance. While Thiam's great-grandfather resisted being photographed and shared his experience of being unfairly compensated, the fact that the photo even exists reminds us of the power imbalance that he faced in France at that time. In Thiam's hands the portrait is more than an image of his grandfather: it is an oral history that marks loss and repossession of historical narrative. Although portraits like these were rooted in anthropological or colonial documentation, they also circulated along paths that inscribed family histories (Edwards 2011, 180): hence this photo's place in Thiam's great-grandfather's collection. Rather than representing the past, this photo speaks to an ongoing negotiation about who owns the past. Thiam's intimate connection to this portrait and his knowledge of the story behind it suggests that this image and others like it should be repatriated.

Given the importance of the exhibition, and the extensive circulation of photographs at the time, it is not surprising that Mame Samba Lawbé Thiam's portrait would be found in two places and that multiple reprints exist. In fact, I found the very same portrait of Thiam's great-grandfather in the Bibliothèque nationale de France in an album of Roland Bonapart of the French Society of Geographers that contained twenty-four portraits of the jewelers who took part in the exposition. Bonapart was a collector of anthropological portraits. I also found the portrait in the Musée du quai Branly.

Privately commissioned portraits, on the other hand, belonged to both the sitter and the photographer. They could become part of the photographer's stock and repertoire of "collection variée de types de noirs du pays et vues du Sénégal" (diverse collection of types of rural Black people and views of Senegal), available for purchase by postcard collectors and authors of scholarly publications who would then send them into new spheres of circulation (Hickling 2014) that sitters were unlikely to have envisioned. Sitters did not provide consent for such uses (Geary 2003, 44).[23]

Figure 1.13, for example, is a gelatin silver print cabinet card signed by Fortier indicating his authorship and ownership, yet it is unlikely that he was the photographer. The sitter was likely quite wealthy, given the length and ampleness of his three-piece mbubu and his walking stick. As Patricia Hickling observes, Fortier was not a photographer of the elite, and there is no evidence that he operated a portrait photography studio that wealthy African families would have visited (2007, 40). He was not an itinerant photographer, seeking clients in

Fig. 1.12A and Fig. 1.12B Mame Samba Lawbé Thiam, *Artiste Bijoutier à l'Exposition Universelle de Paris en 1889*. Photograph VIII Sénégalais (Exposition de 1889) Musee du Quai Branly.

coastal cities with his equipment and backdrop, although he did participate in a few colonial missions.[24] The photograph was likely taken by someone else and reprinted by Fortier, who could have scratched his own name on the original glass-plate negative to claim authorship—something he did with the work of many other photographers whose plates he acquired as postcards. Moreover, many of his postcards titled "Collection Fortier" were taken before his arrival in Senegal around 1900. There was nothing exceptional about passing these other works off as his own; it was a common enough practice among engravers, touch-up painters, and photo editors of the period (Hickling 2007, 46). And it meant that a portrait that might have signified wealth and stature to its sitter and his family would, for an audience in France, suggest exoticism and difference.

Although the early photographic studios in Saint-Louis were owned and patronized by White Europeans living in the colonies, some Senegalese families also patronized these studios, especially Métis families. When families commissioned photographs from colonial studios, they imposed their own visual sense. African photographers who worked as apprentices in these studios also set up their own outdoor spaces to photograph prominent African families. People gathered around the camera and photographers as they did around the radio or the printing press; these were places where social life unfolded.[25]

Fig. 1.13 François-Edmond Fortier, 1900–1910. Gelatin silver print, 6 ½ in × 4 ¼ in. Visual Resource Archive, Department of the Arts of Africa, Oceania, and the Americas. *The Metropolitan Museum of Art, New York. Accession Number: VRA.2014.8.039.*

Families pasted portraits behind protective glass, which they decorated with botanical motifs to enhance their meaning and value (fig. 1.14). Called *suwer* in Wolof or *sous verre* in French, photographic portraits were framed with Muslim iconography that endowed sitters with piety (Bouttiaux 1994). The reverse side of the glass was painted in motifs such as stylized peacocks and flowers, referencing an Islamic conception of paradise and creating a frame for the photograph (Roberts et al. 2003, 94). This practice served in part to replace the chromolithographs that wealthy Senegalese Muslims had been able to import from Moroccan and Lebano-Syrian merchants at the turn of the twentieth century, but that the French had suppressed with a ban around 1911 on the importation of Islamic imagery (Bouttiaux 1994; Harney 2004, 180). Senegalese artists painted animal and floral backdrops (Bouttiaux 1994, 14) that picked up on the vegetal motifs common in Islamic art. The painted frames also suggested something of the stature accorded to daguerreotypes, which were surrounded by fancy gold and embossed leather, or to turn-of-the-century European portraiture, which was surrounded with floral embroidery. They thus helped to signify the social status of the owner of the portrait as well as the people it depicted.

In addition to painted glass, many studio portraits of the era featured mass-produced backdrops, which were manufactured by a handful of companies, such as Englemann & Schneider in Dresden and L. W. Seavy in New York, and sold to photographers around the world. These backdrops were convenient since they could be rolled up and easily transported. Portability was important before electrification, since photographs had to be taken outdoors to obtain better lighting. The backdrops could also be hung in multiple ways: loose, attached to a wooden stretcher, or suspended from wires in the studio or outdoors. The backdrops, combined with movable furniture, allowed photographs to recreate domestic interiors even when outside. Other backdrops were painted with images of tropical foliage (Peffer 2013), which, as discussed above, reinscribed European ideas of the tropics and the "exotic" people who inhabited it. The studio photographer Jean Benyoumoff, who Ibrahima Thiam posited was likely of Lebanese background, created portraits in his Dakar studio using backdrops depicting tropical foliage or interior scenes with architectures of the well-off, including grand staircases and balconies. However, in the below image (fig. 1.15), Ibrahima Thiam explained to me, Benyoumoff's backdrop was painted onto the wall of his studio and thus was likely a less expensive copy of these mass-produced backdrops.[26] This illustrates how photographers were innovative and found ways to serve their clients.

While Senegalese photographers used the same backdrops as their peers in Europe and America, they tended to get closer to their sitters, engaging in

Fig. 1.14 Reverse glass painting with photograph, 49.5 × 51.5 × 2.2 cm. EO.1994.3.4. *The Royal Museum for Central Africa, Tervuren, Belgium. https://www.africamuseum.be/en/research/collections_libraries/human_sciences/photo_reproductions.*

complex negotiations that also characterized patron–client relations in the region (Bigham 1999). African portrait photographers only produced a singular photograph from their glass-plate negatives. Personal portraits were costly and time-consuming affairs. Therefore, the poses and clothing were formal, and poses were generally frontal, though not always. Each portrait depicted a sitter engaging in a philosophy of wealth and value that underpinned vast networks of exchange on the coast. The sitters thus embraced what the Dakar-based fashion designer Selly Raby Kane has called "maximalism," which I have discussed elsewhere: the largest possible number of different kinds of valued objects

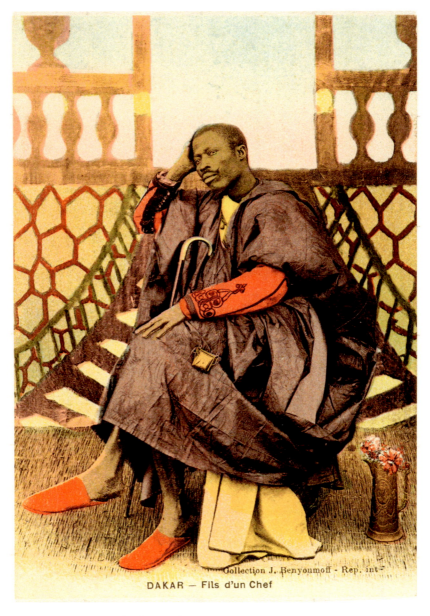

Fig. 1.15 *Dakar—Fils d'un Chef*. Collection J. Benyoumoff, c. 1912. Postcard, collotype, hand-colored, 13.5 × 9 cm. *EEPA Postcard Collection, Senegal, SG-20-12. Eliot Elisofon Photographic Archives, National Museum of African Art, Smithsonian Institution.*

layered on the body (Buggenhagen 2012). Textiles and jewelry were produced through a patronage system and their acquisition and display demonstrated status; photographs were an important way through which people extended their wealth in time and space and made it visible to others.

This kind of display is evident in figure 1.16, titled *Natalou diguenou Domou Ndar* (the wealth of a woman who was born in Saint-Louis). This image could have been reissued from an albumen print judging from the amber color, though the date is listed as 1933, when roll film would have been available. The sitter is elongated on her side on a mat with pillows and adorned with jewelry on her ankle, called *lam u tank* in Wolof, as well as on her wrists, and in her wig. She wears a gold filigree necklace with a larger medallion in the center flanked by two smaller medallions; this combination is known as a Kostine. It was a fashionable and desirable way to display wealth. Her affluence in cloth is also demonstrated in the multiple layers of wrappers covering her lower body. These locally woven wrappers represented a woman's wealth and value exchanged during baby-naming ceremonies and weddings, so they signify not only her own access to resources but her extensive social network (Buggenhagen 2011). Another large bracelet or anklet is positioned in front of her on the mat. These anklets were so heavy that they were made with silver or gold plates (Johnson 1994).

In another example of the display of wealth in portraits, in figure 1.17, a postcard-format gelatin silver print, the sitter's body faces the viewer's right, and her head is turned frontally, looking at the viewer. This was more likely a family portrait, printed on the cheaper postcard stock. Here again, the philosophy of maximalism with respect to bodily adornment plays out. As in the previous portrait, this sitter wears a wig in the fashion of *Nguuka*, which became fashionable around 1902 in Senegal among Wolof women. The sitter in figure 1.18 is wearing *Les Pof*, a slighter version of the Nguuka (Siga 1990, 29). Their wigs are threaded with coins and gold ornaments in the shape of leaves, trefoils, teardrops, and balls, which also suggest the women's wealth.

These portraits, whether printed on postcard stock or framed behind painted glass, worked their way into wedding exchanges through the practice of *xoymet*, a Wolof word meaning "to catch a glimpse" (Siga 1990). During the matrimonial process, portraits were borrowed from kith and kin and hung to blanket the walls of the family home. Families adorned their walls with these visible reminders of social, affective bonds indexing affinal, kin, and age groups. As the photographer Ibrahima Thiam described the practice: "The most important richness that she [the bride] would find there was not a car or money. What she finds important at her new room prepared by her husband are the photos.

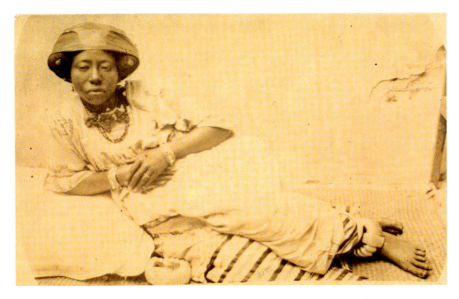

Fig. 1.16 Natalou diguenou Domou Ndar, Diamoney, 1933. Postcard. *Courtesy of the author.*

These photos reassure her that where she now lives is a large family. The room was decorated with all these pictures and reverse glass images combined and with cloth."[27]

In figure 1.18, a photograph has been taken of a room set up for xoymet. The picture of the portraits reveals the reflexivity of the practice of assembling portraits for display, concretizing an ephemeral practice that was meant to offer only a glimpse of a family's networks. A family tied their patrimony to the production, preservation, circulation, and display of such framed portraits, as well as photo albums. This process of image-making and archiving to preserve individual and collective identities stands in sharp contrast to the generic and typological nature of colonial postcards. The latter, including the portrait of Thiam's great-grandfather, were reissued, bought, sold, and sent to persons who would never become kin or affines.

While personal portraiture endured in the cities and spread to the rural areas in Senegal, postcards' popularity faded with the start of World War I. The war reduced postcard production and the enthusiasm for postcards by collectors. Additionally, technological developments in cameras and films ushered in the era of studio photography, and what would later become known as

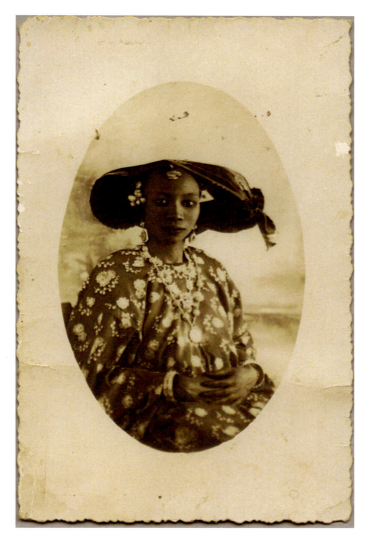

Fig. 1.17 Woman, Unidentified, 1920s–1930s, Senegal. Postcard-format gelatin silver print, 5 ⅜ × 3 ½ in. *Visual Resource Archive, Department of the Arts of Africa, Oceania, and the Americas, The Metropolitan Museum of Art, New York. VRA.2014.8.035.*

Fig. 1.18 Le "Xoymet." Fatou Niang Siga. Reflets de modes et traditions Saint-Louisiennes. *Editions Khoudia, 1990, p. 55.*

photojournalism. In the late 1920s when the gelatin silver negative on celluloid-roll film was introduced it surpassed dry plates in both ease and popularity. These developments facilitated the spread of photography in Senegal's major cities and in the countryside in the interwar period and beyond.

The "emancipatory power" (Bajorek 2010a, 434) and democratization of African studio photography contrasted with scientific claims and narratives of colonial-era photography that presented subjects as specimens and types (Rabine 2010, 314). As the novelist Aminata Sow Fall remarked, "The arrival of photography must have been seen as a gift from the gods, to conspire against the grotesque and insulting caricatures produced by the colonists. We could finally all enjoy looking at ourselves in a snapshot of happiness; immortalized on a card … a photograph should only reflect the beautiful, admirable, dazzling side of our existence. That is why we were photographed for major ceremonies" (Fall 1999, 64). Maximalizing the clothing, accessories, and props that were available to them would become one way through which sitters worked to put forward their dazzling sides.

MIDCENTURY MAXIMALISM IN STUDIO AESTHETICS

By midcentury, social life revolved around photographers' studios. Sitting for a portrait became central to marking important moments in social life. Sitters displayed their studio portraits taken to celebrate a wedding, a baby-naming ceremony, or their return from the Hajj pilgrimage prominently in their homes. Friends would comment on how well the photographer had captured the sitter's *jikko*, or "essence" in Wolof, and how well the sitter had performed *sanse*, or had shone. These portraits preserved a moment in the storied life of an individual and made visible the investments of family and community through the skill and artistry of the photographer in the studio.

Photographers also used their visual acumen to portray their clients' aspirations (Paoletti and Biro 2016, 194). When they commissioned a portrait of themselves, sitters could bring their favorite things to the studio or draw on the photographer's collection of costumes and props as they struck an appealing pose. Through dress, props, and backgrounds, portraits contributed to the sitter's construction of their social persona (Peffer 2013, 6). In Senegal, portrait photographers captured midcentury maximalism, or the way in which sitters made sartorial statements through clothing and adornment about who they were and who they wished to be seen as in the world. These portraits thus blurred image and imagination.

Studio photography across West Africa from during and after the postwar period thrived in the context of a booming economy, migration to the city, an emergent middle class, and mounting euphoria on the threshold of Senegalese independence. Friends gathered under the overhangs of roofs or trees or on the benches surrounding the photo studios to see the photographer's latest portraits hung on studio walls, flip through albums, and have their own pictures taken. In figure 1.19, a photographer displays portraits for the community. A thriving studio culture was also supported by technological changes in film processing and printing that further put the craft in the hands of photographers in Senegal. Film no longer needed to be sent abroad to Paris for developing; photographers could process their own black-and-white 35 mm film and 120 film for medium-format work. Photographers in the port cities of Dakar and Saint-Louis had access to the film, paper, and chemicals necessary to process and print photographs in their studios. Moreover, by the late 1950s, as a wider selection of chemicals became more affordable, photographers refined their printing techniques (Bajorek 2012, 154).

Photo studios became ever more prevalent in the middle of the last century, especially in Saint-Louis where Doudou Diop, Aloune Diouf, Meïssa Gaye,

Fig. 1.19 Vermot-Gauchy (Georges, Guérin) (1916–?), inspecteur du travail aux colonies Sénégal. Kaolack (Sénégal), 1955. Silver gelatin print glued on cardboard, 13 × 18 cm. *Agence économique de la France d'outre-mer. FR ANOM 30Fi25/39.*

Doro Sy, and Adama Sylla worked, among others (Saint Leon and Pivin 2011). Some Lebanese studios continued to operate in Saint-Louis, such as Émile Sursock's studio. Photographers from elsewhere in West Africa also set up shop in the riverine city, including Julien Lopez, of Cape Verdean descent, who opened Studio Artista in the 1960s (Bajorek 2020, 51).[28]

Other photographers started studios in rural areas. For example, Omar Ly' Le Thiofy Studio[29] operated in the rural region of Podor in 1963, with two realist backdrops he had commissioned: a painting of Mecca and an airplane facing Europe (Evans 2015, 34). In choosing his subject matter for these backdrops, Ly surely had his clientele's aspirations in mind by depicting locations where many hoped to travel. Clients often chose to patronize particular studios for their selection of backdrops: theatrical displays whose "magical, associative qualities" might express aspirations or, as Arjun Appadurai (1997, 4) suggests, a "lampoon" of modernity on the part of the sitter who selects the backdrop, the artist who creates it, or the photographer who includes it in their collection. Theater and photography intersected in the development of lightweight, portable backdrops for portraits (Thompson 2015, 79). Placing a sitter in front of a backdrop invites performance, as if one is onstage; "rather than a window on reality, the portrait offers a carefully staged theater-space for the projection of possible selves" (Strassler 2010, 79). When Ly photographed outdoors, he used locally woven textiles or machine-printed cloth—perhaps due to the higher cost of imported backdrops or their lack of availability (Rabine 2017). Oftentimes in his photos, several women would be seated in front of a man who stood with his back to the camera with arms outstretched, so that his maximal-length ten-meter mbubu would create a textile backdrop. In other instances, two young men would hold a cloth between them to form a backdrop. In the way Omar Ly's portraits are exhibited in the present, these details, which were

meant to remain out of the frame, are now depicted, raising questions about art historical visualities, which can at times be at odds with local visualities.

Other photographers also introduced their own innovations in studio portraiture. For example, Meïssa Gaye's (1892–1993) portraits often featured painted scenes and patterned curtains, which sitters sometimes seem to burst through, as if they have just entered a room to greet visitors in their best attire, or as if they are on a stage at the beginning of a performance. Gaye preferred a low camera angle referred to as the "hero shot" used to make people seem larger than life and tended to capture his clients looking at each other or directly at the camera. These aspects of his photography lent agency to his clients, enhanced their status, and, in-group portraits, revealed their affection for each other. Gaye worked with many cameras including a 6" × 6" Rolleiflex, he built an enlarger for his practice, and he hand-colored his portraits (Foadey and Gaye 1994).

Gaye opened his Tropical Studio in 1945 after serving in World War II for the French when he had photographed West African soldiers (C. Bell et al. 1996, 265). Ibrahima Thiam said that like many photographers, Gaye had his studio in a room in his Saint-Louis home.[30] Prior to opening his studio, Gaye, like many early photographers, worked in the colonial service and on the side as an itinerant photographer, going door to door taking portraits. He obtained his first camera, a glass-plate camera, from a European he met while working in the shipyards in Congo. He later served as a customs service agent in Conakry and Dakar and by 1929, he was working exclusively as a photographer in the rural capital of Kaolack, Senegal. Three years later he returned to a civil service position in Ziguinchor, a city in southern Senegal in the region of Casamance. In 1939, Gaye returned to Saint-Louis where he served as an official photographer for the city's Department of Justice. Little remains of Gaye's body of work, however, as his studio was flooded after his death in 1982, destroying many of his negatives (Chapuis 1999, 49).

In Dakar, socialites, political leaders, religious figures, and writers sought to have their portraits taken in Mama Casset's (1908–1992) studio, African Photo. Casset partly adhered to the standard conventions of studio portrait photography common across West Africa, including "compositional centrality, full-length figures shown frontally, shallow pictorial space and the incorporation of backdrops and accessories" (Lamunière 2001, 14). Casset turned to new compositional devices such as lighting to capture subjects' complex personalities. He often emphasized tactility through maximal use of props to create a sensory and affective connection with the viewer. Texture can lend tactility to

a two-dimensional object such as a flat photograph. More than implying the sensation of touching, texture can also make the two-dimensional object appear as if it is three-dimensional, like the human form. Casset also posed his sitters' bodies to accentuate their status as Gaye did.

Mama Casset apprenticed for an acquaintance of his father, the French photographer Oscar Lataque, at age twelve (Saint Leon and Pivin 2011). At twenty, the French photographer Tennequin employed him in his shop, Comptoir photographique de L'AOF, while his younger brother, Salla Casset, took on his apprenticeship for Lataque (Saint Leon and Pivin 2011). Following his apprenticeship for Lataque, Casset worked for the photographic desk of the AOF and, like Meïssa Gaye, he also served in the French military, as an aerial photographer in the French air force.

After the war, Mama Casset opened his studio, African Photo, in the Medina neighborhood of Dakar on the corner of Rue Blaise Diagne and Rue 31, running it from 1946 to 1980 (Chapuis 1999). His clientele came from Dakar's middle- and upper-class families, many of whom he had met through school, a privilege afforded to him by his father's position as Senegal's first police officer (Saint Leon and Pivin 2011). Unfortunately, Casset's studio burned down in 1984, leaving only prints ranging in size from 9" × 13" to 24" × 30" stamped "African Photo" that had been supplied by him for two volumes published by *Editions revue noire*, those still held in the family collections of his sitters, and those that had appeared in *Bingo* magazine.

Not only did Casset photograph Dakar's influential class, but as a devout adept of the Tijani Sufi congregation, he also served as a photographer for the Tidjani scholar and leader Serigne El Hadj Malik Sy and his son (Saint Leon and Pivin 2011). He also took portraits of other leading Sufi figures of the era. Consider the three portraits by Casset in "Les sectes Musulmanes, Le Khadria" published in the popular illustrated magazine *Bingo* in December 1953 (fig. 1.20). These portraits illustrate Casset's distinctive compositional strategies, including the close portrayal of his sitters' hands and the props they held, along with their sartorial statements.

While some elements of these portraits may echo European conventions such as the mass-produced backdrop in the portrait in the upper right or props such as chairs and curtains, West African studio photographers, suggests Manthia Diawara, were producing an aspirational self outside of the colonial view (Diawara 2003). Rather than being "a window on reality," portraits like Casset's are "a surface, a ground, on which presences that look out toward the viewer can be built" (Pinney 2003, 219). Mama Casset partly achieved this affect by accentuating tactility in his photographs by emphasizing hands and touching

in poses (Batchen 2000, 265). In each of the portraits of religious leaders, the hands are central to the composition; they are outstretched or holding props, which signify the figure's status. The presence of religious paraphernalia in Casset's portraiture also adds textural detail to his portraits, combining the presence of the here and the imagination of the hereafter.

Closer inspection of the portraits of Cheikh Sidia Al-Kebir, Cheikh Awa Balla M'backe, and Seydina Issa Laye reveals how the surface effect of tactility or texture contributed to the instantiation of their authority in the eyes of their reader-disciples. For example, Cheikh Sidia Al-Kebir's portrait (top left) depicts several carved leather pouches of the sort used as talismans, to hold miniature versions of the Koran or other religious tracts, or tobacco. The layering created by these objects contributes to the texture of the overall image in addition to the layers of white damask and a saturated, dyed wrapper in a dark shade. Casset has used the same layering effect in the portrait of Cheikh Awa Balla M'backe (top right) from the cloth backdrop and the curtain hung in front and tied to the viewer's left to the tile flooring covered with a rug and the sitters' multilayered ensemble. Casset has created "a world of surfaces and materiality that reach out to their embodied viewers" much as the Indian photographers described by Christopher Pinney (2003, 218) did. Casset's use of tactility in his portraits evoked a visceral reaction in his viewers. The centrality of religious objects, the richness of the layered cloth, and the centering of the subject's hands all highlighted the divine and connected it to the viewer, thus creating deep connections between viewer and subject. These images, and others of venerated Sufi scholars, were widely used in devotional practices as objects of divine contemplation.

As much as these portraits by Casset drew on local discourses of religious authority and applied them to the visual field, they also demonstrated qualities characteristic of the portraiture genre in general. Props, such as religious paraphernalia, have been used by portrait artists in many parts of the globe to develop a narrative, reflect details of individual lives, and convey societal values. In eighteenth- and nineteenth-century European portraiture, props indexed social and political position by providing clues to a sitter's worth as well as the sitter's actual or desired social positions. For example, curtains and pillars symbolized aristocratic origins. Props are entangled with social life; this is a relationship "in which persons and things are involved in a cyclical process of mutual constitution" (Geismar, Kuchler, and Carroll 2016, 3). Colonial-era portrait photographers based in Senegal used props to provide continuity to social lives ruptured by transatlantic voyages for some, and by the violence of colonialism for others. Heavy curtains, tables and chairs, and plants and flowers

Fig. 1.20 Mama Casset, *Bingo* magazine, December 1953.

depicting domestic interiors appeared in colonial imagery to index the status and well-being of African and European families on the move and to display this to those at home.

Midcentury portrait photography in West Africa similarly emerged in contrast to denigrating colonial images, filling the frame with intimacy and dignity. In the theater of the studio, the photographer played the role of a director (Borgatti 2013, 328). In Senegal, portrait photographers such as Casset employed props so that their sitters could envision and play with multiple personas.[31] In neighboring Mali, Seydou Keïta provided props in his studio that young men used to perform *fadenya*, characteristics of individuality and fortitude, by dressing as boxers, cowboys, and dandies (Keller 2013b, 371). As was true elsewhere in the world including India, sitters turned to photography to "increase and attest to the possibilities within" themselves (MacDougall 2006, 148) and to "enlarge" their sense of themselves (MacDougall 2006, 169). Nearby in the Gambia a skilled photographer brought out the inner character, or jikko, of the sitter. Photographers layered backdrops and props, styling social personas by drawing on concepts from the world of adornment and its links to tailoring. Props point to the *jamano*, a Wolof word that translates to "the era or fashion of the times" (Buckley 2000, 76). This is not unlike ideas about photography in mid-nineteenth-century Europe where the "surface of the body, and especially the face and head, bore the outward signs of inner character" (Sekula 1986, 11). In a studio portrait by Mama Casset (fig. 1.21), props and layers play out in the heavily embroidered kaftan worn by a businessman as he sits behind a desk with a telephone and a pen and pad of paper. Shot from the waist up, this photo literally enlarges the man, with his body filling up most of the frame. While we cannot know his profession, his watch, the telephone he holds, and the writing pad suggest his engagement with modern objects, while his richly embroidered dress testifies to his wealth.

In figure 1.22, two women wear the braided-wool wig style that turns up at the ends known as the *jamano kura* in Wolof, or "the time of Coura," named after a dancer Coura Thiaw. This was a popular style in the 1940s and 1950s, designed to cover the heads of married women (Siga 1990, 33). In their hairpieces they have tucked gold ornaments, one in the shape of a leaf called *xob* in Wolof, as well as gold coins called *libido* referring to Louis d'or, which was a twenty-franc gold piece. They wear bracelets called *lam*, which are the first pieces of jewelry a young woman receives. Portraits like this of two women most often depicted co-wives. Such portraits worked to show amicability, emphasized here by the placement of the hand near the shoulder. Casset often posed his clients so that their bodies touched, pointing to—and constituting—affective

Fig. 1.21 *Mama Casset et les Précurseurs de la photographie au Sénégal, 1950.* Editions Revue Noire, Paris, October 1994. *Courtesy of Revue Noire.*

Fig. 1.22 Mama Casset, Studio African Photo, Dakar Senegal ca. 1950–1965. © April 4, 1954. Courtesy of Revue Noire.

bonds. Family portraits, like group portraits, index relationships among the sitters (Brilliant 1991, 92).

Again, we see layers upon layers of textiles: wool wigs ensconced in imported silk scarves, layers of lace upon locally dyed and manufactured cloth, all in front of the rich folds of the curtain backdrop. Casset's use of a simple curtain allowed the composition to dominate the visual field.

Casset's modulation of the image's sharpness and tonal contrasts enhances the effects of the lighting and backdrop choices. When combined with his use of light to highlight the facial features of the sitters who turn their bodies slightly to one direction while facing forward, he created a slight shadow behind them. This results in a three-dimensional figure and asks the viewer to think about the complex identity of the sitter. This is like the use of light in painting to model three-dimensional form.

Casset framed the portrait as an angled bust, in which "the sitter's face was captured in a three-quarter view, with the body appearing to lean toward the edge of the picture frame" (Lamunière 2001, 29) or even to "lean out of the frame" (Mercer 2016, 159). Casset likely originated the pose (Bajorek 2020, 61), but Malian photographer Seydou Keïta used it as well. Commonly appearing in the press kits of the French black-and-white cinema, this pose also became part of the Harcourt style, named after the famous French portrait studio. Among those who patronized Studio Harcourt was the first president of Senegal, Léopold Sédar Senghor. The angle of this portrait style creates an appealing relationship with the viewer. As Kobena Mercer (2016, 159) argues, "the depiction of Africans in prevailing idioms of photo-journalism tends to imply a vertical axis, which literally looks down upon the subject, thereby cast into a condition of pathos and abjection," whereas "Mama Casset's portraits are set on a diagonal" that "evidences an interaction conducted on equal footing" with the viewer. When the photographs circulated, whether on the walls of homes or in albums, they suggested the reciprocal bonds of affect. The aspirational maximalist setting was used to create, document, and aspire to relationships in and across time. Portraiture achieved this effect through careful preparation with an eye toward expansive networks of circulation.

Ibrahima Thiam explained that he understood this circulation in new ways, after a talk with his ninety-four-year-old grandmother. "I wanted to take a portrait of her with a digital camera, but she refused, saying, 'Do not take a picture of me.' For her, a photograph needs preparation. It was like the era of Meïssa Gaye. It took him one week to prepare a photographic session. The sitters would check their clothes, dye their hands and feet, and so on.... Portraiture was part

of a cultural process. People devoted time to it."[32] Indeed, since the turn of the twentieth century, people on this small slice of the Atlantic coast have woven the ties that bind kith and kin with carefully composed photographic portraits. Families marshaled investment through an extensive network of kin and affines (relatives by marriage) to commission a single portrait. This portrait called for new clothes, hennaed hands, a wig studded with ornaments, and jewelry. Families commissioned portraits to mark a marriage and show the *ngeganol*, the collection of jewelry given by a groom to his bride upon marriage.[33] A resplendent ngeganol consisted of a gold or silver necklace, bracelets, rings, earrings, and hair ornaments exhibiting techniques such as filigree, granulation known as *thioup thioup* in Wolof, and hammering in the shape of flower baskets, butterflies, and the claws of the lion.[34]

The sitter in the portrait displays a composite of accumulated actions contributing to the wealth and value of the lineage, a crossroads of the human and material world. Each item worn by the sitter was valuable unto itself. It was also "the effect of aggrandizement"; that is, the assemblage of wealth of which it is in part gathered through multiple paths of relatedness rooted in relations of reciprocity (Strathern 1999, 37). For this reason, Ibrahima Thiam's grandmother emphasized the preparation necessary to sit for a portrait; she was not sitting for herself, but as an assemblage of the collective. In a colonial-era portrait, an ornamented sitter is reduced to an object—a typical Wolof woman, as captions often read—but for Thiam's grandmother, a portrait meant representing the collective, a weighty responsibility considering that each person is a composite of their relations with others. As Thiam often remarked to me, young people failed to appreciate what portraiture had to offer; they did not grasp his grandmother's understanding of the power of the medium. For her and others of her generation, as photographs were taken out and shown time and again, so too were relationships revived and strengthened (J. Bell 2005, 118; Strathern 1999).

Portraits of a sitter in her accumulated regalia, the valued objects of the lineage representing its ability to give and receive, but also portraits as objects unto themselves, contributed to the status and prestige of the lineage and its longevity. Families preserved their portraits in chests, displayed them in their homes, and borrowed and assembled portraits from a vast network of friends, family, and community members for key moments in social life such as weddings. Portraits of religious figures were made into leather medallions and worn around the neck to show devotion, and portraits of leading political figures were stamped onto wax-print cloth and worn by enthusiastic women at rallies.[35] Given this history, Thiam was not surprised that his grandmother

turned down his offer. "For her and other sitters it was not the act of taking a photo, but the legacy created by the photo. The durability of photos across time and their uncontrollable circulation mattered for them."[36]

As objects of value, portraits condense aspiration and apprehension in their material form (Steiner 2001, 229). Yet their circulation raised the possibility that they could enter new networks of relations. Portraits that were once created to be shared among family to affirm the ability of the lineage to withstand wear, pressure, or damage had the potential to be alienated or lost. The loss of the inalienable wealth represented in and by the portraits symbolized a loss of the strength of the lineage as well (Weiner 1992). And as both Thiam and his grandmother well knew, portraits from Senegal that were once family keepsakes were remade as colonial postcards sent off to print media like magazines and newspapers, and bought up by collectors, galleries, and museums. In such contexts, one controls what one can: the angle of a hand, the pattern of a dress, the nature of a backdrop, and the steadiness of a gaze that looks out, inviting the viewer into relation.

NOTES

1. Ibrahima Thiam, interview by the author, May 30, 2016, Dakar, Senegal.
2. Ndar is the Wolof name of Saint-Louis. Thiam, interview, 2016.
3. An administrative grouping under French rule from 1895 until 1958 of the former French territories of West Africa.
4. Giulia Paoletti, "Early Histories of Photography in West Africa (1860–1910)," The Heilbrunn Timeline of Art History, Metropolitan Museum of Art, March 2017, https://www.metmuseum.org/toah/hd/ephwa/hd_ephwa.htm.
5. See for example, Kristin Otto, "Creating the Sowei: Processes of Repairing, Maintaining, and Interpreting Sowei Masks in Global Assemblages" (PhD diss., Department of Anthropology, Indiana University, 2020).
6. For example, the National Archives of Senegal has 1,515 postcards from French West Africa, compared to the French Colonial Archives holdings of 20,000 postcards in addition to more than 60,000 photographs on paper, 15,000 positive photographic plates, 20,000 negatives on a supple medium or glass, albums that represent about 45,000 photos, and 1,000 posters which date from the middle of the nineteenth century to the 1970s.
7. For example, the Boston Museum of Fine Arts collection of postcards by François-Edmond Fortier, a contemporary of Tacher, was accessioned in 2012 from a gift by Leonard A. Lauder, a renowned philanthropist and art collector, who collected them from various postcard dealers in the United States, Canada, and

Europe. This collection consists of collotypes on postcard stock, some of which are hand-colored.

8. Felwine Sarr and Bénédicte Savoy, *The Sarr-Savoy Report on the Restitution of African Cultural Heritage: Toward a New Relational Ethics*, trans. Drew S. Burk (November 2018), https://drive.google.com/file/d/1jetudXp3vued-yA8gvRwGjH6QLOfss4-/view.

9. The Library of Colonial Senegal was founded in 1837.

10. See for example Giulia Paoletti's discussion of the image of Amadou Bamba (Paoletti 2018).

11. Thiam, interview, 2016.

12. French West Africa, Afrique Occidentale Française (AOF), was a federation of eight French colonial territories in Africa: Mauritania, Senegal, French Sudan, French Guinea, Ivory Coast, Upper Volta, Dahomey (added in 1899), and Niger. The federation existed from 1895 until 1958.

13. For further discussion, see Cheikh Tidiane Lo, "Cultural Heritage and Tourism: An Ethnographic Study of the World Heritage Site of Saint-Louis, Senegal" (PhD diss., Department of Folklore, Indiana University, 2019).

14. Thiam, interview, 2016.

15. "Alphonse-Eugène-Jules Itier," Getty Museum, accessed October 5, 2020, https://www.getty.edu/art/collection/artists/1663/alphonse-eugene-jules-itier-french-1802-1877/.

16. Jeff Bridgers, "Augustus Washington, Daguerreotypist," *Picture This* (blog), Library of Congress, February 27, 2013, https://blogs.loc.gov/picturethis/2013/02/augustus-washington-daguerreotypist/.

17. Among the styles of gold necklaces, the flower basket was popular in the 1900s following an earlier style called the *bount u sindone*, or the pendant of Saint-Louis. Both had three medallions; a medallion could be sold under financial duress. For further discussion see Johnson 1994.

18. The Eliot Elisofon Photographic Archives at the Smithsonian National Museum of African Art has a significant collection of cabinet cards by Bonnevide.

19. Prior to the introduction of film, photographic emulsions were made on glass supports, known as glass-plate negatives.

20. Both real photo postcards and collotypes can be found in major collections and on auction sites.

21. I am grateful to Gaya Morris for this insight.

22. Nomusa Makhumu, Self-Portrait Project Series, accessed June 2, 2015, http://nomusa.makhubu.free.fr/page13/page10/page10.html.

23. See also Paoletti, "Early Histories."

24. Many examples of mislabeled postcards can be found in the Smithsonian National Museum of African Art Eliot Elisofon Photographic collection of

Senegal. Due to COVID-19 and the closure of the museum, these images cannot be included here.

25. I am grateful to Marissa Moorman for this comparison.

26. Thiam, interview, 2016.

27. Thiam, interview, 2016.

28. Malika Diagana, "Femme du sahel, femme du monde," accessed March 22, 2022, https://www.zeinart.com/2013/12/femme-du-sahel-femme-du-monde-par.html.

29. *Thiof* is a large grouper fish. A handsome man is referred to as a thiof, or a good catch.

30. Thiam, interview, 2016.

31. For similar examples in the case of photography in India, see Pinney 1997.

32. Thiam, interview, 2016.

33. For further discussion of gold jewelry in Senegal, see Johnson 1994.

34. I am grateful to Amanda Maples and the exhibition *Good as Gold* for this insight. "Good as Gold: Fashioning Senegalese Women," Smithsonian National Museum of African Art, accessed January 22, 2023, https://africa.si.edu/exhibitions/current-exhibitions/good-as-gold-fashioning-senegalese-women/.

35. A vast range of portraiture art related to the Sufi figure Cheikh Amadou Bamba was collected for the exhibition *A Saint in the City* at the Fowler Museum, University of California–Los Angeles (Roberts et al. 2003).

36. Thiam, interview, 2016.

TWO

"SEND US YOUR PHOTOS"
Portraiture in *Bingo* Magazine

WHEN THE ILLUSTRATED MAGAZINE *Bingo: L'illustré africain: Revue mensuelle de l'activité noire* (*The African Illustrated: Monthly Review of Black Affairs*) began monthly circulation in 1953, it brought studio portraiture to new publics in Senegal and abroad. Portraits appeared in the context of celebrity photo spreads, advertisements, and society pages. *Bingo* also invited readers to submit their own portraits for publication on "La page du *Bingo*" (the *Bingo* page), allowing relatively unknown sitters to share space with famous and influential figures. When sitters submitted portraits to the pages of *Bingo* magazine, thus representing themselves in the public sphere, they constituted themselves as citizens of the nation and the world. In contrast to colonial-era portrait photography, *Bingo* offered a new opportunity to present oneself to others through portraiture as one wished to be "seen being seen" (Thompson 2015).

In this imagined community created by the circulation of portraiture in print media (Anderson 2008), readers' portraits and advertisements for consumer goods "materialize[d] the nation" (Foster 2002, 2) through the visual in the lead-up to independence in 1960. *Bingo*'s world of images brought new media to bear on Senegalese publics through advertisements for prêt-à-porter dress and suit styles, wigs and novel hairstyling products, and appliances, offering new ways of being in the world. The publishing of readers' portraits, like letters to the editor, provide a window into the public that *Bingo* helped create by giving it both visual form and voice. These elements point to the practice and experience of consumption (compare to Spitulnik 1996, 164). For example, styles depicted in advertisements were often repeated in portraiture. As reader-submitted portraiture, society pages, and advertising images reflected and created new linkages, *Bingo* both chronicled and cast new publics. This new

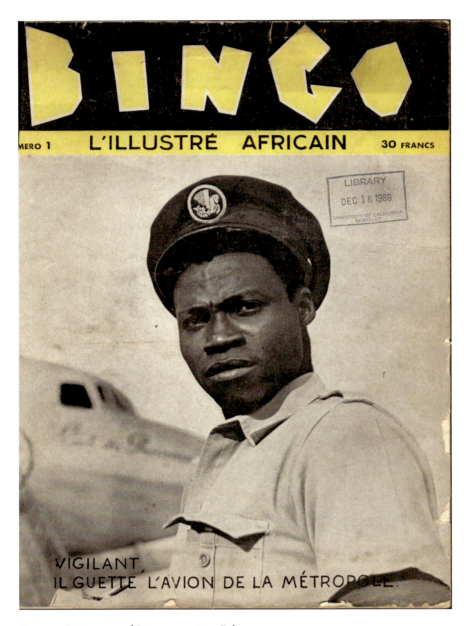

Fig. 2.1 First cover of *Bingo* magazine, February 1953.

Fig. 2.2 An interior decorated in rural Senegal decorated with magazine pages.

public captured in the pages of the magazine showcased desires simultaneously entangled with and undermined by the consumerism that *Bingo* promoted to an emergent Black middle class.

The magazine initially materialized in an oversized format bound in thick, velvety pages with glossy print. A new magazine had the smell and snap of fresh paper that softened with age and handling, like the newsprint used to wrap the morning's baguettes. Friends and family sat cheek to cheek viewing and commenting on the portraits in the magazine, pointing and smiling at images and cracking jokes, in the same ways they did with photo albums. Like photo albums, the magazine became part of a media ecology (Gershon 2017, 21). And just as they might remove individual portraits from their albums and give them to friends, readers often went in search of a pair of scissors to cut out the portraits from *Bingo* to give them away or to paste them on the walls as decoration.

An example of the decorative use of portraiture in homes was apparent in the September 1953 issue, in which two fanning diagonal lines of pictures of society events around Dakar appeared under the title "Pêle mêle Dakarois." In one of the photographs (middle left), a young woman stands in her home, its walls covered with family photos and engravings. This widespread decorative fashion throughout Senegal was linked to the *xoymet* wedding practice where

portraits are borrowed and displayed to represent the groom's vast network of family and friends for his bride (Siga 1990, 54). The photos depicted here feature portraits of the widely venerated Sufi leaders Serigne Baye Niass and Serigne Fallou, among others, as well as photos taken for public identification under the new nation, and *souverre* (reverse-glass) paintings.[1] There is also a framed portrait of a White woman, which appears to be torn from a lifestyle magazine. It may be from *Paris Match*,[2] an imported, French illustrated magazine with a celebrity lifestyle feature that circulated in Dakar at the time. In rural areas, its pages often lined the interior walls of compounds like wallpaper,[3] replicating displays of framed portraiture in wealthier families. Ousman Sembene's novel *God's Bits of Wood* includes a scene in which he describes a character's room lined with "photographs of movies stars and singers, and prints and drawings of white women from fashion magazines" (Sembene 1995, 139).[4] As recently as the 2000s, people still lined their interiors with magazine pages, copying the aristocratic fashion of numerous framed portraits. When, for example, I visited a rural household in the region of Diourbel, the head of the family, a religious leader in his community, had lined his room with pages pulled from a French fashion magazine. Doing so showed visitors and would-be disciples that this local leader was plugged into international circuits of value.

The photograph in *Bingo*, though, displays an assemblage of portraiture that is both drawn from elsewhere and composed of family portraits. Furthermore, the room's occupant, as the caption informs us, "is not incompatible with a concern for progress as can be seen by the pick up on which her favorite records turn." The sitter cleverly holds a record in her white gloved hands as if placing it on the phonograph while casually posing in front of her image-laden wall. Here the phonograph signals consumer aspiration on the eve of independence and connects her to international paths of circulation.[5] The portrait captures almost the full length of the sitter's *kamisolu taraab*, also known as *ndokkette*, a popular dress design at the time that had fan-shaped sleeves embellished with satin ribbon trim. The ensemble mixes a French camisole, the cinched waist of Dior's New Look silhouette (Rabine 2010), and the postwar Senegalese fashion of floor-length gowns that sweep the street (Siga 2006, 19). It thus illustrates the woman's ability to navigate foreign and local fashions and indexes her fashion sense and cosmopolitanism.

The photograph of the figure in front of her picture wall, with its clever feature title "Pêle mêle Dakarois," demonstrates the strategy of mixing and reduplication of the visual as a way of shaping aspirations. The sitter adorns herself with objects of value assembled through multiple paths of reciprocity among kin and affines, thus benefiting from "the effect of aggrandizement" (Strathern

"SEND US YOUR PHOTOS" 89

Fig. 2.3 A reader depicted with her phonograph in the September 1953 issue of *Bingo* magazine.

1999, 37). Each of the portraits behind her offers a dizzying array of strategies of aggrandizement in an infinitely recurring sequence. That the sitter and her portrait collection are then reproduced in this magazine further ensures her aggrandizement as they circulate throughout Senegal and the world beyond. How did *Bingo* present portraiture as *mise en abyme*, stories within stories, and how did these portraits fit into the magazine's attempt to chronicle the emergent Black middle class, the rise of the nation leading up to independence, and the increase of the public's engagement with the international through the spread of mass media and consumer society?

Bingo joined the ranks of picture magazines like *Paris Match*, *Life*, and *Look*.[6] Such publications had enjoyed widespread popularity beginning in the 1930s around the world, stemming in part from their ability to address readers of multiple social strata through the visual medium. *Bingo* also followed on the heels of other illustrated publications for Black readers. In the US, that included

Ebony (first published in 1945 by Johnson Publishing, Chicago); *Sepia* (first published in 1947 by Good Publishing, Fort Worth, TX);[7] and *Jet* (also published by the Johnson company, beginning in 1951). In South Africa, *Zonk!* magazine began in 1949,[8] and *The West Indian Gazette* began in 1958 as the first Black British weekly newspaper. Based in Dakar, *Bingo* was created by and for Black readers across the francophone world. It promoted self-authorship that was both individual and political, national, and diasporic. It did so, in its early years, during an uncertain time in Senegalese history in which West African soldiers had been problematically demobilized after the World War II; rural migration to the urban areas was increasing; and new means of constituting relationships emerged with new wage-based opportunities in the postwar colonial economy.

The *Bingo* page that began with glossy portraits came, by the eve of independence in 1960, to be populated by frontal-shot identity photos in a feature to encourage magazine subscriptions first called "Nos lecteurs se retrouvent" (our readers meet) and then "nos abonnés se retrouvent" (our subscribers meet). Identity photos were a crucial feature of political participation; without them one could not vote, bank, or pursue an education. On the threshold of independence, when the whole of the republic had to be photographed—many people for the first time—photographers found themselves meeting a surging demand by enthusiastic clients and they found the work lucrative (Werner 2001; Bajorek 2020, 204).[9]

Changes in the uses of photography from portraits to identity photos as well as cheaper cameras becoming more widely available contributed to the decline of studio photography. Alongside these shifts, advertising began to take up a larger share of the magazine's pages, undercutting the political potential of the illustrated magazine. Still, as a document of the energies leading up to Senegal's independence, *Bingo* shows how central portrait photography was to popular constructions of self and to the construction of an imagined community.[10]

BINGO AND ITS READERS

Before *Bingo*, news kiosks across Dakar sold mainly French-owned periodicals. A colonial tax on the importation of newsprint and printing machinery prevented the development of a local press, but not the importation of French newspapers and other publications (Ainslie 1966, 130). In addition to the picture magazine *Paris Match*, the primary news publications available to readers in Dakar were *Paris-Dakar*, the leading francophone African daily paper;[11] the

weekly Catholic paper *Afrique nouvelle*; and a French-financed magazine, *La Vie africaine* (Bush 2016, 220). *Paris-Dakar* belonged to the portfolio of the French aristocratic de Breteuil family, a privately owned publishing empire "whose economic resources and social connections were unparalleled" (Bajorek 2020, 120). The newspaper's daily circulation was made possible by La Grande Imprimerie Africaine in Dakar, which owned the only rotary machine[12] in francophone Africa at the time.[13] Moreover, because the paper had its own photographic laboratory in Dakar, a rarity across West Africa, it featured photographs depicting leaders in politics, society, and the arts, mostly Europeans as well as a few Senegalese. *Paris-Dakar*'s photographers made the rounds at high-society events in Senegal such as concerts, outdoor balls, and other social occasions (Benga 2020, 121). *Paris-Dakar* published an illustrated supplement every two weeks (Ainslie 1966, 135, 137), *Dakar-Jeunes* (T. Warner 2019, 107). This supplement largely focused on sports and current debates.

Paris-Dakar found readers primarily among the European community in Dakar and francophone West Africa, but *Bingo*'s founding editor, Ousmane Socé (1911–1973), set out to publish a popular illustrated monthly by and for a Black francophone audience. In its first issue, Socé is quoted as saying, "This magazine is the first fully illustrated publication published by an African from French West Africa for Africans" (Ce magazine est la première publication entièrement illustrée éditée par un Africain de L'Afrique Occidentale Française pour les Africains). Socé's popular periodical by and for Africans turned on readers' desire to see and be seen and to engage in self-representation.[14]

Bingo set out to challenge colonial representations of Africans in postcards, newspapers, and educational media by showcasing portraits of prominent political and religious figures, high-ranking soldiers, and well-heeled readers. During a period of uncertainty and widespread social change, Socé aimed to transform ways of seeing the self, producing a kind of new, international citizen who shared a collective ambition for independence. Far from picturing a shared social reality, the visual elements of the magazine shaped that reality for its readers.

The popular periodical's international circulation covered not only francophone West Africa and Western Europe but also North Africa, the Americas, and Southeast Asia. Distributed in Dakar and Paris from the first issue in February 1953 until 1996, the periodical listed below the masthead the rue Carnot office in Dakar and the rue Marbeuf office Paris as well as a list of boutiques and bookstores where readers could buy *Bingo* in Paris and Marseille (France); Casablanca, Rabat, Kasba-Tadla, and Fes (Morocco); and Saigon

and Hanoi (Vietnam). In the February 1954 issue, two prices for the magazine first appeared: 50 F CFA and 100 F Metro. These two prices, one for France and Western Europe and one for the colonies reflected the periodical's pan-African circulation; its readers lived primarily in West Africa but were also located in the Congo, the Antilles, North Africa, Southeast Asia, and Western Europe.

Bingo's content emphasized this global reach, with the names and locations of readers from around the world appearing in bylines, portraits, letters to the editor, and a section in which readers sought out correspondents or pen pals. The magazine thus promoted a message of international citizenship and Black diasporic belonging. To further this point, the popular periodical introduced columns on Africans in the world and regularly featured famous figures from the US, Brazil, and the Caribbean.[15]

Like popular radio programs that drew different audiences, *Bingo* attracted a variety of readers and offered something to all of them.[16] Unlike a novel, which proceeds linearly, *Bingo* let readers choose their own paths for consuming text and images, not unlike the rich displays of portraiture that decorated Senegalese interiors. The open format invited readers to pick the magazine up, put it down, and enter at any point. The magazine reached multilingual audiences, and its focus on photos was a selling point across West Africa where many readers were not literate in French, the language in which the magazine was published. Readers could buy the monthly review at kiosks in the city center, tucking it under their arms on the bus ride home before giving it to the whole family to enjoy. Readers also traveled with the popular periodical home to rural areas where it could be viewed and read aloud to audiences of varying literacies.

As they turned the pages of the illustrated publication, readers could appreciate fashionable portraits submitted by readers, like the photograph of the woman in the chic kamisolu taraab, see models posing in advertisements for consumer goods like phonographs, and follow celebrity fashions. Flipping through the pages created an arc like the progression of film frames, with the various images building on each other (Batchen 2000, 266); indeed, the growing popularity of magazines in the twentieth century went hand in hand with the popularity of the cinema. The editorial layout added life and movement to the magazine page, making the discontinuity of reading discrete texts pleasurable. This format also made it possible for readers to move effortlessly from feature to advertisement, since they were not bracketed off from each other. This allowed readers to read both genres synchronically, integrating consumerism into the reading experience. The illustrated magazine combined these elements of pictures, text, portraits, and ads into what one critic calls a "graphic

ordering of desire" that was beneficial for circulation as well as for advertisers, who embarked on novel strategies of attaching pleasure to consumer goods.[17] To sustain interest in these viewing pleasures, *Bingo*, and magazines like it, included original content on news, music, fashion, and merchandise.

Bingo's popularity stemmed from its accessibility, its consumer appeal for the fashionable set, and its numerous photographs depicting life at home and abroad. The publication offered visual storytelling through the sequencing of photographs, as did other popular picture magazines of the day, including not only *Paris Match* but also *Life* magazine, to chronicle the mid-twentieth century in West Africa. It circulated in a context in which few families owned television sets on which they could see a newscast. To learn about current events at home and abroad, people gathered around the radio or read newsprint that featured few images of Black life. With its abundance of photographs, *Bingo* added a visual element to these stories, tracking the movements of Senegalese soldiers, or *tirailleurs sénégalais*, across France and North Africa at the close of World War II; depicting the literary and artistic class of Senegalese in France; and displaying the political maneuverings of Senegal's educated leaders at home. The 1950s were an uncertain time for many Senegalese. Not least of their concerns was the stationing of soldiers in North Africa during the Algerian War for Independence and in Indochina, which created misgivings about the empire and allegiance to greater France on the eve of Senegal's own independence in 1960.

Though *Bingo* was notable for its visual strategies, its editor, Socé, who also wrote poems and novels, held literary ambitions for the popular periodical too.[18] Most literary writing of the day appeared in the format of periodicals (T. Warner 2019, 97), and in the magazine's early years, Socé modeled the literary features on those in the Black intellectual journal *Présence Africaine*, founded in Paris in 1947 by Alioune Diop. The 1953 issues of *Bingo* included short stories and excerpts from longer works by Socé himself as well as *L'enfant noir* by Camara Laye. In another issue, Socé penned an article entitled "Nations, Negres, et Culture, En lisant Cheikh Anta Diop" to help readers understand Diop's argument about the Black origins of civilization. In the June 1955 issue, a new section appeared called "Nos lecteurs sont aussi des conteurs..." (our readers are also storytellers), featuring biographies of the authors Quenum P. Ange, Barry Mamadou, and Cisse Mohamed Lamine. But the journal never really achieved Socé's literary ambitions, and in the years leading up to his departure as editor in 1957, there was a decrease in features and in the total number of pages devoted to literary works. Two years later, *Bingo* did serialize a story by Martial Oudrago, "Assetou." However, given that magazines commonly used

serialization of stories to attract and maintain readers' loyalty, this may not have been a sign of renewed literary commitment, but an attempt to retain readership following Socé's departure.

Bingo emerged in a publishing landscape where many illustrated magazines of the era, such as *Life*, focused on social documentary photography to shape political consciousness and social change.[19] On the African continent, *Drum*, which began circulation in 1951 and was published in South Africa and Ghana, provided a platform for this newly emerging genre of visual stories through documentary realism and social documentary photography.[20] *Bingo* and *Drum* often referred to each other in their respective publications. One issue of *Bingo* featured a lead photograph of the newsroom of *Drum* with the headline "Our brothers at Drum magazine." *Bingo* is advertised in *Drum* as well.

Unlike other illustrated magazines, *Bingo* favored portraiture and society pages over social documentary photography. As a lifestyle magazine rich with portraiture, *Bingo* attracted more advertising than other media on the continent that focused on progressive politics such as *Ebony*, *Itinerário*, *Transition*, and *West African Review* (Jaji 2014a, 112). Its focus on social life reflected the unique status of Senegal's political class in France as opposed to those of other colonized parts of Africa. Senegalese men in the four communes of Dakar, Rufisque, Gorée, and Saint-Louis had representation in the French Assembly; they also voted in French elections and had been able to own property since 1848 (D. Konate 2009, 226). Many political leaders, including Socé, had been educated at assimilationist schools such École Normale William Ponty in the interwar period (T. Warner 2016) and had been employed in the French administration. Socé had also served in the French Assembly in the 1940s and 1950s before returning to Senegal to establish *Bingo*. He and his peers balanced their reliance on France, given that the impoverished regions of the French overseas territories were heavily dependent on French aid and administrative services, with their desire for independence. Dignity, autonomy, and civil liberties for Black French West Africans were key issues and *Bingo*'s emphasis on portraiture and images of cultural and social life reflects these concerns.

Bingo relied on resources from the French media ecosystem that the magazine seemed designed, at least in part, to disrupt. Socé was a close friend of the de Breteuil family (Bush and Ducournau 2020), whose West African media empire included *Paris-Dakar*, and he had been a regular contributor to the newspaper during the late 1930s (Gamble 2017, 170). The de Breteuil corporation, led by Michel de Breteuil, with offices in Paris and Dakar, published and financed *Bingo*. *Bingo* benefited from the photo lab and printing press of *Paris-Dakar*, even producing a photo essay in the August 1953 issue that focused on La

Grande Imprimerie Africaine featuring the machinery, workers, and families involved in its operation.

By inviting readers to submit portraits for publication, promoting magazine reading by publishing portraits of readers reading *Bingo*, and privileging space for readers to "be seen being seen" (Thompson 2015, 15), *Bingo* constituted a photographic public.[21] To succeed, Bingo used these techniques to attract the attention of its readers or their uptake to create new publics (Larkin 2013a, 239). This public made Dior's New Look advertised on *Bingo*'s pages their own, played records like the woman in the portrait, and decorated their interiors with framed portraits like European nobility. They took up Socé's invitation to document such self-fashioning for the new magazine.

ALL READERS OF "LA PAGE DE *BINGO*"

In the section featuring letters to the editor in *Bingo*'s first issue in February 1953, Ousmane Socé states his aim to "give as much space as possible to images of contemporary life" (donner toute la place à l'actualité par l'image). Photography featured prominently in the pages of *Bingo*, both as stories told through social documentary photography and as portraits and snapshots of the past and the present. These photographs captured the social and political ambitions of their sitters and cultivated similar aspirations in readers. Among the regular features were "Images d'autrefois" (Pictures from the Past), which reproduced colonial-era photographs and wood-block prints for readers; "La vie religieuse" (Religious Life), in which portraits of religious leaders frequently appeared; "Les sports" (Sports), which covered a wide variety of athletic events including boxing, football, gymnastics, wrestling, and track and field, featuring individual and group portraits; and "Actualités" (News), which featured photographs of events related to art and politics and offered news of Africans across French West Africa and in Europe.[22] More often than not, this latter section covered galas and society events, offering snapshots and portraits of celebrities.

Part of *Bingo*'s appeal to readers was that it showed them a range of aspects of Black life, from celebrities to insights into everyday life on the continent and beyond. The first issue, in 1953, featured a collection of optimistic documentary photo essays depicting students abroad in France, Senegalese soldiers in Indochina, and the visits of papal and political dignitaries to West Africa.[23] Through images covering international events, such as the pilgrimage to Mecca and meetings between politicians of the broader francophone world and those in France, Africans were linked to Black lives elsewhere in greater France and in the diaspora.

Later issues featured visual stories of famous figures like the entertainer and activist Josephine Baker, actress Dorothy Dandridge who won the Academy Award for Best Actress in 1954, and jazz singer and activist Abbey Lincoln, as well as jazz musicians like the Dakar-based band Tropical Jazz. *Bingo* not only offered a glimpse of celebrity and high society but also photographs of rural and working-class readers, which added to its appeal. It devoted space to documentary photo spreads and group portraits of the military and the police as well as to various professions like jewelers, veterinarians, mechanical and industrial workers, railway workers, and musical and theatrical performers.

Lifestyle features displayed photo spreads of weddings of social figures and politicians of African descent in France and Senegal and births of triplets and quadruplets. The June 1953 issue featured five portraits of beauty contest winners from the French overseas territories selected to commemorate the "Festival des Madelons" in Paris through the patronage of a veterans' association in France (L'union départementale des associations française des anciennes combattants). Society pages also featured group portraits of rural and urban women's associations, photos of soirées, and—in one issue in February 1953—pictures of Senegalese mothers taking their children to receive presents from Santa Claus.

Bingo also covered the diaspora. The July 1955 issue featured two boys in Brixton Day Nursery in London on the front cover, one child of Jamaican descent and one White British child, with the caption "aide ton prochaine" (help your brother). Brixton, a south London neighborhood, held a large African diasporic population. Through these richly photographic features, West African readers could see themselves as part of a larger Black world.

Across these features, *Bingo*'s photos consisted mainly of headshots and location shots because cameras were bulky and slow. As newspaper publishing expanded in the 1950s and lightweight cameras appeared on the market, the opportunities for photojournalism grew (Mercer 1998). Yet *Bingo*, in the first decade of its publication, does not seem to have been able to follow the example of other illustrated magazines such as *Life*, whose staff photographers shaped the magazine. Instead, many of the images in the documentary photo essays came from government information services, European-based press agencies, and wire services, whose use of small-format cameras and new flash units opened up the range of photographs that could be taken beyond the headshot to include candid and action photography (Kozol 1994, 29). The February 1953 issue credits the government information services Interpress and Agence Diffusion Presse, and other issues include images from French-owned studios such as Photo Simon-Huchet, YM Pech, Labitte, and Photo Peroche in Dakar,

as well as other publications owned by the de Breteuil family such as *Dakar-Matin* and *Paris-Dakar*. *Bingo* also used *Paris-Dakar*'s photo laboratory to print its own monochrome headshots as well as half, three-quarters, and full-length portrait photographs for the magazine.

Bingo benefited from both a desire for portrait photography and advances in the technology of film processing in the 1950s, which made it possible to access film, paper, and chemicals to process film in Senegal. Furthermore, the advent of new technologies such as process-engraving machines meant that African newspapers could potentially operate independently from colonial presses by obtaining photographs from local studios. The new technology also allowed them to print more quickly and with less expense since they no longer had to ship photographs to France to be reproduced. This meant that they could publish photographs of Black women and men as opposed to the French press, where photographs of White French women and men dominated the pages.[24]

Unlike other illustrated magazines of the day, *Bingo* relied both on readers and on a flourishing culture in studio photography across West Africa to submit photographs of and for the magazine's readers. Socé's appeal "*Bingo* is the reflection of African Life" (*Bingo* est le reflet de la vie Africaine) signaled two competing themes. On the one hand, the popular periodical provided a limited window into the life of the folk, mainly through staged portraits. On the other, *Bingo* attempted to present movers and shakers each month, which involved a rapid turnover in new images. Socé thus appealed to the unique platform that the illustrated magazine offered for performing visibility. On the penultimate page of the first issue in 1953, *Bingo* issued an invitation to readers to submit their photographs: "Participate in its [*Bingo*'s] life by sending us your photographs" (participez à sa vie en nous envoyant des photo). In the May 1957 issue, *Bingo* went further, offering a photo contest with substantial prize monies attached.

"La Page de *Bingo*" featured portraiture, a genre that emphasizes individual identity. In contrast to the colonial postcard or documentary photograph, in which the sitter is presented to the world as an object to be looked upon, a portrait is a way in which the sitter presents herself to the world (Prochaska 1991, 46). The *Bingo* page offered readers the opportunity to share such images broadly. The portraits collected on "La page de *Bingo*" were displayed like a page taken from a family album with various, often unrelated, photographs positioned together on a page. This was still the era when sitters and photographers often just made one print, but those who submitted prints to the magazine likely had the resources for more than one personal portrait so they could choose the best one to send to the publication. Taken together, the portraits pointed to

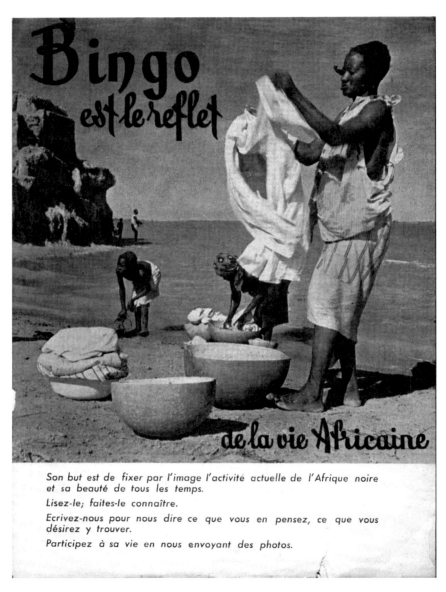

Fig. 2.4 *Bingo* call for reader-submitted photographs, February 1953.

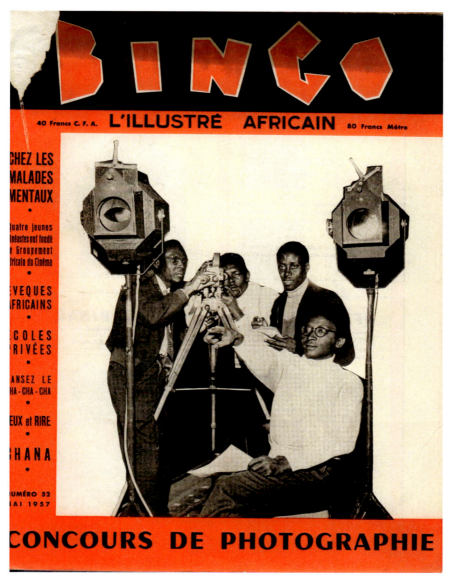

Fig. 2.5 A photography contest is announced on the cover of *Bingo*, May 1957.

and constituted a network of up-and-coming figures. Socé smartly pointed out that these sitters were "all readers of the illustrated African" (tous lecteurs de L'illustre africain!). He meant that readers of *Bingo* were well-positioned, and thus that the magazine was too. The captions that accompanied these portraits made this clear: the subjects patronized the most popular studios; they wore fashion-forward ensembles; and they knew how to pose.

Bingo reflected and constituted an image world attuned to political and cultural discourses leading up to independence. As Tobias Warner observes, Socé used *Bingo* to produce his vision of a public and the photo collages reproduced that public. He "invite[d] that public to constitute itself in the work of representation" (2019, 117). As much as Socé invested in fashioning audiences, the audiences also fashioned the magazine through the submission of their portraits. At the same time, the image worlds and the imagined communities they created helped spur aspirational consumptive practices linked to Europe and the US, desires in tension with the goals of the newly independent nation that sought freedom from the West. By displaying fashionable clothing, accessories, and lifestyles, these portraits encouraged readers to pursue these material goods as a way to assert social value and success.

The inclusion of reader-submitted portraits in the popular periodical added to the broad appeal of the magazine beyond the literate class and contributed to its wide circulation. The magazine-printed studio portraits were submitted by readers on the same expensive coated paper that the rest of the magazine was printed on in the early issues of the publication. Black-and-white photographs and illustrations retained their fine details when they were reproduced on this paper. This created a striking contrast to the rough stock of newsprint.

Unlike photographs placed in an album or portraits arranged on a wall in a home, the editors dictated the arrangement of photographs in the illustrated publication; the advertisers may also have influenced the layout. A pictorial periodical presented a new context for photographic assemblages driven by editorial decisions to recombine and refigure photographs (Barber 1997b; Jaji 2014b, 111). Editorial decisions combined portraits with stories covering art and politics, social documentary photography, and features promoting the magazine and magazine reading in carefully laid-out sequences. Tracing these editorial decisions over the decade illustrates the rise of studio photography and its role in promoting the new elite, new fashions, and new alliances in the early 1950s and the popularization of photography by the end of the decade. It also illuminates the vision *Bingo*'s editors had for its African readers and the effort they devoted to using images to shape emerging nations and their publics.

When editors recombined personal and family portraits on the *Bingo* page like a collage, they created a composite whole. The caption just under "La Page du *Bingo*" refers to "all readers" (tous lecteurs d l'illustre africain!), meaning that the bearers of the portraits were readers of the magazine, and that the page as a composite whole reflected all the readers of *Bingo* magazine. When the editors laid the portraits out on the page and put them into relation with each other, new meanings and new relationships emerged (Batchen 2000, 265).

These relationships represented a network of middle and upper social strata. While *Bingo* may have aimed to include portraits from across West Africa, there were few studios in the rural areas, and portraits and visits to the studio were costly. Further, there were technological limitations on an editor's choice of which photographs to include: only high-quality images could be reprinted. Consequently, the magazine printed a large number of portraits of leaders, educated classes, and local notables including chiefs, shaykhs, veterans, politicians, and business figures. Thus, the magazine's editors created networks indexing social hierarchies and party affiliation despite its avowedly apolitical aims and ambition to reach a mass audience. The *Bingo* page came to represent a social network. As editor, Socé became a gatekeeper for this network.

The photo collage and gridded photo layouts added to the appeal of the magazine by telling a story. Consider "La page de *Bingo*" from September 1953. At the top of the page are five portraits of men wearing western suits and tailored shirts laid out in an arc. The fanned arrangement implies movement, as if in movie frames or a comic strip. The captions describe the sitters as leaders in their communities: merchants, soldiers, entertainers, and the like. The last portrait is of Tandina Maharafa, who worked on the railway, as a journalist, and as a poet. Below his portrait is his poem published in honor of *Bingo*. The bottom half of the page shows two photographs and one portrait: a group shot of entertainers, a photo of two scientists, and a portrait of the fashion designer Khady Sarr wearing the latest dress fashion showing a princess neckline.

As much as Socé encouraged reader-submitted photos, a small number of prominent studios dominated the pages of the magazine. While it is not clear whether the photographers supplied the photographs or if they were submitted by the readers,[25] the magazine circulated and archived their bodies of work. The magazine then also forms an important record of these studio photographers and the sitters whose negatives have since been lost or destroyed. One such studio was Studio Harcourt, a renowned portrait studio that Ousmane Socé and other prominent figures in Senegal frequented in Paris, known for its portraits of celebrities (see also Bajorek 2012, 142). Other studios that dominated *Bingo*'s

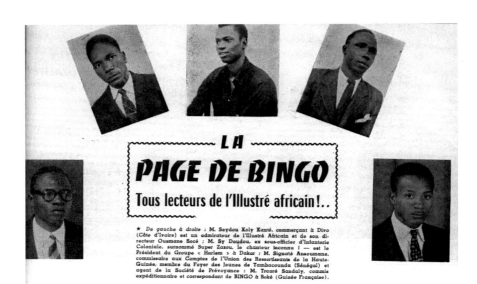

★ *De gauche à droite* : M. Seydou Koly Kanté, commerçant à Divo (Côte d'Ivoire) est un admirateur de l'Illustré Africain et de son directeur Ousmane Socé ; M. Sy Doudou, ex sous-officier d'Infanterie Coloniale, surnommé Super Zazou, le chanteur inconnu ! — est le Président du Groupe « Harlem » à Dakar ; M. Signaté Anaoumane, commissaire aux Comptes de l'Union des Ressortissants de la Haute-Guinée, membre du Foyer des Jeunes de Tambacounda (Sénégal) et agent de la Société de Prévoyance ; M. Traoré Sandaly, commis expéditionnaire et correspondant de BINGO à Boké (Guinée Française).

★ M. Tandina Maharaïa, employé à la 1ère S.A.C. du chemin de fer D.N., à Thiès, et, par ailleurs journaliste et poète, dont nos lecteurs apprécieront ces vers dédiés à BINGO...

(Elisa-Photo, Thiès)

★ Sur le pont du Milo, à Kankan... De gauche à droite : M. Karifa Dioubate, célèbre guitariste de Guinée, Mme S. Traoré, MM. Kaba Mamy, Instituteur et Mouridin Finah, griot estimé

(Photo T. Sandaly)

Ce mot dont on parle dans les rues
Ce mot qui prend de l'étendue
Ce mot qui anime les cœurs
Parce que chanté en chœur

C'est Bingo.
Comme un marmot
Qui se répand et qui expose
Dans toutes les maisons
Comme à toutes les nations
Par des images
Les vrais visages
De notre terre d'Afrique.

Quel est ce mot nouveau ?
C'est Bingo.
Comme un marmot
Qui traverse nos contrées
Qui visite nos forêts.
C'est ce mot qui se déplace
C'est celui qui s'étale et se place
Sur toutes les langues d'Afrique.
Quel est ce mot nouveau ?
B I N G O

★ On dit que les cordonniers sont les gens les plus mal chaussés. Il serait imprudent d'ajouter que ce sont les couturières qui sont le plus mal habillées. C'est Mme Khady Sarr couturière à Dakar, qui a confectionné elle-même la magnifique robe « Princesse » qu'elle porte sur cette photo.

(Electric-Photo)

★ A la Météo de Port-Etienne (Mauritanie) les aides-météo Diallo Cheikh Tidiane (précédemment à Atar) et Sidi Ould Abeidna attendent le « top » pour lancer le ballon de sondage.

(Cliché Fall)

Fig. 2.6 "La page de *Bingo*," September 1953.

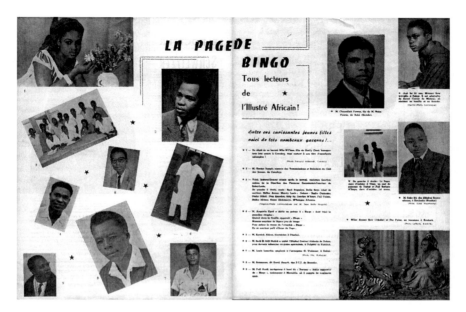

Fig. 2.7 Portrait label #3, by photographer Meïssa Gaye, Tropical Photo. *Bingo*, January 1954.

pages include Tropical Studio, owned by Meïssa Gaye (1892–1993), African Studio, owned by Mama Casset (1908–1992), and Senegal Photo, owned by Salla Casset (1920–1974), all of which catered to Dakar's clients seeking to be photographed in their uniforms, finery for Muslim holidays, and tailored suits, dresses, and *ay kamisolu*.

Several portraits that appeared frequently in the early issues in various sections were attributed to Tropical Studio, owned by Meïssa Gaye.[26] In the January 1954 *Bingo* page the header quips, "Between these beautiful young women, here are quite a few young men" (Entre ces ravissantes jeunes filles voici de très nombreux garçons!). One of Gaye's photographs appears with the caption "Fraternally united" (fraternellement réunis) in the upper left, second from the top. The group portrait shows the employees of the Department of Finance in Saint-Louis. The sitters are grouped closely together, some standing in the door in the upper right-hand corner and others seated at the table below. Their faces create a continuous line down the image. The fancy borders on these two pages along with the stars signal optimism and hope for the period.[27] The use of photomontage and fancy borders to frame captions and images creates "a hybrid

Fig. 2.8 "La page de *Bingo*," December 1953.

piece of work," in which images are set off by frames and layers are created as in a painting (see for example Batchen 2000, 246). The portraits are collaged with frames and borders like the aristocratic dignity displayed in framed portraits that line the domestic interiors of high society.

Another group portrait by Gaye, captioned "These six hard-nosed readers of *Bingo*" (Ces Six lecteurs acharnes de *Bingo*), features six men, four of whom are holding the magazine open and two of whom are reading over their shoulders. The figure in the center is dressed in military uniform. The other readers' dress includes suit jackets, military dress, and kaftans or Wolof or Muslim dress. They reflect Socé's vision for the readership of his new magazine. As Tobias Warner observes, to be pictured under the caption "all readers" was to be included in a new mode of publicness (T. Warner 2019, 117). Socé wanted *Bingo* to appeal to readers of varying religions and professions, including white-collar workers and army recruits. By appealing to a broad range of readers, the magazine worked to build imagined connections between diverse people, an important part of creating independent nations.

No photographer provided more portraits for these new publics than the Dakar photographer Mama Casset. Casset's Africa Studio was frequented by the social set and Casset's portraits appear frequently in the early years of the magazine. An advertisement for the studio "African Photo, Hadj Casset Gnais, Dakar Medina" appears in the first issue. It is set off by a solid black box from another ad for Raoul Daubry, a retailer of poplin button-up short-sleeved shirts and gabardine pants, which "gives the modern colonial silhouette" (donne la silhouette colonial modern), just as one would dress up and head to the studio.

Mama Casset's portraits also appeared frequently in several of the magazine's other sections. In the July 1953 issue, a Casset portrait of Fatou Diop Sabel appeared in the "Actualités" (news) section. The figure stands assertively with one hand on her hip and one hand on her raised knee, with her foot planted on a chair. Casset often used this pose (as did Keïta and others) to show off the yardage of a woman's dress, an important feature of the *Robe Bolok* fashion after the shortages of fabric during World War II. The caption describes her elaborate coiffure and the layering of the white and hand-dyed fabric. The layering of textiles and ornaments adds complexity to the social identity of the sitter. Casset often used tactility to emphasize proximity between sitter and viewers by emphasizing hands and touching in poses (Batchen 2000, 265), or foregrounding a hand resting on a leg, as in this photo.

While Mama Casset largely worked in his studio, Salla Casset, the younger of the two Casset brothers, engaged in social reportage. Salla Casset produced

Fig. 2.9 An advertisement for African Photo. *Bingo*, February 1953.

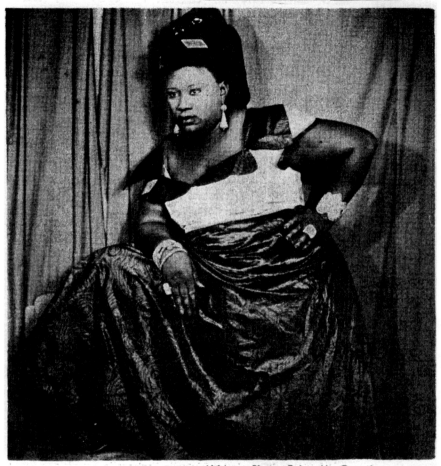

Fig. 2.10 Portrait by Mama Casset, *Bingo*, July 1953.

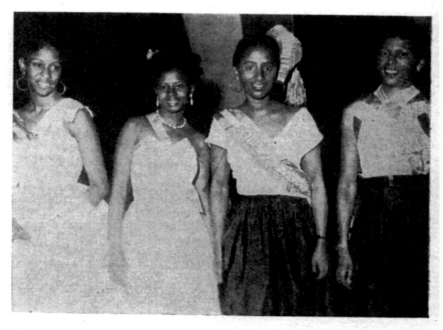

Fig. 2.11 Salla Casset, *Harlem Club of Dakar*, *Bingo*, January 1956.

news snapshots, party scenes, and portraits. The development of lightweight cameras facilitated the ambulant nature of his photography. In the January 1956 issue, Casset's portrait of four young women elected as queen and her attendants at the Harlem Club of Dakar appears. All wear ball gowns of imported fabric with sashes identifying their office. By featuring portraits like this, *Bingo* not only made visible exclusive or elite clubs with ties and knowledge of the artistic and literary importance of Harlem, but it also imparted important diasporic connections and influences to its readers. Socé aimed to

Fig. 2.12 Photography by Salla Casset, *Bingo* magazine, August 1953.

show international connections beyond the metropole and emphasize that the readership was deeply embedded in international circuits.

At the same time, Socé also recognized the role of the religious orders in Senegal and regularly featured both Catholic and Muslim figures. In the "Religious Life" section of the August 1953 issue, Salla Casset contributed a striking photo collage common across West Africa to instantiate the Muslim authority of both past and present leaders of the Tijani Sufi congregation. Like the Gambian studio photographers described by Liam Buckley (2000), Salla Casset also sought to "multiply surfaces": to produce multiple views, and thus meanings, by cutting and composing singular portraits into a form of layout known as montage, photo collage, or composite photographic images. Montage can facilitate the feeling that one has entered into the frame and create visual relationships between images since they are placed in proximity to one another (Roberts and Roberts 2007, 63).[28] In Salla Casset's rendering, the members of the scholarly lineage appear as though they exist both at the same time and also simultaneously out of time. Casset's work features the image of the founding figure of the Tidjani way, el Hadj Malick Sy, which is at the center and larger in size than the four portraits of the shaykhs who surround him. The top two

figures face the camera, while the two figures in the lower right- and left-hand corners are depicted at an angle and are positioned to face toward each other. Casset surrounds each of the figures with white space, amplifying the ethereal quality of the image.

To further promote the magazine and encourage reader submissions, portraits submitted by readers also appeared in a section called "Les amis de *Bingo* . . ." which highlighted readers reading the publication. These portraits appeared alongside images of celebrity readers such as Josephine Baker, suggesting that readers belonged to the same in-group. Often, the portraits under this heading came from readers featured in military uniform reading *Bingo* from North Africa, France, or Indochina, creating additional layers of social connections while also perhaps papering over tensions between soldiers and new politicians in Dakar. In the feature "Les amis de *Bingo* sur la Côte d'Azur," two photographs show soldiers reading the magazine, all of them shoulder to shoulder, holding the magazine together and smiling at its contents. That their bodies are touching and that they are sharing the magazine shows their friendship and intimacy. These are striking images because soldiers who had long been absent from Senegal and emergent politicians in Dakar were often at odds. Soldiers were detached from political elites at home and out of touch with events in Senegal and elsewhere. At the same time, both the French colonial administration and political parties in Senegal sought the allegiance of veterans between 1945 and 1960 (Echenberg 1991, 148). The prominence given to soldiers and veterans in the magazine underscores their importance after World War II.

This section also made visible the social networks of readers at home and abroad. The June 1953 issue features Oumar Diallo reading the popular periodical while stationed in Casablanca and two seated men in uniform read the magazine in Fréjus, a port town on the Côte d'Azur in southeastern France that was a winter garrison for troops. Gregory Mann suggests that soldiers stationed in North Africa and Indochina were able to read *Bingo* at the Maisons Africaines, spaces built to boost soldiers' morale where they could pray, listen to music, read, and enjoy their cuisine (Mann 2006, 160). For soldiers and their families, the photographs in *Bingo* provided a critical connection. Leaves during military service were rare, if not nonexistent, and periods of service were long (Mann 2006, 150). For many soldiers, marriages were often arranged via photographs sent over the vast distances that separated a groom from the prospective bride chosen by his mother, and eventually *Bingo* had a matchmaking column. The uptick in marriages arranged by photographs related to the transformation of military service from conscription to voluntary service and the generous family allocations that followed.

Fig. 2.13 The friends of *Bingo* in la Cote d'Azur, France, printed in the May 1955 issue of *Bingo* magazine.

Socé solicited reader photographs in every issue, and by May 1955 *Bingo* announced that it had received so many submissions that the magazine could only print one photograph per reader. This move reflects *Bingo*'s success, the growing popularity of photography across social classes, and its spread to rural areas. Socé was now able to make editorial decisions regarding the quality of the portraits and the reputations of the photographer and of the sitter. Socé had to choose carefully, as illustrated monthlies are short-lived by nature and *Bingo* was published twelve times a year, a striking number given that it could take up to four months to produce one issue. Portraits published in the magazine that at first look seemed new and exciting (*xewwi naa*) could quickly be seen as old-fashioned or out of date (*démodé*) as new issues came out. Under Socé's careful editorial eye, portraits submitted by readers that were eventually published reflected and created multilayered networks through which the new nation would be constituted.

"THE CAMERA THAT CONQUERED THE ENTIRE WORLD"

Like letters to the editor, readers submitted their portraits in response to magazine content. These published portraits not only offer an opportunity to see Socé's editorial hand but can also be read as their endorsement of the magazine's content since audiences are a critical aspect of understanding how the magazine worked (Barber 1997a). But more than that, these portraits show how the circulation of *Bingo* created new publics through their uptake of its contents (M. Warner 2005, 87; Larkin 2013a, 239). Brian Larkin describes uptake as an intensity of desire that goes from attention to full immersion; indeed, having one's portrait included goes beyond *reading*, to *being in* the magazine. When the photo album portrait is remediated in the form of print media it is also recombined with other images, such as advertisements. These new audiences were constituted through *Bingo*'s circulation not just as reading publics, but a public invested in the potential of the visual as consuming citizens. *Bingo*'s image worlds immersed its readers in this new consumption.

Bingo was a magazine of successful people. The reliance on portraiture as a medium contributed to the inculcation of the performance and habits of the well-heeled. The illustrated nature of this popular periodical and its dependence on portraiture dovetailed with the aims of advertisers from the 1950s into the 1960s. Both offered aspirational visions of success, and both obscured the time, labor, and politics necessary for that version of success. Both obfuscated the unequal nature of colonialism and capitalist exploitation.

Bingo could not support itself through sales revenue and subscriptions alone: readers shared it widely, often with those who could not afford to purchase the publication, passed it along, and reread it many times over. It needed advertisements to sustain it, resulting in a commercialism that distinguished it from other magazines published across the African continent. The French advertising agency L'agence Havas, which held a virtual monopoly in francophone Africa, managed the magazine's advertisements. It offered five-year contracts to its publications, charged 40 to 43 percent commission, and held exclusive contracts and the right to place advertisements at will, preventing publications from negotiating with clients directly (Ainslie 1966, 225). Since *Bingo*'s staff did not control its ads, this meant that it promoted consumerism to an emergent Black middle class—an ethos that was sometimes in tension with their aspirations to self-representation and independence, and that sometimes seemed entangled with those desires.

Readers moved between registers and genres, texts and images with the rustling of each page turn. *Bingo*'s success hinged on the complexity of photography as a medium of representation, especially its openness and indeterminacy. The illustrated nature of the magazine invited readers to bring their own set of interpretive practices to bear on the literary and social texts and advertising copy in illustrated magazines (Jaji 2014a, 2014b, 2018; Yap 2019; T. Warner 2019). Women and men were adept at moving across registers of portrait photography, image-based stories, and adverting images in these monthlies (Jaji 2014b, 124). The latter illustrated the ideal consuming citizen in an era of rapid political and cultural change.

In addition to creating a reading public, Bingo also spread the latest fashions through portraits submitted by readers sitting alongside advertisements. Between pages of celebrities and well-dressed readers, *Bingo* ran advertisements for clothing and consumer goods featuring products made possible by postwar technologies but largely unavailable to West Africans except by mail-order catalog. As clothing shortages came to an end with the close of World War II, urban residents in Senegal became newly interested in French fashions (Faye 1995). New shops emerged, French mail-order catalogs illustrated the latest styles, and retailers advertised heavily in *Bingo*. After the war, Dakar emerged as a leading market for French apparel manufacturers and textiles whose advertisements appeared in *Bingo* targeting students and teachers, midwives, civil servants, and shop clerks. As readers increasingly adopted the fashions that *Bingo* advertised, the reader portraits came to reflect these fashions and to mirror the advertisements.

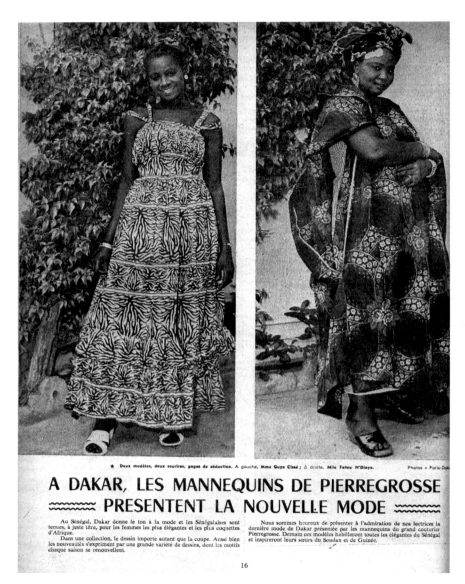

Fig. 2.14 Portraits of models credited to *Paris-Dakar* from the November 1956 issue of *Bingo* magazine.

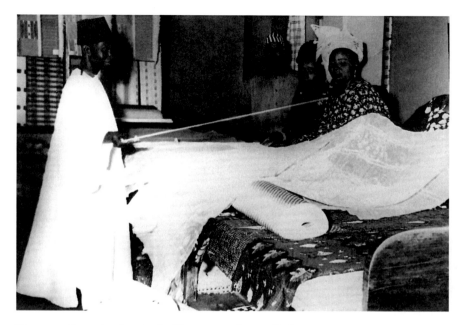

Fig. 2.15 Portrait taken in the Pierregross shop in Dakar.

Widespread interest in these new fashions increased the magazine's readership as a leisure class that enjoyed dressing up for clubs, bars, and movie theaters. The rise of tailored dresses and suits could be seen in both the reader-submitted photos and the advertisements. Throughout Senegal, women and men enjoyed being photographed to show off new styles which emerged from a mix of locally woven, dyed, or manufactured cloth in cuts such as the *kamisolu, mbubu, tay bass,* or *robe bolok,* as well as imported tailored dresses fashioned after the popular designers Gigi Young and dresses with princess necklines (Benga 2020, 118). Women wore locally tailored clothing for religious and family occasions and imported clothing for the office and school. Many fashions fell somewhere in between, reflecting the double identity of many Senegalese under French colonialism, the meaning of which continued to change with each generation (Rabine 1997). In the 1930s, people would have been embarrassed about wearing European clothing, as it indicated subservience to colonial masters, but, by the 1950s, it had come to indicate inclusion in the middle and upper classes. By the 1960s, new President Senghor had mandated such clothing in

the new republic, such that it was a matter of both political obedience and, at the same time, modern, youthful rebellion.[29]

A November 1956 feature borrowed portraits from *Paris-Dakar* to showcase the latest fashions from the French textile firm Pierregross, which had a shop in Dakar (Boone 1992, 72; D. Konate 2009). These fashions included the Robe Bolok on the left and the long mbubu on the right, also known as the mbubu that drags on the street due to its rich and ample length of cloth. It appears that the mbubu is draped over a Kamisolu, adding to its expense (compare to Rabine 2010). In contrast to the mbubu, which is largely uncut cloth, the Robe Bolok and Kamisolu serve as a platform for tailors to demonstrate their skill with embellishment, tucks, and cuts.

The intersection of fashion and photography was directly relevant to Socé's political agenda. The Robe Bolok became one of the most popular fashions of the day, named for the Bloc Africain, a gathering of various political forces led by Lamine Guèye, a Paris-trained lawyer and the first West African to hold a French doctorate in law. The dress, with its fabric in the party color of red, symbolized allegiance to the Bloc Africain, which had successfully campaigned for women's right to vote during and after the war (Benga 2020, 123). The fashion also enjoyed popularity because through it women expressed their French citizenship vis-à-vis French women (D. Konate 2009, 234). The Robe Bolok departed from other fashions of the time not only in its cut and color but also in the twelve yards of fabric used to create a voluminous skirt, which was often spread out in portraits. In the portrait from the shop Pierregrosse, the model on the left is one of the first fashion models in Senegal, Gaye Cisse (b. 1924), who campaigned for Lamine Guèye and later for Léopold Sédar Senghor (Rabine 1997, 103). In this portrait she wears the Robe Bolok, which, over time, appeared in cloth of various colors and patterns. By featuring this style and featuring Cisse, Socé subtly supported the Bloc Africain and suggested to his readers that doing so was not only smart but also fashionable.

Advertising could drive the fashion trends that showed up in reader-submitted portraits. But when it denigrated Blackness and trafficked in colonial stereotypes, it could also undermine Socé's intentions to create a Senegalese public readers across Senegal on the eve of independence. In the early 1950s, advertisements in general were often produced in singularity and then pushed to print media. This meant that a company would run the same illustrations or photographs in all of the magazines, mail-order catalogs, and newspapers of the period so that there was often little concern for cultural differences or sensitivity.[30] In *Bingo* this was also the case, though there were some exceptions, such as ads placed by prominent African-owned shops in Dakar.

Fig. 2.16 Feature on Ousmane Socé Diop next to an advertisement for COFIC featuring an illustration of a *tirailleur sénégalais* soldier printed in the May 1954 issue of *Bingo* magazine.

Many foreign companies featured ads with the figure of the tirailleur sénégalais, or Senegalese sharpshooter, not just in Senegal but across Europe. One example appears in an early feature introducing Socé's editorship. Next to a photographic portrait of Socé and an accompanying feature describing his accomplishments sits an illustrated advertisement for tinned foods from Morocco in the bottom left corner.[31] The advertisement contains an illustration of a childlike Senegalese sharpshooter with his iconic chechia hat, smiling and winking with his arms loaded with canned foods. This infantilized image of gluttony, with the soldier's arms full of food, is a far cry from the starvation conditions that many soldiers and veterans endured in the aftermath of the World War II (Mann 2006, 116; Echenberg 1985, 365). The advertisement destabilized the modern, honorific quality of Socé's photograph and the accompanying feature (Landau and Kaspin 2002, 144). This advertisement was not just a colonial vestige in the broader mission of the magazine; it laid bare how whiteness functioned elsewhere on the popular periodical page over time.[32]

Trends in fashion, technology, and advertising coalesced with a reduction in *Bingo*'s readership by the end of the 1950s. Many of the fashion trends that the magazine had featured had reached beyond the urban middle-class readers, and subscriptions to the magazine fell off as the luster of new clothes faded. As much as fashion and photography were still vital to middle-class consumption, economic disruptions from the 1960s dampened consumer enthusiasm. Photography experienced a similar trajectory to fashion. At first, audiences appreciated fine portraits, which also featured sitters in the latest fashions. Over the decade, as photography became more popular and affordable and spread outside urban areas, the quality of portraits submitted to the popular periodical decreased. Lightweight, medium-format personal cameras, using 120 film, also came on the market. They became easier to distribute across the continent and more marketable as consumers gained access to credit (Bajorek 2020, 5), but they would have remained largely unaffordable to many readers. Still, *Bingo* advertised them widely: the Pontiac Bloc Metal 45; the Kodak Brownie Flash, produced by Kodak Pathé in France; the Belgian Agfa Synchro Box and Agfa Clack, a popular family camera; the French 332 Flash Sacoche; and the Italian black-and-white film Ferrania. By the mid-1950s, the *Bingo* page began to appear alongside such advertisements, suggesting that readers could take the types of portraits the magazine ran if they bought the right machine.

In July 1956, the number of reader-submitted photos was cut in half in the section "Our Readers Meet" to make room for "Nos amies de l'armée" (our friends in the Army), featuring portraits of military personnel in French Indochina. (Incidentally, 1956 was the last year that Senegalese soldiers were

"SEND US YOUR PHOTOS" 119

Fig. 2.17 Pages from the July 1956 issue of *Bingo* magazine.

stationed there.) By the April 1957 issue, the section became "Nos abonnes se retrouvent" (our subscribers meet), featuring smaller photos, likely identity photos, and a list of names of those who subscribed to the magazine. In this section, readers could parse the reader-submitted photographs to find their picture. By the 1960s, "Nos abonnes se retrouvent" was retitled again as "Ils sont membres du Club *Bingo*" (they are the members of Club *Bingo*), and appeared in the back pages to promote *Bingo*'s subscription campaign (Bajorek 2012). After discontinuing the *Bingo* page in the late 1950s, the magazine continued to add features relating to photography, including a column on amateur photographic techniques and a feature story on photography for women. Aspirational portraits were not just on the decline while amateur photography, as a practice, was picking up; identity-card photos were increasing in number as photography spread more widely across the republic.

In the early issues of *Bingo*, reader-submitted photographs dominated the visual plane, often appearing far more prominently than the relatively straightforward, hand-drawn advertisements. Toward the end of the 1950s and into the 1960s, however, reader-submitted portraits were losing space in the magazine, and advertisements, which had begun to include photography, were gaining

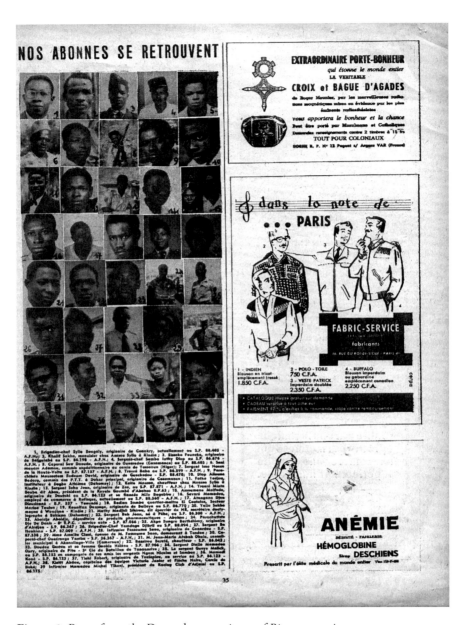

Fig. 2.18 Pages from the December 1957 issue of *Bingo* magazine.

ground. Advertisements grew more complex, and their use of photography more engaging, at the precise moment that *Bingo* shifted away from reader-submitted portraits to identity-style photos at the back to underpin its subscription campaign. This created a sharp contrast between the world as depicted by readers and the world as advertised to them.

Consider an advertisement from Kodak in 1962, with a half-page portrait of a Black woman with short, straightened hair holding a Kodak camera with the caption "the camera that has conquered the entire world" (l'appareil photo à la mode qui a conquis le monde entier). The caption aptly describes both the amateurization of photography worldwide and the conquest of the magazine by its commercial interests. The advertisement was produced for an American audience. Advertising agencies often pushed the same ad to multiple markets without regard for local consumers. Ad-heavy layout at the end of the decade leading up to independence in 1960 and afterward undermined the editorial viewpoint of the popular periodical to portray life in twentieth-century West Africa by and for Black audiences through reader-submitted portraits, and its copy and images competed for attention with what the magazine and its readers created themselves. As advertisements came to dominate the magazine's pages and increasingly depicted life from elsewhere, *Bingo*'s ability to create a sense of imagined community among readers diminished.

By the 1970s, Kodak advertisements pushed for the amateurization of the medium. Advertisements proclaimed that anyone could take pictures, and often featured people in their homes with cameras. Agfa ads emphasized family photography and often showed situations of leisure, such as sleeping in the home den, relaxing on the beach, or sitting in a swinging chair reading a magazine like *Bingo*. These advertisements emphasized the conjugal couple, often wearing Western knee-length dresses and suits to embody what seemed, perhaps, a modern, romantic notion of marriage. Such advertisements yoked photography with leisure, pleasure, and amusement, all taking place in the domestic sphere, rather than at the neighborhood studio. Such advertisements supported family ideals that clashed with many African readers' realities, and also contributed to the decline of photography studios.

Over time, advertisements evolved from literalism portraying objects as they were to featuring consumer goods as objects of desire and possibility. For example, Parker Mondiale radio told its audiences that its radios could connect them to all points on the globe, while Air France promised to transport them there. In advertisements for everything from pens to cosmetics, composite photographic images depict the product, sometimes a line drawing, and the person, implying a relationship between them. Text pins down the meaning of

Fig. 2.19 An advertisement for a Kodak camera and film in the April 1962 issue of *Bingo* magazine.

Fig. 2.20 An advertisement for AGFA in the February 1962 issue of *Bingo* magazine.

these photographs by telling the reader that the person has succeeded because they used the product. The elements of text and image leave out the need for the labor required to earn money to purchase these products: all that matters is the outcome, a vision of consumer happiness (compare to Stein 1981, 43). Of course, the debate over dependence on imported luxury goods underpinned the early days of independence and is captured in Ousmane Sembene's 1975 film *Xala*, which depicts the corruption of the rising business class.

A photomontaged Gillette razor blade advertisement from the early 1960s, for example, features a large, three-quarter bust photograph of a Black man wearing a pilot's uniform and glasses at the top, a tiny hand-drawn illustration of him at a desk just below, another photograph of him shaving, and, at the bottom, a hand-drawn razor and the Gillette Bleue razor blade box adorned with a portrait of a White man. The pilot at the top smiles, his happiness attributed,

Fig. 2.21 *Left*, an advertisement for BiC in the October 1960 issue of *Bingo* magazine; *right*, an advertisement for Gillette in the July 1960 issue of *Bingo* magazine.

in the text below, to his shaving-fueled success: "He succeeds ... he shaves every day with Gillette" (Il a réussi ... il se rase chaque jour avec Gillette). His portrait takes up a full quarter of the print page, in an outsized proportion to the rest of the advertisement. A reader might infer that the figure can buy the razors because he is a salaried pilot, but the message of the advertisement is the opposite: using the razors will make you successful, like the pilot. The advertisement's text claims that this man succeeded, after all, because he shaved daily with a particular razor. Although most readers of the magazine were not pilots and likely could not wield a pilot's purchasing power, these images paralleled the forms of social and public persona promoted by the magazine as worldly and discerning and they provided specific direction on how one might achieve such success.

The magazine's alternation between portraits and advertisements that featured portraits contributed to the slippage between personal portraiture and advertisements and, over time, the two genres resembled each other more and more. Advertisements reflected trends of the era, but they also influenced portraiture conventions in West Africa. Not only did consumer objects from the advertisements appear in reader-submitted portraits, but the aesthetics of the portrait also began to look like the advertisements as more sitters donned tailored European fashions and posed with radios and other objects featured in ads.

For *Bingo*, the line between artifice and realism was crossed early, in the *Bonne Année* January 1956 issue, when an advertisement for Nous Deux perfume from the December 1955 issue became the cover, replacing the cover's customary cover girl photographic portrait. The hand-drawn illustration was reprinted, colorized, and enlarged to show a vanity with boxes on its surface. While the original advertisement features photomontage, the reprinted image does not. The original advertisement shows the couple enveloped in a ribbon that surrounds them and marks off the space of the illustration from the text and caption that follow below. Also featured is a small image of Nous Deux, which was also the title of a French women's popular periodical published in 1947, that featured visual storytelling in drawn panels and photographs in an emergent form called the photo novel. Readers of the day would have recognized the transformation of the cover from featuring a portrait of a local figure to an advertisement and, as such, a signal of the close of the era of reader-submitted portraits.

Again, in February 1959, the popular periodical featured another advertisement on its cover, this time in the form of a collage with a portrait. The advertisement was produced by GIL for La Mode de Paris and features a full-length

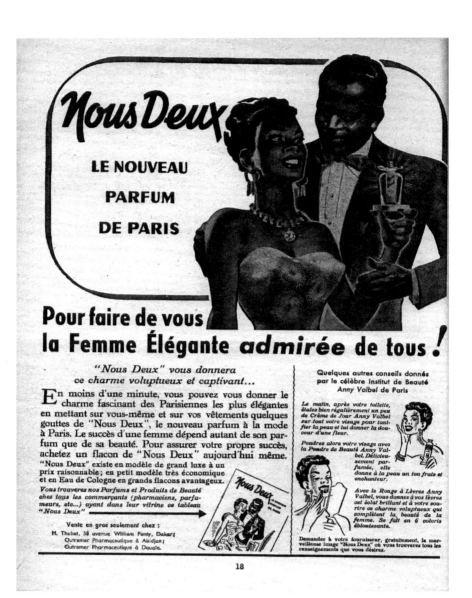

Fig. 2.22 An advertisement for Nous Deux in the December 1955 issue of *Bingo* magazine.

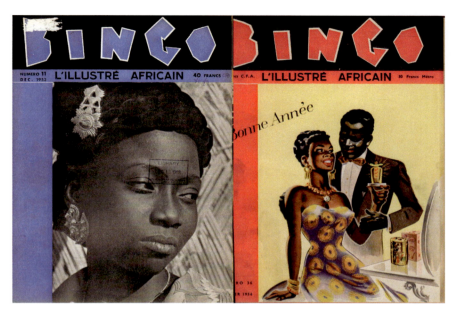

Fig. 2.23 *Left*, a cover girl from the December 1953 issue of *Bingo* magazine; *right*, an advertisement for Nous Deux reprinted on the cover of the January 1956 issue of *Bingo* magazine.

portrait of a woman in a short, tailored dress with a full skirt and heels. Her hair is either in a shortcut or covered by a fashionable wig. The other image features a bust portrait of a woman holding a masque up to her face turned slightly toward the first woman. This cover and a subsequent one also drawn from an advertisement signal the decline of reader-submitted photographs to *Bingo*, the rise of advertising culture, and the poor financial situation of the magazine demonstrated by its need to reproduce ads as rather than feature new photography of cover girls.

Changes in the layout and paper quality also led to a decline in the visual appeal of the magazine. *Bingo* was initially printed on expensive, glossy paper, but just a year into publication, by June 1954, *Bingo* was printed on noticeably cheaper, yellow-gray rough stock. The quality of the photographs decreased too, and fewer credits appeared for local studios. The magazine became subject to its advertising interests that did not depend on the fine-grain detail of a studio portrait. The popular periodical thus lost the dynamism of its imagery. The photographic collage layout of the December 1953 "La page de *Bingo*" was

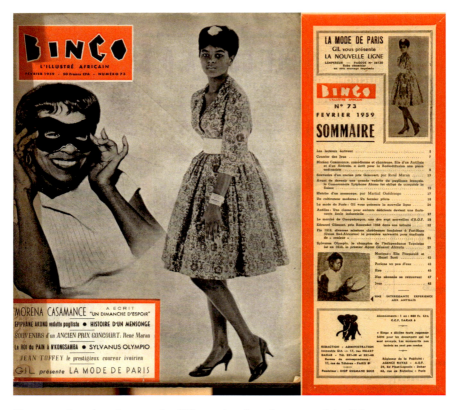

Fig. 2.24 An advertisement for GIL reprinted on the cover of the February 1959 issue of *Bingo* magazine.

replaced, in the February 1957 section "Our readers meet" (Nos lecteurs se retrouvent), by a linear grid. The grid suggested yet another feature of modernity imposed on an uncertain political and economic moment.

Between February and April 1957 Ousmane Socé's name ceased to appear as "Director" on the magazine masthead. In October 1958, the masthead listed him as the "Founder" of *Bingo*, and no editor was named in the masthead until sometime between 1960 and 1962, when the magazine changed its subtitle from *L'illustre africain* to *Le Mensuel du Monde Noire* (the monthly of the Black world) under its new editor Paulin Joachim, a Beninois poet and journalist who had written for the magazine. Socé had a unique visual eye and connection to the vibrant local studio culture, so his departure may have been related to

Fig. 2.25 Photograph of press photographers by an unknown photographer, 1958, National Archives of Senegal.

the declining visual quality of the sections featuring reader-submitted photographs. Socé had functioned as a gatekeeper, procuring portraits of politicians, socialites, and literary figures.

Bingo represented desired, if often unattainable, forms of material culture from the photographs to the phonographs to the cameras advertised on its pages. By the 1960s, the glossy format had shifted to an even duller, yellow newsprint-weight paper. Although sections by and for West African audiences continued, including literary contributions and the pen-pal column, advertisements increased and *Bingo* became a largely commercial publication, focused on women and their domestic lives, with recipes, stories about dress and makeup, and a new advice column (Jaji 2014a, 138). It was not sustainable. Amid the economic decline and stagnation of the 1970s, unable to sustain the demand for the new—in images and consumer culture—*Bingo* remade itself as a political monthly in the vein of *Newsweek* and *Jeune Afrique*. It was published until the 1990s, appearing on thin shiny paper. What had begun as a popular periodical on the eve of independence, its glossy pages reflecting the aspirations and hopes

of its readers, ended in a postindependence era of disillusion and economic contraction. Readers of the new *Bingo* were looking not for triumphant images of self and community, but for a clear accounting of the facts.

Some of Senegal's most prominent photographers had made a similar shift in focus. In the immediate aftermath of independence, several studio owners including Amadou Mix Gueye (1906–1994) took up positions as official photographers in the new republic. Gueye became an official photographer for the Senegalese Ministry of Information and News. His studio was in the Plateau neighborhood of Dakar on Rue Amadou Assane Ndoye, not far from the *Bingo* magazine office, where he was a regular contributor, located at 4 Rue Carnot.[33] From the period immediately before independence to the present, Senegalese photographers have played a role in photojournalism.

By the 1970s and 1980s, many more studio photographers shifted to photojournalism, a move that in part was enabled by the liberalization of the press in Senegal, as well as by a new political consciousness.[34] Moves were afoot across the continent to engage in politically relevant photographic work. In Senegal, the photographers Djibril Sy and Boubacar Touré Mandémory described how they became involved in a newly emergent organization based in Dakar called PANAPRESS.[35] PANAPRESS sought to assemble a team of African reporters and photographers based on the continent who could pursue editorial independence. They aimed to publish without regard to the political pressures of the day and to counter stereotypical images of Africa in the international media.[36] In South Africa, the photographer Cedric Nunn described how the photography collective and photo agency known as Afrapix continued its own projects, which often carried complex personal themes and allowed for critical self-reflection, alongside their photojournalism and anti-apartheid work.[37] Other Senegalese photographers worked as stringers for international press agencies, including Reuters and the Associated Press, earning money that could support their artistic and creative work in and out of the studio.

As photographers shifted their focus, so did their clients. It would be easy to say that *Bingo*'s history is, in a way, a microcosm of the history of portrait photography: after a flowering of masterful work energized a populace to project their images to a broader public, the relentless wheels of capitalism pulled emphasis elsewhere. But that isn't quite right. *Bingo*'s early years reflect enduring practices of using photographs to connect self and others, to see and be seen, that—while studio portraits are less common today—endures today in other forms. As cameras became more portable, and film easier to have developed quickly, photography became more casual, practiced by mobile amateurs. And as people's homes became sites of modernist consumption of luxury goods,

photographers traveled to them to create portraits that glorified the domestic world. The blurring between self-imaging and consumption that characterized the first few decades of *Bingo* continued, in a new and different form.

NOTES

1. Ibrahima Thiam, interview by the author, February 1, 2019, Bloomington, IN.
2. *Paris Match* was launched in 1949 as the successor to *L'Illustration* (1843–1944), which was discredited during World War II.
3. Kandioura Drame, personal communication, May 2019.
4. I am grateful to Gaya Morris for this insight.
5. For comparison with India, see Pinney 1997, 185.
6. *Life*, the innovative picture magazine of the Henry Luce *Time* empire, began circulation in 1936 in the United States. Its rival, *Look*, published by the Cowles Media Company, began circulation in 1937.
7. Good Publishing also published *Hep, Bronze Thrills*, and *Jive* for Black readers.
8. The full title is *Zonk! African People's Pictorial*. *Drum* magazine's peak circulation in South Africa was 100,000; it was distributed in Nigeria, Ghana, Tanzania, Kenya, Uganda, Zimbabwe, and Zambia. "Look: Apartheid Exposed," *New York Times Magazine*, September 11, 2012, http://archive.nytimes.com/www.nytimes.com/interactive/2012/09/16/magazine/drum-magazine.html.
9. Werner suggests that at the time, whole villages might have been photographed in a single day at the behest of the ruling authority and thus enthusiasm may have been tempered by such directives.
10. Compare to Strassler's discussion of photography in Indonesia in relation to nation making (2010, 13).
11. *Paris-Dakar* was published between 1933 and 1961. In the 1960s *Paris-Dakar* became *Dakar-Matin* and in the 1970s it became *Le Soleil*.
12. A rotary printing press prints on paper passing between a supporting cylinder and a cylinder containing the printing plates.
13. Though *L'imprimerie Diop* was advertised in the first issue of *Bingo*.
14. Seeing and being seen, as Krista Thompson argues for African diasporic visual practices, and the process of learning and transmitting the value of being seen are vital to "the right to self-representation" (2015, 10).
15. Readers were also encouraged to learn geography in an early section called "Connaissez-vous l'Afrique" which later expanded to the various regions of France. These sections featured maps and demographic data.
16. For further discussion of African-print cultures and popular, traditional, and elite modes of cultural production, see Barber 1997a, 8.
17. For further discussion of magazine formats see Stein 1989.

18. Ousmane Socé published the novel *Karim* in 1935 and *Mirages de Paris* in 1937 in addition to tales in *Contes et légendes d'Afrique noire* in 1942 and poetry and music in *Rythmes du Khalam* in 1956. *Karim* was awarded the Grand Prix Littéraire d'Afrique Occidentale in 1947 and is canonical in African literature courses today. Born in Rufisque, after attending École Normale William Ponty, Socé studied in France in the 1930s and became a veterinarian who served in World War II. After the war, Socé engaged in politics. He served in the French Assembly from 1946 to 1952. He later served in the Sénat de la Communauté from 1959 to 1961 and as the Mayor of Rufisque from 1961 to 1964. He became Senegal's ambassador to the United States and delegate to the United Nations until his retirement in 1968 (Hogarth 2012). See also Sénat, "Diop Socé, Ousemane," accessed November 27, 2018, http://www.senat.fr/senateur-4eme-republique/diop_soce_ousmane0042r4.html.

19. Although realism in social documentary photography is often viewed as a mode of social and political critique to expose the artifice of portraiture, editorial interventions between reader and content are also made in realist photography. For example, while social documentary photo essays may give the impression of looking in or through a window, the layout and organization of the visual narrative, along with the written text or captions, also represent editorial interventions (Kozol 1994, 9). Captioning images, organizing them into features, and the use of text boxes and enlarged typeface represent editorial modes of intervention. Furthermore, realism in photography is an historical form of representation just as is portraiture.

20. For further discussion of *Drum's* publication history see South African History Online, "Drum Magazine," accessed April 4, 2022, https://www.sahistory.org.za/article/drum-magazine.

21. For further elaboration of the idea of the public, see Brian Larkin's discussion of Michael Warner (Larkin 2013a, 239).

22. "Actualités photographiques," which appeared in the first issue, later became just "Actualités," beginning in the July 1953 issue.

23. The coverage of Black student life in France made sense given Socé's own experience studying veterinary medicine in France in the 1930s.

24. For further discussion of the advent of the process-engraving machines in West Africa see Kunstmann 2015, 533.

25. The 1953 issues featured reader-submitted photos in the section "La page de *Bingo*" with the reader's name and a short description alongside photo credits for the studios; for example: "Photo T. Sandaly" (Mali); "Elisa-Photo, Thies" (Senegal); "Electric-Photo"; "Cliché Fall," "African Photo Gnias M. Casset" (Dakar, Senegal); "Photo Bel-Ami, Cotonou" (Benin); "Cliché Tropical-photo" (Saint-Louis, Senegal); "Medina, Photo M. Casset" (Dakar, Senegal); "Photo Betouni"; "Photo Dominique." These credits reveal not only the circulation of *Bingo* magazine across

francophone Africa but also the movement of its readers, since several studios located in Senegal point to the origins of their owners outside of Senegal. For example, there were a number of studios in Thies owned by Beninois, such as Elisa-Photo, due to the large population of railway workers from Benin stationed there. I am grateful to Ibrahima Thiam for describing the Beninois studios to me (Thiam, interview, 2019).

26. Ibrahima Thiam, interview 2016, Dakar.

27. I am grateful to Eileen Julien for this observation.

28. For further discussion of contemporary practices of montage with respect to the Murid Sufi congregation, see Buggenhagen 2010.

29. But by the 1970s people abandoned prêt-à-porter in the context of a global economic recession and returned to locally woven and dyed textiles as a matter of resourcefulness (Rabine 2002).

30. I am grateful to Heather Akou for this observation.

31. Sally Stein (1989) suggests that in the period between 1919 and 1939, advertising agencies controlled the placement of their advertisements in American magazines. While Socé's feature appears early on in the magazine's pages, the ad is also situated in a place of prominence, in the editorial section of the magazine.

32. I am grateful to Michelle Moyd for this observation.

33. Thiam, interview, 2019.

34. For further discussion of the development and emergence of political photography in Senegal see Jennifer Bajorek's stunning book, *Unfixed: Photography and the Decolonial Imagination in West Africa* (2020).

35. The Organization of African Unity founded PANAPRESS, or *L'Agence Panafricaine de Presse* (the Pan African News Agency, PANAPRESS), in Addis Ababa in 1979. One of the largest financial supporters of PANAPRESSE was Muammar Gaddafi, who led Libya starting in 1969.

36. Djibril Sy, interview by the author, December 2011, Dakar.

37. Cedric Nunn, interview by the author, September 2013, Bloomington, IN; Santu Mofekeng, interview by the author, October 2013, Bloomington, IN.

THREE

FAMILY PORTRAITS

DESPITE THE SUGGESTIVE ADVERTISEMENTS by Kodak and Agfa in *Bingo* magazine, portable cameras became no more widespread after independence in Senegal than the miniskirts that the models wore in the advertisements. As the post–World War II economic boom began to fizzle and finally ended with the 1973 worldwide recession, imported cameras were too expensive for the average Senegalese consumer. Moreover, people still valued patronizing a photographer even when the studios began closing in the face of rising rents in the city.[1] Given these changes and continuities, how did photographic practices shift in the context of new financial constraints as people sought to create a successful portrait of themselves and their families in the face of economic strife?

The new constraints were characterized by an influx of rural migrants to Dakar who were escaping harsh environmental conditions, and also by increasing pressures on land and rents in the city. Pervasive, recurring drought had struck the northern region of the Sahel, beginning in the 1960s and returning in the 1970s and 1980s. The political response failed to mitigate extensive famine from 1968 to 1974 and into the 1980s. Furthermore, worldwide prices for peanuts, which many Senegalese farmers relied on as a single crop in the colonial period, plummeted, and France reduced its economic aid. Faced with economic and environmental devastation, migrants from rural areas came to Senegal's coastal cities of Dakar and Saint-Louis.[2] In the wake of these hardships, the currency was devalued, the economy liberalized, and an unregulated and unofficial economy flourished, driven in part by new migrants in search of work. These economic shifts provided the perfect environment for a new kind of itinerant photographer to succeed.

While during the final decades of French rule, many members of the political class had left Senegal to pursue an education in France, now a ravaged economy fueled a longer-term and much vaster form of out-migration as young people looked abroad for new opportunities. Migration split families and divided their photographic patrimony. Some women packed up their portraits in suitcases bound for France, while others left them behind on the walls of the homes they once occupied. For the many women left behind by migrating spouses, family portraits were all that remained of fractured households. These portraits remained central to repairing the damage and loss wrought by prolonged rural-to-urban and overseas migration that kept young people apart from their families, even as these stays extended as migrants searched for the means to support families at home or tried to escape family pressures altogether. When hung on walls, assembled over a dresser, or placed in albums, portraits could anchor a family facing strife; however, the pressure and even failure to create pleasing displays could also weigh families down. When death struck, the visual commemoration of a life was given new energy, and these portraits were brought out to guests from women's bedrooms, placed near televisions and screens, and generally became topics of ongoing conversation as they were stroked, blessed, and even cried over. When divorce occured albums were tossed aside, stuffed to the back of armoires, or left under mattresses where they deteriorated, their social life snuffed out.

By the 1990s, when I first visited Senegal, I noticed enterprising young men offering photographic services as part of the unregulated and unofficial sectors of the economy. I noticed that photography, like working in the telecenters and tailor shops that populated the urban economy, was an especially attractive occupation for young men because it was easy to get into and required little startup money, and they were physically fit enough to canvas neighborhoods with equipment in tow. Aspiring photographers also did not need to rent the space a telecenter required. Nor did they need to apprentice to a master, like tailors, or to belong to specialized occupational orders, like weavers. Rather than relying on patrons to commission their work on a regular basis as studio photographers before them had done, they capitalized on their mobility, expanding on foot throughout the city. Ambulant photographers bought film cheaply, rented 35 mm cameras and accessories from any number of Korean-owned photography labs popping up around Dakar, and brought their film back to these same labs to be developed (Buckley 2000; Werner 1999). Many of these Korean-owned photo labs were in heavily populated areas, such as on Avenue Pompidou in the Plateau neighborhood of Dakar, near the central

Fig. 3.1 A packet of portraits returned by a photographer at a celebration. *Collection of the author.*

Fig. 3.2 Negatives from Fina Photo Rapide en 18 min. *Collection of the author.*

market Sandaga, and they catered to a mix of amateur photographers, tourists, and Embassy and NGO workers. By the 1990s, many of the labs in the working-class neighborhoods were run by young Senegalese men, and the number of labs outpaced the number of studios run by men of their father's ages. Ambulant photographers could promise quick turnaround times, sometimes as little as seven minutes for automatic processing, before selling photographs to their sitters. Young men could pick up the trade quickly, and the profession became increasingly contingent and casualized. This is in part how portraiture has endured in Senegal into the present, by moving out of the studio and onto the street.

Rural migration to cities made for congestion and skyrocketing rents. Studio-based photographers, with their high overhead, could no longer compete with the new generation of mobile, largely self-taught commercial photographers who flooded the unofficial economy. The rise of lightweight, digital cameras further exacerbated the problem. Although they were first introduced in the 1990s worldwide, I did not see digital cameras in wide use in Senegal until

well after the 2000s, due to their steep cost. By the 2010s, however, they had become more mainstream for ambulant photographers.[3] Enterprising commercial photographers often took to the streets in search of an event worth photographing, looking for telltale signs such as a large tent erected in front of a home, livestock tethered to a post, or the beat of *sabar* drums and a sound system broadcasting Muslim litanies. The signs that signaled such gatherings to photographers were also signs that a family had received remittances of cash from migrant fathers, sons, and brothers, and would be able, and eager, to have their success recorded. The more affluent families of course called the photographers that they patronized to their homes to stage their portraits as well as videographers to record the event so that migrants (presumably those who had sent the remittances) could appreciate from afar how these gatherings might amplify their reputations at home despite their prolonged absences.

As photography became an ambulant and amateur profession, many professional photographers could not compete. Countless studios closed across Dakar. Where studios had once relied on demand for identity photos for national identity cards and passports to sustain their businesses, they were now competing with mobile studios with lower overhead. Mobile studios, such as Studio Mobil Tiger, were located in vans parked on busy streets. Clients entered the rear of the van, sat for a portrait, and watched their picture as it was printed instantly on an inkjet printer before they exited the van. When I visited in 2011, it was nearly impossible to find a photo studio in urban working-class neighborhoods such as the Medina, Grand Yoff, and Pikine where they once dominated.

When I asked lens-based artists such as Boubacar Touré Mandémory what happened to the photo studios and what to make of the success of what art historians had long derided as popular photography, they too lamented what they described as the banalization of photography. Mandémory explained that 35 mm film cameras required artistry and technical skill. These attributes came into play in the darkroom, where photographers honed their artistic and technical knowledge as they developed the film into prints. For these artisans, authorship was key to how they understood photography as a communicative and creative medium. According to Mandémory, digital technology eliminated such artistry, allowing unskilled photographers to take many more shots, to see the images instantly, to edit images directly on the camera, and to choose which images to print. Once consumed, he said, portraits taken by peripatetic photographers quickly became passé.[4] Rapid photo processing and quick delivery met the needs of the same audiences who scrolled the social media app Instagram, where newness itself is paramount to audiences. As photography was remediated from the print to the digital screen, sitters and their audiences partook

in these screen-based fantasies about their own and others' lives. But even in print photography in India, as Christopher Pinney argues, people sought to come out better, or appear better in their portraits (Pinney 1997). In this way, the new media enters a preexisting web of media ideologies or ways that people conceptualize and understand various forms of media (Gershon 2010). This new form of media, social media, has reconfigured how young people in Senegal view their photographic past.

Mandémory's points may be correct: that digital photography has shifted how lens-based artists work and how their work is valued. This claim has special valence for how we think through the materiality of photographs. At the same time, the rise of digital cameras and the demise of studio culture has not lessened the value of portraiture for the average Senegalese family or for artists themselves working in the medium of photography. Even social media images, quickly consumed, can cement social relationships and build reputations. What is more, many Senegalese people continue to patronize the handful of photography studios that remain, while others hire photographers to work in their homes to capture and project their social successes. Women in Senegal construct and share albums, hang photographs at home, and send them to far-flung families. In the process, they depict their own hopes of success. Sometimes the images accord with what takes place outside the frame, and at other times, they attempt to remake it.

A LIGHT PURSE MAKES A HEAVY HEART

The casualization of photography parallels the disappointments of the postindependence period and continues into the present. Photography now takes place in the space of ruins of the economy and in half-built homes that stand either as monuments to past aspirations or as dilapidated structures (Buggenhagen 2001; Melly 2017). The city is marked by the rumble of construction and the illegal siphoning of the beach sand necessary for cement, thus furthering erosion to build up that landscape of apartment house after apartment house. Indeed, "this new face of Dakar," as Mame-Diarra Niang's photographic essay "Sahel Gris" (Gray Sahel) (2012) remarks, is "forged from the ubiquitous sand that creeps into every crevice of this coastal city and the concrete formed from it, in an omnipresent grey landscape."[5] Is this construction rubble of cement blocks, piles of sand, and rows of rebar indicative of buildings undergoing construction, or is it ruins of buildings in various points of dilapidation? Either way, Niang posits, it marks the emergence of a built environment composed of new architectures of enclosure of cement brick framing individual consumerism.

In these moments of rupture, ordinary things like photographs that people take for granted come to carry added weight as they try to stitch our social lives back together, in what Joshua Bell discusses as a social process of repair (J. Bell 2021). Indeed, inside these half-built homes across Senegal, photographic albums, assembled displays, and collections-in-the-making sit alongside collections of miniature porcelain figurines, silk flowers, and cosmetic jars and bottles. Albums, as forms of women's wealth and value, as ways of knitting together friendships and family relations, largely feature women. Men also sit for portraits, especially religious, political, and professional portraits, but their numbers are more restrained and their presence in albums is limited. They also do not generally keep their own albums.

Albums thus both commemorate the past and project the future. Yet they are also shot through with absences, like a bathroom with new porcelain fixtures and no plumbing. Not every migrant is successful: potential can go unfulfilled, and sometimes be undone, as when whole boats, headed to Europe, tragically capsize.[6] The uncertain visa status of many overseas migrants can leave them stranded abroad for years on end. Encounters with slender albums with missing pages and empty sleeves arouse silence rather than banter. Whether these albums have been emptied of their photographs or whether they were yet to be filled, these gaps refract the ruptures of social life, of people gone, forgotten, or yet to return.

Few storefront photo studios remain scattered across Dakar in the working-class neighborhoods of self-built dwellings where one might commission a photo or an album to commemorate an event.[7] In the early 2000s, I spent time in one such studio in Pikine following a bride who had rejected the photos I had taken of the various celebrations surrounding her wedding and had taken me to the studio to show me good photos. She pointed to the outdated props and tattered, faded fantasy backdrops to explain why she had chosen to stage her portraits in her new home with her new living room set. The photojournalist and lens-based artist Djibril Sy describes such studios as stocked with the old mail-order backdrops of palm trees and faraway cities for patrons who still dream of going abroad in an airplane or visiting the coastal resorts along the pristine beaches and nature preserves across Senegal's La Petite Côte, stretching almost 100 kilometers (62 miles) from Dakar to the Sine-Saloum Delta. Sy described the return of Serer migrants to their natal villages in 2011 this way: "They line up their chariots (horse carts) and each head of the family has with him his photo album and they continue in this progression out of Dakar toward their rural residences."[8]

Fig. 3.3 "'Imagorium' in the household of a Tijani elder in Zone B, Dakar, juxtaposing photos of family members with those of Senegalese holy people to gain their *baraka*, or blessing."

Fig. 3.4 In Dakar with the portraits of six religious figures displayed on the upper walls and top shelf. Another portrait of religious figures is placed to the left of the television. *Collection of the author.*

Fig. 3.5 An inexpensive vinyl photo album with the portrait of a religious leader, Serin Saliou of the Muridiyya, inserted into the cover sleeve. *Collection of the author.*

As studio portraiture has become less common among city dwellers, the numbers of wedding portraits carefully hung in living rooms across Dakar have declined. Today, assemblages of portraits of religious scholars and less expensive, mass-produced scenes from Mecca tend to adorn living room walls in lieu of, or alongside, family portraits. At first, these were locally reproduced studio portraits of religious figures plucked from the archives. They could be bought from any of the dozen salesmen in the street, strong enough to carry them up and down the side of the highway along the Corniche leading into Dakar. By the 2000s, most of these images were reproduced in China and exported back to Senegal.[9] One could stroll along the Boulevard du Centenaire, which had become dominated by merchants from China, and bargain for a full-color laminated portrait (Roberts 2010). As processes of social reproduction are stretched across the Atlantic and social relationships become strained, visual reminders of religious piety come to take the place of absent portraits of filial piety.

While religious iconography may lay claim to a certain moral orientation in the face of familial strife, portraits, whether hung on walls or kept in albums, reveal desires to lay claim to household space despite fallings-out. This can be especially poignant for sitters who are now absent from it, having migrated some time ago. For those left at home, portraits show that one is being taken care of and in a position to care for others in the face of an absent spouse, sibling, or parent. Photography, as Jean-Bernard Ouédraogo has pointed out, shows "traces of those expectations, fulfilled or otherwise, that go hand in hand with migration" (2012, 108). Portraits both reveal and conceal the movements and makings of social life across the vast geographical paths created by migration. For example, in this assemblage in a living room next to the television, the family placed a portrait of their grandfather with a portrait of his grandson living in the United States below it and decorated the two with a vase of flowers showing an upward migration in the socioeconomic expectations and status of the family. The flowers draw attention to these photos, highlighting the migrant's photo and the hope that his travels will improve the family's wealth and reputation.

Personal portraiture such as this display does not just represent a social world in motion; it is the means through which women and men make their social worlds despite motion. These images stand as objects of value that condense social networks "and come to stand for the networks that formed them" (J. Bell 2021, 170). Keane (2005) has referred to this social process as bundling (of semiotic signs), and attention to photographs shows how the valuation of these objects shifts over time and across media (analog, digital) and platforms. For example, collections of photographs accumulated over a lifetime, in albums or assemblages on walls or over bedroom mirrors, instantiate who the sitter has

Fig. 3.6 A portrait of a grandfather with a portrait of his grandson living in the United States set just below the bouquet of silk flowers. *Collection of the author.*

become and how they think about that process of becoming, which is always incomplete. These images document the sitter's social network, including how it has shifted over time, thus displaying the centrality of social connections to women's and men's lives. This process of creating self and network is also as fragile as the objects in which these processes rest—the objects like photographs that make and are made by social networks (J. Bell 2021, 182; Strathern 1996, 523).

In every family home I have visited, no matter how ordinary or imposing, sits an assemblage of family portraits propped up on the vanity or tucked into the mirror, hung in gilded frames on the walls or stashed in albums brought to visitors to flip through. Women sit side by side looking at these albums together exclaiming how this or that pose, facial expression, or outfit would be better for the camera, similar to how the griot, known as a *gewel* in Wolof, praises and applauds socialites. Such praise is offered not for posterity, but for the future. The opening pages of an album might feature portraits of the bearer in formal wear documenting the number of floor-length gowns, boubous, and kaftans changed into for a wedding or baby-naming celebration. These portraits might be followed by portraits of the album holder in other ensembles or hairstyles with various ornaments skillfully woven in for friends' fêtes. In time these album pages come to include similar portraits of neighbors, sisters, cousins, and other close friends. Evidence of the swapping of photos mirrors the swapping of clothing and financial support through which women flourish socially.

Portrait albums demonstrate disparities in marriages and means, since for many young women in Senegal, commissioning an album would be financially unmanageable and unimaginable. In these situations, women may buy blank albums and fill the pages with portraits that they buy from itinerant photographers. However, both the finest albums and the humblest albums are brought out to a room that suddenly goes quiet with expectation. Many women collect packets of photographs or individual portraits and prop them on their dresser or tuck them into a mirror frame. Women buy individual photographs from itinerant photographers who take their pictures at family celebrations and religious festivals. Friends were always delighted when I purchased these photos for them as it showed both affection and admiration and a desire to enter a friendship.

These loose photographs lack the orderly structure of albums, yet they can still gain meaning by virtue of their relationship to the other objects with which women arrange them. For example, a singular portrait might be juxtaposed with an image or photograph of Mecca, a desktop calendar, or a box that once contained a bottle of perfume, with its own image printed on the front. Several

Fig. 3.7 A 4" × 6" wedding portrait, taken in 1999 by an unknown photographer, swapped out of an album. *Collection of the author.*

portraits of the sitter displayed together might show a progression of attendance at important social and religious events. When singular prints are arranged in this way, they gather new weight from their relationship with other photographs. A personal portrait next to a photograph of a religious leader amplifies the sitter's piety, even if the original context for the photograph was a party or any other gathering. Displaying a progression of portraits illustrates a woman's wealth and social connections, documenting her beautiful dress and her presence at important events.

Assembling photographs for display dates to the early 1900s. Families gathered collections of photographs to create temporary displays in the marriage process in a practice called *xoymet*, a Wolof word meaning "fleeting," "in the blink of an eye," or "to catch a glimpse." To create these displays, the family would borrow framed portraits from kith and kin (Mustafa 2002, 176). Family members hung photographs in the bride's bedroom to visually represent these social networks. The practice of xoymet indicates that framed portraits were regularly borrowed and circulated among families hosting weddings.[10]

The process of gathering up images, placing them side by side, and creating a display for an audience suggests the reflexive creation of individual and collective identities through visual practices. These are visual stories about how sitters would like to be seen. Such displays could be understood as a semiotic process of entextualization in which texts are produced by extracting discourse from its original context (Silverstein and Urban 1996). In this case the portrait is removed from its original context—the initial impulse for and setting in which the portrait was made and displayed—and decontextualized when it is given over for xoymet. The portrait is recontextualized when placed with all the other portraits collected from various relations for the occasion. At each moment, the portrait gathers new meaning from its context of display. A matrimonial portrait placed next to an image of the Kaba in Mecca, for example, amplifies the piety of the bride and the promise of the marriage. A portrait of a father on the other side of the image of Mecca or just under that of a Sufi shaykh points to the piety of the father (Batchen 2000, 265). The image of the groom next to that of his grandparents emphasizes the family lineage and suggests the strength of his relationships and his family's support.

Consider another display, created by a young unmarried woman in Dakar on her bureau in 1999. She had arranged five recent portraits of herself along with an invitation to a Muslim conference and a paper desk calendar from a business school featuring a line drawing of a computer. The portraits from left to right depicted her role as a *Bajan*, or honorary mother figure, at the wedding of a younger relative in front of their freshly painted house with her older brother's

Fig. 3.8 A display of portraits on a vanity, Dakar, 1999. *Collection of the author.*

white car in the background, a second portrait at the same event but in a different outfit later that day, a portrait of her with her headboard as a backdrop, a portrait of her veiled at an Islamic conference, and out of view, a full-length portrait of her walking at a dance with several peers. In the first four portraits, the photographer has focused on her head and shoulders in a bust portrait. The crocheted doily and the lace curtain further set off the portraits like a three-dimensional backdrop or frame. Not only do these portraits illustrate her important role in her community and her piety, but the backdrops within them as well as the nearby image of a computer emphasize her modernity and access to wealth. These images do more than just capture memories; they help this woman assert a particular persona.

While portraits continue to grace many homes, women also create photo collages to post on social media for occasions such as birthdays. In this montage, the poster has repeated two images of herself at opposite poles of the images of the person whose birthday she is celebrating. The image in the center is a close-up in which their bodies are touching, further cementing the intimacy of their relationship.

Social media and smartphones have increased the financial pressure on both studio-based and ambulant photographers, as cell phone, Facebook, and

Fig. 3.9 A photo collage that was posted on Facebook. *Collection of the author.*

Instagram albums replace their vinyl predecessors. Such technologies make photographs more portable than albums, and digital filters and other editing and enhancing features can alter the aesthetics of individual portraits before they are shared. People can borrow and repost pictures without leaving a gap on the wall or an empty sleeve in an album. Instagram, with its focus on the instantaneous, further filters out context and specifics by virtue of the equalizing nature of its frame prioritizing the scrollable nature of its 1 × 1 square format photos, which is the same ratio for some medium format cameras that popularized photography at the turn of the twentieth century.[11] And because social media apps such as Facebook and Instagram allow free access to the internet, in contrast to having to purchase a phone card to access the internet, they have become, for many, the sole means of accessing the web, experienced as a platform for the endless circulation of images and the creation of reputations.

Despite these changes, it is not uncommon for a family to hire a photographer for an event that they are hosting and to commission an album afterward. Most of the photography takes place in the social setting of the home, except for several portraits that may be taken at the beauty salon. Like a good hairdresser or dressmaker, a good photographer boosts a sitter's social prominence. Photographers, like praise singers, hold the power to make or break reputations; botched photographs diminish the power of the event, undermining its status as a spectacular occasion and thus failing to further the family's reputation.

But as much as photographers vary in their skill, similarly do their clients vary in their social proficiency. Some sitters excel at performing the suitable aesthetic tied to an occasion. For example, to instantiate her piety, a woman returning from the Hajj might have a portrait of herself made upon her return. The sitter might wear all white, which is associated with Muslim virtue, draping a large, white cloth over her head and shoulders, and include Muslim paraphernalia from Mecca such as prayer beads in one hand. Women who had yet to go on the Hajj might also drape a large white scarf over their heads and shoulders for religious events to demonstrate piety and modesty. A woman headed out to a family celebration, influenced by the same style, might also choose to wear all white. Such images may stand in where an image of oneself returning from the Hajj has yet to be obtained. Properly posed for, and properly photographed, such images signal a sitter's moral virtue and religious commitment. In this way, photography plays a central role in developing one's social persona and reputation.

When photographers return to family celebrations with images that were rapidly developed at the photo lab, women gather around the portraits picking out the best performances, passing them around and talking about which sitters

Fig. 3.10 The passing of a rapidly printed portrait at a celebration. *Collection of the author.*

shone (*sanse*), or came out better (see for example Pinney 1997). Their conversations express their expectations surrounding what photographs can do, including reflecting and establishing a network of social relations.[12] Or, in other words, their actions point to the "strategies communities use to materialize their social relations, desires and values" (J. Bell and Geismar 2009, 3). While Pierre Bourdieu (1990, 23) refers to European family albums as "sociograms" or representations of social relationships, for families in Dakar, albums and photographs more generally are events unto themselves (see also Wright 2013). As Marilyn Strathern (1990) has observed, things can be both representations and performances. While photographs may be both, the "showing and telling of an album"—or a photograph on its own—"is a performance" (Langford 2001, 5).

It is not long before rapidly processed prints gather fingerprints and scratches and become soft and pliable to the hand. Quick processing and infrequent changing of chemicals cause some pictures to take on a pink hue within months, and cheap paper contributes to their ephemerality. Thus, these objects, their performances, and the albums they are placed in often thwart documentary attempts. More often, as I learned during fieldwork from the 2000s on, they paper over disruptions that plague social life in some families more than others.

THE WEIGHT OF FAMILY ALBUMS

Over the course of a decade, during trips taken over summer and winter breaks, I sat with women during long afternoons in towering apartment buildings throughout Dakar leafing through magazines, scrolling the pages of social media apps on smartphones, and flipping through photo albums. We talked about which family members had gone abroad since my last visit and which had returned. As we talked about marriages and births that had taken place in my absence, I noticed that women often turned to family photographs to repair ruptures in their social worlds such as babies born before marriage and family members who vanished—some by choice, evading family expectations, and others through no fault of their own. Facing fiscal uncertainty over the long durée, numerous families send kin along precarious migration routes through the Sahara and across the Mediterranean to Europe. A portrait, as a unique genre of photography, often abstracts the person from the background; while sometimes props are strategically placed to give a clue to the sitter's position, context rarely figures into the composition. As Marianne Hirsch argues, "the ambiguity that results from the still pictures absent context perpetuates the mythology of the family as stable and united, static and monolithic" (1997, 51).

These albums worked to present idealized and stable versions of families, trying to erase loss and rupture.

These photographs, like the people they depict, move overseas and back again, creating idealized images to mend fraught and fragmented lives. Through haptic, aural, and emotive labor, women make, view, share, talk about, and keep photographs. These personal portraits are not just visual representations of individuals and families, but they are also visceral; they have an affective and sensory dimension. People's moods lightened when they viewed photos of faraway loved ones, for example. Not only does viewing, talking about, and passing around photographs move women and men to different emotional states, but when photographs are held in the hand, as with an album or a pile of loose photographs, their tactile and sensory properties come to the fore.[13]

This labor underlies the spaces where photographs were removed or albums left incomplete. Like archivists and museum curators, women knit family stories with the pairings and sequences in albums; some of these are fictions, and there are also obvious omissions. As Martha Langford (2001, 4) has observed, "a book of photographs layers surface upon surface of real and virtual intersections; clusters and breaks are spaces of association whose meaning must be taken into account." Albums, unlike loose photographs, generate a narrative structure by virtue of the layout and sequencing of photographs.

Photo albums are also multidimensional objects. While largely mass-manufactured abroad and consisting of vinyl sleeves, more expensive versions feature cameo covers and pages with insets for portraits of various dimensions. Sometimes the vinyl versions are purchased with the original commercial portrait of a young white woman displayed. Others are remade for the local context and depict portraits of religious leaders on their covers before being sold by local vendors in neighborhood markets such as Centenaire where goods imported from China can be found. Albums are meant to be taken off shelves or out of drawers and carried; they are moving things. Moreover, the images they contain are also moving, like a film, with each arc of the page turn narrating a story held within. Placing photographs in the form of a book creates the spatial and temporal qualities of a story.

If I was not brought an album when I arrived to visit a home, I often asked to sit and view albums. Such a request is almost always viewed favorably. Albums show and bring into being social connections. They highlight the number and frequency of invitations, density of social relations, intensity of social circulation, and the fundraising and social support garnered to purchase clothing for and to pay for pictures documenting this social activity. Not only are albums

costly, but so are the social events that are worthy of photographs. A photograph involves more than just sitting in front of the camera—it entails particular ways of moving from place to place, such as by taxi rather than public transport to avoid crushing a beautiful outfit and to demonstrate the ability to pay for private transport. It also entails making one's way through the city with a particular rhythm as the result of wearing particular shoes, stacking bracelets that clink, and heavily starched fabric that swishes and swoops with the breeze, every step tempting the passersby to look up and take interest. Having a portrait done thus requires investments beyond just the cost of the photo, and the act of preparing for a photo also transforms the sitter into the most costly version of herself.

People would talk with me about how their portrait albums featured them as enmeshed in a network of relations. By doing so they were also teaching me how to look at photographs, not as documentary evidence, but as a strategy for building social life. They would describe a good album as *"diis naa,"* or heavy, referring to both its weight and importance, its many photos indexing the density of social connections constituted in and through ritual moments such as marriages, childbirth, and religious festivals and how the success of those celebrations depends on good albums. A good album with many pages could be just as heavy as paper itself, a bulwark against infertility and instability. Heavy was the heart of the owner of a light album. A cheap album was as light as its plastic cover and vinyl pages, prone to mildew and decay in seaside homes just like the marriages to spouses who crossed those seas. Similar to the massive exchanges of cloth at family ceremonies that resulted in folded stacks of wrappers contained in armoires, women held stacks of portraits they had swapped with newly married women and those who had become mothers; amassing and later displaying piles of cloth and photos were both ways through which women engaged in reputation-building. Rather than archives of the past, these albums, when done well and when attuned to their audiences, create social futures through their display and exchange.

People would also talk about how they evaluated people based on their albums. Joanna Grabski (2011) has discussed how Dakaroise are proficient at sizing each other up and speculating on the limits and possibilities of others, whether in the market or at a family ceremony or religious festival. Through these performances of looking and being looked at, of indexing this network culture through personal photographs, women seek out a *"retombées,"* or a payoff.[14] These photographs and the performances of respectability that they entail are like religious talismans holding the potential to be generative of something else. This one performance will pay off and attract other good things to them.

As an audience, one tries to parse the multiple poses of a single actor at the center of the album whose portrait appears over and over again and to follow her relationships to the supporting actors and the parts they play. The eye tries to trace the backgrounds, the participants, their clothing, their physical resemblance, and the photographer's composition to figure out the relationships. The narration is often punctuated with tea, juice, and maybe sugary beignets or Cape Verdean pastel, tuna enveloped in a savory pastry dough and fried. But then after refreshments, the album is picked up again and the story unwinds, although the owner often quickly flips to the highlights to obscure the occlusions.

Family albums sit at the interstices of idealized and normative forms and affective relations of kith and kin and the experience of family life, which is often fraught and fractured. Fatou Binetou Dial (2008) has commented on this disparity between the ideal and the real in the life of a marriage. Likewise, albums expose and resist the myth and the lived reality of family life, providing an image to aspire to (Hirsch 1997). These assemblages often base themselves in unrealistic and overbearing notions of what a family is or could be, displaying unrealistic opulence and relational harmony. Yet every woman seems to have an album if not an envelope of photos tucked away and brought out for visitors. It is as if many women would not have reason to visit or cause for conversation were it not for photos.

If most women in Dakar have spouses abroad in Europe, the US, or East Asia, many women in the rural regions have a spouse in Dakar or other regional capitals. Living apart for much of the year, or for many years, has long characterized marriages in Senegal (Buggenhagen 2001; Hannaford 2017). Such widespread migration contributes to the family in Senegal as being both powerful and vulnerable. This dichotomy is reflected in the surveillance of young newlywed women whose husbands have departed for work abroad (Hannaford 2017, 9). Scrutinizing eyes focus on wives and thus reflect broader concerns with social reproduction wrought by extensive, long-term migration of young men who return home as old men. Dinah Hannaford refers to novel arrangements in family life as emergent "flexible forms of kinship" (2017, 6). While abroad, migrant men and women often establish new relationships and partnerships, some resulting in marriage, that help them sustain their migrant lives. At the same time, they endeavor to support family and spouses at home.

The idea of family is powerfully threatened by the new relationships that many women take up in the context of these "missing men" (Melly 2011). Foley and Drame (2013) write about *mbaraan*, the relationships outside of marriage that resemble marriages of convenience. These relationships often provide the

means with which women create portraits of happy families, whether it is supplying fat handsome sheep to be slaughtered for feasts or new fabric for children's clothing on the holidays (Hannaford and Foley 2015). At the same time, many more women delay entering marriages altogether. Francis Nyamnjoh (2005) has remarked on the difficulty many women have faced in finding a good fish, or a suitable husband, at a time when employment in the wage economy, civil service, and agricultural fields has declined in the postindependence period. Through migration men find the means to marry, and when men are unable to migrate, women turn them away as potential suitors.

As Moussa Konaté has argued, a photograph contains a "multilayered message" (2012, 75). As much as albums can show the social possibilities and moral qualities of their bearers, they can also express inequality within the family, the neighborhood, and globally. I noticed that wealthier families kept numerous large-format albums with embossed frames setting off each portrait. They were also more likely to have family collections of studio portraiture from the middle part of the last century. Less well-off families, and those strapped for cash daily just to provide the afternoon meal, often pulled packets of faded photos from under a mattress, inside a drawer, or the bottom of an empty pocketbook. People appreciate pictures of themselves looking good because everyone knows the hardships that they are all up against regardless of where they are on the economic ladder. In their visual practices and use of new technologies, such as digital photography, social networking sites, and cell phone cameras, these urban spaces are progressive sites of inspiration and invention (Mbembe and Nuttall 2004). That creativity may often be both inspired and tempered by hard times wrought by a long history of encompassing global volatility (see for example Makhulu, Buggenhagen, and Jackson 2010).

A TALE OF TWO ALBUMS

In 2011 when I visited a family friend, Fanta, I was struck by what I saw in her photo album. Fanta lived in Khar Yalla, which was first settled by families who were forcibly removed when their homes in the center of the city had been demolished as part of the government's so-called "clean up campaigns" from 1960 to 1970. These homes were then replaced by middle-class housing for civil servants. Their homes were razed, and poor families fled to the outskirts of town. Over time, other families joined them, escaping conflict in Casamance and Guinea-Bissau as well as agricultural areas that—due to global warming—had become unworkable. Like other impoverished areas of Dakar, such as Colobane and Pikine, Khar Yalla shows the damage of economic volatility in stark terms.

Some homes tower over others as evidence of a family member overseas who has added new floors to the home; others sink further into the ground with each rainy season spent on this marshy land. Although structural adjustment plans, privatization schemes, and economic liberalization affect residents of the capital city broadly, poor residents feel it more keenly. Budgets are tight, and people live close to the bone. I have worked in Khar Yalla off and on since the 1990s, tracking its interconnected and multilayered infrastructures. For as much as Khar Yalla looks like a makeshift neighborhood where people make do, or *goorgoorlu*, it functions through improvisation and interconnection that depend upon creativity, strength, and social bonds.

When women pose for, display, and pass around portraits of themselves at key moments in their lives, whether in the medium of social networking sites or photo albums, they revel in pulling it all together and pulling it off as much as they conceal how they do it. When women successfully perform for the camera, they index their urban neighborhoods not as peripheral, but as central to the city at large and to the lives and imaginations of their families abroad. Women and men outside of these neighborhoods talk about urban spaces, and especially the *quartier populaire* of Khar Yalla, as noisy, unruly, and fraught spaces with vast inequalities and incommensurability. Yet it is in these neighborhoods that women and men actively shape and construct "social infrastructure" (Larkin 2013b; Simone 2004) vital to their well-being.

One can look at the circulation of portraits as a network, and an album, whether analog or digital, is a particular kind of network (Gilbert 2019; Kea 2017, 52). Where infrastructure may have broken down or be disorderly, or conventional forms of citizenship and belonging difficult to identify, these social networks provide a different view of urban life. Photography has come to reflect not only the changing fortunes of individuals and families but also transformations in the urban landscape itself.

Personal portraiture points to social infrastructure and the use of new technologies that connect where material infrastructure often disconnects. Photography can be a means through which self and social configurations are produced as well as social networks (Wright 2013, 12). Portraits viewed in new social and physical contexts undergo a semiotic process of remediation, gathering new meanings in new contexts. Brought out to share with visitors, a photograph may be a sign of success; packed in a suitcase prior to traveling, it may cement a commitment to home.

Whatever the setting, portraits generate interest and desire, which attract attention or uptake. As Brian Larkin describes it, following Michael Warner (2005), such uptake is key to the process of creating a public (2013a, 239). In

Senegal, that means portraits do not just reflect, but also shape, women's lives and reputations. The manners in which women sit for, view, discuss, and share portraits help determine when uptake happens and when it does not, and the results can bring honor or shame upon the family.

I was visiting Fanta just after the birth of her first daughter, so I expected she would eagerly offer to show me an album of photographs from the baby-naming ceremony, which takes place seven days after the baby is born. During previous periods of fieldwork, I had seen countless albums in family rooms in Dakar filled with commercial photography that featured elaborate cutwork, multiple exposures, and artistic photomontages.[15] I remembered one album, from a family in Noire Foire, a middle-class suburb near the old airport. It was a creamy, winter white, leather-bound album, so large that I had to set it in my lap and use both hands to turn the pages. It held mainly 8" × 10" portraits of the bride in gold-embossed sleeves. The sitter was portrayed in numerous ensembles and various poses. Her face was glowing from the photographer's skillful use of lighting. Given Fanta's family's economic situation, I assumed that the baby's naming ceremony might not be documented so lavishly, but it surely would be a similar source of pride. But it was only after I asked to see her album several times that, in a barely audible voice, she asked a younger relative to retrieve it for me.

Fanta's album was slim, vinyl, and clammy to the touch, with a plastic window on the front that was a cheap copy of the embossed, gilded frames I had seen on other cameo albums. It was also narrower: the pages were as wide as a 4" × 6" print rather than the pages of fancy albums that were double the width. The photos were covered in puckered plastic, and they showed a linear progression from marriage to motherhood. As I looked through it, a quiet fell on the other family members in the room. Some looked away toward the television, and some left the room altogether. Ever conscious to learn how people looked at photographs, their unwillingness to look led me to set my camera gently on the floor. At this point I thought that photographing the album would feel as if I were making light of Fanta's clearly difficult situation. The silence caught me off guard as well since once I opened the album not one person spoke to break the expectant silence that accompanies the showing and performing of the album.[16] Although women may initially be silent when they view an album, they usually quickly begin to point out particularly beautiful ensembles, explain the relationships between the people in the photos and the album's owner, and reminisce over the depicted events.

I turned the pages, which contained simple frontal shots of Fanta and her family in 4" × 6" prints. The sitters were often shot against the exterior wall of

the house or seated on a couch with a blank wall behind them. While these could technically be called portraits and not snapshots, they lacked the glamour of the former and had all the faults of an amateur hand that mark the latter. Skilled portrait photographers know how to create angled, bust portraits with a three-dimensional presence, but these pictures were shot as full frontals—an angle that people associate with identity cards and other documentary forms. Several of the photographs had been printed on cheap stock paper with a simple red rose at the edge or a scroll. There were a few other images including a picture of her mother shaving the infant's head at the naming ceremony and a group shot of the men assembled there. But there were few poses of Fanta with kith and kin, and all in all, the pictures did not create a convincing visual argument of a stable family, let alone a social ascent.

The stark documentary style of the album conflicted with what I knew of Fanta, who had been an active, or *"sob,"* five-year-old when we first met in the spring of 1992. She remained youthful, edgy, and sometimes a bit shameless—an engaging, vivacious presence. But these photographs portrayed a woman who might very well go unnoticed at a social event. The album was, however, consistent with the developments in Fanta's life over the past couple of years. In separate conversations, her family members described her marriage as *jaffe*, or difficult, because "Fanta? She got around" (*bare na dox*). Fanta was somewhat of a *disket*, a young woman who likes discos, fashion, and parties.[17] Some families will swiftly marry off a girl whose modesty needs protecting, and Fanta's experience fits that pattern. Her mother and her husband's mother had arranged Fanta's marriage by showing portraits of her to the groom, a member of the Murid Sufi way who had migrated to Barcelona seeking work in Spain's shrinking construction industry.[18] He was a distant relative on her mother's side, even though, for Wolof, the preferred relation would be to marry a father's brother's son. After the 2012 mortgage meltdown in the US reverberated globally, his working conditions were increasingly precarious, and he suffered financially.

Their newlywed life was turbulent. Fanta was never brought into her husband's compound, an essential stage in the marriage process. Rather, she remained in her parents' home. Her siblings told me the baby had been born while her husband was absent. The *ngente*, or baby-naming ceremony, had taken place in the morning, without the customary afternoon gathering of women exchanging gifts of cloth. Therefore, only the strictly Muslim practices had taken place—the bare necessity to ensure a blessed life for the infant and to protect her—and the wider community of women had not gathered for her. The thin album reflected these fractures and left me wondering about the state of her relationships. Was her husband absent from the festivities because he was still

working construction in Spain, or had he disappeared in a more fundamental way? Or was it Fanta who had strayed?

Albums like Fanta's often work to repair the breaches wrought by migration. When husbands are absent for long periods of time, and with men rarely being much of a presence at family ceremonies anyway, portraits of in-laws—especially a husband's sisters[19]—can stand in for men's presence, as signs of meaningful bonds between the families. Such photographs make social entities like the family or nation tangible, "helping to produce the effects they appear merely to record" (Strassler 2010, 4). In Fanta's case, her album should have worked not just to document but also to create, her standing in her family and wider community as a stable, married woman. Instead, her husband's family seemed absent from its pages. Empty sleeves, which would normally have held their pictures, spoke volumes.

Fanta explained that she had commissioned the photographer to record her baby-naming celebration and to put together the album for her after the event. Pointing to the empty sleeves, she added, "I gave some photos away after" (*Maay na ay photo après*). Women often swap 4" × 6" portraits of themselves with their close friends by removing them from their album sleeves—but they then replace the empty spot with a friend's portrait. It is part of a broader process that generates uptake and cements affective ties (Larkin 2013a, 241). Since sitters gaze out of a picture looking directly at the viewer, when women swap portraits with each other, these gazes extend to new places, becoming part of new circuits of exchange that knit together families and social circles. Like the albums filled with *cartes-de-visite* of famous figures, these albums show proof of connection and mutual esteem within a community. Through commissioning or making their own albums, and showing and narrating their contents, women index social networks and make them visible to other audiences. Rather than merely preserving family histories, these photo albums create and expand those histories. Fanta's photo album, though, reflected how her marriage had broken down. She may have tried to expand her social network and spark new relations by giving out pictures, but she received few pictures in return, and these were mostly from her immediate family. This lack of uptake related both to the meager resources her spouse sent her and to her in-laws' hesitation to invest in her.

As Fanta and I viewed her album, her narration seemed to reflect a desire to affix positive meaning to the images. Viewing her album and listening to her describe the portraits it contained shows how the relationship between "discursive formations and image worlds" (David Freedberg quoted in Roberts et al. 2003, 22) is ever shifting, allowing for the "transformational potentialities" and "volatility" of photographic practices (Pinney and Peterson 2003, 6).

Rather than describing the events or their place in time, such as "and then I was married" or "just after I had the baby," she constructed a visual argument for her social acumen. She described her outfits and their origins, saying "and this is the ensemble my aunt gave me," and "this is the ensemble my in-laws provided." Fanta pointed out the three different outfits that she wore during the baby-naming ceremony, a modest number given that well-off women often chose five outfits. Each dress was made from ten meters of locally dyed, manufactured cloth known as *bazin*. I told her that I thought the ensembles were "beautiful" (*rafet na*). In response, she retrieved a woven wrapper, *sër-u-rabbal*, comprised of six bands of cotton cloth sewn together. It was not visible in the portraits, which were three-quarter bust shots, but she explained that her mother's sister gave her the wrapper to commemorate the birth of this first child. The wrapper was woven with a highly saturated cotton thread the color of eggplant and with silver Lurex thread.[20] It was the first of many such wrappers that a woman aspires to accumulate and redistribute during her lifetime during baby-naming ceremonies, weddings, and funerals. Photographs resemble such cloth wrappers, which are wound around women's bodies with decorative care, since both cloth and images are gifted and regifted, binding friends and family together. Fanta drew on both the wrapper and the photographs to construct a narrative of reciprocal relations, so that I, as the viewer, would still place her in her desired social context. Yet it was clear that her album reflected the fragility of her marriage and the uncertain future of the bond between the families.

When we finished looking at the album, I asked to interview Fanta's photographer, hoping to see comparable work. Both Fanta's niece and her sister-in-law, Amina, who was married to Fanta's brother, had remained in the room, and they replied to my question in unison, "leave it" (*baay ko*), to indicate that I should let the subject drop. This is a phrase I had heard many times, and it meant that it was time to pull back or retreat from a line of inquiry. I understood not to inquire further: the marriage process and the baby-naming ceremony had been modest affairs, given the fraught nature of Fanta's marriage. I surmised that the family was pointing me toward more successful unions and celebrations; events that brought them more joy and pride and that better reflected their desired social status. The fact that Fanta's niece and Amina then directed me to a different set of photographs hammered this home.

Unlike Fanta's photographer, they said, Amina's photographer, Alpha, did work that was "good" (*baax na*). They told me that many commercial photographers rent their cameras, but Alpha had his own, and had acquired a studio space in Khar Yalla where he took pictures against various backdrops featuring tropical themes and silk flowers and offered a panoply of props to his clients.

This setup was a sign of his success, although Fanta and Amina added that such practices were old-fashioned (*démodé*, or not *xewwi*, meaning "hip")—they were what older men and women and new migrants to the city might choose. The young women preferred to have their photographs taken against the backdrop of their own living room to show potential audiences their handsome things, "like furniture, curtains, and lamps" (*meubles yi, rideaux yi, lampe bi*), said Fanta as she pointed around the room and explained that her brothers had purchased many of these items after going abroad. Fanta had told me something similar just after her marriage in 2009: "I would never have my picture taken in a photo studio. Everyone would know that backdrop was full of studio props. In my home, everyone knows that the items belong to me."

Fanta's view corresponded with what I had noticed over time, viewing many other albums in my interlocutors' homes. The skillful arrangement of the body by the photographer has become less important than the backdrop of the home. In Khar Yalla, clients have become more concerned with capturing the contexts in which the photograph is taken to instantiate their social positions. For example, women returning from the religious pilgrimage, the Hajj, also most often had their portraits staged in their homes to show their exalted status and demonstrate their good fortune. After all, many of the valued objects owned and displayed by women were the product of complex social networks and negotiations of buying, borrowing, and gifting. A photograph could index a woman's social sense or skill in managing social relations and acquiring new things. And yet, in Fanta's own album, blank walls dominated as backdrops in her portraits rather than richly appointed rooms with objects that could be counted on to define her social trajectory. The absence of the richly appointed room that would have added texture and depth to the portrait, that would have showed who she was, pointed to the lack of skill of the photographer that she was able to afford.

Amina climbed the stairs to her room and returned with one of her albums, explaining to me that many women might have as many as three albums to hold photographs of their first child, but that with subsequent children, there might be less effort and expense dedicated to documenting this event. She handed me her wedding album, and I realized that its weight required both of my hands to receive it. She laughed and asked, "Heavy?" (*dis naa*). The leather-like, bound album was smoother and more enticing to the touch than Fanta's, with inset pages that created frames embellished with golden lines and curlicues that highlighted the value of the portraits they set off. It contained 8" × 10", 5" × 7", and 4" × 6" prints, with a dizzying array of cutwork and signage. Such techniques, along with repetition, multiple exposures, and photomontage,

have been hallmarks of Senegalese portraiture since midcentury (Behrend 2001; Buckley 2000), when photographers would often reproduce and collage together many copies of the same image, or would manipulate the surface of a print with a razor blade. Nowadays, digital manipulation can achieve similar effects. Wedding albums often feature images of the bride or of the bride and groom with romantic sayings and motifs such as hearts and flowers cut into the surface of the printed image with a razor blade. That such techniques were visible in Amina's album showed the skillful hands of a photographer, as well as her own good social standing that allowed her to afford a skillful photographer.

Almost all the images were taken at her in-laws' home, where she now lived with her husband. There were three-quarter bust portraits focused on her face and shoulders, with lighting that illuminated her skin against a backdrop of heavy curtains, velvet upholstered couches, and silk flowers. Single frames included double and multiple exposures of Amina. In one, there were seven reprints of the same portrait of her arranged in a montage. As we turned the pages, Fanta's niece said several times "Hey you, Amina, you are elegant!" (*Waay yo, Amina, danga jekk!*) There were similar poses with sisters and sisters-in-law appearing singly and then in multiples as though they were looking through a disco ball or a set of mirrors. Sometimes they appeared in symmetrical oppositions, and on other pages Amina was at the top of a hierarchy of repeating images. These fancy photos showing the artistry of the photographer would remain in the album. There were also single portraits of Amina in various poses that I had learned were common among Dakar women, such as squatting with her chin on her hand and lounging on a bed. These are the portraits that might be taken out and exchanged. There were also full-length portraits of her taken as though she were walking into the room, adding a sense of movement to the static image.[21]

Amina had lived across the street from Fanta's natal home and had married into Fanta's family before she was twenty years old, protecting her propriety. Both families were invested in the success of the marriage. Her husband had built a suite for her in his parents' home so that she had both privacy and prestige, as well as the support of the larger household in carrying out mundane tasks like cooking, housework, and childcare, thus ensuring that she still had time for social activities. Since her marriage, Amina had given birth to several children, two boys and a girl. Unlike many of his older brothers, who had gone overseas for work, Amina's husband remained with her in Dakar, managing his older brother's tile shop.

The investments that Amina's husband, his family, and her own family had made in her were all on view in her album. Her photographs were a performance

of selfhood and community, as well as an attempt, as Christopher Pinney has described in his work on Indian portraiture, to "come out better" (Pinney 2003, 218). Pinney describes personal portraits not as a window on reality, but as "a ground on which presences that look out toward the viewer can be built" (Pinney 2003, 219). Indeed, every time Amina brought out her album to show to a visitor, she augmented her reputation of not only being well-off and well cared for but also being able to care for others on future occasions. Not only did the rich and plentiful photos suggest her wealth and deep social connections, as did the leisure time she had to share such albums with others, but the social status they created suggested that she was a person who could invest in relationships herself. To ensure that this impression would remain, she might offer to give her viewer one of her photographs as a memento. The multiple images of herself were the product of, and the potential for, abundance. Whatever new contexts in which Amina's portraits might be seen, by virtue of being placed in her friends' albums, it would be hard to imagine them being taken as anything but a sign of her standing in her family and community.

Even though Amina's album revealed a more fruitful marriage and set of social relations than Fanta's, I did not feel comfortable asking to photograph it, since Fanta was still in the room. My initial idea, to take photos of photo albums and analyze them, seemed so flat in contrast to the rich stories that the albums produced. But perhaps this is the point, to focus not on the documentary power of photography, but on the stories told around photographs. My camera was left sitting on the floor as the albums were quickly whisked away. In conversations that I have had with Fanta since 2011, I learned how very shaky Fanta's marriage was. She confided that she had tried to exit it several times. She told me that she struggled with the idea that marriage was the only path to social respectability. If Amina's album helped her, and her marriage, "come out better," Fanta's album, in a sense, was her marriage. Portraiture has as much to do with neglect, despair, and the attempt to conceal inequality (see for example Poole 1997) as it does with love, beauty, and success. Fanta's album conveys this point.

Commercial photographic practices reflect and remake the changing fortunes of young urban women in Dakar's peripheral neighborhoods. Popular photographic practices aimed at coming out better point to the precariousness of sitters, their finances, and their sense of the prospects for the future. After all, when men and women work abroad and send remittances home to family, the means through which they make a living tend to remain unseen. In Dakar's varied urban neighborhoods, wealth and the images of wealth have become distorted. Personal portraits may present wealth, or merely its image. As such, they speak to the promise of prosperity, a promise that is associated

with transnationally connected urbanity, but that is often not delivered. Yet, this promise, rather than the actual transfer of wealth, is often sufficient to fulfill the expectations of families and friends. Thus, through successful portraits women can connect to other women who hope to become the recipients of their future gifts, even when those gifts often do not, or cannot, materialize.

Photographs, as valued objects and elements of visual culture, both mediate and create meaningful links between subjective experience and encompassing economic changes. They help young women such as Amina and Fanta make sense of, and make do with, the vast disparities on display in Dakar, including inequalities in wealth, in Western and Muslim education, in access to technology and media, and in opportunities for work. Photographs enable Senegalese sitters and viewers to create meaningful social worlds despite the financial troubles they may experience. The production and circulation of personal portraits and family photographs aims to capture and project images of happiness, luck (*warsek*), and religious grace (*baraka*). Residents seek to create and remake their social and moral personhood in tandem with these changing times. Their portraits succeed when they bridge the gap between what they see and what they experience, between themselves and others who are coming out better, between what they desire and what life has dealt them. Whether displayed on a wall or in an album, shared on social media, mailed, or carried across continents, portraits—themselves the product of collaboration between sitters and photographers—create value and cement relationships, offering a sense of stability, however temporary, amid the flux of contemporary life.

NOTES

1. In contrast to Indonesia and Japan (Strassler 2010, 102).
2. For further discussion of the Sahel drought and famine, see Meillassoux 1974.
3. This happened when Nikon was releasing early D-series (e.g., D60) and Canon was producing early Rebels. I am grateful to Richard Powis for this observation.
4. Boubacar Touré Mandémory, personal communication, December 2011.
5. Mame-Diarra Niang, "Dak'Art 14: These Landscapes are Extremely Contemporary," *Contemporary And*, accessed December 11, 2014, https://contemporaryand.com/magazines/these-landscapes-are-extremely-contemporary/.
6. Compare for example with Susanna Fioratta's 2021 ethnography of Peul migrants from Guinea who are rarely successful migrants.
7. Djibril Sy, personal communication, December 2011.

8. Djibril Sy, personal communication, December 2011.

9. Published in Allen F. Roberts and Mary Nooter Roberts, "The Visual Performative of Senegalese Sufism," in *Practicing Sufism: Sufi Politics and Performance in Africa*, ed. Abdelmajid Hannoum (New York: Routledge, 2016), 175–208.

10. Compare to Okiek circulation of photographs in Kenya (Kratz 2012, 250).

11. My thanks to Richard Powis for this observation.

12. Compare with expectations of photography in the Solomon Islands (Wright 2013, 63).

13. For further discussion of the sensory and affective dimensions of photographs see Elizabeth Edwards 2012, 228.

14. See also Grabski 2011 for further discussion of the idea of payback and Dakar as a network culture.

15. Liam Buckley (2000) has collected some of the most skilled examples of such work pre- and post-darkroom in his piece "Self and Accessory in Gambian Studio Photography."

16. For further discussion of silences in photographs see Edwards 2006, 38–39.

17. I am grateful to Richard Powis for pointing this out: "Disket can be a category of physical shape/figure (falling between *agneau* and *drianke*), or it can be a ranking of her beauty (as in, she is a *dix sur dix*), or both."

18. For discussion of matchmaking by photo ("se marier a photo") in Senegal during the service of soldiers in the colonial territories see Bajorek 2020, 93, and more recently for comparison in Mali see M. Konate 2012, 80.

19. One of the husband's sisters is often given the honorary title of *njëkke* meaning "female husband" and enters into a special relationship of rights and responsibilities with her brother's wife. I am grateful to Richard Powis for this observation.

20. Lurex is the trademark name of a dye-resistant machine-made metallic yarn produced in Leicester, United Kingdom.

21. I have not included images of these albums to protect the identities of the two women.

FOUR

IBRAHIMA THIAM'S VINTAGE PORTRAITS

"THE NEW CAMERAS," PHOTOGRAPHER Ibrahima Thiam said during one of our conversations, "killed photography." Thiam went on to describe how photography became more accessible to everyone over the last century, a process that others have referred to as the democratization of photography (Bajorek 2020). This change was wrought in part by new photographic technologies, especially digital cameras, but also by new platforms for viewing and sharing images such as social media. Thiam worried that the selfies young people like his nieces posted on social media platforms offered a different register of social exchange than the swapping of album portraits across living rooms in Senegal. Although performing for the camera and swapping portraits from albums memorializing these performances remains a vibrant social practice especially for women, Thiam felt that the younger generation did not appreciate their photographic heritage largely rooted in studio portraiture.

It was this perceived lack of density of social relations not just across age groups but across generations reflected in the lack of connection to these family photographic collections that motivated Thiam's approach to his work. Several of his photographic series address the disconnect that he sees between Senegalese interest in the visual and their lack of interest in photographic patrimony whether it be national or family collections. Through his art, Thiam encourages young viewers in Senegal to recognize connections between early photographic materials, vintage portraits, and digital selfies. As he explains, "You used to learn many things from photography—history, and several other aspects—compared to today's digital photos. Testimonial objects could teach us anthropology, history, and society."[1] Thus, Thiam has set out to help young

Fig. 4.1 Ibrahima Thiam, *Clichés d'hier, Saint-Louis* (Pictures of Yesterday, Saint-Louis). Photographic installation at the tenth edition of the Bamako Biennale of African Photography, 2015. *Photograph courtesy of Ibrahima Thiam.*

people to see what he sees, and to share his appreciation of how portraiture has the potential to enlarge the person as he had learned from his grandmother.

Through this work, Thiam reenergizes and reconfigures portraiture in Senegal. By circulating vintage portraits and encouraging his sitters to engage with them in ways that evoke feelings and sentiments, he pushes viewers and subjects to rethink the past, including the importance of these photographic traditions, as well as their own futures. In doing so, he illustrates the dynamic nature of portraiture, expanding its frame by combining analog and digital, experimental and documentary, seen and unseen, all while working across time and space. His use of vintage photographs in his work and the way he invites sitters and viewers to dynamically engage with these images also calls into question archival practices, suggesting alternative ways of memory and making meaning about the past.

These themes are illustrated in Thiam's series *Clichés d'hier, Saint-Louis* (Images of Yesterday, Saint-Louis). In this series, he reconstructs a mid-twentieth-century Senegalese portraiture studio, thus bringing attention to these heritage

issues. The installation invites audiences to step into the space lined with black-and-white checkered vinyl flooring, immerse themselves in the three white walls of a studio, and come face to face with original vintage prints from his collection—portraits of men and women, including siblings, co-wives, and neighbors—that he has hung at eye level. Thiam created this installation for the tenth edition of the Biennial of African Photography in Bamako in 2015, a biennial that is for Malians and other West Africans as well as outsiders, given that it is ultimately sponsored by the French. One can imagine that it is both African and European audiences that Thiam seeks to engage with his questions of what a photograph is. Is it the singular vintage print, its meaning drawn from its original size, quality of paper, talent of the photographer, and social context for which it was commissioned? As we have seen, such portraits intended to be held in the hand have historically been the outcome of and the medium for constituting dense social networks that are of value to many Senegalese. His installation displays these small album-sized prints in direct contrast to the color-soaked, large-scale digital prints that now populate such exhibitions of contemporary photography.

Although the vintage prints that hung in his installation were of unequal dimensions, some destined for albums and others to be hung on walls at home or in a studio, Thiam created unity among them by placing them behind black mats and within square frames of uniform size. He hung them at eye level in four rows, in a checkered pattern like that of the floor, thus emphasizing sequencing, connection, and spacing. The images' placement seemed to speak to the movement of bodies through the course of life, a progression that is often not linear. By being sequenced in this way, the arrangement also conjured time as in the history of photography or the history of migration, which forms a central, collective experience of moments of presence and absence. As the viewer's eyes moved from photo to photo, the sequencing also illustrated the way that photographs capture some moments but not others.

The arrangement also suggested an ongoing relation of presence and absence, with squares alternating between photographs and empty spaces. The installation thus suggested the ways in which people move in and out of each other's lives over time, demonstrating how social networks can be simultaneously resilient and fragile. These gaps might also suggest a collective lack of knowledge, which is reflected in an archive that is always incomplete. To emphasize relationships among the sitters, Thiam often shows his portraits as a collection, like a strip of film negative, a contact sheet (a positive print of all the images from a roll of 35 mm film, or medium-format film), or perhaps even a magazine page pulled from a 1950s issue of *Bingo*, which Thiam has collected.

Thiam framed the vintage prints in squares of black to create a pattern of uniform size. Through the use of square tessellation, Thiam created four squares around the portraits hung in the second and third rows. In so doing, he created relationships among the sitters depicted within them. These relationships recall the displays that, in a front window, might entice potential customers off the streets and into the studio space, or, in the studio space, might inspire sitters to choose various poses. But they also suggest the common displays of portraits in homes throughout the twentieth century, which demonstrated connections of kith and kin. These displays initiated visitors to the home and into the set of relationships in which residents were enmeshed. More particularly, Thiam described his installation as an effort to replicate yet another practice of display: xoymet, the gathering, borrowing, and temporary hanging of portraits during the matrimonial process. In each of these settings, photographs both suggest and create relationships and community across time and place. Thiam's work continued those relationships and commented upon their creation.

While relationships remained central to his installation, the idea of photography remained central for Thiam. "This is a visual archive," he said, describing the work. While a photographic studio would have been painted in bright colors, jammed with props, and filled with patterned textiles that might have served as backdrops, Thiam decided to make the space in black and white. The experience, he explained, was more like walking into a black-and-white photo of a neighborhood studio rather than into a neighborhood studio itself. "They are photogenic colors," Thiam said. "Black generates whites. It is in a darkroom that a photo is printed out."[2] In other words, even as he was inviting viewers to enter the past, he was reminding them that their access to that past was mediated by photography itself—and that, even though he was presenting a three-dimensional, sensorially rich installation, he saw it as related to the work of photography.

With the black-and-white checkerboard pattern reinforcing a sense of depth, Thiam's installation transformed the printed portraits from two-dimensional to three-dimensional objects, part of an immersive sensorium for viewers to enter. The photographs became objects that people could view from different angles, while the reconstructed studio created the experience of traveling through time surrounded by these figures. The studio's three walls replicated the three-dimensional form of life and its past, present, and future, and the photographic forms within it introduced the notion of permanence in tension with the impermanence of life. While these images preserved people from the past, they also suggested to viewers that many of these people had passed on. In this installation, time, story, and life did not just exist as independent realities

for viewers to experience passively. Instead, the photographs and the people who gazed at them together created meaning, in relation to one another.

The checkered pattern on the walls and floors of the installation also suggested a textile draped across the body. West African textiles often feature checkered patterns created by sewing bands of narrowly woven strip cloth together or through the process of resist dyes. In Senegal, these strip-woven cloths are used as women's wrappers, baby blankets, and funeral shrouds, thus following bodies through the cycle of life (Buggenhagen 2012). That Thiam's geometric installation drew on textile techniques is not surprising given that his grandmother was a textile dyer. Pieced squares are also used to create patchwork clothing that holds significance for disciples of the Murid tariqa, the branch of Sufi Islam to which Thiam adheres. Their founding figure, Amadou Bamba, exiled by the French to Gabon, is said to have pieced together his garment, patching and repairing it while refusing new clothing until he could return to Senegal. He did so to demonstrate his detachment from this world but also to embrace the spiritually protective properties such patchwork garments are thought to offer.

Although the installation *Clichés d'hier, Saint-Louis* was built within an exhibition space, Thiam did not follow standard museum protocols for displaying photographs. Gallery and museum curators abroad have tended to isolate, enlarge, and display pristine reprints from original negatives, including those of photos by the now-famous Malian photographers Seydou Keïta (1921/3–2001) and Malick Sidibé (1936–2016) (Bigham 1999; Keller 2021; Moore 2020). Curators tend to reprint these images that were intended for photo albums as the large-format prints popular in contemporary photography. This practice has also been common on the gallery walls of the new Museum of Contemporary Photography (MuPho) opened in November 2018 by the collector Amadou Diaw in Saint-Louis. The MuPho's permanent exhibition features large-scale reprints of portraiture from Senegalese photographers who were active in midcentury Senegal. While the MuPho represents the growth of new spaces for preservation, curation, and exhibition of photography in Senegal, it also replicates gallery and curatorial practices popular in Europe and the US, raising questions of the audience. The large scale of the reprinted portraits clearly appeals to the aesthetic expectations of Euro-American audiences.

In contrast, Thiam's *Clichés d'hier, Saint-Louis* replicated local histories and aesthetics of portraiture practices across West Africa. This installation featured original vintage portraits in their actual print size as they would have been displayed and shared in the past so they could be appreciated anew by audiences at the Bamako biennial. By placing these portraits in relation to one another,

Thiam demonstrated the networked relations that often underpin family collections, relations that are cut off when an object is displayed as a singular example by a museum. Within these collections, objects are composed of relations and thus rather than things, these objects are processes (J. Bell 2017, 245). By combining collection and exhibition in the same frame, Thiam created tension for his viewer about the opposition between object and process as well as the politics of exhibition while conserving photographic patrimony and communal memory. Thiam seemed to be suggesting that the photographic patrimony was bigger than the photographs themselves. Preserving Senegalese photography would not just mean protecting images but also preserving practices of display, communal memory, and collective meaning-making. Thiam worked to do both in this exhibition, showing audiences new forms of preservation and suggesting that such practices do not have to be confined to the archives.

Furthermore, in bringing elements of his personal photographic archive out and displaying them in exhibitions, Thiam questions how archives keep patrimony out of circulation for the sake of preservation. Thiam says that he does not want to see these photographs buried in the archive or held in "incarceration" as described by Okwui Enwezor (2008, 40). He contends that their preservation on the Continent depends on their circulation so that his compatriots develop an appreciation for this patrimony. Thiam's broader oeuvre involves exposing his fragile prints to light, air, humidity, and dust. In some of his portraiture practices, he encourages his sitters to handle the prints without gloves. These practices challenge conventional curatorial practices regarding preserving photographs in archives and museum collections.

Beyond questioning archival practices, this exhibition and Thiam's larger oeuvre also expand the frame of portraiture with his photographs that are at once analog and digital, Islamic and pre-Islamic, seen and unseen, experimental and documentary, aesthetic and conceptual, vintage and contemporary. Thiam upends art historical categories and periodization of modern, contemporary, and popular by holding these classifications in tension within the same frame. By displaying vernacular portraits in an exhibition of contemporary art, Thiam challenges the framing of art as that which is in the museum, not outside of it. As a recreation of a commercial photo studio, the installation might be more like an exhibition one might find in an ethnographic museum, which often features immersive, experiential exhibitions in a historical context. And yet, as installation art with its clean white walls, *Clichés d'hier, Saint-Louis* is also conceptual, experimental, contemporary art.

Through circulation and sensory engagement with these photographic objects, Thiam reenergizes portraiture in Senegal, which he views as key to

involving Senegalese in preservation efforts. His portraits represent figures who were forces of life, and their portraits are charged with that force. By encouraging his viewers to walk into a recreated studio or, in another photographic series, *"Portraits 'Vintage,'"* to handle and pose with vintage portraits, Thiam relies on the potentiality of these photographic objects to move his viewers to think differently about the past and objects as representations of it and thus themselves and their own potentiality.

Thiam is also one of a growing number of African artists, including Sammy Baloji, Mohamed Camara, Saïdou Dicko, and George Osodi, who are engaged in critical self-imaging or self-representation (Strother 2016) and reengaging with photo archives and their colonial histories (Nimis 2014a, 557). These contemporary artists who work in the medium of photography are like family archivists, the women who frame and reframe personal and collective histories for audiences in Africa and its diaspora. The photographic work of these artists offers a window into seeing how communities view themselves and wish to be viewed by others. These contemporary artists draw on popular visual practices across the African continent and in the diasporas from prom photographs to party pics to family albums.

Contemporary lens-based artists like Thiam push the boundaries of portraiture in new directions, redefining the genre as well as asking the fundamental question: What is a portrait? Is it a likeness, a fantasy, a talisman, a social network? In *Clichés d'hier, Saint-Louis,* Thiam turns to installation to create an affective connection to these vintage prints that one must step into the studio to experience. Thiam's exhibit reflects how the original sitters might have displayed their portraits themselves and seeks to replicate that experience for the viewer. In so doing, Thiam stimulates curiosity about portraiture's past for a younger generation more drawn to making short-lived selfies. He does so by stretching the boundaries of what portraiture can be.

Newer approaches to portraiture move away from likeness or telling a social biography as a defining criterion. Where portraiture in the African context has been discussed as "illusionism," "resemblance," or "likeness,"[3] novel approaches also move beyond these theatrical and documentary practices (Strother 2016). These inventive approaches have been redefined as *experimental* portraiture (Cohen, Colard, and Paoletti 2016). Whereas documentary and staged portraiture converge around questions of representation, self-representation, and identity, experimental portraiture may move beyond them. Thiam's work holds these movements in tension; his work is simultaneously documentary and experimental. For example, in this installation, Thiam both chronicled the social fabric of photography and also used photographs to show that the

art of photography lies not in its documentary quality, but in images' relationships to other images and their materials, both of which deteriorate and can be repaired. In *Portraits "Vintage,"* Thiam further experiments with new genres of portraiture, questioning likeness as a criterion for self-representation by obscuring his sitters' faces in favor of their hands. In other series, he captures the distorted reflections and the backs of his sitters, blurring the boundaries of the photographic and the sculptural. In this way, Thiam pushes the boundaries of portraiture by calling into question the representational function of and aspirational character of West African portraiture.

DEPTH OF FEELING: BETWEEN ART AND ARCHIVE

Ibrahima Thiam describes himself as an autodidact. Originally from Saint-Louis, he descends from a family of artisans of blacksmiths and fabric dyers.[4] Explaining, "I have grown up in a family that deals in manual jobs,"[5] he described how his familiarity with blacksmithing tools and processes sparked his interest in cameras as tools for photographic processes.

"Photography was always one of my childhood passions," Thiam says. "Growing curious about relics of the past, I immersed myself in family photo albums from an early age." His grandmother collected portraits, and, he explains, "When she saw that I was interested in her collection of prints, she offered me some and I bought others from acquaintances."[6] He sought photos from his family, and, as his interest in preservation became clear, other members of the community often brought photographs to him directly "to safeguard them." He took this role seriously, explaining, "After viewing, I retook the photos and kept them. I never wanted the photos to get lost or let people take them away carelessly."[7] Photographing photographs creates a digital file for preservation and safer access; photographs can be viewed in digital form and shared without risking damage to the originals.

As Thiam noticed the lack of care and consideration some people gave to old photographs, he became more interested in collecting and preserving them for himself. He explained, "At some point, I would preserve the photos well. I would put the photos away and safeguard them. From time to time, when I did not go to school, I would contemplate the photos. I took around eight photographs of my parents, brothers, and me to preserve them." He grew to appreciate the larger project of preserving this cultural patronage for himself and others. Thiam continued, "When we were about to move from Saint-Louis to Dakar, I realized that the photos were dispersed. I asked my mother if I could take care of them. She agreed. Since then, I have kept the photos on me." In

time, he also began to purchase vintage prints to prevent their acquisition by art collectors elsewhere, and to undertake research in official archives. That opened new questions for Thiam. For example, in chapter 2 I discussed how he grappled with a portrait of his grandfather at the 1889 Exposition Universelle in France that he found in an archival collection in Senegal.[8]

Over the past eighteen years, Thiam has amassed a significant collection of Senegalese photography. Although it represents a rich slice of renowned photographers from Senegal, numerous photographs show signs of deterioration. In describing the condition of his collection, Thiam points to discolored paper, curled or frayed edges, creases, water stains, and yellowed marks from the glue that was used to attach photographs to pages of albums compiled by commercial photographers. Others would see these elements as detracting from the quality of the vintage prints, but for Thiam, these imperfections are valuable, because they show that the photographs had a rich social life before they came into his possession. An important piece of collecting for Thiam is not only preserving the photographic objects themselves but also understanding the social relationships that produced them. Those social relationships, which involved the handling and sharing of portraits, led to their deteriorated status.

Thiam's collecting practices reflect his awareness of the artistry of the photographer, the self-presentation of the sitter, and the role of the audience who would gaze at, and create meaning with and around, photographs. His appreciation for photography grew, he explains, as he realized that it could help him understand social relationships. "At home in Saint-Louis, when we had guests or visitors, my mom would ask me to bring the photo album for them. I was very pleased. I would see myself in the album and my mom. I liked the fact that they introduced people to me via the pictures. 'This person is X. This one is no longer here.' I was very happy."[9] Thiam's sentiments regarding his collection point to how scholars have argued that photographs can be viewed as a "form of extended personhood, in that they constitute a sum of relations over time" (Smith 2003, 11) and that the relationship between persons and things is a social one (Geismar, Kuchler, and Carroll 2016).

Viewing these photos with his mother helped to incorporate Thiam into his family and make him aware of his social relationships. "I tried to decipher the feelings of those figures that were frozen on yellowing paper, people who had been part of my family,"[10] said Thiam. In employing his own collection in his portraiture and installation work, Thiam relies on his own sensory memory, recalling how photographs moved him and meditating on the power of photographs to go beyond representing relationships of kith and kin to evoke particular feelings.[11] His practice reminds us that the circulation of photography

in social life must be understood not just visually but also via other physical responses such as laughing and crying, or being moved to speak or hold a photograph more closely to apprehend it. This social process can be discursive and rooted in language, and it can also be embodied and expressed in other registers such as gestures, scents, sounds, textures, and so forth. Consider a story that Thiam talks about bringing out his family's albums to one of his aunts visiting Dakar:

> Here in Mermoz, [a neighborhood in Dakar] when we received guests from Saint-Louis, my mother would say 'Ibrahima, please bring the photos for our guests'.... One day, one of my aunts came to visit us. She is over fifty years old and now lives in England. After lunch, in our conversation, I felt the need to show her one rare and old photo of her. When she saw the photo that I offered her, she broke into tears as she was moved. I asked if she recognized the photo and she said yes. She said she even did not have the photo. Her strong memories triggered by her image moved her into tears. She was very excited with my gift and in return she gave me a shirt. She promised to show the photo to her children, saying that they would be surprised as well. It was in those circumstances that I began keeping photos and built my collection.[12]

The significance of photographs in social life can be better understood by tuning into a broader emotional and physical sensorium, while also disclosing how processes of sharing photographs foster reciprocal feelings of affection. For Thiam's aunt, seeing a youthful photo of herself literally moved her to tears, while Thiam's sharing it with her brought them closer together. In this context where emotions are elicited and shared by viewing photographs together, affect has a reciprocal quality; affect "captures a way of acting on other actions due to its inherently reflexive quality.... It is the transitive and reflexive capacity of affect—actions that affect others and oneself—that makes it particularly useful for documenting how subjects are mutually constituted"(Richard and Rudnyckyj 2009, 59). Thiam created an enduring connection with his overseas aunt by sharing photographs with her.

Over time, Thiam says, he realized that photography is both a social practice and "the greatest of the arts."[13] He began to practice photography himself after visiting an open studio set up by the Goethe-Institut during Photography Month in Dakar in 2009.[14] He has since exhibited his work in national and international solo and group exhibitions, including the Bamako Photography Biennial; the annual *Les itinéraires artistiques* (Artistic Itineraries) at the Musée du CRDS in Saint-Louis, Sénégal; *Partcours*, an annual exhibition in Dakar; at multiple OFF editions of Dak'Art; in Europe; and in the US at the Longwood

Fig. 4.2 Ibrahima Thiam. *Maam Coumba*, Bang Series, 2018. Photograph, 40 × 40 cm. *Courtesy of Ibrahima Thiam and Joseph L. Underwood.*

Art Gallery in the Bronx, the State University of New York–Stony Brook, Haverford College, Kent State University, Beloit College, and Indiana University. Working primarily in photography, Thiam's corpus addresses themes related to memory, archive, installation, and portraiture but also absence and loss, and the unseen and the seen.

For example, in his series *Reflet*, Thiam offers a series of literal "reflections" that invite us to consider how we see ourselves and others, in the practice of looking and being looked at. In creating this series, Thiam searched for pools of water in the street, both large and small, from turned-up buckets and tipped bottles to neighborhood thoroughfares that had been flooded by seasonal rains. Then he photographed the rippled, distorted reflections of the human

form as people sought passage around the rank water. The series included images of people caught up in the seasonal flooding of homes with inadequate foundations built on marshland, a problem exacerbated by global warming and the rising Atlantic Ocean around Saint-Louis. Viewers of the photographs would lean in, trying to see the disfigured, anonymized figures more closely. In the process they might see their own reflection in the glass, a visual reminder of the way their own perceptions overlaid what they saw.

Thiam exhibited *Reflet* alongside the series *Reflet du miroir* at the Athena bookstore as part of Dak'Art OFF, the numerous unofficial exhibitions erected around the city as part of Dak'Art 2014, the Biennale of Contemporary African Art. For *Reflet du miroir*, Thiam placed a mirror in the street. Curious pedestrians walked over to the mirror and looked at themselves or passed by and glanced at the mirror. Thiam captured these intimate moments on film. The photographs he took captured both the mirror and the reflection in the mirror. This method reflects his approach to photography as a mirror to life. This mirror was like the camera itself, also a mirror, and allowed Thiam to extend the picture beyond the frame to explore issues related to framing.[15] This series largely captured views of workers in the unofficial economy of the street, people who often escape notice by pedestrians because of their ordinary tasks such as selling coffee or small items like toothpicks and gum. Thiam's photography captures these ordinary presences. It thus reflects Thiam's longstanding interest in how we see ourselves and how we are seen by others as well as our past, present, and future selves. Like the tattered archival photographs that Thiam prizes, these portraits also reveal broader milieus beyond the frame, including the wear and tear of time, environmental degradation, and urban inequality.

Thiam explored these ideas anew in his self-portrait *Maam Coumba*, which he showed in *The View from Here*, a 2018 Dak'Art OFF exhibition curated by Joseph Underwood. In the picture, Thiam's face is not visible. He shows himself from the back, emphasizing the sculptural form of the human body. The viewer sees this shape and is reminded of the prominent position given to carving in African art. The sculpture presents the human body in three-dimensional form, unlike the flat nature of photographs. This photograph of Thiam, which also contains a calabash, lait caillé (sour milk), and kola leaves, carries the name of Maam Coumba, a legend in oral epic. Maam Coumba is of the water; she both watches over and is the body of water. Thiam describes how the addition of milk (lait caillé) and kola leaves to the portrait are related to her: "I remember that if we invited someone to Saint-Louis my grandmother would tell me to buy some curdled milk and kola nuts. Then we could pour that into the river so the sea would protect this person during their stay."[16] *Maam Coumba* juxtaposes the

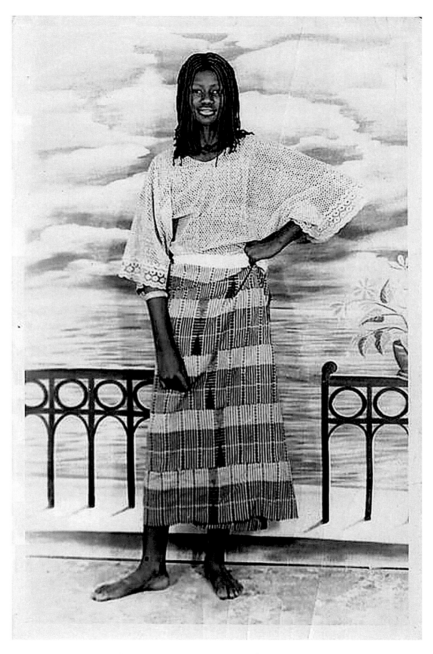

Fig. 4.3 Photograph by Omar Ka of Ibrahima Thiam's aunt. Photograph, 7 × 9.3 cm. *Courtesy of Ibrahima Thiam.*

weight and mass of Thiam's foregrounded body with the body of water where Maam Coumba dwells. As with the checkerboard pattern in *Clichés d'hier, Saint-Louis*, Thiam here pits presence against absence.

Maam Coumba also recalls Malick Sidibé's Back Views [Vues de Dos], 2001, series. In this series, Sidibé photographed sitters in his studio standing with their backs to the camera, often as if they were leaving the scene.[17] These portraits were reminiscent of shots of lead characters exiting a scene in a film. By photographing his sitters from behind and obscuring their faces, Sidibé concealed his sitters' identities. If portraiture shows a likeness, then Sidibé's portraits, which refused resemblance, pushed the boundaries of portraiture by prompting his viewers to question his sitters' identities.[18] As Sidibé does in this work, Thiam creates tension in the opposition of being both in front of and behind the camera at once.

When Ibrahima Thiam sells a work of art, he invests the proceeds in his collecting and preservation efforts. Through purchases, visits to family archives, and donations from others, Thiam has collected around 350 individual and family portraits by well-known Senegalese photographers Meïssa Gaye (1892–1993), Mama Casset (1908–1992), Salla Casset (1920–1974), and Oumar Ka (b. 1930), among others. In fact, he may have the largest collection of photographs by Meïssa Gaye, whose archives were destroyed. The photographs in Thiam's collection are the original prints made by these photographers (as opposed to reprints from the negatives, which are less valuable).

Thiam secures these once commercial—and now vintage—prints to keep them out of the hands of art prospectors who seek to buy up family collections for a growing art market. The value of vintage photography lies in its "vintage" quality: a vintage print is a photograph that is produced within ten years of the exposure of the negative (Willumson 2004, 76).[19] Vintage prints have been increasing in value in the art market for some time alongside contemporary photography as part of a broader interest in photography. In Mali, for example, the development of photography in the past twenty-five years has been driven in part by the art market (Nimis 2018). Likewise, in Senegal, the Dak'Art biennial and its OFF exhibitions have opened to and shown more photography in response to the growing value of photography in the art market.

Where collections of the photographic past do exist in place, such as in the National Archives of Senegal, they are largely comprised of postcards and reprints. Much of the photographic patrimony of Senegal and other French colonies remain in French archives and museum collections in France and elsewhere, thanks to the way colonial powers stripped artifacts from the continent for their own museums. Thiam hopes that his growing archive will help

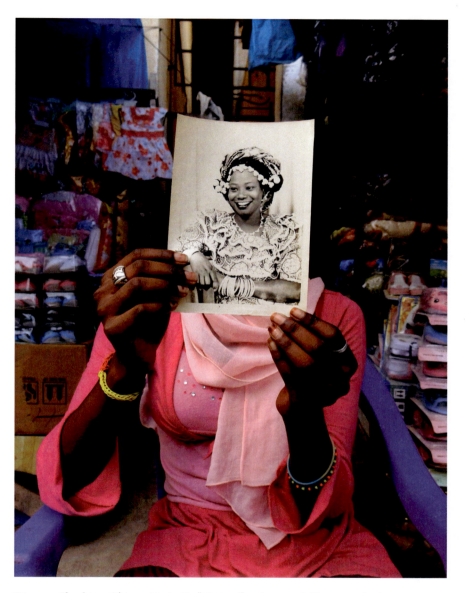

Fig. 4.4 Ibrahima Thiam, *Portraits "Vintage"* series, 2016. Photograph, 60 × 40 cm. Installation view. *Courtesy of Ibrahima Thiam and Joseph L. Underwood.*

to remedy this problem so that others can study and connect with Senegal's photographic past in the place where it originated.

Thiam has trained in proper care and handling of archival materials as well as storage methods and environmental control so that he can preserve his photographic archive and prolong the life of these materials. But in contrast to the collections at the National Archives of Senegal, the Centre de recherches et documentation du Sénégal, CRDS, and other official archives that remain in storage, Thiam's collections see the light of day. "For me, the collection is a passion and a methodology, aiming to raise awareness of the photographic predecessors whose work I've had the chance to preserve," he explains. This involves allowing people to interact with the photos, including through touch. This is something Thiam believes the photographers would have wanted: "I would be doing them an injustice if I acquired their artwork only to store it away in filing cabinets. These photographs will exist for many generations to come. That's one way to reignite this collective memory."[20] He aims to conserve the communal memory and history that these photographs inscribe, in all their social complexity. In the process, he both extends past relations and creates new ones, fostering interest among young people in their own family collections and in Senegal's photographic patrimony to guard against its deterioration, sale, and loss.

PORTRAITS "VINTAGE"

In his series *Portraits "Vintage,"* Ibrahima Thiam renegotiates the boundary between photography as art and artisanal production. Photography was long lumped with the latter and has only made its way into blockbuster museum exhibitions and global biennials relatively recently, especially in Senegal. Thiam has noted that, while younger generations have a sense that contemporary photography can be fine art, they largely fail to appreciate what early photographic materials and vintage prints have to offer and thus these objects are even more vulnerable to being bought up by the global art market, rather than being preserved in Senegal.

Thiam has worked to get young people to see beyond the binaries of old-fashioned versus in style and the past versus the present to help them appreciate parallels in visual strategies across analog and digital divides and across time and space. Portraiture in Senegal has always circulated in a network of "likes" and sharing, whether actual or virtual, because the sitters' social acumen in assembling objects to represent their social standing thus presenting themselves as a composite of the whole. Thiam expressed curiosity about how people of different generations engage with media forms such as printed photographs

and social media images, or what anthropologists have called chronotopes of media (Vokes and Pype 2018, 207), to achieve this purpose. For Thiam, photographic objects, like a crossroads, condense and expand intersections of past and present stories. Layering digital and analog media in his practice, he seeks to access their power and prompt young people to reflect on their image-making practices. While young people may have seen earlier media such as print photographs as old in contrast to the allure of the digital screen, Thiam seeks to produce connections across time and media as part of his preservation efforts. In the digital, with its vibrant colors and the ease with which one can share images, see "likes," and "call forth new publics" (Gershon 2017, 16), immediacy displaces the intimacy of sharing a bound photo album in one's home. In his photographic practice, Thiam understands the power of new media, not as new technological forms, but as generative of new social practices and connections and the power of placing that media in an ecology of existing media forms.

I observed that Thiam and the young people whom he often engaged with in his photographic practice not only held differing visualities (Roberts et al. 2003), ways of seeing (Berger 2014), and preferences for genres (Strassler 2010), but that they also held different media ideologies or beliefs, strategies, and attitudes about media (Gershon 2010). Older people continued to favor the printed image taken and sold back to them at major events by ambulant commercial photographers, whereas young people called photographers to their homes to stage environmental portraits that would circulate on social media.

For those who might not value the older photographs, Thiam brings the archive to them. As part of the *Portraits "Vintage"* series, Thiam canvassed the riverine landscape of Saint-Louis with a mobile studio, like the peripatetic portrait photographers who traveled the coast of Atlantic Africa from the late 1800s. These photographers plied the streets of coastal cities seeking clients and taking photographs outdoors to take advantage of the natural light in pre-electrification Senegal. Like ambulant photographers before him, Thiam also set up open-air studios; sometimes he invited his sitters in, while other times he combed the streets in search of sitters to participate in his "mobile studio." Embracing flexibility and happenstance, his movements reflected the unpredictability of social life in Senegal's coastal cities more generally, as seasonal floods inundate whole neighborhoods and migrants set out on repurposed fishing boats for the European coast in search of better prospects.

Thiam embraces his own movement as well as that of his peers to decipher what moves his sitters to feel a connection to his collection of historic portraiture. Moving through the city with a digital camera in hand and his packet of historic portraits to share, Thiam said that he seeks to elicit a range of sensory

responses in his sitters to evoke cultural memory among members of his generation. Images themselves not only move; they move audiences (Spyer and Steedly 2013, 8). This process of exchange and sharing, or commensality, creates its own social dynamics through the shared sensory responses to material culture (Stoller 1997, 85). Thiam makes his collection tactile, to encourage his viewers to pick up the images and hold them, in an attempt to move viewers from the "dominance of looking at the image alone," as one might do by looking at the panel of the digital camera to see the image taken, to seeing images as "objects of affect" to emphasize both the sensory and emotive quality of photographs (Edwards 2012, 231).[21]

By allowing viewers to hold photographs rather than viewing them behind museum glass, Thiam creates sensory experiences that tap into the tactility of the photographic print; he thus seeks to move his viewers and sitters to new emotional states that create a connection with the photographs. This practice is not unlike Sufi devotional practices whereby sitters seek deeper meaning by contemplating images of deities. Photographs are "relational objects" when they bring together social interaction and material form (Edwards 2006, 27). Viewers access their weightier and denser meanings by expanding their ways of knowing beyond the visual to encompass that, which is felt and sensed. Thiam seeks to go beyond conventional understandings of portraiture as social documentation to the ways in which portraits evoke feelings and sentiments; rather than showing social networks, they evoke feelings about those relationships, they may serve as an anchor in turbulent times, or they may remind one of the relations gone awry. Thiam's project was effective because it was affective.[22] He put the images in the hands of his sitters to evoke an emotional response through the sensation of holding and touching.

In this series, Thiam draws on his personal archive of vintage prints, extending his aim to preserve this valued heritage while at the same time allowing it to circulate in new contexts. He asks his sitters to thumb through the collection and eventually to choose one portrait. This process creates its own dynamics of sociability as Thiam invites his sitters to touch, sort through, and hold the images in their hands. This process not only elicits conversations about these images, as opposed to silently regarding the photographs, but touching the photos also moves people physiologically, sometimes moving them to another emotional state, evidenced by tears. The sitters then hold their chosen printed portrait photographs in their raised hands, covering their own faces. Thiam takes the shot from the waist up, full frontal, revealing only the sitter's hands up close, with their body slightly pivoted to the right. The sitter's hand reaches toward the frame to display the photograph.

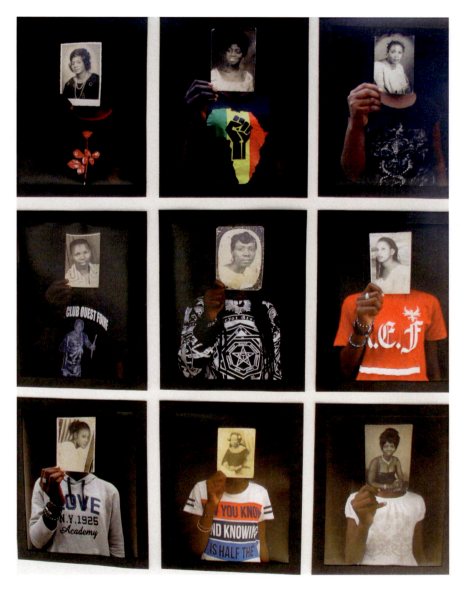

Fig. 4.5 Ibrahima Thiam, *Portraits "Vintage"* series, 2016. Installation view. *Courtesy of Ibrahima Thiam and Joseph L. Underwood.*

Through such participation and collaboration in his mobile portraiture studio, Thiam uses the material form of the image, the photographic print, to engage his interlocutors. His ambulatory studio privileges the experiential, affective aspects of photographs. This process of ownership and identification uses the body, the senses, and sentiments. His potential sitters experience photographs, like textiles, through their sense of touch and the movement of their hands over the prints.

The mobility of Thiam's studio also reflects his generation's experiences and aesthetics; they are hustlers trying to survive in volatile times. His sitters are cloth vendors, porters, and coffee sellers. Consider a portrait taken in a market, in which a young woman dressed in shades of rose perches on a blue chair. Behind her, we see the market of imported consumer products in which she works. She holds a black-and white-photograph in front of her face with her two hands, with her *naari loxo* (literally "two hands" in Wolof), as an expression of sharing. In the vintage portrait she holds, a woman wears a tailored ensemble of manufactured cloth in a fancy print and adorns her black wig with gold coins demonstrating her standing as a married woman. She is also seated and several gold bracelets adorn her folded arms.

Thiam emphasizes that his mobile studio reflects the movements of young Senegalese women and men today like this sitter: "Of course. We are no longer determined by time and space. That's the philosophy of my work. Photos and architectures transcend time. We still see them. The birthplace is not that important. We are not bound to remain in one place—we move with the globalization. In history, Senegal has always been a global space, with Islam, colonization, and the slave trade. It was a strategic point."[23]

Thiam collaborates with his sitter, encouraging her to participate by selecting a portrait that appeals to her and taking her picture. In so doing she is connected to her past and becomes part of a longer historical trajectory of trade with the wider world of which Senegal has always been a part. Thiam explains that "these 'vintage' portraits are composed of old photographs of stories, emotions, and time, slices of lives of individuals of today's generation who invite a real journey through the past."[24] In asking his sitters to hold portraits over their faces, Thiam says that he hopes that they will see their shared visual heritage though these haptic ways of knowing. In this respect, his use of vintage portraits posits "nostalgia as a co-temporality of past and present."[25]

Thiam takes the three-dimensional paper portrait in the hands of his sitter and recreates ethereal digital portraits. The digital nature of the final photographs conjures up the idea of being in opposition to the material. Yet, by holding the digital and the analog in the same frame, Thiam shows how the digital can be enmeshed with the same social relations and processes as a photograph

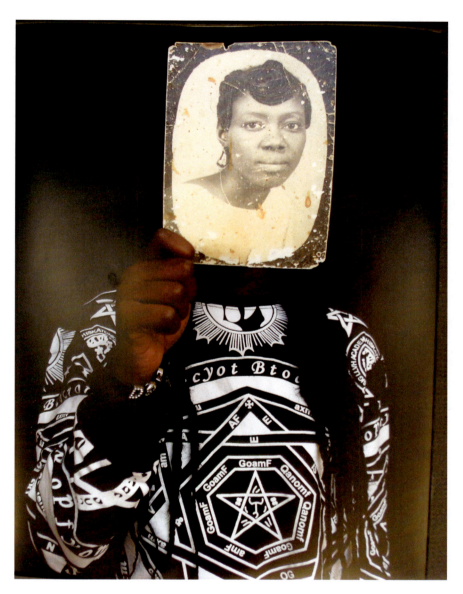

Fig. 4.6 Ibrahima Thiam, *Portraits "Vintage"* series, 2016. Photograph, 60 × 40 cm. *Courtesy of Ibrahima Thiam and Joseph L. Underwood.*

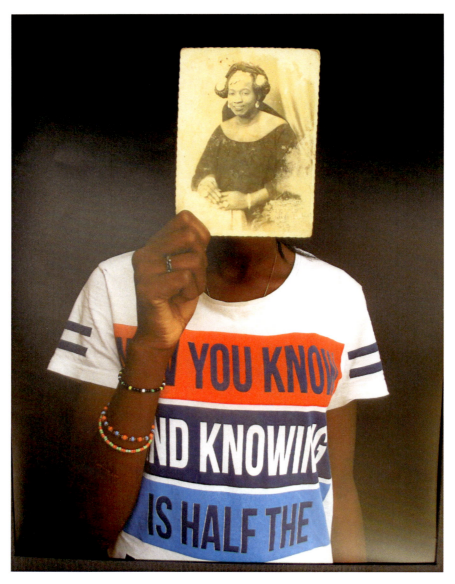

Fig. 4.7 Ibrahima Thiam, *Portraits "Vintage"* series, 2016. Photograph, 60 × 40 cm. Courtesy of Ibrahima Thiam and Joseph L. Underwood.

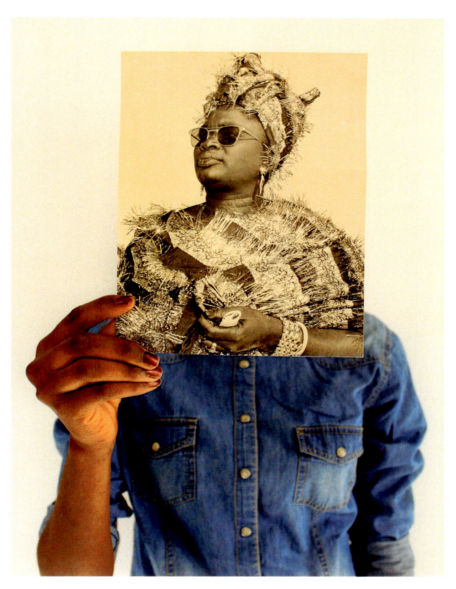

Fig. 4.8 Ibrahima Thiam, *Portraits "Vintage"* series, 2017. 60 × 40 cm. *Courtesy of Ibrahima Thiam and Joseph L. Underwood.*

printed by the movement of photographic paper by hands through various fluids and chemical reactions resulting in an image on paper that is hung to dry. Digital images engage both the corporal and the sensory (Deger 2016; Pink 2009, 117). They also engender gathering around a screen, be it the back of a camera or a phone, just as their analog the printed photograph prompts gathering around an album. While digital images cannot be physically grasped in the hands, they can still be "held" by residing in one's memory or remaining as an idea to which one is attached.

In *Portraits "Vintage,"* Ibrahima Thiam juxtaposes vintage and contemporary photography, digital and analog. In so doing he transforms the photographic object, explaining that "the particularity of this work is to combine two technologies into one, two photographers into one."[26] He combines his photography with that of the photography of the vintage prints that appear in the series. At the same time, he combines two sitters—past and present—into one to make a statement about the future. If in *Clichés d'hier, Saint-Louis* the viewer steps into the studio and immerses themselves in photography's past, in *Portraits "Vintage"* the viewer becomes the sitter. Where the viewer is typically positioned in front of the photograph as in *Clichés d'hier, Saint-Louis*, in *Portraits "Vintage"* the viewer sits behind the portrait. It is through producing these layers that Thiam adds depth of meaning and a density of connections, linking various photographs and sitters across space and time.

In a set of images that are also part of *Portraits "Vintage,"* Thiam approached his nieces and asked them to pose with portraits of their grandparents "to celebrate and commemorate their parents." In these portraits the sitters recede against a black backdrop that causes the printed portrait to pop. Thiam's use of a black backdrop allows the analog image to capture the limelight. These are aesthetically quiet images; the visual noise is reduced by the black backdrop. Aspects of the pictorial space seem to be intentionally depicted as disappearing. The sitter's body recedes into the background because it is matte in contrast to the lustrous body and face that she holds up in the vintage print.[27] Many of the digital portraits in the series feature minimal colors and within them Thiam often plays with contrasts of black and white. Laying these images out in a grid emphasizes the digital nature of the series, while the fact that all the photos are of the same composition and size and thus interchangeable reinforces the idea of the contemporaneity of the images. That his sitters are all young and smartly dressed further enforces the contemporary moment.

In contrast, in another portrait in the series, a woman wears a denim button-up shirt against a light-colored canvas. The sitter's body is out of focus in the background, and only her raised hand, holding the vintage portrait that she has

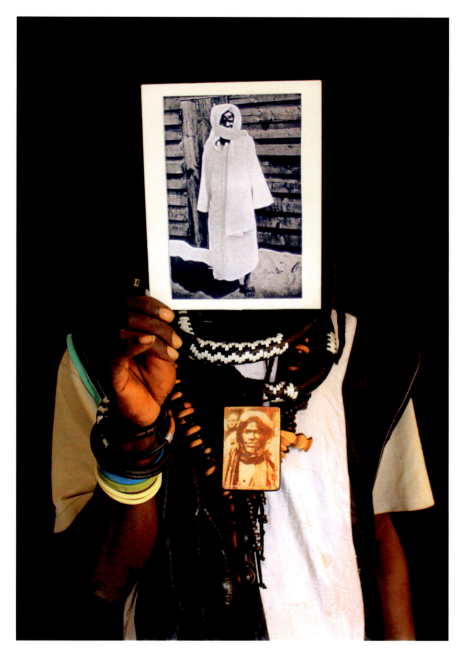

Fig. 4.9 Ibrahima Thiam, *Portraits "Vintage"* series, 2018. 60 × 40 cm. *Courtesy of Ibrahima Thiam and Joseph L. Underwood.*

chosen, is sharp and foregrounded. In the vintage portrait, a woman wears gold-rimmed sunglasses reflecting the bright studio lights. The vintage print features diagonals, which were commonly used in midcentury studio photography from West Africa to give the impression of a three-dimensional presence (Strother 2016). The sitter looks out diagonally in a three-dimensional pose, with light bouncing off shiny objects like gold jewelry and heavily starched boubous or silky factory prints. Its subject is performing *sanse*, or shining, displaying their social and visual acumen, and enjoying the performance of being seen. The woman who holds the portrait seems to embrace and enact that same potentiality, treating the photograph not as a memento, but rather as a state to which she might aspire. Like the use of light in painting to model three-dimensional form, Thiam's portraits bring figures from the past to life.

In both portraits, the hands dominate. The sitter's right hand, the *ndeyjoor* (also the word for "birth mother" in Wolof), is elongated, reaching out toward the viewer, holding out the singular vintage portrait, as if to say, "look, the future is in your hands." It is the matriline that sustains kin relations (Diop 1985). In Thiam's photography, the hands become essential tools of learning, of connecting, of making, and of being in touch; he is, after all, a craftsperson. The single hand also underpins the singularity of the printed image, reminding the viewer of the artistry of the photographer in and out of the darkroom and bringing the analog world into the digital age. Hands processed the film and now other hands hold the results, a reminder that photographs are objects with social histories and social trajectories (Willumson 2004).

In these two-dimensional photos, the flat pictorial space created by the backdrop contains three spaces of time simultaneously. The sitter is both in front of and behind the vintage portrait; the hand reaches into the future as the body holds back, receding into the past, while the vintage print rests in between. Thiam explains that "it is important to revive family memories for the new generation. They are testimonial objects, visual and memorial archives. We could learn to know better our past. I am just communicating with them, exchanging ideas about what I do as a photographer, to generate reflections about the past."[28] In encouraging young people to engage with these photos and embrace the past, Thiam's photos also signal how such awareness of history is an important part of moving into the future.

In yet another photograph in this series, Thiam takes up localized forms of Muslim visuality in Senegal, demonstrating how practices ideologically separated as "Islamic" or "secular" converge in compelling ways. In this photograph, a man holds a portrait of a Muslim scholar in his uplifted right hand. The sitter wears a patchwork tunic of black-and-white cotton damask with a white shirt

characteristic of the Baay Fall sect of the Murid tariqa, a Sufi congregation with its roots in colonial Senegal. The disciple holds the only existing photograph of the founding figure of the Murid tariqa, Amadou Bamba, in front of him as if it is a protective talisman. This photograph is a reprint; the original and its negative are now lost and subject to much myth. Amadou Bamba's portrait has become an object of veneration and contemplation for his followers; this image has been reproduced in other media across time and is ubiquitous throughout Senegal as interior decoration and public art. The sitter's patchwork tunic recalls the exile of Bamba by French colonizers to Gabon where he was forced to repair his tattered clothing with patches. The patched clothing represents the ascetic vision of the Baay Fall following in Bamba's disavowal of this-worldly things. The sitter also wears leather amulets, prayer beads, and an image of Cheikh Ibrahima Fall, Bamba's first disciple, around his neck.

The way in which Thiam has layered the portraits in this image invokes the Muslim idea of *zahir*, the seen, and *batin*, the unseen. Photographs, and indeed all aspects of Sufi life, are thought to "possess a secret side," or batin. For Sufis "the insightfulness of *not* seeing, then, is often believing" (Roberts et al. 2003, 47). It is this relationship between "display and secrecy [that is] essential to Mouride visuality" (Roberts et al. 2003, 80). To "see" this image of Bamba, both its seen and unseen or otherworldly qualities, the zahir and batin, involves other senses, such as touch. By holding Amadou Bamba's image close to his body, the Baay Fall adept benefits from the *baraka*, or blessings, of the scholarly figure.

In general, Thiam's *Portraits "Vintage"* series works the contradictory forces of that which is concealed and that which is revealed, of conservation and of change. In *Portraits "Vintage,"* Thiam asks his young sitters to obscure their faces by holding a vintage portrait over them, calling into question the representational function of portraiture. With the sitter's face covered, the portrait does not show a likeness or a social persona, or *jikko*. The young sitters are not performing sanse (shining); instead, they are not being seen. Thiam obscures them with the past to transform the possibilities of portraiture, and to enable the viewer and the sitter to imagine what could be.

In these portraits, the young sitter's bodies become a screen, "a surface onto which images are projected, displayed or attached" (Thompson 2015, 33). Thiam's sitters inhabit the surface of the picture. The sitter's shirt and the vintage photograph are shown in surfacist detail while the body recedes. With this technique, Thiam is highlighting the juxtaposition between the visibility of the surfacism of the shirt and the invisibility of the receding parts of the body as well as the complete absence of the face. The subject of Thiam's image is not the

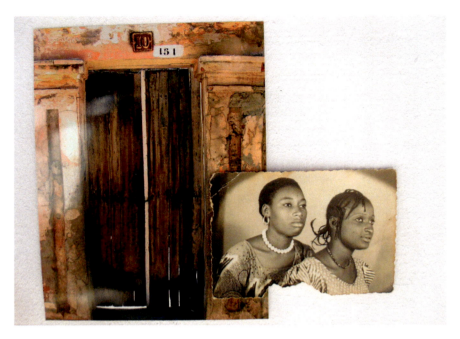

Fig. 4.10 Ibrahima Thiam, *Les objets témoins II*, 2016. Installation view. *Courtesy of Ibrahima Thiam and Joseph L. Underwood.*

sitter; it is the surfacist detail of the vintage portrait brought to the foreground. In an exhibition setting, the lights are focused on the vintage portrait, causing the sitter to recede even further.

The tensions that Thiam creates in his portraits between photorealism and abstraction, luminescence and darkness, and appearance and disappearance accord with his view of his subjects in photographic histories. Where artists such as the painter Kehinde Wiley have placed Black sitters in the frame to challenge who is included and represented in art and in the museum, Thiam's sitters are simultaneously inhabiting and not inhabiting the frame. They are at the interstices of visibility and disappearance, raising questions about imaging Black subjectivities along the Atlantic.

In not fully displaying his sitters, Thiam also pushes them to ask how they might reconsider how they see themselves and their futures. In Saint-Louis, as in West Africa more generally, most young people seek to migrate to improve their chances in life. Many of these migrants are at once economic and environmental migrants. Saint-Louis was once dependent on fishing, but those waters have long been overfished just as inland agricultural yields have declined as the

Sahara has expanded due to climate change. Young people in Saint-Louis face unstable livelihoods marked by the presence of some and the absence of many through migration. Part of Thiam's motivation in creating this series, he says, is not only to show young people their history but also to push them to value what is there for them in Senegal.

LES OBJETS TÉMOINS I AND II

During Dak'Art 2016, Thiam exhibited his series *Les objets témoins* (Objects that Bear Witness) *I* and *II* (2016) in the *OFF* exhibition *Chez/Home* curated by Joseph Underwood at the West African Research Center in the embassy neighborhood Point E. In contrast to the hulking homes of Point E, with their tall enclosures covered in rosy flowering bougainvillea, steep setbacks, and guard posts lining the boulevard leading to the ocean, *Les objets témoins I* and *II* feature the dilapidated exteriors of colonial-era homes on the narrow streets of the island of Saint-Louis—or, as inhabitants tend to call it, using its Wolof name rather than its colonial one, "Ndar." The former colonial capital is a UNESCO World Heritage Site, but preservationists lament its current state of being. Many of its buildings are in desperate need of repair. Others have been torn down, controversially, to make way for new construction. And since the city lies at the mouth of the Senegal river and the Atlantic, it is also threatened by rising sea levels. In *Les objets témoins I* and *II*, Thiam superimposed portraits from his prized collection atop the city's old, colonial-era doorways and windows. For the vintage prints in this series, Thiam chose works by renowned, studio-based photographers in Senegal from the 1930s on, featuring families who inhabited Saint-Louis at the midcentury. This exhibit was a double act of preservation that focused on both the built environment and vintage photography as vital components of Senegalese heritage.

In the first series, *Les objets témoins I*, Thiam affixed fifteen vintage prints to digital photographs of the windows of colonial-era buildings. He mounted these fifteen images on a white background, laying them out in a modernist grid pattern such that each final image was of the same dimension. In a few images, a portrait of a figure, superimposed atop a window whose wooden shutters were closed, looks out at the viewer. In other windows, the slatted and solid wood panes remained shuttered, and the image appears in the upper-right or left quadrant. In Thiam's portrayal, the families that could have inhabited these homes are made visible and knowable.

The second series, *Les objets témoins II*, features eleven images of some combination of portraits and photographs of a door, including the door to the studio where Thiam's grandfather had practiced his craft of ironwork. These images

are not positioned in a true grid pattern, since the vintage print is positioned to overlap slightly with the photograph of the door. One door does not have a portrait paired with it, another has two portraits, and one portrait floats alone in the white space provided by the background. In both series, Thiam seeks to restore life to these closed homes, to imagine them as they were in the past with the women of the house coming and going about town. His work thus challenges many heritage projects, which tend to focus on physical architecture rather than the social infrastructure that gives meaning and life to buildings.

In these series, Thiam creates a strong opposition between the black-and-white vintage prints, produced in the darkroom, and the colored digital prints, whose doors and windows are characterized by the washed-out indigo, sea green, and amber walls that comprise the tropical landscapes that contribute to colonial nostalgia and are subject to preservation efforts. The portraits have smooth surfaces, and show poised, smartly dressed women and men, but in the current era, the buildings have weathered walls with layers of peeling paint, cracks from shifting foundations, lumpy cement patches with trowel lines through them, and rough-hewn, imprecisely cut, or splintered wood filling in for spaces where doors or windows used to be. Thiam seems drawn to the texture and the tactility of these surfaces and to the surface of the photographs. Here Thiam suggests perhaps that it is the social histories worth preserving rather than the dilapidated buildings that serve as monuments to a colonial past.

Like the pages of *Bingo* magazine, the gridded layout of these images reflects ideas about a rational, modern order. The white space between the pictures creates new relationships among the images, while also allowing the eye to rest and recognize boundaries. We never see what is behind the door or out the window. As the sitters for these portraits look out through this crumbling architecture, they draw viewers in, asking them to imagine the unseen based on the seen, in this case a vibrant history and a vulnerable future.

The two series feature an overlaying of two techniques, two eras, and two generations. If in his other works, such as *Clichés d'hier, Saint-Louis,* Thiam seeks to translate between photography and sculpture, making the two-dimensional object more lifelike to evoke affect and thus appreciation for the photographs, in *Les objets témoins I* and *II*, Thiam takes three-dimensional structures and turns them into photographs, which are two-dimensional objects. The process suggests a kind of loss—of texture, as well as of family history, photographic patrimony, and the built environment, which in and of itself may romanticize a violent past of dispossession.

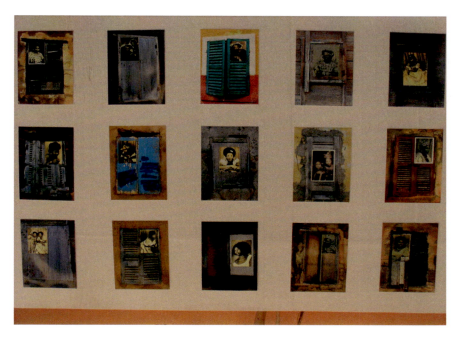

Fig. 4.11 Ibrahima Thiam, *Les objets témoins I*, 2016. Installation view. *Courtesy of Ibrahima Thiam and Joseph L. Underwood.*

His installation also suggests other forms of photographic display, such as large album pages, where figures look out of frames—or in this case, windows and doors—to create a relationship with the viewer. At the same time, the gridline arrangement of pictures resembles unedited contact sheets, a direct print of a roll or sequence of negatives, on which albums were built, providing multiple takes of a photographic event. Contact sheets themselves form an album of an artist's work. Thiam's arrangement and framing of the vintage portraits recall the practice of xoymet, the borrowing and display of portraits during the matrimonial process to exhibit the social fabric of the family and their wealth. The juxtaposition of the built environment and its former inhabitants creates a strong, affective pull for the viewer and highlights the contradiction faced by many of the city's migrants: that many must migrate abroad to earn money to build a life at home for others. Thiam overlays architectural features with vintage portraits as though to propose that—even when the buildings are in disrepair—family and history provide a strong foundation for forging

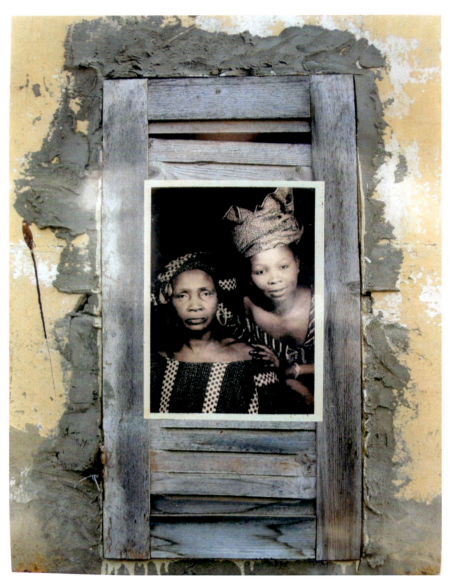

Fig. 4.12 Ibrahima Thiam, *Les objets témoins I*, 2016. Installation view. *Courtesy of Ibrahima Thiam and Joseph L. Underwood.*

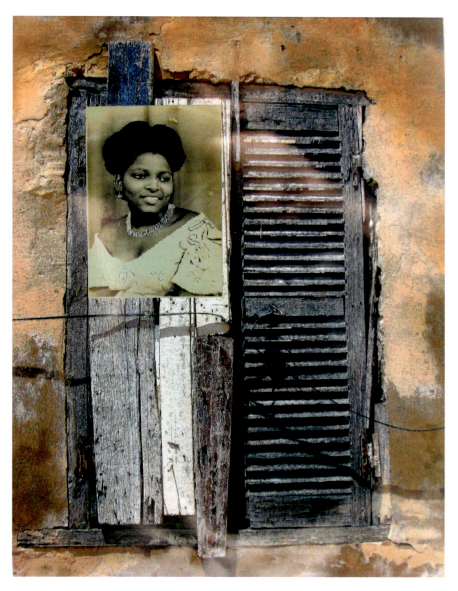

Fig. 4.13 Ibrahima Thiam, *Les objets témoins I*, 2016. Installation view. *Courtesy of Ibrahima Thiam and Joseph L. Underwood.*

identities. For Thiam, *Les objets témoins I* and *II* are about the value of that social fabric that could provide ballast for the overseas migration of young people in Senegal today.[29]

In this series, as in his wider body of work, Thiam searches for ways to connect younger generations to family histories and national patrimony through photography. He sees photography as part of a social fabric and uses both his archives and his art photography to weave it anew. He does so by relying in part on its material qualities as a printed object that can be handled and passed around or viewed in its social context of the home or photo studio. In these series, at least, he eschews the large-scale digital prints so prevalent in contemporary photography, turning to vintage prints to bring to life the networked relations and social processes that these collections of portraits are comprised of, relations that are no longer seen when such images become parts of collections or museum display. For Thiam, then, the value of preservation lies with the social relations photographic objects engender, and with their social potential rather than their documentary power. Preserving Senegal's photographic patrimony entails conserving practices of display, communal memory, and collective meaning-making.

NOTES

1. Ibrahima Thiam, interview by the author, May 30, 2016, Dakar.
2. Thiam, interview, 2016.
3. See for example Borgatti 2013.
4. Hereditary occupational orders, or social divisions such as freeborn and nobles, artisans, including potters, weavers, dyers, blacksmiths, leatherworkers, and so on, and descendants of those who were enslaved are indicated by last name; "Thiam" is a blacksmith name.
5. Thiam, interview, 2016.
6. "One Way to Reignite This Collective Memory: In Conversation with Ibrahima Thiam," Contemporary And (C&), accessed May 2, 2014, http://www.contemporaryand.com/magazines/one-way-to-reignite-this-collective-memory/.
7. Thiam, interview, 2016.
8. Thiam, interview, 2016.
9. Thiam, interview, 2016.
10. "One Way to Reignite."
11. For further discussion of the evocative nature of photographs see Edwards 2012.
12. Thiam, interview, 2016.
13. "One Way to Reignite."
14. "One Way to Reignite" and Thiam, interview, 2016.

15. For further discussion of this series see "A Shared Darkroom: Interview with Ibrahima Thiam in Dakar, 2014," Photography and Orality: Dialogues in Bamako, Dakar, and Elsewhere, accessed December 5, 2020, http://dakar-bamako-photo.eu/en/ibrahima-thiam.html.

16. Ibrahima Thiam, interviewed by Joseph Underwood, 2018.

17. Joseph Underwood, *The View from Here. Dak'Art Biennale of Contemporary African Art OFF Exhibition*, WARU Studio, Dakar, Senegal and Kent State University, OH, May 2018.

18. Malick Sidibé, "Back Views [Vues de Dos]," The Met, 2001, https://www.metmuseum.org/art/collection/search/520569.

19. The value of the vintage print increases when the photographer either supervises or develops the image themselves so that the final print image reflects the photographer's original intent. Later reprints are not considered vintage and thus their value is not as high.

20. "One Way to Reignite."

21. While scholars in visual anthropology have made this argument for film, as Tina Campt has argued, "affect is clearly not confined to the moving image" (2012, 13).

22. For further discussion of affect in anthropology, see Mazzarella 2009; Newell 2018. The turn to affect in anthropology and the arts in part seeks to capture and address the volatility of life (Stewart 2017). As such, a focus on affect moves away from described fixed objects to social processes and to "what moves and matters in social life" (Lutz 2017, 181).

23. Thiam, interview, 2016.

24. "Ces portraits « Vintage » sont composés d'anciennes photos d'archives chargées d'histoires, d'émotions et de temps, ce sont des tranches de vies d'individus de la génération d'aujourd'hui qui invitent à un véritable voyage dans le passé." www.afriqueinvisu.org/portraits-vintage-2014-2015, accessed June 30, 2017.

25. Joseph Underwood, "Chez/Home: Spatial Rootedness in the Photography of Ibrahima Thiam and Fiona Cashell," Dak'Art OFF, Exhibition, May 1–31, 2016, West African Research Center, Dakar, Senegal.

26. "La particularité de ce travail consiste à réunir deux technologies en une, deux photographes en un." Ibrahima Thiam, *Portraits "Vintage" 2014–2015*, Afrique in Visu, February 19, 2016, www.afriqueinvisu.org/portraits-vintage-2014-2015.

27. For further discussion of listening to images see Campt 2017.

28. Thiam, interview, 2016.

29. For further discussion of the exhibition's themes, see Joseph L. Underwood, *Chez/Home* Curatorial Statement, May 2016, https://drive.google.com/file/d/0Bxw9kpWhYMfrbnN5Uo5ub1EoeHc/view.

FIVE

CUT FROM THE SAME CLOTH
Omar Victor Diop's *The Studio of Vanities*

BACK IN MAY 2014, the photographer Omar Victor Diop constructed a pop-up portrait studio in the open-air courtyard of the Institut Français de Dakar (French Cultural Center) for the eleventh Dak'Art Biennale of Contemporary African Art. This event was significant, since Dak'Art is the oldest and largest art biennial in Africa, and one of the ten major biennials in the world. Diop built his set atop a small stage using floor mats of vinyl tile and woven rugs as well as a variety of textiles—some locally woven, some imported, some machine-made—which he could clip to a portable backdrop support stand. He invited artists and art world figures to collaborate with him by selecting backdrops and then sitting for him as part of a series of over one hundred photographic portraits he titled *The Studio of Vanities*. The setup echoed Ibrahima Thiam's work in that it recreated the practice of itinerant West African portrait photographers popular in the early to mid-1900s, as well as that of neighborhood studios where families might commemorate major holidays and celebrations. Some of the portraits for the series were indeed shot in "the neighborhood," as it were, at Diop's home studio.

In his pop-up studio, Diop reimagined the older rituals of sitting for a portrait to commemorate an important event, altering them to serve a kind of contemporary art world family. Through collaboration he provided a stage for his sitters' sartorial expression, a studio of vanities. Unlike Thiam, who was interested in reinvigorating portraiture in Senegal partly as a way to rethink the preservation of patrimony, through this project Diop strove to extend Senegalese portraiture beyond national boundaries as he worked to export his reworked versions of these traditions to new audiences. His aim was not just to preserve this heritage but also to address visibility through his portraiture. The

artist sought to provide global art audiences another view of a vibrant, contemporary Africa beyond the portraiture of midcentury studio photographers that had come to dominate the art world's idea of African photography.

Diop talked with me about his project one late afternoon in 2014, under the shade of the kapok tree, its trunk thick with grooves and nooks, that towers over the French Cultural Center's courtyard. We had just met for the first time at the biennial. He was at a small table, taking a break with a dish of peanuts, a camera, and a laptop, smoking a cigarette, and drinking thick, pungent espresso near the studio set. I walked up to him and asked if he would talk to me about his work. I learned that Diop had been working with mobile portraiture studios off and on since the early 2010s, when he participated in Rencontres de Bamako, the Malian photography biennial. By then, he had been practicing photography for some time.

Arts writers, curators, and audiences often compare Diop's work to that of the internationally renowned midcentury Malian portrait photographers Seydou Keïta and Malick Sidibé. The family portraits taken by Keïta and Sidibé in Mali's capital of Bamako became an instant success when they began appearing in exhibitions around the world in the 1990s (Bigham 1999; Keller 2014; Nimis 2014b). During this period, both photographers experienced a rapid and radical transition from vernacular studio photography to fine art, which included transforming their small family prints into large-scale prints that were shown worldwide (Moore 2020, 61). These photographs have since been acquired by museums, galleries, and foundations in the US and Europe. These images generally sell for between $3,000 and $15,000, with some going for as much as $40,000 at auctions held at Sotheby's and other similar venues. To be seen as the next Seydou Keïta could put Diop in a lucrative position to be represented by an internationally reputable gallery, to participate in group shows at major art institutions, to have his works collected by those institutions, to be included in major biennials, and to have his work reviewed in art publications, much of which has since come to pass. Yet at that moment, in 2014, Diop explained to me that contemplating such potential success made him uncomfortable. "You know, let me tell you a history, which I have never told to anyone," he said. "In the beginning, I had a conflict with this project. I was like, am I trying to reinvent the wheel, to take advantage of their legacy?" He continued, "But now I am more at peace with this project because I think I am building from what I call our patrimony."

The patrimony to which Diop refers is simultaneously regional, national, and personal. He draws his sense of heritage from his own family history, held in albums and displayed on the walls of his family's homes in photographs

that embody what he calls "codes from this West African studio photography tradition." Growing up, he would watch families host visitors to their homes by bringing out first a drink and then the family photo album. No matter how well guests might know the family, they would flip through the album together, their impressions shaped by how people present themselves to others through portraiture. There are even times, he told me, when he looks at studio photography of people he does not know and is reminded of a "picture of my mom or grandma that is in our family album just like it."

But *The Studio of Vanities* does not simply mimic these practices. Rather, Diop said, it extends "this tradition of dressing up, of going to the studio, and taking this picture that we have staged in the family album," enlarging it to encompass the contemporary art world in Dakar and beyond.[1] Indeed today, family portraits do not simply remain in albums housed in bureaus and wardrobes in Dakar; collectors and museum curators are also snatching up such photographs. As much as Diop admires the portraiture of Seydou Keïta and Malick Sidibé, both their work and the proceeds of their fame often land in the pockets of art enthusiasts in Europe and America (Keller 2014). Diop does not reject this kind of global attention. Rather, he tries to capitalize on it, both as a way to draw wider attention to the Senegalese tradition of portraiture and as a way to reinvigorate it to attract new generations of art collectors, curators, and critics.

Diop expressed concern by his own generation of artists' reluctance to embrace this patrimony, noting that "Part of me wants to reinvent the great heritage of elaborate studio photography that we have in Africa."[2] Diop finds it troubling that many African artists avoid engaging with the creative past. He continued: "African artists shy away from anything labeled old-school Africa because for us it is the opposite of being part of this modern world."[3] While some American and European art audiences marvel at the surprise of seeing a scooter or a radio in a portrait from the 1950s in West Africa, Senegalese artists and art-going audiences know otherwise, and see these portraits as "kitsch," said Diop. Besides, with the exception of work by a few especially skilled photographers who have been "rediscovered" by art collectors, curators, anthropologists, and art historians, most portrait photography across the continent tends to be categorized as vernacular or popular photography—the stuff of everyday life, not of fine art.

Diop pushes against such categorization, searching for a new photographic language that confounds neat categorizations such as art historical periodization and its attendant categories of indigenous, popular, traditional, modern, and contemporary. With his vibrant portraits, Diop encourages his viewers to

rethink how such categories and definitions shift. By searching for and creating a new vernacular language that is not confined by location but is enhanced by being rooted in a rich creative history, he also seeks to expand ways of seeing that encompass multiple geographies and eras to address visibility and inclusion in the art world and at home, in Senegal. As he puts it, he wants to "modernize" and "translate" the idioms of portraiture "into a more universal language, because I am not just doing it for here, I am trying to export it."[4] Unlike Thiam, whose focus remains primarily on Senegal and the impact his work can have on how new generations of young people engage with the past and present, Diop's interest is focused on the global art world, asking how such photos can shift the marginalization of African artists within it and challenge the genre of portraiture more broadly.

To achieve his goal of translating portraiture into a universal language, Diop taps into the visual strategies of the past masters, including Keïta and Sidibé. To celebrate the aesthetics and visual strategies of his own generation, he also is inspired by the practices of photographers working across Senegal. That includes many of the artistic figures he photographed for *The Studio of Vanities* as well as the commercial photographers in the neighborhoods of Dakar who continue to record family ceremonies and create family albums. Diop explained that he was "definitely inspired by all these anonymous photographers in every 'hood who do the groundwork and are so creative. Sometimes it can be a bit kitsch, but you know that is the charm of it."[5] His sense of vernacular photography's value as tacky seems motivated, at least in part, by his own cosmopolitanism. He has a sense of how photography works locally and globally, as well as how it signifies differently in different locales and different frames.

After all, we were speaking amid Dak'Art, the leading and longest-running biennial on the continent. Buyers and critics of African art regard it as the premier platform for viewing and transacting new works by both emerging and established artists in Africa and in its diasporas. Dak'Art brings artists, gallerists, art historians, curators, museum directors, critics, and collectors from across the world together in intimate spaces, offering unusual access to the participating artists. Perhaps this is due to the relatively modest size of Dakar in comparison to megacities like Lagos, Cairo, Nairobi, or Kinshasa—though certainly, the recent rapid growth and congestion of Dakar could confound even those well-acquainted with the city, so that finding some of the newer venues for the two hundred or so OFF exhibitions could be tricky. For Diop, the accessibility of Dak'Art amounted to a unique opportunity to photograph significant figures in the global art world, thereby documenting the scene, cementing his own place within it, and forging connections between major players.

First held in 1992, the Dakar biennial is considered the descendant of the 1966 World Festival of Black Arts (also known as FESMAN), organized just six years after Senegalese independence. The festival took inspiration from Léopold Sédar Senghor, poet, politician, and Senegal's first president. Senghor's philosophy of Négritude sought to cultivate consciousness and valorization of Black civilizations and cultures in the context of French neocolonial influences in the economy, politics, and beyond in the aftermath of independence. Dak'Art is indicative of how cities in the Global South once considered marginal to global capital are now on the front lines. If the Second World Black and African Festival of Arts and Culture, known as FESTAC '77 and held in Lagos, Nigeria, married cultural tradition and fast capitalism (Apter 2005, 22), Dak'Art foreshadows an unhinging of art and its commodity form. The biennial has emerged not merely as a global marketplace for African art but also as a space in which artists, including Diop, speak presently to historical experience through their work.[6] Many of the artists who display their work in this setting are not trying to simply produce work that will appeal to the global art community, but rather to express the experiences of Africans on the continent and in the diaspora.

From the early 2000s, Dak'Art has featured work that reflects the highly variable and changing experiences of artists across the continent and abroad; for example, what it was like to live and produce amid new religious formations and urban realities, including the expansion of unregulated forms of labor and housing in the context of deepening inequality. Indeed, Dak'Art has showcased the shared experience of the global as a state of precarity that could at once be the result of exclusion as well as intensive exploitation. Displaying contemporary works by artists with a shared historical and political consciousness, Dak'Art has become more than a space for transacting art: it is the authoritative space from which African artists speak about Africa.

The French Cultural Center, where Diop set up his mobile studio in 2014, serves as a cultural nucleus of Dakar during Dak'Art and throughout the year. It is frequented by artists, musicians, and academics, and hosts a library, a restaurant, a gallery space, a cinema, and an open theater for musical performances. It is one of the few venues frequented both by people who live in Dakar and by those who do not. Many artists recognize its centrality to art markets in Senegal, constituted as they are in the interpersonal connections and networks among artists, critics, curators, and buyers. At the same time, they often point to its fading relevance. It is located on the Plateau, the colonial center of town, but much of the action in the local scene has shifted to art centers on the outskirts of Dakar, with less congestion and larger villas, run by Black artists and

curators, including the Raw Material Company in the Dakar neighborhood of Rue 10 and the Black Rock residency in Yoff. Diop makes his home near Black Rock, and he takes photographs there, too. But at the French Cultural Center, he seemed to be positioning himself and his sitters in the midst of a global flow of images, people and ideas as well as, with the pop-up studio itself, a rich local history. Those same forces animate his work as a whole, which extends traditions for new audiences, creating new forms of connection and disconnection in its wake.

"LOVE LETTER TO THE FUTURE"

Despite this connection to global art and ideas, Diop's past is firmly rooted in Senegal's rich portraiture tradition. Although Diop was born in 1980 and came of age in the digital era, and works in a digital medium, his family's photo albums include vintage prints by well-known photographers. His mother descended from a prominent political family that had the means to sit for portraits from the very early days of photography. For example, the powerful political position of *Serigne Ndakaru* (leader of Dakar) was often chosen from her family, a prominent Lebou family based on the Cap Vert peninsula that is now Dakar. In 1878, the ruling Serigne Ndakaru was photographed by the well-known French colonial-era photographer Bonnevide (Hickling 2014).

A visit to Diop's Instagram feed shows his collection of family portraits, arranged in ways that invite viewers to see similarities and differences in portraiture practices over time. One post showcases a historic portrait of young women dressed for the Muslim Eid holiday with a commentary by Diop: "Grandma, her cheekbones and her grace." Her head is covered with a fancy scarf on one side, while on the other side, you can see thick coils of the wig worn by married women, threaded with French franc coins and gold and silver hair ornaments. This image follows Senegalese portraiture practices, which commonly reveal and conceal the body and bodily ornamentation as part of a politics of display, thus exhibiting women's wealth, value, and grace.

In another Instagram image, Diop sits on a couch beneath two framed photographs, which are positioned one above the other. The first and lower portrait is of his aunt, taken in 1972 by an unknown photographer. This image shows a frontal three-quarter black-and-white shot of a formally dressed woman. She wears a solid-colored boubou, a long flowing garment with loose sleeves, and several strings of beads. A floral motif printed on the photograph rings her portrait. The second framed portrait that sits above the first is also in black and white. It shows a head-and-shoulders portrait of a young woman whose body is

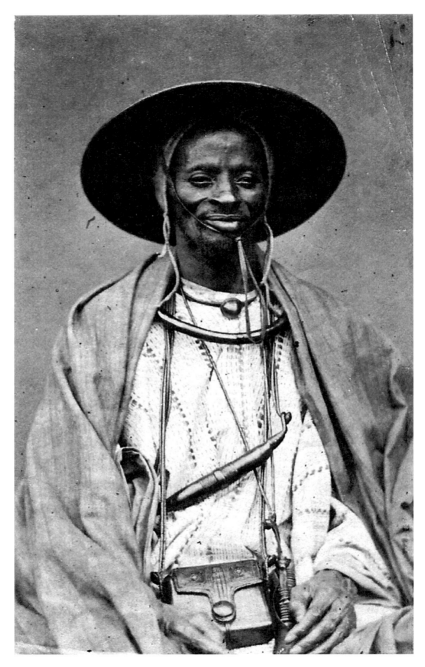

Fig. 5.1 Felix Bonnevide, *Serigne Ndakaru*, 1878. Collection Patricia Hickling.

turned entirely to the right (the viewer's left) with her head turned back to gaze at the viewer directly with a wide smile. Diop's own presence beneath these images positions him as an inheritor of this familial and photographic patrimony, even as it also shows him as a kind of curator in his own home and online. That pattern continues in another post, where Diop places two photographs side by side. One is a photograph of his grandfather taken by Mama Casset in 1946. The second photograph is a self-portrait. In this photograph Diop dressed like his grandfather, wearing a similar kaftan with a tight row of buttons up the front, a choice that emphasizes the family resemblance. The resemblance between these images works to pitch Diop as both the descendant of his grandfather and of Mama Casset. Through social media Diop asserts his patrimony, pictures himself in relation to it, and makes those relationships available globally. He thus engenders new forms of relationship, such as drawing connections between his patrimony and a well-known photographer to help firmly situate himself as inheriting the lineage of an important African artist and cast himself into a global art family.[7]

Even as Diop reflects upon photographic practices in the making of public reputations among families in Senegal including his own, he also concerns himself with visibility on a global scale. With the possibilities afforded by the digital medium, he says, "I am taking advantage of the technical possibilities now in terms of equipment and processing. The world is opening up to contemporary creation and provides a place for it." He characterizes many of *The Studio of Vanities* portraits as African and diasporic, and though he photographs his sitters in Dakar, their notions of self are not defined by their location. Instead, Diop asks his sitters how they wish to see themselves and be seen by others.[8] He then works closely with them to create wardrobes, backdrops, and props to reflect their views of themselves and how they wish to make themselves seen. He has called these portraits, past and present, "love letter(s) to the future,"[9] referring to the sitters' hopes and aspirations for themselves and their communities, and the photographer's skill in portraying them.

Diop's corpus of staged portraiture includes other works that extend both vernacular and documentary techniques to engage questions of self, history, and visibility. *Re-Mixing Hollywood, 2013* (with Antoine Tempé), for example, remakes images from major Hollywood films including *The Matrix* and *Breakfast at Tiffany's* to feature Black protagonists. *Project Diaspora: Self-Portraits, 2014* depicts figures posing as important Black historical figures, such as Frederick Douglass and Jean-Baptiste Belley, to address inclusivity in museums and in art history more generally. And *Liberté: Universal Chronology of Black Protest, 2016* restages scenes of Black struggle around the world. Portraits in this

Fig. 5.2 Omar Victor Diop, *Tête propre*, from the series *Fashion 2112: Le Futur du Beau*, 2011. *Courtesy Galerie MAGNIN-A, Paris.*

series include *Trayvon Martin, 2012*; *Selma, 1965*; and *Aline Sitoe Diatta, 1944*. While *Re-Mixing Hollywood* and *Diaspora* draw attention to the invisibility and marginalization of Black bodies in historical and contemporary spaces, *Liberté* documents the universality of Black struggle around the world.

Diop's work has found global success, but when he was accepted for his first major exhibition, the 2011 Rencontres de Bamako, the biennial of photography in Bamako, Mali, he said, "I literally screamed." At the time he was working outside of the art world for a company where he was "in charge of corporate events," and was acting as the emcee of an event that was a "major function with investors." Holding the microphone and scanning the internet for a joke, Diop happened to see he had received an email acceptance from Bamako Encounters. "There were five hundred submissions and they only picked twenty-seven and I was one of them," he said. He was so surprised that, forgetting himself, he shared his excited scream over the speakers with the whole room.[10]

The Bamako biennial, which began in 1994, has successfully positioned itself as the primary international biennial on the continent dedicated to photography. The event takes place at the National Museum of Mali, the Institut

Français, and several other venues. The biennial affords visiting artists with opportunities for networking and exchange, international exposure, and patronage. For example, participating artists have received invitations to show their work at Paris Photo, an art fair that features many of the world's leading photographers. Although the Bamako biennial did not begin with the intention of establishing itself as part of a wave of new biennials taking place outside of the dominion of biennials in Venice and New York City, it is now seen as part of that movement (Bajorek and Haney 2010, 264).

For the 2011 biennial, Diop showed his portrait series *Fashion 2112: Le Futur du Beau* (Fashion 2112: The Future of Beauty). In the series, Diop addressed issues of visibility in fashion photography by casting models of color, offered a commentary on environmental issues, and used his eye for textiles and other woven objects to focus on women's value. The futuristic series also lampooned fashion and fashion photography. The sitters wore haute couture, but the materials were of the everyday. For example, the series featured portraits of women of color wearing ensembles tailored from household objects such as cleaning rags, scouring pads, and butcher paper. In the head-and-shoulders portrait *Tête propre*, for example, the sitter, in a studio with a simple backdrop, faces the camera and looks directly at the viewer; her clothes tell the story. Her uncovered shoulders are turned slightly toward the viewer's left side of the frame. In her hair are a number of red and blue scouring sponges, a single stainless steel scouring pad, and a piece of red plastic netting also used for scouring pots. The portrait seems to borrow from both sculpture and architecture with its emphasis on form underpinned by the model's uncovered shoulders.

When I asked Diop why he was surprised to learn that his work had been accepted by the Bamako biennial, he responded, "The thing is, I have always looked at photography and always felt quite sad that I had never been to an art school." (In fact, many schools of fine art on the continent lack photography curricula.) He continued, "I come from a very corporate family. My father is a charter accountant, my mother is a lawyer ... and art." He paused and fell into laughter as he covered his face with his hand. He explained that in his twenties he had been working in corporate communications at Ernst and Young and British American Tobacco in Kenya and Nigeria, executing corporate strategies and developing messages for a variety of purposes inside and outside the corporation. Although his demanding work made it difficult to focus on his art, he continued to develop his practice in his free time.

While Diop may have felt like an outsider, that status seems to have increased his visibility in the global art world. Press coverage in the *New York Times*, the *Guardian*, and CNN has characterized Diop as a corporate-figure-turned-artist,

who, as one writer put it, "gave up a lucrative career to pursue his passion."[11] In these stories, his success seems so quick as to be instantaneous—a story that plays directly into the fantasies of those stuck in middle management around the world, some of whom also happen to also be art buyers. Diop understands the appeal of his life trajectory and employs it to increase his appeal to global curators and buyers.

In fact, Diop did not so much reject the corporate world as draw on its teachings to advance his artistic career. His corporate preparation, especially his fluency in English, facilitated his access to and navigation of global art spaces from afar (Grabski 2015). Drawing on "market logic," that is, his understanding of marketing and communications, he has developed a strategy and promoted his message (Grabski 2011). What's more, he continues to work in advertising and fashion photography, blurring the lines between these genres. His work in commercial photography helps him better understand and reach the audience of collectors and buyers for his artistic work. Diop's rapid career trajectory stems from his understanding of the links between the marketing of branded goods, the creation of art, and the valuation of art by the market. He can, in short, speak the language of the neoliberal art system, which prioritizes the market value of art (Nzewi 2015a, 11).

Through his marketing expertise Diop navigates the capitalist underpinnings of the art system, such as its notions of taste and its financial apparatus, that perpetuate the inequalities among artists based on the continent and those based in Euro-America.[12] Euro-American art curators, critics, and audiences have long romanticized African artists it sees as self-taught, rather than academically trained, and have been drawn to African art that meets their perceptions of primitivism, such as sculpture. They have thus collected primarily nineteenth- and twentieth-century objects. Artists based on the continent have had to overcome the legacy of colonialism and imperialism that underpinned collecting and the funding structures that supported this view of African art. Yet in recent years, lens-based artists have been able to make inroads into modern and contemporary art markets. Diop has experienced success through a combination of vernacular aesthetics, vibrant colors, large-format prints, and compositions that speak to European portraiture.

Some Senegalese artists endeavor to opt out of such international market pressures altogether. For example, Boubacar Touré Mandémory, who lives and works in Dakar and is known for his low-angled, unrehearsed photographic portraits of city dwellers, has long pointed out that the funding structures of the Bamako biennial favor French dominion over the event to the detriment of the agency of local artists.[13] French support of the Bamako biennial,

he maintains, has effectively created a center of photography that reflects the tastes and interests of French audiences more so than African audiences and artists across the continent. Mandémory and other artists have withdrawn their participation from the biennial as a consequence. And while many artists born on the continent pursue residencies and work in Europe where arts infrastructure and funding are more robust and opportunities abound, Mandémory has eschewed European residencies. Such residencies afford artists increased visibility, networking, and financial support to concentrate on their art, but he prefers to remain in Senegal. He invests the proceeds of his photographic work in his equipment and the communities in which he works. Rather than living in the city center near the Plateau or in the up-and-coming neighborhood of Yoff-Virage, Mandémory lives in the modest working-class neighborhood of Guédiawaye, northeast of Dakar.

Mandémory is not alone. Younger artists, radicalized by the exclusions and neocolonial domination of the arts in West Africa by France, have organized other funding structures, networks, and platforms for communication and exchange with artists across the continent (Bajorek and Haney 2010, 264). One such example is the Depth of Field, a photographic collective based in Lagos, Nigeria that emerged from the 2001 Bamako biennial. Similar moves have taken place around the festival Lagos Photo organized in 2010 by Africa-based artists to use photography to create social awareness. The documentary photographer George Osodi, known for his images of the Niger delta and the impact of the oil pipeline on people's lives in the region, has played a key role in supporting those endeavors.[14]

Omar Victor Diop keeps a home base in Dakar, but, unlike Mandémory, he has not been afraid to embrace the idea that, to circulate one's work, an artist also needs to circulate. That makes him a somewhat controversial figure in the local scene. Some Senegalese artists see him as an outsider with closer connections to Paris than to the Dakar working-class suburbs where many local artists live and work. While many African artists have turned away from the dominion of the global art system, Diop has embraced it. Moreover, he understands his own precarious visibility as he positions himself as an outsider to the art world and an African artist, and at the same time secures the signs and values of the Western art market such as having his work acquired by Fondation Louis Vuitton. Diop's global platform is further instantiated by his gallery representation in France through the collector André Magnin and his gallery Magnin-A.[15] Magnin turned Seydou Keïta's portraits of urban Mali in the 1950s into a series of global blockbuster exhibitions after seeing his work in Susan Vogel's *Africa Explores* exhibition in New York City (Keller 2014).

Importantly, the value of Diop's work rests not only in the hands of buyers and dealers but in the hands of the curators, critics, and art historians who also shape the circulation and appreciation of art. Diop is adept at speaking to the market value as well as the historic value of his work. For example, in his self-portraiture series *Project Diaspora*, he references distinguished historical figures. He dons their clothing and recreates their portraits, as in his portrait of himself as Frederick Douglass. His aim is to bring to light other little-known figures by including such a well-known historic figure as Douglass and as such, he draws attention to his work as a whole.

While Diop's work has been shown around the world in group and individual shows, he makes his home in Dakar, a city that serves as the context and motivation for his work. He has recently built a modest modernist house about twenty minutes northwest of the city, not far from Black Rock at Yoff-Virage. The American portrait painter Kehinde Wiley established Black Rock as an artist residency program. Wiley is best known for restaging heroic Baroque portraiture meant to flatter rich, White Europeans in ways that center Black women and men. His work addresses the absence of the Black experience in art museums worldwide, as well as the racial politics of representation more broadly. Named for the black volcanic rock that lines Dakar's beaches, the beachfront institution Wiley founded provides studio and gallery space, residencies, and funding for Black artists from around the world, so that they can, he says, "create work outside of a Western context."[16] Wiley also created the residency to provide a platform for Black diasporic and African artists on the continent.

Diop built his home along the long and winding Corniche highway that stretches from Yoff to downtown Dakar in proximity to major figures in fashion in Dakar. His neighbors include the showroom of the fashion designer and artist Selly Raby Kane; a shop run by Adama Ndiaye, also known as Adama Paris; and the gallery and residence of textile and interior designer and arts patron Aïssa Dione, who also designed Black Rock's cool, calm, modernist rooms. The geographic proximity of their homes and studios helps facilitate collaboration, but these artists also located their spaces beyond the city center dominated by the French Cultural Center, which many deem to be a relic of the domination of French patronage of the arts in Senegal. Like Mandémory, Diop does operate outside of French patronage of the arts on the continent; yet, unlike Mandémory and others, he has achieved global status by crossing over into fashion photography and advertising. Through these endeavors he stands among a few artists who can afford to be based in Dakar, in a wealthy enclave no less. But he also must navigate the challenge of claiming his position as an

African artist, while continuing to navigate his standing in the global art world. His *The Studio of Vanities* series is part of his attempt to do just that.

CUT FROM THE SAME CLOTH: *THE STUDIO OF VANITIES*

The Studio of Vanities series consists of portraits of influential figures in art, music, and fashion on the continent and in its diasporas. While many of the portraits in the series were shot at Dak'Art, many more of these staged portraits were created in Diop's studio. Diop renders these large-scale, high-resolution, high-gloss, and archival-quality digital pigment inkjet prints in sharp, vivid colors, and frames them behind museum-quality glass.[17] Diop's portraits of movers and shakers look like those in the glossy 1950s illustrated magazines like *Bingo*, with poses and expressions that pay homage to midcentury portraiture in West Africa. He portrays his generation's unique aesthetics and ambitions, and describes the series as "staged portraits of Africa's contemporary urban scene ... a gallery built in the tradition of our legendary portrait masters."[18] Of his turn to a digital medium, Diop says, "it makes sense to recreate this tradition of studio photography and to update it with technological advances."[19] For example, Diop reprises the riot of patterned clothing and backdrops favored by some midcentury portrait photographers such as Seydou Keïta, to whom critics often compare his work. And yet, Diop's strategy of hypersaturated colors contrasts sharply with Keïta's crisp black-and-white photographs and contributes to his efforts to create a novel vernacular language of the visual.

Diop layers colors, textures, and lighting in these images, using rich textiles and sometimes props to add depth and complexity to his sitters' self-presentation. He gives the photographs a painterly visual plane, an impression he deliberately enhances during postproduction, using digital editing to help the photographs resemble fine oil paintings. Diop emphasizes poses and compositions that blur the supposed boundaries between West African studio photography and European portraiture. This puts Diop in the company of other modern and contemporary artists, such as Wiley, who update and rethink classic works of art.

Diop's photography also disrupts canonical notions of portraiture long held in the West and redefines the genre in response to new audiences. European portrait painters and their American descendants presented a likeness or a social biography (Borgatti 2013; Brilliant 1991). In his series *The Studio of Vanities*, Diop takes these conventional notions of portraiture that are based on preserving the likeness of a sitter and pushes toward the realm of fantasy. To do so he draws on the aesthetic, material, and sensual qualities and compositional

strategies of prominent midcentury photographers who owned studios in Senegal and the surrounding area. Their portraitists conveyed a message of social identity that was achieved through the aesthetics of self-presentation including compositional centrality, shallow picture space, backgrounds and props, and surface and light. Omar Victor Diop recasts the multilayered aesthetics and visual strategies of midcentury portraitists to capture this aspirational, future-oriented view of the self and the potential of the camera, while he also devises new visual strategies to index the complexity of his sitters' identities. Unlike European portraits that focused on producing their sitters' likeness, Diop's images are not static but rather convey his sitters' potentiality and their multifaceted identities.

Even though portrait photographers of the past were at times itinerant or migrants—such as Tijani Sitou, a photographer of Nigerian origins who settled in Mali—their corpus is often portrayed in the present in an ethnic or nationalist frame, a classification common to art history. Seydou Keïta and Malick Sidibé are celebrated as Malian photographers, and Mama Casset and Meïssa Gaye as Senegalese photographers; never mind that Gaye later traveled extensively as a *fonctionnaire*, a sort of bureaucrat in the French colonial order, or that sitters themselves often traveled. In response to these portrayals, Diop's corpus has sought to destabilize the nationalist categorization by linking Africa and its diasporas as he interrogates articulations of the near and the far, global currents, and conversations over time. For example, in *Liberté* he chronicles global Black struggles and in *The Studio of Vanities* he stages diasporic identities. Diop further transcends the nationalist frame through his focus on individuality and interrelatedness, much in the way that photo albums provide pictures of individuals as well as families, showing links across age grades and generations and capturing individual and collective identities.[20]

As much as Diop's work has been compared to the work of Seydou Keïta and Malick Sidibé, he contends that Mama Casset, the photographer his father patronized in Dakar, remains his strongest influence. Diop says, "Sidibé did studio photography but even the studio photography had this journalistic feel to it." Both his portraits and party pictures had titles that seemed filmic, or as Diop sees it, "like articles' titles, *The Christmas Night in Bamako*." Keïta, on the other hand, titled his photographs with the names of his sitters, and in *The Studio of Vanities*, Diop does the same. "Sidibé is about movements," Diop explains, "where Seydou Keïta and Mama Casset were about people."[21] In such work, the scene does not obscure the sitters' identities—the sitters are the scene. They shine. They are not limited by imposed geographies or categorizations of who they are.

Some of the sitters in Diop's *The Studio of Vanities* series hail from Dakar, and others work as artists—in music, film, fine arts, fashion—who are traveling through Dakar. Whether Diop has photographed them on location at Dak'Art or in his home, he draws on the practices of both ambulant and studio-based commercial photographers from midcentury. Like Ibrahima Thiam, he employs his own mobility to capture the imagination and attention of his global body of artists, who are themselves also often traveling from one event to another. Diop explains that he does not think of himself as bound to a single studio. "I always say that my studio is in my suitcase because all I need is a wall and my single light."[22]

Diop, like many midcentury West African photographers, approaches the set as a space of play and fantasy and encourages sitters to do the same. In so doing, he destabilizes the assumption that the photographer's point of view dominates the frame. Diop, like many other photographers, grapples with the way in which colonial photographers created naturalistic photographs that appeared to be unmediated by the photographer to establish facticity. He also grapples with anthropological approaches that relied on reenactment to serve the evidentiary strategy of replicability to demonstrate facticity that underpinned nineteenth-century science. Colonial-era photography, especially portraiture, also had a stillness to it, as a feature of the technological limitations as well as of ideas about documentation and scientific method. In contrast, Diop approaches photography as a collaborative performance in terms of pose, composition, and backdrops and props. In his portraits sitters look directly into the camera, reflecting the collaboration between them and the photographer, revealing a performance (Firstenberg 2001). Azoulay describes this process of sitting for a portrait as an encounter (2010, 11). Rather than focusing on the opposition between sitter and photographer and privileging the vision of who is behind the camera, an encounter focuses on the articulation of the sitter's desires and the photographer's vision.

In expanding on his collaborative approach with his sitters, Diop said, "It's a conversation. They get to ask questions, and I get to ask questions too."[23] For *The Studio of Vanities* portraits taken in his home studio, the process was "a meeting, a mutual discovery. The subject is always someone I know; someone I have bumped into or been introduced to. I am always the one who suggested that we should do something together, it is more like an invitation, let's do something together rather than me summoning them," he said. "From there it is a conversation—Do you know what you are going to wear? Maybe we can go shopping together? Or maybe you can come over and see what I have in store? Or do you want us to order something from a tailor?—So it is something that

we always do together. It is always a collaboration and then we are always alone in the studio, there is no viewer, no makeup artists, no third party because it needs to feel like you are coming over for coffee or something. It is always in my apartment."[24] This process is indeed an encounter, a meeting in which both sitter and photographer collaborate to advance their respective reputations. The resulting photograph then "contains both more and less than that which someone wished to inscribe in it" (Azoulay 2010, 12).

Through this process, Diop forms relationships with his sitters through which he constitutes his new vernacular language that is both of and beyond his locality. For Diop, these visual strategies succeed when they draw on local ways of seeing, so he tries to create an atmosphere that permits his sitters to fully express themselves.[25] He explains, "I really want us, by the time that we are done with the shoot, to have the feeling that we worked together and that we have achieved something together."[26] Diop's series reflects both his own artistry and his relationship with his sitters whom he seeks to help feel at ease during the shoot. He describes how he works: "Monday afternoon I am shooting but you would be surprised by how short the session is, it is probably five to ten minutes," thanks to work done ahead of time to select "a good combination between background, the clothes." He continues, "You know what will be easy for them, people need to be in a safe space. It isn't fashion photography, it's not an advertising campaign, there is not an objective—and so you know I have this conversation with people, and it happens very quickly," before sitters begin "getting tired and getting tense."[27] The "first or second picture," he says, tends to be "the good picture."[28]

Consider two portraits of Selly Raby Kane and Mamadou Diallo taken in Diop's home studio for *The Studio of Vanities*. Diallo, a Columbia University–educated arts writer and critic, writes and publishes widely on the arts scene in Dakar and beyond. He contributes frequently to *Chimurenga* magazine, based in Cape Town. Selly Raby Kane, the creator of the fashion line SRK, mixes high and low fashion, combining locally woven and manufactured African wax-print cloth with high-end fabrics in her designs, not unlike Diop's portraiture. Kane is a successful designer. Among her many collaborations, the most widely known is with IKEA, and in 2016 Beyoncé was photographed wearing one of Kane's kimono designs with a shrimp motif. Both visible figures in the local art scene, Diallo and Kane have helped it ripple out internationally.

The portraits of Kane and Diallo are like those from the pages of a family album, in that they consist of an individual portrait of each figure as well as another in which they are photographed together. The portrait in which Kane and Diallo appear together reflects doubles and twins portraits across West Africa,

in which the sitters dress in similar clothing and stand in a mirror relationship to each other or next to each other, often with their bodies touching (Micheli 2008, 67). Sidibé employed this technique, indexing Bamana social values of *badenya* and *fadenya*, cooperation and competition, among siblings, co-wives, initiatory groups, youth clubs, and professional colleagues in his compositions by placing sitters next to each other with their bodies touching (Keller 2013b). Some viewers suggest that such doubles and twin portraits are too staid, often because of their symmetric composition; however, Diop uses this genre to great and dynamic effect to show the complementarity between the Kane and Diallo. He explains that he thinks deliberately about the relations between sitters in his portraiture, which might involve the collaboration of *doom-u-ndey* (mother's child) or the rivalry of *doom-u-baay* (father's child).

Diop thus depicts familial relations between Kane and Diallo in his composition. Kane stands with her right arm on the shoulder of Diallo, who is seated next to her. Their pose appears open and inviting. Their composition creates a diagonal line through the center of the pictorial space. The top left corner features the muted horizontal stripes of the backdrop sewn from narrow bands of locally woven and dyed cotton strip cloth. In the triangular space below, Diallo and Kane wear high-contrast, bright orange, contemporary couture pieces from Kane's Dakar-based line, SKR (for which Diop created the look book)—a similarity that suggests they are cut from the same cloth. The locally woven strip cloth background has historically symbolized women's wealth and value, making it an appropriate foundation for the global launch of designer and critic.

In portraiture across West Africa, photographers often focus on the placement of sitters' hands to show connection and intimacy. In this portrait, Diop has posed Diallo and Kane so that their outstretched hands contribute to the relaxed nature of the pose and the comfort that the sitters have with one another. They lean toward each other, their bodies touching, in a pose that both implies and creates a warm affective bond. The portrait suggests collaboration and rapport between artist and critic.

In her individual portrait, Selly Raby Kane stands, suggesting the full scale of her importance, as this pose also did in her picture with Diallo. Her body faces slightly to the viewer's left, but her head is turned toward the viewer. In a technique borrowed from fashion photography, Diallo hung a locally woven orange-and-blue checkerboard strip cloth behind her, and laid a black-and-white-striped woven wool textile on the floor. The textiles create movement, shadow, and depth, as well as suggesting a connection between the local textiles and Kane's own creations. The checkerboard motif of the backdrop matches the rust color of her coat and echoes and enlarges the checkerboard weave of her

Fig. 5.3 Omar Victor Diop, *Selly Raby Kane*, from the series *The Studio of Vanities, since 2012*. Pigment inkjet print on Harman by Hahnemuhle. 90 × 60 cm. Courtesy Galerie MAGNIN-A, Paris.

Fig. 5.4 Omar Victor Diop, *Mamadou Diallo,* from the series *The Studio of Vanities, since 2012.* Pigment inkjet print on Harman by Hahnemuhle. 90 × 60 cm. *Courtesy Galerie MAGNIN-A, Paris.*

pants. Diop has created a diagonal line with her body, so that the upper-left side of the picture is brighter and lighter than the lower-left side, which is in shadow. The light, amplified in part by Kane's white shirt, illuminates her forehead and cheekbones and directs the eye toward her face. It also creates a slight shadow behind her, suggesting a three-dimensional presence befitting the complexity of her social persona. She seems confident, intent on being seen on her own terms—an impression enhanced by the presence of a single prop, a locally crafted wooden stool, turned on its side, on which Kane confidently places her right foot suggesting an upward ascent, perhaps of her career or her celebrity.

Such simple, serviceable stools, assembled from rough-hewn wood, are found in bars, shops, and homes throughout Dakar. One shows up in the bottom third of Diop's portrait of Mamadou Diallo, too, but here, Diallo sits upon it, its sharp corners providing a sense of texture, weight, and dimension. The stool underscores Diop's proficiency in bringing together the local vernacular with other art historical traditions. And it suggests that local creations work as both the stage and the resting place for Dakar's younger generation. Diallo leans forward from his waist, his strong hands clasped in front of him, as he looks directly out at the viewer. He appears as an attentive listener and

observer, leaning toward the exterior of the frame, as though eager to engage in conversation. The movements of his body suggest the attentiveness of the critic. His white shirt, like Kane's, reflects the light upward toward his face which occupies the top third of the portrait. Like her, he wears rust-colored garments—his pants and details on his sweater—and is positioned in front of a piece of locally woven strip cloth that harmonizes with his outfit, in this case, the aubergine of his sweater. The backdrop consists of alternating bands of silk and cotton fabric, some deep and solid, others with bright silver Lurex thread woven in complex patterns. Some bands repeat these patterns and others change, emphasizing again relations of similarity and difference, cooperation and competition. Seen as a group, the individual portraits of Kane and Diallo, together with their paired portrait, suggest a complete ensemble, characterized by similarity and differentiation. In this and in other portraits in Diop's series he casts his sitters in a family relation. He turns to photography to explore and create bonds within the art world.

CLOTH AND COUTURE: PATTERNS OF BELONGING

The patterned backgrounds Diop chooses in his portraits of Kane and Diallo work as key compositional elements for the whole of *The Studio of Vanities* series. They enhance his sitters' performances of visibility and suggest particular ideas about their social personas. Diop's backdrops include locally woven strip cloth, vinyl tile, woven mats, and machine-made cloth. He selects and sometimes has backdrops sewn to coordinate—sometimes via harmony, and sometimes contrast—with his sitters' fashion choices. Oftentimes he commissions couture fashions for his sitters from local tailors whom he patronizes in markets surrounding Dakar, such as Colobane. His use of textiles pulls on a range of emotions, sensations, and experiences—his own, those of his sitters, and those of his viewers. He creates a sensorium through his lens using contrasting colors that conjure powerful images and harmonizing colors that produce peaceful renditions.

These explosions of color appear above the vinyl tile that is ubiquitous in the self-built homes throughout the city of Dakar because it is so much less expensive than ceramic and porcelain tile. Residents often lay vinyl tile over cement floors and, when the elements dry out the adhesive and the tiles can be moved, the space underneath them becomes a convenient place to stash religious tracts, love letters, and even cash. Diop's use of local materials such as vinyl tiles and the unfinished wooden stools suggest a distinctly local, everyday sense of absurdity and fun that cannot easily be read from elsewhere. For

Dakaroise, however, such features are immediately recognizable. How these portraits are read thus depends upon the viewer's context; for some foreign viewers, the colors, vinyl, and wooden objects merely add vibrancy and interest to the work, while for locals they ground the portraits firmly in a meaningful place. This is just another example of how Diop navigates between appealing to where he came from and the broader global art world.

While some photographers, such as Philip Apagya in the Ivory Coast, rely on realist backdrops, Diop uses textiles to bring out his sitter's personality and to point to the vitality of arts and culture in Dakar, marking it as a global city with a particular character. He selects his backdrops from his personal collection of textiles. "I have a huge collection of hand-woven fabrics from all of West Africa from Nigeria to Sierra Leone. If you saw my mom's collection you would see that some of them are from her mom, and you have to be very careful, because they can be torn apart,"[29] explained Diop. In fact, the strip cloth hung for Selly Raby Kane's portrait shows its age, with portions where the dye has faded, as well as its handcrafted nature since some loom threads are still attached.

This fabric is deeply meaningful for the artist. Diop says, "I can't even explain what the relationship is when I touch a fabric and when I smell it, I am like, 'This is what I am, it is my link.'" His description evokes Paul Stoller's (1997, 10) observation that ways of knowing and remembering are often embodied and that it is the senses that trigger cultural memories. In Senegal, these memories are often linked to and evoked by the feel and scent of textiles worn by family and guests, by flipping through photo albums and talking about life unfolding around them, as well as by the fine dust that collects on framed images hung on walls and surrounding televisions.

Such cloth also has important meaning more broadly in Senegal. Women commission fabrics to memorialize and enlarge important occasions and persons, including International Women's Day, the visit of the Pope, the election of a political candidate, and, more immediately, significant family milestones. Sometimes they collectively purchase commemorative cloth with a portrait printed on it to commemorate a political or religious figure; other times they purchase locally dyed, woven, or imported cloth so that they can wear matching outfits. Cloth also serves as a form of wealth and value for women that they may pass down to their children (Buggenhagen 2011). "When a woman is expecting a child," Diop told me, "the husband's sister or cousin will order the fabric that will be given at the *ngénte* [naming ceremony] and she [my mom] gave it to me then." His mother laid aside the cloth she was gifted at Diop's naming ceremony for him. He continued, "I still have it. Of course, I will still always have it. It was made for me. It is as old as me, we have the same age, and when I die that

is what they are going to take to cover me in my grave."[30] Such locally woven textiles make powerful and evocative backdrops for his portrait photography, evoking both personal and collective sentiments.

Diop's work is often compared to Seydou Keïta's based on their juxtapositions of patterned backdrops and dress. Diop's colorful, textured backdrops, he points out, can give the impression of a collage, such that the sitter's face appears to be floating in a sea of African-print cloth. As Momodu-Gordon describes Diop's use of pattern, "every inch of the photograph is covered by color, form, or figure, creating an all-over pattern evocative of the textiles the image depicts" (2017, 267). Keïta's formal portraits similarly included "overlays of fabric patterns, ornaments, props, textures, poses, and gestures" that created layers of meanings, and that worked, as one writer puts it, as "signs evidencing key roles in various mechanisms of self-fashioning" (Firstenberg 2001, 176). These portraits worked as both personal commemoration and aspirational new order. Diop's *The Studio of Vanities* suggests the achievements of such aspirations: his sitters are globally known as cultural figures.

Keïta would create a single visual plane that both flattened the image and allowed the subject to pop or burst forth from it,[31] and Diop does the same. As he puts it, "there is not much depth of field in my pictures, even when it is fashion photography. I tend to flatten things out because I see the elements of décor as items that have as much importance as the subject." Even in these shallow fields, though, the subject achieves prominence. Consider two images, one by Seydou Keïta and a second, *Aminata* from Diop's *The Studio of Vanities* series. In the full-length Keïta portrait, two co-wives stand with their bodies facing each other. Their heads are turned, looking out at the viewer with solemn expressions. Their locked arms speak to relations of solidarity. In the monochrome print, the combination of the patterned backdrop and the patterned, floor-length boubous worn by the two women obscures their bodies. As a result, the viewer's eye focuses on the women's facial expressions and hands on which the light falls.

In comparison, in Omar Victor Diop's *Aminata*, the fashion model Aminata Faye poses in a flowing, loose-fitting red and green boubou created from ten meters of cotton cloth. She wears the headscarf of a married Muslim woman, made from the same fabric. The pattern of the boubou repeats that of the backdrop, which is of a contrasting yellow color. The effect is that her body fades into the background, with the exception of her face and shoulder. "It almost looks like a collage," Diop says of the portrait, but "God knows it is real." A patterned backdrop, Diop says, "drives the eye toward a central feature of the image, usually the hands and the face."[32] Indeed, Amanita's face, shoulder,

Fig. 5.5 Seydou Keïta, *Untitled [Seated Woman with Chevron Print Dress]*, 1956 (printed 1977). Gelatin silver print, 24 × 20 in. © *Metropolitan Museum of Art, ART409182, 1997.364.*

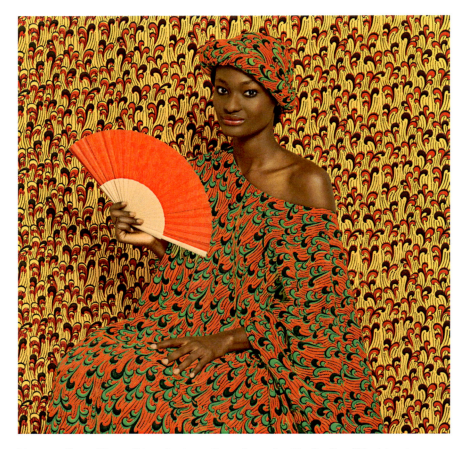

Fig. 5.6 Omar Victor Diop, *Aminata*, from the series *The Studio of Vanities, since 2012*. Pigment inkjet print on Harman by Hahnemuhle. 90 × 90 cm. *Courtesy Galerie MAGNIN-A, Paris.*

and left hand—whose elongated fingers are a sign of high status among Wolof women—pop out from the bright, vegetal patterns that surround them.

This technique does more than attract attention. Diop seems to be alluding, in this portrait, to the politics of revelation and concealment common to Senegalese women's dress and gift-giving practices. Such poses were common in portrait studios across Senegal and Mali from the 1930s where women allowed a garment to hang off one shoulder. Combined with smoldering eyes with lids half closed and bodies turned away from the camera, such poses also speak

to women's competition for reproductive potential. Muslim clergy have often criticized as irreverent the practice of cutting the hole ever larger in the top of the boubou to reveal more of the body. Yet the female body has often been depicted in European portraiture in ways very similar to this, as well as in the modern history of fashion photography. Aminata Faye's own career spans the locations and conventions of these visual histories. She studied finance in Paris (where she also competed as a professional volleyball player) and became interested in modeling in 2010 after she returned to Senegal. She has participated in the Dakar Fashion week but currently lives and works in New York City as a professional model.

According to Hansi Momodu-Gordon (2017), Diop's choice of contrasting colors of red, yellow, and green in *Aminata* echoes the colors of the Senegalese flag and makes a complex statement about national pride and cooptation of that identity by European and Chinese factories. Diop often uses a type of fabric popular in Senegal known as fancy cloth, African-print cloth, or wax-print cloth. The cotton fabric carries bold designs and is dyed in highly saturated colors with industrial dyes, in a wax-resist dyeing process that leaves vein-like crackles on the fabric.[33] Wax refers to the resin that is used to create the design. In the 1950s and 1960s, wax-print factories started opening in West Africa in countries such as Mali, Senegal, Cote d'Ivoire, Ghana, and especially Nigeria. Wearing these fabrics suggested pride in a pan-African identity.[34] Today wax-print cloth remains linked to African fashion and identity and is worn in a variety of circumstances from everyday wear to business settings to formal wear. Yet many of the West African wax-cloth factories, including GTP (Tex Styles Ghana Limited), Woodin, and Uniwax, have been taken over by Vlisco, a Dutch manufacturer, or by Chinese conglomerates. Those that remain under African control face steep competition from fakes manufactured by companies in China. Diop's portraiture series from *The Studio of Vanities* to *Wax Dolls* interrogate these complex global relations underpinning sartorial statements made with wax-print cloth that is often associated with African subjectivities.

Diop seems to extend this critique by having Aminata Faye hold an open, bright red imported mass-produced fan in her right hand. Its half-circle shape directs the eye toward her face. The fan also creates a diagonal line across the image, in contrast to the diagonal line of Aminata Faye's body, giving the viewer a sense of motion (another technique commonly used in fashion photography). Senegalese portraiture sometimes uses fans as props to draw attention to the sitter's face and her movement through social life, yet this fan is not an *oppukay*, a type of fan woven from grass that older, rural women often carry and which historically was often used in portraiture. It looks like it was bought in

the Chinese-dominated market stalls selling imported factory-made goods along the Centenaire neighborhood.[35] If so, this could be another way Diop explores and critiques both the popularity and the disdain expressed in social discourse of goods produced off the continent, often to the detriment of the local economy. His attention to issues such as these keeps his work firmly rooted in this region, although its global circulation also draws attention to similar concerns elsewhere.

Diop explains his use of such props as part of the "codes from this West African studio photography tradition."[36] Photographers such as Keïta, Sidibé, Casset, and Abderramane Sakaly (of Moroccan descent, but born in Senegal) indexed their clients' modernist aspirations by including bicycles, motorcycles, telephones, and radios in their studio photography (Bigham 1999; Haney 2010; Nimis 2005; Keller 2013a, 2013b, 2014). Props let sitters play with artifice and realism and added tactile complexity. The surfacist use of light and textural details in many such photographs that create multifaceted identities helped counter colonial representations that tended to portray a singular identity often based on ethnic labels (Pinney 2003, 210). Yet the practice has a longer lineage. Centuries earlier, European portraitists had used similar, surfacist techniques that they employed to bounce light off their oil paintings in ways that reenforced a sense of opulence and power (Thompson 2015, 192).

Both West African photographic and European painterly traditions are on display in Diop's *Elise Atangana*, which features a surfacist sheen that enhances his judicious use of props. The portrait is part of *The Studio of Vanities* series, shot in his pop-up studio at Dak'Art 2014. Curator Elise Atangana, normally based in Paris, was in town to co-curate the international exhibition of the eleventh Dak'Art with Abdelkader Damani and Ugochukwu-Smooth C. Nzewi. Atangana sits at a slight angle in a dark, straight-backed wooden café chair, her head turned so that she looks squarely at the viewer. The café chair is more polished than the unfinished wood stool made from two-by-fours in *Selly Raby Kane*. Her legs are crossed at the ankles; her right arm rests in her lap; and her left arm is raised to her neck, drawing attention to her face. The stack of four wide bracelets on her wrist—they are wrapped in African wax-print cloth in the nationalist colors of black, white, yellow, and red—also pulls the eyes up, as does the reflection of light upwards from her simple white dress. Light floods the portrait, creating a slight shadow behind the chair, glowing in long bars down her body, and bouncing off her white dress onto her face.

Whereas *Aminata* shows a figure relatively close-up, her feet well out of the frame, Atangana appears further from the viewer, emphasizing her stature and distinction. Other than the bracelets, the palette is neutral, with a pale,

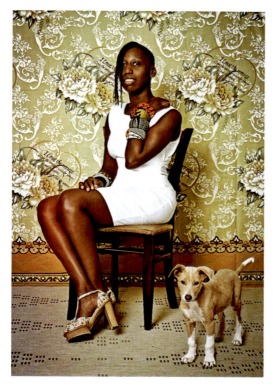

Fig. 5.7 Omar Victor Diop, *Elise Atangana*, 2014, from the series *The Studio of Vanities, since 2012*. Pigment inkjet print on Harman by Hahnemuhle. 90 × 60 cm. © *Omar Victor Diop. Courtesy Galerie MAGNIN-A, Paris.*

woven floor mat and a beige backdrop covered in white and gold cabbage roses, scrolls, and the text "I love the nature." This may be meant as an ironic jab at conspicuous consumption and cheap labor, given that the only nature on view here seems to be the raw materials that were turned into artificial representations: plants processed into fabric and paper on which flowers are printed. Or perhaps it refers to the tame animal near Atangana's feet: a small, buff-colored dog with a diamond collar. Dogs were often depicted alongside their owners in European portrait paintings as a sign of wealth and control over the natural world. Overall, the combination of aesthetic conventions and props reflects both local traditions and global achievement, as well as the particulars of Atangana's own individual identity.

Elise Atangana, like Diop's other depictions of global cultural figures, highlights the performative aspect of "being seen being seen," as Krista Thompson (2015) puts it. A unifying thread of pan-African and diasporic identity, of transnational Blackness (Beliso-de Jesus and Pierre 2020), is the shared experience

of exclusion, exploitation, and invisibility. Photographic portraits offer an alternative, a modality in which "diasporic subjects engage in a shared performance of visibility" (Thompson 2015, 10). Writing about Indian photography, David MacDougall explores the concept of *darshan*, the ability of sitters to see those who regard them (2006, 173). Something similar happens in portraiture like Diop's, because the sitters are given power and agency: they are not just looked at; they look back. These works are performative and political, and Diop's use of his sitters' names as titles furthers the cause, attaching the representation to the real.

In his artistic practice, Diop continually thinks about the frame of Euro-American art and what is left out, what is not seen, and how to expand that frame. That interest came through powerfully when Deborah Willis, curator of the *Framing Beauty: Intimate Visions* exhibition at Indiana University in 2017, placed portraits by the painter Kehinde Wiley and Diop in a diagonal position to each other on adjacent walls. Diop's portrait *Frederick Douglass* features Diop portraying a young Douglass, who was among the most photographed American men in the nineteenth century, having had over 160 portraits taken to counter racist imagery.[37] *Frederick Douglass* is part of the series *Project Diaspora: Self-Portraits, 2014* in which Diop photographs himself in the role of important Black figures in history. His placement of football (soccer) props in the frame—a yellow whistle replaces a pocket watch—calls attention to racial inequities. By centering sports paraphernalia in this portrait of a civil rights leader, Diop suggests how many other pathways for success often remain closed off for Black individuals. Diop's portrait replaces the oval frame of the early daguerreotypes taken of Douglass with a circular frame in a square photo with the aspect ratio of an Instagram post, thus firmly locating the image in the present. Diop, as Douglass, appears in front of a blue-and-green paisley backdrop and behind a vest tailored in the same pattern. He is both in front of and behind the backdrop, as it were. In this fashion, Diop brings studio portraiture to a global audience that may be more familiar with soccer and Instagram aesthetics than with West African portraiture conventions. This piece is part of his larger project to engineer new relations through portraiture including across the art world, within the diaspora, and through history.

The exhibition layout put Diop's Douglass in conversation with Wiley's *Ena Johnson, 2012*. Both portraitists approach background and foreground similarly. Like many of Wiley's figures, Johnson is dressed in a couture ensemble—a white dress by Riccardo Tisci—and set against a floral backdrop with blue, red, and yellow paisley. As one writer puts it, Wiley often "engages the signs and visual rhetoric of the heroic, powerful, majestic and the sublime in his

Fig. 5.8 Kevin O. Mooney, Gallery photographs of *Framing Beauty* exhibition. *Courtesy of Grunwald Gallery, Indiana University.*

representation of urban, Black and brown men found throughout the world."[38] Here, the tendrils from the backdrop wrap around the front of Johnson's skirt. The sitter is both in front of and inside of the patterned surfacist detail, pushing the viewer to question which one has representational domination. As Thompson suggests in reference to Wiley's paintings, "the difference between the figure and the ground, between human and object, between the subject of portraiture and the surface of the decorative, and between the individual and the global becomes interpolated and flattened" (2015, 245). As a consequence, the sitter bursts through the frame and pieces of the backdrop swirl in front of them.

Wiley relies on his art-going audience to read his layered references to European portrait painters, but Diop also relies on his audience, at home and abroad, to read the signs of midcentury portrait photographers from West Africa layered in his portraits. Both the Douglass portrait and those in *The Studio of Vanities* echo sensibilities that were commonplace in the abundant, midcentury

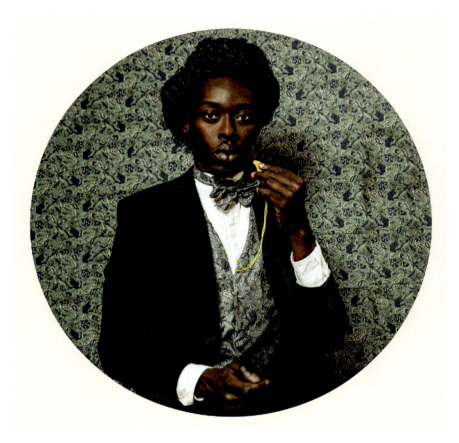

Fig. 5.9 Omar Victor Diop, 2015 *Frederick Douglass* from the exhibition *Framing Beauty*. 90 × 90 cm. *Courtesy of Grunwald Gallery, Indiana University.*

urban portrait studios, including use of props, patterned fabric, and particular poses. Diop thereby elevates and creates new contexts for vernacular portraiture practices in West Africa. At the same time, he hooks into the lucrative market for vintage portraiture from the heyday of West African studios, as well as the growing demand for contemporary lens-based art from the continent. He and Wiley both appeal to their generation's aesthetics by employing vibrant colors and bright faces as well as studio lighting that flatters sitters and emphasizes their power and influence as cultural figures, even celebrities. These are images that pop on Instagram feeds and other digital platforms—a circulation that serves to further sitters' and artists' visibility.

Fig. 5.10 Kevin O. Mooney, Gallery photographs of *The Studio of Vanities, since 2012* and *Project Diaspora* by Omar Victor Diop. *Courtesy of Grunwald Gallery, Indiana University.*

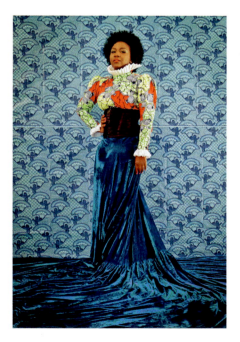

Fig. 5.11 Omar Victor Diop, 2011, *Khady Niang*, from the series *The Studio of Vanities, since 2012*. Pigment inkjet print on Harman by Hahnemuhle. 60 × 90 cm in. © *Omar Victor Diop. Courtesy Galerie MAGNIN-A, Paris.*

In all of his portraits, Diop works to navigate the past and the present, the methods of midcentury West African photography and contemporary techniques, and his place as an African artist who has made a splash in the global art world. Diop's portrait *Khady Niang* combines all of these influences—digital and painterly, European and African, old and new—to display the Dakar-based makeup artist in a heroic position. Khady Niang Diakite, of Red Lips Beauty, has participated in Dakar Fashion Week and FESMAN, and was the chief makeup artist for the film *Timbuktu*, directed by Abderahmane Sissako, which received the Palme d'Or at the Cannes Film Festival. Diop took her picture from below, using what Nigerian photographers call the "hero pose" (Sprague 1978), to emphasize her high status. We see her whole body, and her long, blue velvet skirt extends well beyond her feet, across the floor, and outside the frame, swirling like an ocean riptide, gathering everything up as she rises from its center, almost like a mythical water spirit. Her right hand is on her hip, her left leg slightly forward, and her body turned on the diagonal, with her face tilted up and her eyes angled slightly down so she can gaze directly at the viewer. Her bodice has puffed sleeves at the shoulders, with starched, frilled white cuffs at her wrists and a standing white collar—a ruff—at her neck. Collars and cuffs of this sort are often associated with the aristocracy of the European Renaissance and thus evoke this older portraiture tradition. She wears an under-bust corset laced up on the exterior of her dress—an exterior version of an older style—yet the bodice itself is sewn from brightly colored African wax-print cloth, thus highlighting her importance in Senegal. It, along with her face, is the focal point of the photograph, set off by the otherwise blue picture plane of the skirt and a printed backdrop. While the cloth is so flat that it absorbs the light, other light creates a play of shadow and depth. Diop lights her face from the side, and the shimmering light reflecting off the velvet skirt and onto her face helps concentrate the viewer's attention there. The overall effect is of a powerful individual with a multidimensional personality.

Diop's work focuses on individual figures like Khady Niang to build upon both African and European portraiture traditions and extend them in new directions. In his hands, the legacy of young women parading in front of the camera for itinerant photographers at baby-naming ceremonies, marriages, parties, and Muslim celebrations serves as a foundation for capturing a new generation of global leaders and cultural producers. His figures, like those of the past, occupy linked networks in which they, and in turn the artist, emerge both as powerful individuals and also as part of a broader artistic collective. At the same time, Diop pushes the boundaries of the aesthetics of the genre, not just by the inclusion of underrepresented groups but also through what Pinney

describes as capturing "a world of surfaces and materiality that reach out to their embodied viewers" (2003, 218). Bright colors, saturated visual planes, and assertive faces gazing out of the image's frame make up a new kind of album, or perhaps, a set of cartes-de-visites. Circulating in museums, galleries, and reproductions, they both portray and stitch together strong communities of creators who are rooted in the past and their cultural patrimony while also very much welcoming and shaping the future. These techniques both center and decenter the sitters, entangling them with cloth, flooring, and props that conjure up a vibrant vision of the African continent.

NOTES

1. Omar Victor Diop, interview by the author, May 2014, Dak'Art 2014, Dakar.
2. Omar Victor Diop, interview by the author, September 5, 2016, Bloomington, IN.
3. Diop, interview, 2016.
4. Diop, interview, 2014.
5. Diop, interview, 2014.
6. Ugochukwu-Smooth Nzewi, personal communication, May 2014, Dakar.
7. Omar Viktor Diop (@omarviktor), Instagram, accessed January 25, 2023, https://instagram.com/omar_viktor/.
8. For further elaboration of the idea of how individuals and communities see themselves and wish to be seen, see Campt 2012.
9. Omar Victor Diop, "Love Letter to the Future," *New York Times*, February 6, 2020, https://www.nytimes.com/interactive/2020/02/06/world/africa/africa-independence-year.html#diop.
10. Diop, interview, 2014.
11. Nick Parker and Daisy Carrington, "Omar Victor Diop: The Newbie Photographer Who Went Pro," *CNN*, August 5, 2015, http://www.cnn.com/2015/08/05/arts/omar-victor-diop-photography-career/.
12. For further elaboration see the debate in *African Arts* between Grabski, Nzewi, and Sanyal in 2015 (Grabski 2015; Nzewi 2015b; Sanyal 2015).
13. Boubacar Touré Mandémory, personal communication, December 2011, Dakar.
14. George Osodi, personal communication, 2012, Bloomington, IN.
15. Magnin is, of course, not without controversy in the world of African art. My thanks to Richard Powis for this reminder.
16. "About Black Rock: Our Story," Black Rock, accessed August 6, 2020, https://blackrocksenegal.org/our-story/.
17. In addition to the gallery formats, Diop has created other formats for sale such as a series of one hundred images that consisted of a black cardboard envelope

containing a 5" × 7" card with each portrait, reminiscent of the cabinet cards produced by photographers in the 1860s that preceded postcards. A cabinet card was a stiff piece of cardstock, about 6 ½" × 4 ½", with the image on one side and the photographer's stamp embossed on the other. The photographs were often albumen prints but sometimes gelatin silver or carbon. They superseded the cartes-de-visite that people often collected and placed in albums.

18. https://www.omarvictor.com/the-studio-of-vanities, accessed May 9, 2015.
19. Diop, interviewed by author, Bloomington, IN, September 5, 2016.
20. See for example, Joseph Underwood's discussion of Omar Victor Diop's *Ken* in which Underwood discusses how Diop goes beyond the nationalist frame (Underwood 2017).
21. Diop, interview, 2016.
22. Diop, interview, 2016.
23. Diop, interview, 2016.
24. Diop, interview, 2016.
25. See for example Ouédraogo 2002.
26. Diop, interview, 2016.
27. Diop, interview, 2014.
28. Diop, interview, 2016.
29. Diop, interview, 2014.
30. Diop, interview, 2014.
31. See for example, Krista Thompson's discussion of Christopher Pinney and Olu Oguibe's discussions of the "substance" and the "surface" of the image (2015, 191).
32. Diop, interview, 2016.
33. Jelle Bouwhuis and Kerstin Winking, "Context," in *Hollandaise: Un voyage à travers un tissue emblématique* (Dakar: Raw Material Company, 2013) (Exhibition catalog).
34. I am grateful to Heather Akou for this observation.
35. I am grateful to Richard Powis for this observation.
36. Diop, interview, 2016.
37. For more on Douglass's relationship to photography, see Allison Meier, "Why Frederick Douglass Was the Most Photographed 19th-Century American," Hyperallergic, February 6, 2017. The portrait Diop creates of Douglass appears most similar to the 1847–52 daguerreotype held at the Art Institute of Chicago in which Douglass is photographed in a paisley vest and tie.
38. "About," Kehinde Wiley Studio, accessed November 3, 2016, http://kehindewiley.com/about/.

EPILOGUE
New Thresholds for "Reigniting Collections"

FROM THE EARLIER CHAPTERS on archival, museum, and family collections to the later chapters on the studio photography of Ibrahima Thiam and Omar Victor Diop, the theme of preserving Senegal's photographic patrimony through the circulation of portraiture runs through this book. For Diop, that means turning to the historic practice of studio photography across West Africa to address issues related to visibility on a global scale. For Thiam, that means engaging in the past to embrace the future. He seeks to give life to portraits tucked away in collections in archives and museums. Taking his family collections out in the world means that they will deteriorate more rapidly than if they remained in acid free boxes in climate-controlled facilities. In Senegal, humid air and fine dust deteriorate books and paper. The glue quickly dries in spines and pages fall out. Photos curl and fade. In Thiam's hands, these materials are not deteriorated; their value and meaning is deepened by their use. The photos might be distressed like the relationships they preserve, stretched and strained by time, distance, and age. But these images circulate as an active part of social relationships. When they are loved, these photos stitch together self and social relations. They are the outcome of and the motivation for these relationships. So Thiam continues to bring out his photos to reinsert them into social life, to remind people of how long relationships have lasted, or to return them to the sitters, a faded keepsake from their past.

I began this book with a question posed by the lens-based artist Ibrahima Thiam about how to "reignite" photographic collections held in archives in Senegal. Unlike personal and family collections, these photographs may have been commissioned by colonial officers to document the colonial project or

to surveil religious leaders and associations suspected of planning resistance movements. There are images of bridges, buildings, and schools that document colonial influence; craftspersons invited to world's fairs and exhibitions; and commemorative events like Bastille Day that were central to the instantiation of French colonial power in Senegal. There are also many individual and family portraits commissioned by Senegalese families that were taken by French photographers or their Senegalese apprentices in the private commercial photography studios that they ran on the side. These photographs, removed from social circulation, rest in archives to be protected against the effects of deterioration.

Should these photographic collections be reinserted into social life in Senegal? If they were, what effect would their circulation have? Could they connect young people to their heritage and address legacies of colonialism? Thiam's question about reigniting collections reflects a conversation long in the making among art critics such as Okwui Enwezor, who has observed how archives have languished across the continent (2008, 40), and museum scholars such as Elizabeth Edwards, who has described the archives as "a dead controlling space in which photographs gather dust in the sense of being removed from active social contexts" (2003, 92). Others, including Dan Hicks (2021), have even gone so far as to propose that museum ethnographies based on archival material could be better reframed as "necrographies" to reflect the death of objects once they are removed from their social context and placed into archives.

Thiam's questions about reigniting collections emerged at a time during which radical changes took place regarding mobility. The writing of this book was marked by the unfolding of the global pandemic and Black Lives Matter protests. The latter amplified calls to decolonize museums that have long been in place and to repatriate artifacts to the continent, moves that are underway at the moment of writing (Roberts 2019). This moment, then, was marked not only by the dramatically diminishing mobility of people, but also by increased calls for a more ethical movement of objects as well as recognition of ownership. Such processes are important ways for countries to reclaim parts of their heritage; however, Thiam's work highlights that how such artifacts are used matters in the ways they can impact local populations.

Mobility has long been central to the arts, cutting through time and place, and yet COVID-19 threatened that very precept. For many African artists that movement was predicated on systems of funding and management for artists abroad in Europe or North America. Similarly, for many people across Senegal, movement is life, since men and women migrate within and beyond the country seeking a means to control and improve their futures. And that life is predicated on the location of capital outside of the African continent. Lens-based artist

Omar Victor Diop addresses the question of movement versus stasis by asking, can an artist locate themselves in West Africa, or to be successful must one take up residence abroad? In many ways, Dakar has been in transition for some time, moving from an art outpost or satellite to the threshold of becoming an art center or "Art World City" (Grabski 2017). Rather than being a location for those who stayed behind, it has become the privilege of those who can afford to return like Diop.

Major art fairs, museums, and galleries responded to the threat of COVID-19 with delays, closures, and shifts online. As thousands of art and museum spaces were forced to close due to COVID-19, art and artists were suspended in transit, hidden behind closed doors, and in some cases, moved online. Many artists remain on the threshold, in a state of unknowing. They were waiting. As I was finishing this book, on March 20, 2020, all international air travel to and from Senegal was suspended until April 17, 2020, a ban that later was extended until May 31, 2020. Land borders were also closed. This was just over two months before the fourteenth edition of Dak'Art 2020, the Biennale of Contemporary African Art that was set to open on May 28. Its delay was one of several actions taken by Senegalese authorities to stem the spread of COVID-19. The theme for the thirtieth anniversary since the biennial's founding was *L'Ndaffa*, or out of the fire, a word from the Serer language meaning "to forge."[1] This was to be a remarkable year for the biennial. Not only was 2020 the thirtieth anniversary of Dak'Art, but concerns about attacks that had marked previous editions since the 2013 attack on the Hotel Radisson Blu at the Bamako Biennial of Photography were on the wane, meaning that attendance would greatly increase. Two new museums had also opened recently in Senegal: the MUPHO, Museum of Photography in Saint-Louis and MBC, the Museum of Black Civilizations in Dakar.

The Museum of Black Civilizations, a 14,000-square-foot museum that opened in 2018, had been in the works since 2003 and was originally launched by Senegal's first president Léopold Sédar Senghor more than fifty years ago (De Jong 2022, 37). It was first envisioned by Senghor at the First Festival of Negro Arts in 1966. The MBC architecture evokes the round adobe-and-thatch buildings of the southern Casamance region in Senegal where extended families live around a communal open space as well as the ruins of Great Zimbabwe (De Jong 2022, 214). The museum's exhibitions include objects from around the world and across time. It features archaeological objects as well as contemporary art developed with technical support from the United Nations Educational, Scientific and Cultural Organization (UNESCO). It has the capacity to store 18,000 objects and its exhibition space spans three floors. China also

made a $34 million donation to this museum as part of its efforts to expand its soft power across the continent.[2]

The opening of this museum coincided with France's acquiescence to return 90,000 artifacts to the continent. The announcement dominated the news and was based on the findings of the November 2018 Sarr-Savoy report from academics and researchers Felwine Sarr and Bénédicte Savoy.[3] Such a project would involve not only the inventory and return of objects but also their recontextualization in their communities of origin. Sarr had highlighted how doing so would reconnect young people with their sense of history through valued objects. In *Afrotopia*, Sarr (2020) writes of revaluing heritage to heal the wounds of colonialism. Ferdinand De Jong also describes the transformational potential of heritage projects in Senegal as "a technique for the decolonization of time, repair of trauma, and reclamation of the self" (2022, 32). While these are important steps in rectifying the wrongs of the colonial period, what Thiam's work cautions is that simply relocating artifacts to their countries of origin does not go far enough in helping these objects realize their full potential or impact people's lives in a meaningful way.

While the report and acknowledgment of the need to return artifacts is an important first step, a rich trove of early Senegalese photographic materials remains in many museum collections worldwide. In this book, I began to ask how it has come to pass that so many early photographic materials remain outside of Senegal. What questions are artists asking themselves about the worldwide dispersion of the heritage? What does their art suggest about what museum and archives administrators should do with this restituted art as well as their current holdings? This line of inquiry led me to other questions emerging from this moment concerning the restitution of museum objects to their source communities. How might photographers like Ibrahima Thiam and their communities retain and control the circulation of valued objects? How might they "reignite collections?" Thiam's circulation of his personal collection and his urging of sitters to explore it offers one possibility, a version of which could be adopted by museums and archives.

Thiam posed this question about reigniting photographic collections in response to how he observed young people's deep interest in images as they swapped portraits from albums and shared images on social media. However, they did not demonstrate interest in their parents' old photos. Young people saw photographs as part of how they created a stylish persona in the same way that they went to the tailor or the barbershop. According to Liam Buckley (2014, 720), portraits belong to *jamano*, or the present in Wolof, and not *coosan*, or the

past. For Thiam, reigniting collections and archives involves turning young people's attention to their heritage and seeing its future potential. He wants people to grasp that when they hold their parents' and grandparents' photos in their hands, they are also holding the future. Reigniting collections happens through the process and practice of taking photos as well as in the outcome of his lens-based work when it draws on the past to rethink periodization by collapsing past, present, and future.

When Ibrahima Thiam asks young people to engage in his photographic projects by inviting them to pick up and hold colonial-era photographs, he encourages them to imagine connections to the sitters in these portraits. This recalls Saidiya Hartman's (2008, 11) work on critical fabulation, in which she seeks to paint as full a picture as possible of enslaved lives with a minimum of historical materials, "straining against the archive," and recognizing the limits of narrative. Thiam too engages "fabulography." The violence of colonialism, like that of enslavement, is in the stories that cannot be told in so far as the archive is the colonial narrative. Thiam thus aims to restore life to colonial-era portraits. He does so by filling in the gaps of the past, inhabiting them and creating with them. He seeks to regain what might have been lost to generate potentiality and aliveness around objects such as photographs, around these images that belong not to the past, but to the future. Thiam's work is very different than Dan Hicks's notion of necrography, which Priya Basil sees as the cataloging and digitalization projects surrounding objects like photographs, for restitution projects for example, as the domain of museum professionals. Fabulography in contrast is the domain of artists and those outside of the museum space engaged in collective projects (Hicks et al. 2021). For Thiam, fabulography is an essential means of bringing life and meaning to photographs and exposing the broader public to their power and meaning. His work raises the specter of the artist working within the community as a possible alternative to the museum that the museum's best work might be done outside of its walls.

Further drawing on Hartman's work, Basil suggests that fabulography involves a subtle shift between thinking of *objects* and *belongings* to bring up "notions of (not) having, of being, of longing" (Hicks et al. 2021, 7). She asks how to account for the consequences of the disconnection between people and their belongings. As Fernando Domínguez Rubio responds, this disconnection may make the impulse toward storage, rather than being a form of protection, a form of violence (Hicks et al. 2021, 36). There is a brutality in alienating photographs from the social contexts of their making and in taking them out of social circulation. These archival photographs were belongings of individuals, families,

and associations, intimate to men's and women's senses of self and community. Resting them in storage in a museum or archive arrests these objects' potential for life. Unlocking the potential of those stored memories is central to Thiam's practice. He describes these belongings as heavy (*diis naa* in Wolof) with potential. Thiam talks about these collections in the way in which people discuss heavy subjects like life and death as "diis naa" or the ways in which people evaluate and appreciate each other's photo albums as "diis naa." By circulating these heavy objects, Thiam reignites their meaning and allows them to act on the world. He thus releases these photographs' potential and demonstrates an alternative model to cultural preservation in archives and museums.

Between the invisibility of photographs pristinely stored in museum collections worldwide and the tattered effects of love on family collections at home, Thiam has also expressed concern about the sale of family and other private archives to eager gallery figures and collectors seeking profit in Senegal's rich photographic heritage. Certainly, the loss represented by the outward flow of this heritage mirrors the loss that took place during the colonial period when artifacts were removed from the continent. But his work also reminds us that it is not just the return of objects that is important, but also how they are used upon their return.

While museums may work to extend the life of objects, what value do these belongings have when removed from the very hands that give them meaning? For this reason, in his lens-based work, Thiam returns time and again to the hands as he focuses on contemporary sitters holding this valued photographic patrimony. While pushing the boundaries of portraiture by eclipsing the likeness of his sitters, his work returns to the visceral, particularly the sense of touch and how holding an object facilitates seeing. He is interested in how holding these photographs returns his sitters to the weight of the photographic past and its potential for imagining futures. By encouraging them to hold these historic portraits in their hands, Thiam invites his sitters to do more than just connect with the past; he invites them to consider what this past can illuminate about their futures and how what they literally hold in their own hands can be a pathway into new visions of self and country.

In this ethnography, I have discussed what stories a humanistic, sensory-based exploration of photographic practices, aesthetics, and semiotic ideologies reveals. This approach shows the importance of images in forming and maintaining connections between people across space and time as well as how photographs can evoke visceral reactions that cement these connections. I have considered displaying framed portraits, viewing magazines, keeping albums,

posting photos on social media, and the staking of new artistic positions in contemporary African photography. Could a sensorial approach to the material culture of photography achieve a connection to Senegal's photographic heritage for young people, as Thiam insists? Could photography also be a mode of achieving visibility and weighing futures, individually and collectively, and over and above stereotypes of what Africa is, as the lens-based artist Omar Victor Diop aspires to? To find out, photos need to be circulated, touched, and reactivated in social life. Both Diop and Thiam invite sitters into a studio space to experience and reflect on Senegal's photographic past through this process of reenactment.

Although there have been projects of digital repatriation of photography to source communities for some time, future research will have to ask how figures such as Ibrahima Thiam reignite collections outside of their community of origin. For example, some museums such as the Smithsonian Museum of the American Indian have added spaces in which collections may be used for ritual purposes; such museums view belongings in their collection as living entities rather than objects. They invite communities to interact with their collections and eschew the idea that they are engaged in "storage," which implies preserving nonliving objects, instead preferring to discuss how their collections can be kept alive. Similarly, how might Thiam envision collections in Senegal and abroad as vehicles for social action? In this manner, such photographs could be agents, rather than representations, of history (Geismar 2006, 558). Might these collections be restituted, rephotographed, digitized, and re-embedded in social life in Senegal? If so, what would the effects of such processes be? When such efforts allow for the viewing and handling of photographs in private and communal spaces, then the ways in which people interact with them are much more akin to the moment in which the photographs were created. The viewers could then imagine more closely and more intimately the perspective of the sitter in a space "where emotions stirred by photographs are supported in their own cultural environment" (Edwards 2003, 92).

Many museums such as the Musée du quai Branly and archives such as the Bibliothèque nationale du France have been in the process of cataloging and digitizing photographic materials removed from Senegal and elsewhere and putting them into the public domain. While valuable, beyond these digitizing efforts that potentially make archives visible to those far away, such digital objects should be used to make meaningful calls for collaborative research. Such engagements might develop at a variety of scales, whether between artists and their communities where they seek to reanimate these belongings stored far

away or between scholars and artists seeking to understand both their "role in these dispossessions," and new understandings of heritage materials and the value transformations that have unfolded over time (J. Bell 2017, 244).

We might then seek to understand how belongings come to carry weight, in the Wolof idiom of "diis naa," and at what points they and the relationships they carry might also become lost like the lives of young Senegalese who cross dangerous seas in search of a meaningful life. In this book, I have engaged the practices, discourses, and concerns of contemporary visual artists based in Senegal, who address these themes of family, separation, visibility, rupture, and repatriation through portraiture. I have also shown how, both today and in the past, portraits fill homes with importance and meaning for a community caught between worlds—the worlds of migrants and the worlds of those who remained at home. These objects weave these worlds together, creating intersections and concretizing otherwise ephemeral relations. In this light, photographs are moving and movable objects, ever more so in their digitized forms. Personal portraits show that a person was well cared for and well integrated into the circuits of exchange that sustain social, political, and economic life. It is this power of portraiture that pushes us to consider the ethics of amassing these images in archives and museums. The work of artists such as Thiam demonstrates the urgency of portraiture, not just as a form of art, but as a means of recapturing history and envisioning how this history can shape the future. Held in his sitters' hands, his portrait collection acts on these viewers, urging them to make connections between themselves and the past in a way that may animate their futures. It is not just his sitters, but museums and archives as well that sit on the threshold of what these materials in the right hands might reveal.

NOTES

1. Maximiliano Duron, "Coronavirus Postponements Hit Biennial Circuit as Africa's Biggest Exhibition Delays Opening of 2020 Edition," *Art News*, March 20, 2020.

2. Yomi Kazeen, "Photos: Inside the Sprawling Museum of Black Civilizations in Senegal," *Quartz Africa*, December 19, 2018, https://qz.com/africa/1493002/museum-of-black-civilizations-opens-in-senegal/.

3. Sarr et al. 2018.

BIBLIOGRAPHY

Ainslie, Rosalynde. 1966. *The Press in Africa*. London: Victor Gollancz.
Akanji, Olajide O. 2019. "Sub-Regional Security Challenge: ECOWAS and the War on Terrorism in West Africa." *Insight on Africa* 11 (1): 94–112.
Amkpa, Awam, Tamar Garb, and Walther Collection. 2013. *Distance and Desire: Encounters with the African Archive*. 1st ed. Printed in Germany by Steidl.
Anderson, Benedict. 2008. "Imagined Communities: Reflections on the Origin and Spread of Nationalism." In *The New Social Theory Reader*, edited by Steven Seidman and Jeffrey C. Alexander, 282–88. London: Routledge.
Appadurai, Arjun. 1986. "Introduction: Commodities and the Politics of Value." In *The Social Life of Things: Commodities in Cultural Perspective*, edited by Arjun Appadurai, 3–63. Cambridge: Cambridge University Press.
———. 1997. "The Colonial Backdrop." *Afterimage* 24 (5): 4.
Apter, A. 2005. *The Pan-African Nation: Oil and the Spectacle of Culture in Nigeria*. Chicago: University of Chicago Press.
Araujo, Ana Lucia, Alice L. Conklin, Steven Conn, Denise Y. Ho, Barbara Kirshenblatt-Gimblett, and Samuel J. Redman. 2019. "AHR Conversation: Museums, History, and the Public in a Global Age." *American Historical Review* 124 (5): 1631–72.
Azoulay, Ariella. 2008. *The Civil Contract of Photography*, Rela Mazali, Ruvik Danieli. New York: Zone Books.
———. 2010. "What Is a Photograph? What Is Photography?" *Philosophy of Photography* 1 (1): 9–13.
Bajorek, Jennifer. 2010a. "Of Jumbled Valises and Civil Society: Photography and the Political Imagination in Senegal." *History and Anthropology* 21 (4): 431–52.
———. 2010b. "Photography and National Memory: Senegal about 1960." *History of Photography* 34 (2): 158–69.

———. 2012. "Ca Bousculait! Democratization and Photography in Senegal." In *Photography in Africa: Ethnographic Perspectives*, edited by Richard Vokes, 140–65. London: James Currey.

———. 2020. *Unfixed: Photography and Decolonial Imagination in West Africa*. Durham, NC: Duke University Press.

Bajorek, Jennifer, and Erin Haney. 2010. "Eye on Bamako: Conversations on the African Photography Biennial." *Theory, Culture, Society* 27:263–84.

Barber, Karin. 1997a. "Introduction." In *Readings in African Popular Culture*, edited by Karin Barber, 1–11. Bloomington: Indiana University Press.

———. 1997b. "Preliminary Notes on Audiences in Africa." *Africa: Journal of the International African Institute* 67 (3): 347–62.

Barthes, Roland. 1981. *Camera Lucida: Reflections on Photography*. New York: Hill and Wang, A division of Farrar, Straus, and Giroux.

Batchen, Geoffrey. 2000. "Vernacular Photographies." *History of Photography* 24 (3): 262–71.

———. 2002. *Each Wild Idea: Writing, Photography, History*. Cambridge, MA: MIT Press.

Behrend, Heike. 2001. "Fragmented Visions: Photo Collages by Two Ugandan Photographers." *Visual Anthropology* 14 (3): 301–20.

Beliso-de Jesus, Aisha M., and Jemima Pierre. 2020. "Introduction: Anthropology of White Supremacy." *American Anthropologist* 122 (1): 65–75.

Bell, Clare, Okwui Enwezor, Danielle Tilkin, and Octavio Zaya. 1996. *In/Sight: African Photographers, 1940 to the Present*. New York: Guggenheim Museum.

Bell, Joshua A. 2005. "Looking to See: Reflections on Visual Repatriation in the Purari Delta, Gulf Province, Papua New Guinea." In *Museums and Source Communities: A Routledge Reader*, edited by Alison K. Brown and Laura Peers, 120–31. London: Routledge.

———. 2017. "A Bundle of Relations: Collections, Collecting, and Communities." *Annual Review of Anthropology* 46:241–59.

———. 2021. "'Go Throw It in the River', Shifting Values and the Productive Confusions of Collaboration with Museum Collections." In *Museums, Societies and the Creation of Value*, edited by Howard Morphy and Robyn McKenzie, 169–89. London: Routledge.

Bell, Joshua A., and Haidy Geismar. 2009. "Materialising Oceania: New Ethnographies of Things in Melanesia and Polynesia." *The Australian Journal of Anthropology* 20:3–27.

Benga, Ndiouga. 2020. "A Body and Sex Issue? Fashion in Colonial Dakar." *Journal of Arts & Humanities* 9 (2): 117–26.

Berger, John. 2014. *Selected Essays of John Berger*. London: Bloomsbury Academic.

Bigham, Elizabeth. 1999. "Issues of Authorship in the Portrait Photographs of Seydou Keïta." *African Arts* 32 (1): 56–67, 94–96.

Binney, Judith, and Gillian Chaplin. 2005. "Taking the Photographs Home: The Recovery of a Māori History." In *Museums and Source Communities: A Routledge Reader*, edited by Alison K. Brown and Laura Peers, 109–19. London: Routledge.

Boone, Catherine. 1992. *Merchant Capital and the Roots of State Power in Senegal, 1930–1985*. Cambridge Studies in Comparative Politics. Cambridge: Cambridge University Press.

Borgatti, Jean. 2013. "Likeness or Not: Musings on Portraiture in Canonical African Art and Its Implications for African Portrait Photography." In *Portraiture and Photography in Africa*, edited by John Peffer and Elisabeth L. Cameron, 315–40. Bloomington: Indiana University Press.

Bourdieu, Pierre. 1990. *Photography: A Middle Brow Art*. Cambridge: Cambridge University Press.

Bouttiaux, Anne-Marie. 1994. *Senegal Behind Glass: Images of Religious and Daily Life*. Munich: Prestel, in association with the Royal Museum of Central Africa.

Brilliant, Richard. 1991. *Portraiture*. London: Reaktion Books.

Buckley, Liam. 2000. "Self and Accessory in Gambian Studio Photography." *Visual Anthropology Review* 16 (2): 71–91.

———. 2005. "Objects of Love and Decay: Colonial Photographs in a Postcolonial Archive." *Cultural Anthropology* 20 (2): 249–70.

———. 2014. "Photography and Photo-Elicitation after Colonialism." *Cultural Anthropology* 29 (4): 720–43.

Buggenhagen, Beth. 2001. "Prophets and Profits: Gendered and Generational Visions of Wealth and Value in Senegalese Murid Households." *Journal of Religion in Africa* 31 (4): 373–401.

———. 2010. "Islam and the Media of Devotion in and out of Senegal." *Visual Anthropology Review* 26 (2): 81–95.

———. 2011. "Are Births Just 'Women's Business'? Gift Exchange, Value, and Global Volatility in Muslim Senegal." *American Ethnologist* 38 (4): 714–32.

———. 2012. *Muslim Families in Global Senegal*. Bloomington: Indiana University Press.

———. 2014. "A Snapshot of Happiness: Photo Albums, Respectability, and Economic Uncertainty in Muslim Senegal." *Africa* 84 (1): 78–100.

Burke, Timothy. 1996. *Lifebuoy Men, Lux Women: Commodification, Consumption, and Cleanliness in Modern Zimbabwe*. Body, Commodity, Text. Durham, NC: Duke University Press.

Bush, Ruth. 2016. "'Mesdames, Il Faut Lire!' Material Contexts and Representational Strategies in Early Francophone African Women's Magazines." *Francospheres* 5 (2): 213–36.

Bush, Ruth, and Claire Ducournau. 2020. "'Small Readers' and Big Magazines: Reading Publics in *Bingo*, *La Vie Africaine*, and *Awa: La Revue de La Femme Noire*." *Research in African Literatures* 51 (1): 45–69.

Campt, Tina M. 2012. *Image Matters. Archive, Photography, and the African Diaspora in Europe*. Durham, NC: Duke University Press.

———. 2017. *Listening to Images*. Durham, NC: Duke University Press.

———. 2019. "Black Visuality and the Practice of Refusal." *Women & Performance: A Journal of Feminist Theory* 29 (1): 79–87.

Chapuis, Frederique. 1999. "The Pioneers of Saint-Louis." In *Anthology of African and Indian Ocean Photography*, edited by P. M. Saint Léon, N. Fall, and L. Pivin, 48–63. Paris: Revue Noire.

Cohen, Joshua I., Sandrine Colard, and Giulia Paoletti. 2016. *The Expanded Subject: New Perspectives in Photographic Portraiture from Africa*. Munich: Hirmer Verlag.

Collier, J., and M. Collier. 1986. *Visual Anthropology: Photography as a Research Method*. Albuquerque: UNM Press.

David, Philippe. 1978. "La Carte Postale Sénégalaise de 1900 à 1960." *Notes Africaines* 157:3–12.

———. 1980. "Fortier, Le Maître de la Carte Postale Ouest-Africaine: Inventaire Provisoire d'une Production Cartophilique en AOF (1900–1925)." *Notes Africaines* 166:30–37.

Deger, Jennifer. 2016. "Thick Photography." *Journal of Material Culture* 21 (1): 111–32.

De Jong, F. 2022. *Decolonizing Heritage: Time to Repair in Senegal*. The International African Library. Cambridge University Press.

De Jong, Ferdinand, and Elizabeth Harney. 2015. "Art from the Archive." *African Arts* 48 (2): 1–4.

Dial, Fatou Binetou. 2008. *Mariage et Divorce à Dakar: Itinéraires Féminins*. Paris: Karthala.

Diawara, M. 2003. *The 1960s in Bamako: Malick Sidibé and James Brown*. Malick Sidibé: Photographs, 8–22. Gottingen: Hasselblad Center; Steidl.

Diop, Abdoulaye Bara. 1985. *La Famille Wolof: Tradition et Changement*. Hommes et Sociétés. Paris: Karthala.

Echenberg, Myron. 1985. "'Morts Pour La France;' The African Soldier in France during the Second World War." *The Journal of African History* 26 (4): 363–80.

———. 1991. *Colonial Conscripts: The Tirailleurs Sénégalais in French West Africa, 1857–1960*. London: James Currey.

Edwards, Elizabeth. 2003. "Talking Visual Histories: Introduction." In *Museums and Source Communities: A Routledge Reader*, edited by Alison K. Brown and Laura Peers, 83–99. London: Routledge.

———. 2006. "Photographs and the Sound of History." *Visual Anthropology Review* 21 (1 and 2): 27–46.

———. 2011. "Tracing Photography." In *Made to Be Seen: Perspectives on the History of Visual Anthropology*, edited by Jay Ruby and Marcus Banks, 159–89. Chicago: University of Chicago Press.

———. 2012. "Objects of Affect: Photography Beyond the Image." *Annual Review of Anthropology* 41:221–34.

———. 2013. "Looking at Photographs: Between Contemplation, Curiosity, and Gaze." In *Distance and Desire. Encounters with the African Archive*, edited by Tamar Garb, 48–54. Göttingen: Steidl.

———. 2021. *Raw Histories: Photographs, Anthropology and Museums*. London: Routledge.

Enwezor, Okwui. 2006. *Snap Judgments: New Positions in Contemporary African Photography*. Gottingen: Steidl/Edition7L.

———. 2008. *Archive Fever: Uses of the Document in Contemporary Art*. Göttingen: Steidl.

———. 2010. *Events of the Self: Portraiture and Social Identity: Contemporary: Contemporary African Photography from the Walter Collection: Events of the Self Portraiture and Social Identity*, 23–28. Gottingen: Steidl.

Evans, Chloe. 2015. "Portrait Photography in Senegal: Using Local Case Studies from Saint Louis and Podor, 1839–1970." *African Arts* 48 (3): 28–37.

Fall, Aminata Sow. 1999. "Vague Memory of a Confiscated Photo." In *Anthology of African and Indian Ocean Photography*, edited by P. M. Saint Léon, N. Fall, and L. Pivin, 64–67. Paris: Revue Noire.

Faye, Ousseynou. 1995. "L'habillement et Ses Accessoires Dans Les Milieux Africains de Dakar (1867–1960)." *Revue Sénégalaise d'Histoire, Nouvelle Série* 1:69–86.

Fioratta, Susanna. 2021. *Global Nomads: An Ethnography of Migration, Islam, and Politics in West Africa*. London: Oxford University Press.

Firstenberg, Laurie. 2001. "Postcoloniality, Performance, and Photographic Portraiture." In *The Short Century: Independence and Liberation Movements in Africa, 1945–1994*, edited by Okwui Enwezor and Chinua Achebe, 175–89. Munich: Prestel.

Foadey, Gilles Eric, and Absa Gaye. 1994. "Meïssa Gaye. L'ancêtre des Photographes Sénégalais. 1892–1933." In *Mama Casset. Les Précurseurs de la Photographie au Sénégal, 1950*, edited by Pascal Martin Saint Léon, 67–69. Paris: Revue Noire.

Foley, Ellen E., and Fatou Maria Drame. 2013. "Mbaraan and the Shifting Political Economy of Sex in Urban Senegal." *Culture, Health & Sexuality* 15 (2): 121–34.

Foster, Robert John. 2002. *Materializing the Nation: Commodities, Consumption, and Media in Papua New Guinea*. Bloomington: Indiana University Press.

Gamble, Harry. 2017. *Contesting French West Africa: Battles Over Schools and the Colonial Order, 1900–1950*. Lincoln: University of Nebraska Press.

Geary, Christraud. 2003. "Photographic Trade: Portraits into Postcards." In *At First Sight: Photography and the Smithsonian*, edited by Merry A. Foresta, 44–49. Washington, DC: Smithsonian.

———. 2018. *Postcards from Africa: Photographers of the Colonial Ear*. Boston: Museum of Fine Arts Boston.

Geary, Christraud, and Virginia-Lee Webb. 1998. *Delivering Views: Distant Cultures in Early Postcards*. Washington, DC: Smithsonian.

Geisar, Haidy. 2006. "Malakula: A Photographic Collection." *Comparative Studies in Society and History* 48 (3): 520–63.

———. 2015. "Anthropology and Heritage Regimes." *Annual Review of Anthropology* 44:71–85.

———. 2018. *Museum Object Lessons for the Digital Age*. London: UCL Press.

Geisar, Haidy, and Anita Herle. 2011. Moving Images: John Layard and Photography on Malukula since 2014. Honolulu: University of Hawaii Press.

Geisar, Haidy, S. Kuchler, and T. Carroll. 2016. "Twenty Years On." *Journal of Material Culture* 21 (1): 3–7.

Gershon, Ilana. 2010. "Media Ideologies: An Introduction." *Journal of Linguistic Anthropology* 20 (2): 283–93.

———. 2017. "Language and the Newness of Media." *Annual Review of Anthropology* 46:15–31.

Gershon, Ilana, and Joshua A. Bell. 2013. "Introduction: The Newness of New Media." *Culture, Theory and Critique* 54 (3): 259–64.

Gilbert, Julie. 2019. "Mobile Identities: Photography, Smartphones and Aspirations in Urban Nigeria." *Africa* 89 (2): 246–64.

Gimon, Gilbert. 1981. "Jules Itier, Daguerreotypist." *History of Photography* 5 (3): 225–44. https://doi.org/10.1080/03087298.1981.10442673.

Grabski, Joanna. 2011. "Market Logics: How Locality and Mobility Make Artistic Livelihoods in Dakar." *Social Dynamics* 37 (3): 321–31.

———. 2015. "Regarding Artists, the City, and the Global Art World." *African Arts* 48 (2): 9–10.

———. 2017. *Art World City: The Creative Economy of Artists and Urban Life in Dakar*. Bloomington: Indiana University Press.

Gruber, Martin. 2021. "Precious/Precarious Images: Cameroonian Studio Photography in the Digital Age." *Visual Anthropology* 34 (3): 214–33.

Haney, Erin. 2010. *Photography and Africa*. Exposures. London: Reaktion Books.

Haney, Erin, and Jürg Schneider. 2014. "Beyond the 'African' Archive Paradigm." *Visual Anthropology* 27 (4): 307–15. https://doi.org/10.1080/08949468.2014.914845.

Hannaford, Dinah. 2017. *Marriage Without Borders: Transnational Spouses in Neoliberal Senegal*. Philadelphia: University of Pennsylvania Press.

Hannaford, Dinah, and Ellen E. Foley. 2015. "Negotiating Love and Marriage in Contemporary Senegal: A Good Man Is Hard to Find." *African Studies Review* 58 (2): 205–25.

Harney, Elizabeth. 2004. *In Senghor's Shadow: Art, Politics, and the Avant-Garde in Senegal, 1960–1995*. Durham, NC: Duke University Press.

Hartman, Saidiya. 2008. "Venus in Two Acts." *Small Axe: A Caribbean Journal of Criticism* 12 (2): 1–14. https://doi.org/10.1215/-12-2-1.

Hickling, Patricia. 2007. "The Early Photographs of Edmond Fortier: Documenting Postcards from Senegal." *African Research & Documentation* 102:37–53.

———. 2014. "Bonnevide: *Photographie des Colonies*: Early Studio Photography in Senegal." *Visual Anthropology* 27 (4): 339–61.

Hicks, Dan. 2020. *The Brutish Museums: The Benin Bronzes, Colonial Violence and Cultural Restitution*. London: Pluto.

———. 2021. "Necrography: Death Writing in the Colonial Museum." *British Art Studies*, no. 19. https://www.britishartstudies.ac.uk/issues/issue-index/issue-19/death-writing-in-the-colonial-museums.

Hicks, Dan, Priya Basil, Haidy Geismar, M. Kadar, E. Ogboh, F. D. Rubio, C. Deliss, N. Mirzoeff, B. Bennett, and C. Rassool. 2021. "Necrography: Death-Writing in the Colonial Museum." *British Art Studies*, no. 19. https://www.britishartstudies.ac.uk/issues/issue-index/issue-19/death-writing-in-the-colonial-museums.

Hirsch, Marianne. 1997. *Family Frames. Photography, Narrative, and Postmemory*. Cambridge, MA: Harvard University Press.

Hogarth, Christopher. 2012. "Ousmane Socé Diop." In *Dictionary of African Biography*, edited by Henry Louis Gates and Emmanuel K. Akyeampong. Athens: Ohio University Press.

Jackson, Jason Baird. 2016. *Material Vernaculars. Objects, Images, and Their Social Worlds*. Bloomington: Indiana University Press.

Jaji, Tsitsi. 2018. "Bingo Magazine in the Age of Pan-African Festivals: A Feminist Archive of Global Black Consciousness." *Nka: Journal of Contemporary African Art* 42–43 (2018):110–23.

Jaji, Tsitsi Ella. 2014a. *Africa in Stereo: Modernism, Music, and Pan-African Solidarity*. Oxford: Oxford University Press.

———. 2014b. "Bingo: Francophone African Women and the Rise of the Glossy Magazine." In *Popular Culture in Africa: The Episteme of the Everyday*, edited by Stephanie Newell and Okome Onookome, 111–30. New York: Routledge.

Johnson, Marian Ashby. 1994. "Gold Jewelry of the Wolof and the Tukulor of Senegal." *African Arts* 27 (1): 36–95.

Jones, Hilary. 2011. "Métissage in Nineteenth Century Senegal: Hybrid Identity and French Colonialism in a West African Town." *Afrika Zamani*, no. 19: 1–20.

———. 2013. *The Métis of Senegal: Urban Life and Politics in French West Africa*. Bloomington: Indiana University Press.

Kea, Pamela. 2017. "Photography, Care, and the Visual Economy of Gambian Transatlantic Kinship Relations." *Journal of Material Culture* 22 (1): 51–71.

Keane, Webb. 2005. "Signs Are Not the Garb of Meaning: Social Analysis of Material Things." In *Materiality*, edited by Daniel Miller, 182–205. Durham, NC: Duke University Press.

Keller, Candace. 2013a. "Transculturated Displays: International Fashion and West African Portraiture." In *African Dress: Fashion, Agency, Performance*, edited by

Karen Tranberg Hansen and D. Soyini Madison, 186–203. London: Bloomsbury Academic.

———. 2013b. "Visual Griots: Identity, Aesthetics, and the Social Roles of Portrait Photographers in Mali." In *Portraiture and Photography in Africa*, edited by John Peffer and Elisabeth L. Cameron, 363–406. Bloomington: Indiana University Press.

———. 2014. "Framed and Hidden Histories: West African Photography from Local to Global Contexts." *African Arts* 47 (4): 36–47.

———. 2021. *Imaging Culture: Photography in Mali, West Africa*. Indiana University Press.

Killingray, D., and A. Roberts. 1989. "An Outline History of Photography in Africa to ca. 1940." *History in Africa* 16:197–208.

Klein, Martin A. 1998. *Slavery and Colonial Rule in French West Africa*. African Studies Series 94. Cambridge: Cambridge University Press.

Konate, Dior. 2009. "Women, Clothing, and Politics in Senegal 1940s–1950s." In *Material Women, 1750–1950: Consuming Desires and Collecting Practices*, edited by Maureen Daly Goggin and Beth Fowkes Tobin, 2:224–43. Burlington and Surrey: Ashgate.

Konaté, Moussa. 2012. "Pictures from Here for the People Over Yonder: Photographs in Migratory Circuits." In *Shoe Shop*, edited by Marie-Helene Gutberlet and Cara Snyman, 75–86. South Africa: Fanele.

Kozol, Wendy. 1994. *Life's America*. Philadelphia: Temple University Press.

Kratz, Corrine A. 2012. "Ceremonies, Sitting Rooms & Albums: How Okiek Displayed Photographs in the 1990s." In *Photography in Africa: Ethnographic Perspectives*, edited by Richard Vokes, 241–66. Suffolk: James Currey.

Kunstmann, Rouven. 2015. "The Politics of Portrait Photographs in Southern Nigerian Newspapers, 1945–1954." *Social Dynamics* 40 (3): 514–37.

Lamunière, Michelle. 2001. *You Look Beautiful Like That: The Portrait Photographs of Seydou Keïta and Malick Sidibé*. Cambridge, MA: Harvard University Art Museums; New Haven, CT: Yale University Press.

Landau, Paul Stuart, and Deborah D. Kaspin, eds. 2002. *Images and Empires: Visuality in Colonial and Postcolonial Africa*. Berkeley: University of California Press.

Langford, Martha. 2001. *Suspended Conversations: The Afterlife of Memory in Photographic Albums*. Montreal: McGill-Queen's University Press.

Larkin, Brian. 2013a. "Making Equivalence Happen: Commensuration and the Architecture of Circulation." In *Images That Move*, edited by Patricia Spyer and Mary Margaret Steedly, 237–56. Santa Fe: School for Advanced Research.

———. 2013b. "The Politics and Poetics of Infrastructure." *Annual Review of Anthropology* 42:327–43.

Lutz, Catherine. 2017. "What Matters." *Cultural Anthropology* 32 (2): 181–91.

MacDougall, David. 2006. *The Corporeal Image: Film, Ethnography, and the Senses*. Princeton Paperbacks. Princeton, NJ: Princeton University Press.

Makhulu, Anne-Maria, Beth Buggenhagen, and Stephen Jackson. 2010. *Hard Work, Hard Times: Global Volatility and African Subjectivities*. Berkeley: University of California Press.

Mann, Gregory. 2006. *Native Sons: West African Veterans and France in the Twentieth Century*. Durham, NC: Duke University Press.

Massot, Gilles. 2015. "Jules Itier and the Lagrené Mission." *History of Photography* 39 (4): 319–47. https://doi.org/10.1080/03087298.2015.1106714.

Mazzarella, William. 2009. "Affect: What Is It Good For?" In *Enchantments of Modernity: Empire, Nation, Globalization*, edited by Saurabh Dube, 291–309. London: Routledge.

Mbembe, J. A., and Sarah Nuttall. 2004. "A Blasé Attitude: A Response to Michael Watts." *Public Cult* 16 (3): 347–72.

McKeown, Katie. 2010. "Studio Photo Jacques: A Professional Legacy in Western Cameroon." *History of Photography* 34 (2): 181–92.

Meillassoux, Claude. 1974. "Development or Exploitation: Is the Sahel Famine Good Business?" *Review of African Political Economy* 1 (1): 27–33.

Melly, Caroline. 2011. "Titanic Tales of Missing Men: Reconfigurations of National Identity and Gendered Presence in Dakar, Senegal." *American Ethnologist* 38 (2): 361–76.

———. 2017. *Bottleneck: Moving, Building, and Belonging in an African City*. Chicago: University of Chicago Press.

Mercer, Kobena. 1998. "Africa by Herself: African Photography from 1840 to the Present." *Frieze Magazine* 43 (November–December). https://www.frieze.com/article/africa-herself-african-photography-1840-present.

———. 2016. "Home from Home: Portraits from Places in Between." In *Travel & See*, 157–69. Durham, NC: Duke University Press.

Micheli, C. Angelo. 2008. "Doubles and Twins: A New Approach to Contemporary Studio Photography in West Africa." *African Arts* 41 (1): 66–85.

———. 2012. "Les Photographies de Studio d'Afrique de l'Ouest: Un Patrimoine En Danger." *Africultures*, no. 2: 116–32.

Momodu-Gordon, Hansi. 2017. "In the Making: African Print-Fashion and Contemporary Art." In *African Print Fashion Now! A Story of Taste, Globalization, and Style*, edited by Suzanne Gott, Betsy Quick, and Leslie Rabine, 263–73. Los Angeles: Fowler Museum, University of California–Los Angeles.

Moore, Allison. 2020. *Embodying Relation: Art Photography in Mali*. Durham, NC: Duke University Press.

Morton, Christopher. 2015. "The Ancestral Image in the Present Tense." *Photographies* 8 (3): 253–70.

Morton, Christopher A., and Darren Newbury. 2015. *The African Photographic Archive: Research and Curatorial Strategies*. London: Bloomsbury Academic.

Moyd, Michelle. 2016. "What's Wrong with Doing Good? Reflections on Africa, Humanitarianism, and the Challenge of the Global." *Africa Today* 63 (2): 92–96.

Mustafa, Hudita Nura. 2002. "Portraits of Modernity: Fashioning Selves in Dakarois Popular Photography." In *Images and Empires: Visuality in Colonial and Postcolonial Africa*, edited by Deborah D. Kaspin and Paul S. Landau, 172–92. Berkeley: University of California Press.

Newell, Sasha. 2018. "The Affectiveness of Symbols. Materiality, Magicality, and the Limits of the Anti-Semiotic Turn." *Current Anthropology* 59 (1): 1–22.

Niang, Mame-Diarra. 2012. "Sahel Gris" (Gray Sahel). https://www.mamediarraniang.com/sahel-gris-cbba.

Nimis, Érika. 2005. *Photographes d'Afrique de l'Ouest: L'expérience Yoruba*. Paris: Karthala; Ibadan: IFRA.

———. 2014a. "In Search of African History: The Re-Appropriation of Photographic Archives by Contemporary Visual Artists." *Social Dynamics* 40 (3): 556–66.

———. 2014b. "Mali's Photographic Memory: From Outsider Readings to National Reclaiming." *Visual Anthropology* 27 (4): 394–409.

———. 2018. "'Outside The Framed Image': An Empirical Perspective on/from The Story of Felix Diallo and His Archive." *Critical Interventions* 12 (2): 197–217. https://doi.org/10.1080/19301944.2018.1492274.

Njami, Simon, ed. 2010. *Samuel Fosso*. Paris: Revue Noire.

———. 2017. "De l'éthographie à La Photographie." In *Le Métier de Photographe en Afrique: 10 Ans Afrique in Visu*. Paris: Clémentine de la Féronnière.

Nyamnjoh, Francis. 2005. "Fishing in Troubled Waters: Disquettes and Thiofs in Dakar." *Africa* 75 (3): 295–324.

Nzewi, Ugochukwu-Smooth C. 2015a. "In the Long Shadows of Euro-America, or, What Is Global Contemporary?" *African Arts* 48 (2): 10–11.

———. 2015b. "In the Long Shadows of Euro-America, or, What Is Global Contemporary?" *African Arts* 48 (2): 10–11.

Ouédraogo, Jean-Bernard. 2002. *Arts Photographiques en Afrique: Technique et Esthétique dans la Photographie de Studio au Burkina Faso*. Paris: Harmattan.

———. 2012. "Traces of African Migratory Identities in the Photographic Space." In *Shoe Shop*, edited by Marie-Helene Gutberlet and Cara Snyman, 108–16. South Africa: Fanele.

Ousmane, Sembene. 1975. *Xala* (Motion picture) *Xala* [videorecording] / Filmi Domireew et Société nationale cinématographique presentment. Distributed by New Yorker Films, New York, 2001.

Paoletti, Giulia. 2018. "Searching for the Origin(al): On the Photographic Portrait of the Mouride Sufi Saint Amadou Bamba." *Cahiers d'études Africaines*, no. 230: 323–48.

Paoletti, Giulia, and Yaelle Biro. 2016. "Photographic Portraiture in West Africa: Notes from 'In and Out of the Studio.'" *Metropolitan Museum Journal* 51:182–99.

Peffer, John. 2013. "Introduction: The Study of Photographic Portraiture in Africa." In *Portraiture and Photography in Africa*, edited by John Peffer and Elisabeth L. Cameron, 1–34. Bloomington: Indiana University Press.

Pink, Sarah. 2009. *Doing Sensory Ethnography*. London: Sage Publications.
Pinney, Christopher. 1997. *Camera Indica: The Social Life of Indian Photographs*. Chicago: University of Chicago Press.
———. 2003. "Notes from the Surface of the Image." In *Photography's Other Histories*, edited by Christopher Pinney and Nicolas Peterson, 202–20. Durham, NC: Duke University Press.
———. 2004. *"Photos of the Gods": The Printed Image and Political Struggle in India*. London: Reaktion Books.
Pinney, Christopher, and Nicolas Peterson, eds. 2003. *Photography's Other Histories*. Objects/Histories. Durham, NC: Duke University Press.
Poole, Deborah. 1997. *Vision, Race, and Modernity: A Visual Economy of the Andean Image World*. Princeton Studies in Culture/Power/History. Princeton, NJ: Princeton University Press.
———. 2005. "An Excess of Description: Ethnography, Race, and Visual Technologies." *Annual Review of Anthropology* 34 (1): 159–79.
Prochaska, David. 1991. "Fantasia of the *Photothèque*: French Postcard Views of Colonial Senegal." *African Arts* 24 (4): 40–98.
Rabine, Leslie. 1997. "Dressing Up in Dakar." *L'Esprit Créateur* 37 (1): 84–108.
———. 2002. *The Global Circulation of African Fashion*. New York and London: Berg.
———. 2010. "Fashionable Photography in Mid-Twentieth Century Senegal." *Fashion Theory* 14 (3): 305–30.
———. 2017. "Portraits in Print." In *African Print Fashion Now! A Story of Taste, Globalization, and Style*, edited by Suzanne Gott, Betsy Quick, and Leslie Rabine, 123–37. Los Angeles: Fowler Museum, University of California–Los Angeles.
Reynolds, Rachel R. 2006. "Professional Nigerian Women, Household Economy and Immigration Decisions." *International Migration* 44 (5): 167–88.
Richard, Analiese, and Daromir Rudnyckyj. 2009. "Economies of Affect." *Journal of the Royal Anthropological Institute* 15:55–77.
Roberts, Allen F. 2010. "Recolonization of an African Visual Economy." *African Arts* 43 (1): 1–8.
———. 2019. "Is Repatriation Inevitable?" *African Arts* 52 (1): 1–7.
Roberts, Allen F., and Mary Nooter Roberts. 1998. "L'aura d'Amadou Bamba. Photographie et fabulation dans le Sénégal urbain." *Anthropologie et sociétés* 22 (1): 15–40.
———. 2007. "Mystical Graffiti and the Refabulation of Dakar." *Africa Today* 54 (2): 51–77.
Roberts, Allen F., Mary Nooter Roberts, Gassia Armenian, and Ousmane Guèye. 2003. *A Saint in the City: Sufi Arts of Urban Senegal*. Los Angeles: Fowler Museum, University of California–Los Angeles.
Rutherford, D. 2016. "Affect Theory and the Empirical." *Annual Review of Anthropology* 45:285–300.

Saint Leon, Pascal Martin, and Jean Loup Pivin, eds. 2011. *Mama Casset: PHotoBolsillo*. Madrid, Spain: La Fabrica.

Sanyal, Sunanda K. 2015. "'Global': A View from the Margin." *African Arts* 48 (1): 1–4.

Sarr, F., B. Savoy, I. Maréchal, and V. Négri. 2018. *The Restitution of African Cultural Heritage: Toward a New Relational Ethics*. France: Ministère de la culture. OCLC number 1077598452.

Sarr, Felwine. 2020. *Afrotopia*. Minneapolis: University of Minnesota Press.

Sealy, Mark. 2019. *Decolonizing the Camera: Photography in Racial Time*. London: Lawrence & Wishart.

Searing, James F. 1988. "Aristocrats, Slaves, and Peasants: Power and Dependency in the Wolof States, 1700–1850." *The International Journal of African Historical Studies* 21 (3): 475–503.

———. 2002. *"God Alone Is King": Islam and Emancipation in Senegal*. Social History of Africa. Portsmouth, NH: Heinemann. http://www.loc.gov/catdir/toc/fy02/2001026389.html.

Sekula, A. 1986. "The Body and the Archive." *October* 39:3–64.

Sembene, Ousmane. 1995. *God's Bits of Wood*. Portsmouth, NH: Heinemann.

Shumard, Ann M. 1999. *A Durable Memento: Portraits by Augustus Washington, African American Daguerreotypist*. Washington, DC: National Portrait Gallery, Smithsonian Institution.

Siga, Fatou Niang. 1990. *Reflets de Modes et Traditions Saint-Louisiennes*. Saint Louis, Senegal: Centre africain d'animation et d'échanges culturels.

———. 2006. *Costume saint-louisien sénégalais d'hier à aujourd'hui*. [Saint-Louis?: s.n.]. Dakar, Senegal: Imprimerie Midi-Occident. //catalog.hathitrust.org/Record/006945239.

Silverstein, Michael, and Greg Urban. 1996. *Natural Histories of Discourse*. Chicago: University of Chicago Press.

Simone, AbdouMaliq. 2004. *For the City Yet to Come: Changing African Life in Four Cities*. Durham, NC: Duke University Press. http://www.loc.gov/catdir/toc/ecip0416/2004007449.html.

Smith, B. R. 2003. "Images, Selves, and the Visual Record: Photography and Ethnographic Complexity in Central Cape York Peninsula." *Social Analysis* 47 (3): 8–26.

Spitulnik, Debra. 1996. "The Social Circulation of Media Discourse and the Mediation of Communities." *Journal of Linguistic Anthropology* 6 (2): 161–87.

———. 1998. "Mediated Modernities: Encounters with the Electronic in Zambia." *Visual Anthropology Review* 14 (2): 63–84.

Sprague, Stephen. 1978. "Yoruba Photography: How the Yoruba See Themselves." *African Arts* 12:240.

Spyer, Patricia. 2001. "Photography's Framings and Unframings: a Review Article." *Comparative Studies in Society and History* 43:181.

Spyer, Patricia, and Mary Margaret Steedly. 2013. "Introduction." In *Images That Move*, 1–40. Santa Fe: School for Advanced Research.

Stein, Sally A. 1981. "The Composite Photograph and the Composition of Consumer Ideology." *Art Journal* 41 (1): 39–45.

———. 1989. "The Graphic Ordering of Desire: Modernization of a Middle-Class Women's Magazine, 1919–1939." In *The Contest of Meaning: Critical Histories of Photography*, edited by Richard Bolton, 145–63. Cambridge, MA: MIT Press.

Steiner, Christopher. 2001. "Rights of Passage: On the Liminal Identity of Art in the Border Zone." In *Empire of Things. Regimes of Value and Material Culture*, edited by Fred Meyers, 207–31. Advanced Seminar Series. Santa Fe: School of American Research.

Stewart, Kathleen. 2017. "In the World That Affect Proposed." *Cultural Anthropology* 32 (2): 192–98.

Stoller, Paul. 1997. *Sensuous Scholarship*. Philadelphia: University of Pennsylvania Press.

Strassler, Karen. 2010. *Refracted Visions: Popular Photography and National Modernity in Java*. Durham, NC: Duke University Press.

Strathern, Marilyn. 1990. "Artefacts of History: Events and the Interpretation of Images." In *Culture and History in the Pacific*, edited by J. Siikala, 25–44. Helsinki: Finnish Anthropological Society.

———. 1996. "Cutting the Network." *Journal of the Royal Anthropological Institute* 2 (3): 517–35.

———. 1999. *Property, Substance, and Effect: Anthropological Essays on Persons and Things*. London: Athlone.

Strother, Z. S. 2016. "Preface." In *The Expanded Subject. New Perspectives in Photographic Portraiture from Africa*, edited by Joshua I. Cohen, Sandrine Coward, and Giulia Paoletti, 9–13. Munich: Hirmer Verlag.

Tatsitsa, Jacob. 2015. "Black-and-White Photography in Batcham: From a Golden Age to Decline (1970–1990)." *History and Anthropology* 26 (4): 458–79.

Teitelbaum, Matthew, ed. 1992. *Montage and Modern Life: 1919–1942*. Cambridge, MA: MIT Press.

Thomas, Nicholas. 2009. *Entangled Objects: Exchange, Material Culture, and Colonialism in the Pacific*. Cambridge, MA: Harvard University Press.

Thompson, Krista A. 2006. *An Eye for the Tropics: Tourism, Photography, and Framing the Caribbean Picturesque*. Durham, NC: Duke University Press.

———. 2015. *Shine: The Visual Economy of Light in Africa Diasporic Aesthetic Practice*. Durham, NC: Duke University Press.

Tsinhnahjinnie, Hulleah J. 2003. "When Is a Photograph Worth a Thousand Words?" In *Photography's Other Histories*, edited by Christopher Pinney and Nicolas Peterson, 40–52. Durham, NC: Duke University Press.

Underwood, Joseph L. 2017. "Joseph Underwood on Omar Victor Diop." In *Accelerate: Access & Inclusion at the Tang Teaching Museum*, edited by Ian Berry and Rebecca McNamara, 1:116. Saratoga Springs, NY: Frances Young Tang Teaching Museum and Art Gallery.

———. 2018. *The View from Here. Contemporary Perspectives from Senegal*. Exhibition. Dakar, Senegal: WARU Studio and Kent State University, OH.

Viditz-Ward, Vera. 1999. "Studio Photography in Freetown." In *Anthology of African and Indian Ocean Photography*, edited by P. M. Saint Léon, N. Fall, and L. Pivin, 35–42. Paris: Revue Noire.

Vokes, R., and K. Pype. 2018. "Chronotopes of Media in Sub-Saharan Africa." *Ethnos* 83 (2): 207–17.

Warner, Michael. 2005. *Publics and Counterpublics*. New York: Zone Books.

Warner, Tobias. 2016. "Para-Literary Ethnography and Colonial Self-Writing: The Student Notebooks of the William Ponty School." *Research in African Literatures* 47 (1): 1–20.

———. 2019. *The Tongue-Tied Imagination: Decolonizing Literary Modernity in Senegal*. New York: Fordham University Press.

Weiner, Annette B. 1992. *Inalienable Possessions: The Paradox of Keeping-While-Giving*. Berkeley: University of California Press.

Werner, Jean-François. 1996. "Produire Des Images En Afrique: L'exemple des Photographes de Studio." *Cahiers d'études Africaines* 36 (141/142): 81–112.

———. 1999. "Twilight of the Studios." In *Anthology of African and Indian Ocean Photography*, edited by P. M. Saint Léon, N. Fall, and L. Pivin, 92–97. Paris: Revue Noire.

———. 2001. "Photography and Individualization in Contemporary Africa: An Ivoirian Case-study." *Visual Anthropology* 14 (3): 251–68.

Willis, Deborah. 2009. Posing Beauty: African American Images from the 1890s to the Present. New York: W.W. Norton & Company.

Willumson, Glenn. 2004. "Making Meaning: Displaced Materiality in the Library and Art Museum." In *Photographs, Objects, Histories: On the Materiality of Images*, edited by Elizabeth Edwards and Janice Hart, 62–80. London: Routledge.

Wright, Christopher. 2013. *The Echo of Things. The Lives of Photographs in the Solomon Islands*. Durham, NC: Duke University Press.

Yap, InHae. 2019. "Reaching for Freedom, Touching Modernity: Political and Consumptive Desire in Francophone African Magazines, 1950 to the 1960s." *Critical Interventions* 13 (2–3): 197–212.

Zeitlyn, David. 2019. "Photo History by Numbers: Charting the Rise and Fall of Commercial Photography in Cameroon." *Visual Anthropology* 32 (3–4): 309–42.

INDEX

Italic page numbers indicate illustrations.

advertising: *Bingo* (magazine) and, 85, 92–93, 94, 100, 105, *106–7*, 112–18, *114, 117,* 119–27, *119–20, 122–24, 126–28,* 134; Diop and, 212, 214; personal cameras and, 118, *119,* 121, *122–23,* 134
Afrapix, 130
Africa Explores (New York, 1991), 213
African diaspora: *Bingo* (magazine) and, 90, 91–93, 95–96, 108–10; Diop and, 209, 216, 229–30
African Spirits, 2008 (Fosso), 17
Afrique nouvelle (weekly newspaper), 90–91
Afrotopia (Sarr), 240
Agence Diffusion Presse, 96–97
L'agence Havas (advertising agency), 113
Agfa, 118, *119,* 121, *123,* 134
Algerian War for Independence, 93
Alt+Shift+Ego (Diop), 22–25, *23*
American Colonization Society, 48
Amina (magazine), 10
Aminata (Diop), 224–29, *226*
Amkpa, Awam, 54
Ange, Quenum P., 93

Apagya, Philip, 223
Appadurai, Arjun, 72
archives: fieldwork and ethnography in, 29–32; role of, 16–27, 237–38; Thiam on, 17, 19–20, 172. *See also* National Archives of Senegal (Archives nationales du Sénégal); restitution and repatriation projects
Archives nationales d'outre-mer (Overseas Colonial Archives) (Aix-en-Provence), 39
Archives nationales du Sénégal. *See* National Archives of Senegal (Archives nationales du Sénégal)
"Assetou" (Oudrago), 93–94
Associated Press, 130
Atangana, Elise, 228–30, *229*
Audema, Jean, 59
Azoulay, Ariella, 26, 217, 218

baby-naming ceremony (*ngente*), 13, 67, 158, 159–61, 223–24
backdrops: M. Casset and, 73–74, 80; colonial photography and, 50–51, 53, 57; Diop and, 202, 209, 215–16, 219–35,

226; Keïta and, 224, 225; Tacher and, 42, 47; Thiam and, 170, 190, 192; uses of, 64–65, 72, 140, 161–62; Wiley and, 231
Bajorek, Jennifer, 46, 91
Baker, Josephine, 96, 110
Baloji, Sammy, 173
Bamba, Amadou, 83n35, 171, *191*, 192–93
Barthes, Roland, 18
Basil, Priya, 241
Bell, Joshua A., 13, 44, 140, 143, 151, 243–44
Belley, Jean-Baptiste, 209
Beloit College, 176–77
Benyoumoff, Jean, 54, 64, *66*
Beyoncé, 218
Bibliothèque nationale du France (BnF, Paris), 39–40, 61, 243
Bingo (magazine): advertisements in, 85, 90, 92–93, 94, 100, 105, *106*, 112–18, *114*, *117*, 119–27, *119–20*, *122–24*, *126–28*, 134; African diaspora and, 90, 91–93, 95–96, 108–10; Breteuil family and, 94–95, 96–97; M. Casset and, 74–77, *76*, 101–3, 105, *106–7*; S. Casset and, 101–3, 105–10, *108–9*; circulation of portraiture and, 6, 9, 26, 85–90, *86–87*, *89*, 130–31; Diop and, 215; *Drum* (magazine) and, 94; fashion and clothing in, 88–89, 92–93, 100, 101, 105, 113–16, *114–15*; Joachim and, 128–29; layout and paper quality of, 87, 127–29; literary content of, 93–94; as political monthly, 129–30; portraits of religious leaders in, 74–77, *76*, 95, 109–10, *109*; portraits of soldiers in, 93, 95, 110, *111*, 118–19, *119*; range of photographic content of, 95–97; readership and circulation of, 90, 91–93, 118; Socé and, 91, 93, 94–95, 97–101, 105, 108–9, 112, 116–18, *117*, 128–29; studio photography and, 97–105, *98–99*, *102–4*, *106–7*; Thiam and, 169, 196
Black Lives Matter, 238

Black Photo Album/Look at Me, 1850–1950 (Mofokeng), 17
Black Rock, 206–7, 214
Bloc Africain, 116
Bonapart, Roland, 61
Bonnevide, Felix or Blaise, 51–53, *52*, 59, 60, 207, *208*
Boston Museum of Fine Arts, 82n7
Bourdieu, Pierre, 152
Breteuil, Michel de, 94
Breteuil family, 91, 94–95, 96–97
British Museum (London), 39–40
Brown, E. Ethelred, 57
Buckley, Liam, 18, 109, 240–41
bundling, 15–16, 29, 143–45

cabinet cards, 235n17
Cabral, Amílcar, 37–38
Cabral cap (*Laafa*), 37–38
calling cards (*cartes-de-visite*), 51, 52
Camara, Mohamed, 173
Campt, Tina, 26, 201n21
Carroll, Timothy, 75
cartes-de-visite (calling cards), 51, *52*, 160
Casset, Mama: *Bingo* (magazine) and, 74–77, *76*, 101–3, 105, *106–7*; Diop and, 209, 216; nationalist framing of, 216; props and, 228; studio photography and, 73–80, *78–79*; Thiam and, 180
Casset, Salla: *Bingo* (magazine) and, 101–3, 105–10, *108–9*; studio photography and, 74; Thiam and, 180
Center for Research and Documentation in Senegal (Centre de recherches et documentation du Sénégal, CRDS), 40, 182
Chimurenga (magazine), 218
China, 239–40
chromolithographs, 64
cinema, 92–93
Cisse, Gaye, 116
Cliche´s d'hier, Saint-Louis (Images of Yesterday, Saint-Louis) (Thiam), 168–74, *168*, 180, 190, 196

cloth: in Diop's portraits, 219–35; *sër-u-rabbal* and, 161; social significance of, 219, 223–24; in Thiam's portraits, 171; wax-print cloth, 81, 218, 227, 234
clothing. *See* fashion and clothing
CNN, 211–12
Collier, John, 28
colonial photography: Diop and, 217; postcards and, 38, 41–46, 54, 56–59, 58, 61, 67–70, 68–69; studio photography and, 49–59, 52–53
Comptoir photographique de L'AOF, 74
Contes et légendes d'Afrique noire (Socé), 132n18
corpothetics, 22, 41
COVID-19 pandemic, 15, 29–30, 238–39

daguerreotypes, 24, 48–49, 64
Dakar: Black Rock program in, 206–7, 214; Diop in, 213–14; FESMAN (1966) in, 206, 234; Institut Français in, 202–7, 214; Khar Yalla area in, 156–61; Mandémory in, 212–13; migration from rural areas to, 134; Museum of Black Civilizations in, 239–40; photography labs in, 135–37, *136*; studio photography in, 101–3, 140. *See also* Casset, Mama; Casset, Salla; Dak'Art (Biennial of Contemporary African Art, Dakar); Gaye, Meïssa
Dakar Fashion Week, 234
Dakar—Fils d'un Chef (postcard), 66
Dakar-Jeunes (illustrated supplement), 91
Dakar-Matin (newspaper), 96–97
Dak'Art (Biennial of Contemporary African Art, Dakar): Atangana and, 228; COVID-19 pandemic and, 239; Diop and, 202–6. *See also The Studio of Vanities, since 2012* (Diop); origins and importance of, 30, 205–7; preservation of portrait photography and, 5; Thiam and, 29, 36, 176–77, 178, 180, 195
Damani, Abdelkader, 228
Dandridge, Dorothy, 96

Daubry, Raoul, 105
Decampe (daguerreotypist), 49
Decker, John Parkes, 49
Deger, Jennifer, 6, 44
De Jong, Ferdinand, 240
"Une demi-mondaine" (Tacher), 42, 43, 44–45
Depth of Field (photographic collective), 213
Diakite, Khady Niang, 233, 234
Dial, Fatou Binetou, 155
Diallo, Mamadou, 218–22, *221*
Diallo, Oumar, 110
Diaw, Amadou, 171
Diawara, Manthia, 74
Dicko, Saïdou, 173
Dieng, SashaKara, 24
digital photography: Diop and, 207, 209, 215; double exposure images and, 3–4; impact on social role of photography of, 5, 6–10, 11, 13–16, 137–40, 167; Mandémory on, 138–39; Thiam and, 167, 182–83, 186–96; visual ethnography and, 30–32. *See also* social media
digital repatriation, 28, 243–44
diis naa (heavy), 4, 6–10, 152–56, 162, 242, 244
Dione, Aïssa, 214
Diop, Alioune, 93
Diop, Anta, 93
Diop, Doudou, 71–72
Diop, Omar Victor: collection of family portraits of, 207–9; Dak'Art and, 202–6. *See also The Studio of Vanities, since 2012* (Diop); digital photography and, 207, 209, 215; family and background of, 207, 212; fashion photography and, 22–25, *23*, 210, 211, 214; global art world and, 26–27, 29, 202–6, 209–12, 213–15, 238–39; props and, 209; self-portraits of, 209, 214, 230. *See also Project Diaspora: Self-Portraits, 2014* (Diop); on Senegal's photographic heritage, 19–20; studio photography

tradition and, 12, 25–26, 26, 202–6, 215–22, 220–21, 237, 243; use of backdrops and cloth by, 202, 209, 215–16, 219–35, 226
Diouf, Aloune, 71–72
Diouf, Elizabeth and Abdou, 7
Domínguez Rubio, Fernando, 241
double exposure images, 3–4
Douglass, Frederick, 209, 214, 230, 232
Drame, Fatou Maria, 155–56
Drum (magazine), 94

Ebony (magazine), 89–90
Edwards, Elizabeth, 14, 28, 35n3, 40–41, 238, 243
Elise Atangana (Diop), 228–30, 229
Ena Johnson, 2012 (Wiley), 230–31
L'enfant noir (Laye), 93
Englemann & Schneider, 64
Enwezor, Okwui, 16, 17, 172, 238
ethnographic methods, 27–31
experimental portraiture, 173–74
Exposition Universelle (Paris, 1889), 60–61, 62

fabulography, 241
Fall, Aminata Sow, 70
Fall, Fatima, 40
Fall, Ibrahima, *8*, 193
Fallou, Serigne, 88
family portraits and photo albums: as decorative element in homes, *141*, 143–48, *144*, *146*, *148*; as *diis naa* (heavy), 4, 6–10, 152–56, 162, 242, 244; Diop and, 203–5; ethnographic methods and, 32; global art market and, 18–19. *See also* museums; migration and, 1–5, 10–11, 13–16, 135, 143, 155–56, 159–60; social role of, 10–13, 135, 140, 143–48, 148–49, 150–65
fans, 227–28
fashion and clothing: in *Bingo* (magazine), 88–89, 92–93, 100, *101*, 105, 113–16, *114–15*; in colonial photography, 51,

59, *60*; in Dakar, 214. *See also* Kane, Selly Raby; Diakite and, 234; in Diop's portraits, 218–22; in magazines, 10; maximalism and, 65–67, 70, 71–82. *See also* fashion photography
fashion magazines, 10
fashion photography: Diop and, 22–25, 23, *210*, *211*, 214; Faye and, 224–26, *226*
Fashion 2112: Le Futur du Beau (Fashion 2112: The Future of Beauty) (Diop), *210*, *211*
Faye, Aminata, 224–29, *226*
FESTAC '77 (Second World Black and African Festival of Arts and Culture) (Lagos, Nigeria, 1977), 206
Festival Mondial des Arts Nègres (FESMAN, World Festival of Black Arts) (Dakar, 1966), 206, 234
Firstenberg, Laurie, 224
First Festival of Negro Arts (1966), 239
Foley, Ellen E., 155–56
Fondation Louis Vuitton, 213
Fortier, François-Edmond, 54, 57, 61–62, *63*, 82n7
Fosso, Samuel, 17
Foster, Robert John, 85
Fowler Museum (Los Angeles), 83n35
Framing Beauty: Intimate Visions (Indiana University Bloomington, 2016), 230, *231*–32
Freedberg, David, 160
French Assembly, 94, 132n18
French citizenship, 48
French Society of Geographers, 61
French West Africa (Afrique Occidentale Française, AOF), 37

Gambia, 77
Garb, Tamar, 54
Garvey, Marcus, 57
Gaye, Meïssa: *Bingo* (magazine) and, 101–5, *103*; French military and, 73, 74; nationalist framing of, 216; studio

photography and, 71–72, 73; Thiam and, 180
Geary, Christraud, 56
Geismar, Haidy, 13, 75, 151
Gershon, Ilana, 183
Ghana, 94
Gillette, 123–25, *124*
God's Bits of Wood (Sembene), 88
Grabski, Joanna, 154
Grande Imprimerie Africaine, 91, 94–95
GTP (Tex Styles Ghana Limited), 227
Guardian (newspaper), 211–12
Gueye, Amadou Mix, 130
Guèye, Lamine, 116

Hannaford, Dinah, 155
Harcourt style, 80
Hartman, Saidiya, 241
Haverford College, 176–77
Hickling, Patricia, 61
Hicks, Dan, 19, 40, 238, 241
Hirsch, Marianne, 152
Hostalier, Louis, 53, *53*

identity photos, 90, 119–21, 138
IKEA, 218
Indiana University, 176–77
Indochina, 4, 93, 118–19
Institut Français (French Cultural Center, Dakar), 202–7, 214
Interpress, 96–97
Islam and Muslim iconography, 64, 65. See also Murid tariqa; religious leaders, portraits of
Itier, Alphonse-Eugène-Jules, 48
itinerant photography: Diop and, 202–3, 217; Gaye and, 73; nationalist framing of, 216; role and impact of, 11–12, 134, 135–38, 145, 150–52, *151*; Thiam and, 183–86, 202, 217

Jackson, Jason Baird, 13
Jamaica, 57

Jamaica League, 57
jamano, 77
Jet (magazine), 89–90
Joachim, Paulin, 128–29
Johnson, Ena, 230–31

Ka, Oumar, 180
kamisolu, 115, 116
kamisolu taraab (*ndokkette*), 88, 89, 92
Kane, Selly Raby, 24, 65–67, 214, 218–22, 220, 228
Karim (Socé), 132n18
Keane, Webb, 143–45
Al-Kebir, Sidia, 75–77, *76*
Keïta, Seydou: backdrops and, 224, *225*; Diop and, 203, 204, 205, 215, 216, 224–26; global art world and, 18, 28, 171, 213; nationalist framing of, 216; props and, 77, 228; studio photography and, 80, 105
Kent State University, 176–77
Khady Niang (Diop), 233, *234*
Kodak, 118, 121, 122, 134
Konaté, Moussa, 156
Kostine (gold necklace), 49, 67
Küchler, Susanne, 75

Laafa (Cabral cap), 37–38
Labitte, 96–97
Lagos, Nigeria: Depth of Field (photographic collective) in, 213; FESTAC '77 in, 206
Lagos Photo, 213
Lagrange, Etienne, 49–51, 54
Lamine, Cisse Mohamed, 93
Lamunière, Michelle, 73, 80
Langford, Martha, 153
Larkin, Brian, 112, 157–58
Lascoumettes, J., 49
Lataque, Oscar, 74
Lauder, Leonard A., 82n7
Laye, Camara, 93
Laye, Seydina Issa, 75–77, *76*
Le Thiofy Studio, 72–73

Liberté: Universal Chronology of Black Protest, 2016 (Diop), 209–10, 216
Life (magazine), 89, 93, 94, 96
Lincoln, Abbey, 96
Lo, N'Diaye, 8
London, 96
Longwood Art Gallery, 176–77
Look (magazine), 89
Lopez, Julien, 72
L. W. Seavy, 64
Ly, Omar, 72–73

Maam Coumba (Thiam), 177, 178, 180
MacDougall, David, 22, 59, 77, 230
magazines: Black readers and, 89–90; in colonial Senegal, 90–91; fashion and clothing in, 10; popularity of, 89; social documentary photography and, 94. *See also Bingo* (magazine)
Magnin, André, 213
Magnin-A (Paris), 213
Maharafa, Tandina, 101, *102*
mail-order catalogs, 113
Makhumu, Nomusa, 17, 59
Mali. *See* Keïta, Seydou; Rencontres de Bamako/African Biennale of Photography (Bamako, Mali); Sidibé, Malick
Mamadou, Barry, 93
Mandémory, Boubacar Touré, 130, 138–39, 212–13, 214
Mann, Gregory, 110
maximalism, 65–67, 70, 71–82
M'backe, Awa Balla, 75–77, *76*
Mbacke, Serigne Abdou Khadre, *21*
Mbacke, Sokhna Nata, 8
mbaraan, 155–56
mbubu, 51, 61, 72, 115, 116
Mercer, Kobena, 80
Metropolitan Museum of Art (New York), 39–40
migration: family portraits and, 1–5, 10–11, 13–16, 135, 143, 155–56, 159–60; from rural areas, 2, 134, 137–38; from Saint-Louis (Ndar), 194–95

Mirages de Paris (Socé), 132n18
mobility, 238. *See also* itinerant photography; migration
Mofokeng, Santu, 17, 29
Momodu-Gordon, Hansi, 224, 227
Moore, Allison, 22
Murid tariqa, 22, 171, *191*, 192–93
Musée du CRDS (Saint-Louis), 176–77
Musée du quai Branly (Paris), 39–40, 243
museum anthropology, 30
Museum of Black Civilizations (Dakar), 239–40
Museum of Contemporary Photography (MuPho) (Saint-Louis), 171
Museum of Fine Art (Boston), 39–40
Museum of Photography (Saint-Louis), 239
museums: COVID-19 pandemic and, 239; fieldwork and ethnography in, 29–32; photographic collections from Senegal in, 18–19, 39–41, 42–43, 61; protocols for displaying photographs in, 171. *See also* archives; restitution and repatriation projects; *specific museums*

Natalou diguenou Domou Ndar (postcard), 67, *68*
National Archives of Senegal (Archives nationales du Sénégal): history and collections of, 16–17, 36, 38–39, *39*, 41–46, *43*, *47*, 47, 60–61, *62*, 180–82; Thiam at, 22, 36–39, *37*, 41–46, *47*, 60–61, *62*
Ndiaye, Adama, 214
ndokkette (*kamisolu taraab*), 88, 89, 92
necrography, 241
Négritude, 206
New York Times (newspaper), 211–12
ngeganol, 81
ngente (baby-naming ceremony), 13, 67, 158, 159–61, 223–24
Nguuka, 67
Niang, Mame-Diarra, 139
Niass, Serigne Baye, 88

Nigeria. *See* Lagos, Nigeria
Nimis, Érika, 18
Njami, Simon, 36
Noal, Émile, 53–54, 55
Nunn, Cedric, 130
Nyamnjoh, Francis, 156
Nzewi, Ugochukwu-Smooth C., 228

Les objets témoins I (Objects that Bear Witness I) (Thiam), 195, 196–200, 197–99
Les objets témoins II (Objects that Bear Witness II) (Thiam), 194, 195–200
Okereke, Emeka, 29
Osodi, George, 29, 173, 213
Oudrago, Martial, 93–94
Ouédraogo, Jean-Bernard, 143
Overseas Colonial Archives (Archives nationales d'outre-mer) (Aix-en-Provence), 39

pan-Africanism, 227, 229–30
PANAPRESS, 130
Paris-Dakar (daily paper), 90–91, 94–95, 96–97, 116
Paris Match (magazine), 88, 89, 90–91, 93
Paris Photo, 211
Partcours (annual exhibition), 176–77
Paysages et types de mœurs du Sénégal (Landscapes and customs of Senegal) (Bonnevide), 59, 60
Peffer, John, 46
personal cameras, 118, 119, 122–23, 134
Peterson, Nicolas, 160
photo-elicitation, 28
photography labs, 11, 135–37, 136–37
photojournalism, 51, 68–70, 96, 130
Photo Peroche, 96–97
Photo Simon-Huchet, 96–97
Pinney, Christopher: on corpothetics, 22, 41; on portraiture, 74, 75, 139, 163–64, 234–35; on "transformational potentialities" and "volatility" of photographic practices, 160

Les Pof, 67
portable cameras, 118, 119, 122–23, 134
Portraits "Vintage" (Thiam): backdrops in, 190, 192; portraits of religious leaders in, 191, 192–93; Underwood and, 36; vintage and contemporary photography in, 20, 21, 173, 174, 181, 182–95, 185, 187–89, 191
portraiture in Senegal: archives and, 16–27, 237–38. *See also* National Archives of Senegal (Archives nationales du Sénégal); as decorative element in homes, 87–88, 87, 89, 141–42, 143–48, 144, 146, 148; as *diis naa* (heavy), 4, 6–10, 152–56, 162, 242, 244; ethnographic methods and, 27–31; global art market and, 5, 18–19. *See also* museums; importance and role of, 5–13; migration and, 1–5, 10–11, 13–16, 135, 143, 155–56, 159–60; preservation efforts and, 5. *See also* Dak'Art (Biennial of Contemporary African Art, Dakar); Diop, Omar Victor; Rencontres de Bamako/African Biennale of Photography (Bamako, Mali); Thiam, Ibrahima; as visceral, 13–16. *See also* itinerant photography; studio photography
postcards: colonial photography and, 38, 41–46, 54, 56–59, 58, 61, 67–70, 68–69; at National Archives of Senegal, 38, 41–46, 43, 47, 47, 180–82
Powis, Richard, 166n17
Présence Africaine (journal), 93
Project Diaspora: Self-Portraits, 2014 (Diop), 209–10, 214, 230, 232
props: Diop and, 209, 215–16, 221, 227–28, 230; Keïta and, 77, 228; maximalism and, 70, 71, 73–74, 75–77

Reflet (Thiam), 177–78
Reflet du miroir (Thiam), 178
religious leaders, portraits of: in *Bingo* (magazine), 74–77, 76, 95, 109–10, 109; as decorative element in homes, 88,

141–42, 143, 147; in popular culture, 6, 8, 81; Thiam and, *191*, 192–93
Re-Mixing Hollywood, 2013 (Diop and Tempé), 209–10
Rencontres de Bamako/African Biennale of Photography (Bamako, Mali): Diop and, 203, 210–12; Mandémory on, 212–13; preservation of portrait photography and, 5; Radisson Hotel attack (2015) and, 29, 239; Thiam and, 168–73, *168*, 176–77
restitution and repatriation projects, 28, 40–41, 44, 240, 241, 243–44
Reuters, 130
reverse-glass (*souvrre*) painting, *9*, 88
Richard, Analiese, 176
robe bolok, 105, 115, 116
Roberts, Allen F., 6, 193
Rudnyckyj, Daromir, 176
Rutherford, Danilyn, 42
Rythmes du Khalam (Socé), 132n18

Sabel, Fatou Diop, 105, *107*
"Sahel Gris" (Gray Sahel) (Niang), 139
Saint-Louis (Ndar): history, population and economy of, 46–47; as hub for photographers in colonial Senegal, 46, 47–59, 62–64; migration from, 194–95; migration to, 134; Musée du CRDS in, 176–77; Museum of Contemporary Photography (MuPho) in, 171; Museum of Photography in, 239; studio photography in, 71–72; Tacher's postcards of, 42, *43*, 44–45, 47, *47*; Thiam and, 41–42, 44, 194, 195–200, *197–99*
"Saint-Louis, Rue André-Lebon ou Grande Rue" (Tacher), 47, *47*
Sakaly, Abderramane, 228
Sarr, Felwine, 40, 240
Sarr, Khady, 101
Sarr, Yayou, 24
Savoy, Bénédicte, 40, 240
Searing, James, 16–17

Second World Black and African Festival of Arts and Culture (FESTAC '77) (Lagos, Nigeria, 1977), 206
Self-Portraits (Makhumu), 17
Sembene, Ousmane, 88, 123
Senegal Photo, 101–3
Senghor, Léopold Sédar, 80, 115–16, 206, 239
Sepia (magazine), 89–90
sër-u-rabbal, 161
Short Century (Museum of Contemporary Art, Chicago), 28
Sidibé, Malick: Diop and, 203, 204, 205, 216, 219; global art world and, 171; nationalist framing of, 216; props and, 228; Thiam and, 180
Sidibé, Malik, 18
signare (wealthy women), 46, 47–48
silver gelatin photography, 49, *50*, 56, 61–62, *63*, 68–70, *69*, 72
Simpafric-Sotiba, 7
Simpson, H. A. L., 57
Sissako, Abderahmane, 234
Sitou, Tijani, 216
Smith, Benjamin Richard, 175
Smithsonian Institution, 39–40
Smithsonian Museum of the American Indian, 243
Smithsonian National Museum of African Art, 42–43
Socé, Ousmane: *Bingo* (magazine) and, 91, 93, 94–95, 97–101, 105, 108–9, 112, 116–18, *117*, 128–29; education and political career of, 94; literary ambitions of, 93
social documentary photography, 94, 95, 100
social media: Diop's use of, 207–9; social role of photography and, 3–4, 6, 11, 13–16, 138–39, 148–50, *149*; Thiam on, 167
social networks and social relationships: *Bingo* (magazine) and, 101; role of

family portraits and photo albums in, 10–13, 135, 140, 143–48, *148–49*, 150–65; social media and, 3–4, 138–39, 148–50; Thiam on, 167, 169, 173–78, 182–95, 200, 237
South Africa, 90, 94, 130
souverre (reverse-glass) painting, 9, 88
Spyer, Patricia, 56
State University of New York–Stony Brook, 176–77
Stein, Sally, 133n31
Stoller, Paul, 223
Strassler, Karen, 72, 160
Strathern, Marilyn, 88–89, 152
Studio Artista, 72
Studio Harcourt, 80, 101
Studio Mobil Tiger, 138
The Studio of Vanities, since 2012 (Diop): backdrops and cloth in, 202, 209, 215–16, 219–30, 226, 229, 233, 234; global art world and, 202–6; studio photography tradition and, 26, 202–6, 215–22, 220–21
studio photography: *Bingo* (magazine) and, 97–105, *98–99*, *102–4*, *106–7*; in colonial Senegal, 49–59, *52–53*, 68–70; decline of, 5, 11, 18, 90, 130, 134, 137–38, 140; Diop and, 12, 25–26, 26, 202–6, 215–22, 220–21, 237, 243; global art market and, 18–19. *See also* museums; maximalism and, 71–82, 72
Sufi Islam, 184. *See also* Murid tariqa
Sursock, Émile, 54, 72
suwer (*sous verre*) portraits, 64, 65
Sy, Djibril, 130, 140
Sy, Doro, 71–72
Sy, Malick, 74, 109–10, *109*
Sylla, Adama, 40, 71–72

Tacher, Pierre, 42, 43, 44–45, 47, *47*, 54
Tempé, Antoine, 209–10
Tennequin, 74

Tête propre (Diop), 210, 211
Thiam, Ibrahima: on archives, 17, 19–20, 172; on Benyoumoff, 64; collecting and preservation practices of, 174–76, 179, 180–82; on colonial photography, 56; Dak'Art and, 29, 36; family and education of, 174; on Gaye, 73; global art world and, 29, 176–77; itinerant photography and, 202; Murid tariqa and, 22, 171, *191*, 192–93; at National Archives of Senegal, 22, 36–39, *37*, 41–46, 47, 60–61; on new photographic technologies, 167; on portraiture as cultural process, 80–82; self-portrait of, *177*, 178–80; on Senegal's photographic heritage, 18, 19–22, 36, 38, 40, 205, 237–38, 240–43; on social networks and social relationships, 167, 169, 173–78, 182–95, 200, 237; work on vintage photographs by, 12, 17–18, 26–27, 167–74, *194*, 195–200, *197–99*. *See also Cliche´s d'hier, Saint-Louis* (Images of Yesterday, Saint-Louis) (Thiam); *Portraits "Vintage"* (Thiam); on *xoymet*, 67–68
Thiam, Mame Samba Lawbé, 60–61, 62
Thiaw, Coura, 77
thick photography, 6–10, 44
Thompson, Krista A.: on "being seen being seen," 85, 95, 131n14, 229–30; on colonial photography, 25, 54, 56, 57; on screens, 193
Timbuktu (film), 234
tirailleurs sénégalais (Senegalese sharpshooters), 93, 95, 110, *111*, 118–19
Tisci, Riccardo, 230
Touré, Samory, 53–54, *55*
tourism, 56
Tropenmuseum (Amsterdam), 39–40
Tropical Jazz (band), 96
Tropical Studio, 73, 101–5, *103*. *See also* Gaye, Meïssa
Tsinhnahjinnie, Hulleah J., 17

Underwood, Joseph, 36, 178, 195
UNESCO (United Nations Educational, Scientific and Cultural Organization), 46, 195, 239
United States: magazines in, 89–90; migration to, 2–3; photographic collections from Senegal in, 39–40, 42–43
Universal Negro Improvement Association, 57
Uniwax, 227

La Vie africaine (magazine), 90–91
vintage prints, 38–39
Vlisco, 227
Vogel, Susan, 213
Vues de Dos (*Back Views*) (Sidibé), 180

Walther Collection, 54
Warner, Michael, 157–58
Warner, Tobias, 100, 105
Washington, Augustus, 48–49
Wax Dolls (Diop), 227
wax-print cloth (fancy cloth, African-print cloth), 81, 218, 227, 234
Webb, Virginia, 56
wedding photographs: in *Bingo* (magazine), 96; as decorative element in homes, 143–48, 146, 148; *ngeganol* and, 81; photo albums and, 162–64; studio photography and, 140; *xoymet* and, 67–68, 70, 87–88, 147, 170, 197
Weiner, Annette, 18

The West Indian Gazette (weekly newspaper), 90
wet-collodion negative, 49
wigs, 67, 68–69, 77, 79, 80, 207
Wiley, Kehinde, 194, 214, 215, 230–31
Willis, Deborah, 26, 230
Willumson, Glenn, 27
women: as migrants, 1–5; as *signare*, 46, 47–48; social role of family portraits and photo albums and, 10–13, 135, 140, 143–48, 148–49, 150–65
Woodin, 227
World Festival of Black Arts (Festival Mondial des Arts Nègres, FESMAN) (Dakar, , 1966), 206, 234
World War I, 4
World War II: Gaya and, 73; Senegalese soldiers and, 4, 90, 93, 110, 118; shortages of fabric and clothing and, 105, 113
Wright, Christopher, 13

Xala (1975 film), 123
xoymet wedding practice, 67–68, 70, 87–88, 147, 170, 197

YM Pech, 96–97
Young, Gigi, 115

Zinsou, Emile-Derlin, 9
Zonk! (magazine), 90

BETH BUGGENHAGEN is Associate Professor of Anthropology at Indiana University. She is author of *Muslim Families in Global Senegal: Money Takes Care of Shame* and editor (with Anne-Maria Makhulu and Stephen Jackson) of *Hard Work, Hard Times: Global Volatility and African Subjectivities*.

FOR INDIANA UNIVERSITY PRESS

Tony Brewer *Artist and Book Designer*
Brian Carroll *Rights Manager*
Allison Chaplin *Acquisitions Editor*
Gary Dunham *Acquisitions Editor and Director*
Sophia Hebert *Assistant Acquisitions Editor*
Samantha Heffner *Marketing and Publicity Manager*
Brenna Hosman *Production Coordinator*
Katie Huggins *Production Manager*
David Miller *Lead Project Manager/Editor*
Dan Pyle *Online Publishing Manager*
Jennifer L. Witzke *Senior Artist and Book Designer*